BEGINNER'S GUIDE TO
ZBRUSH®

3dtotalPublishing

BEGINNER'S GUIDE TO
ZBRUSH

3dtotalPublishing

3dtotalPublishing

Correspondence: publishing@3dtotal.com
Website: www.3dtotal.com

Every effort has been made to ensure the credits and contact information listed are present and correct. In the case of any errors that have occurred, the publisher respectfully directs readers to the www.3dtotalpublishing.com website for any updated information and/or corrections.

First published in the United Kingdom, 2017, by 3dtotal Publishing.
Address: 3dtotal.com Ltd, 29 Foregate Street, Worcester, WR1 1DS, United Kingdom.

Soft cover ISBN: 978-1-909414-50-1
Printing and binding: Taylor Bloxham (UK)
www.taylorbloxhamgroup.co.uk

Visit www.3dtotalpublishing.com for a complete list of available book titles.

Editor: Marisa Lewis
Graphic design: Matthew Lewis

Special thanks to 3D artist James Suret (www.artstation.com/zerojs) for reviewing the technical aspects of this book.

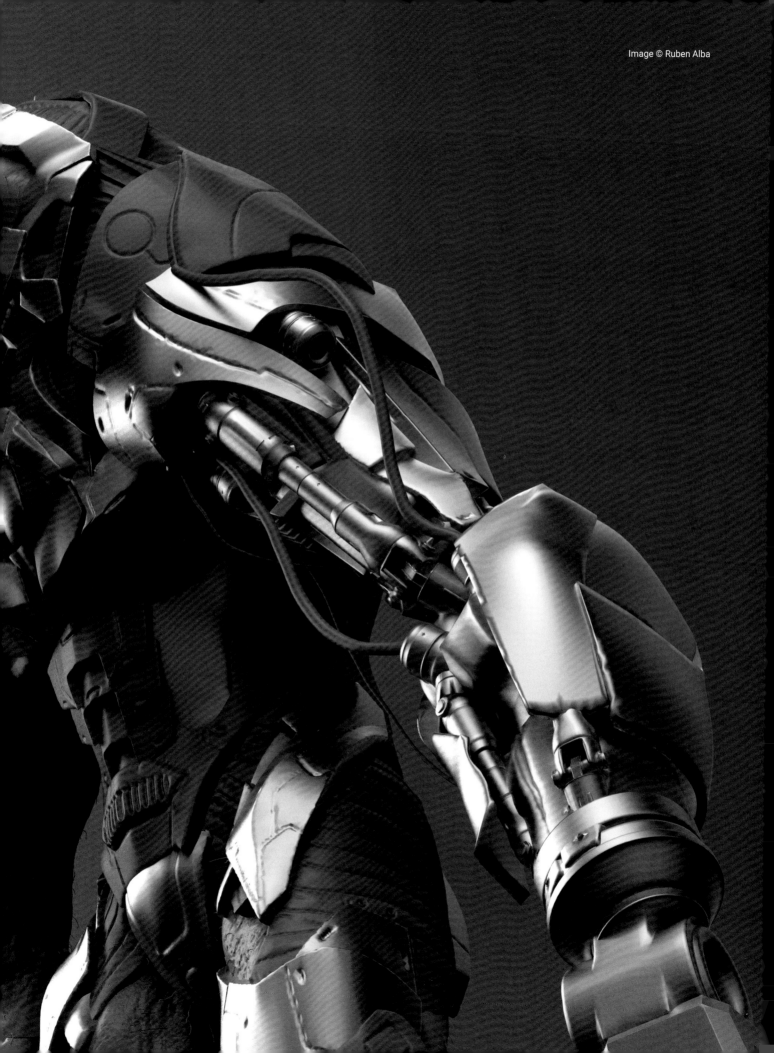

Contents

ZBrush and I

ZBrush was, and still is, a life-changing artistic experience for me. I had been drawing for as long as I could remember, and always wanted to create "things," and so I began my journey to find a way to make a living from making monsters. I come from a period when computers seemed like dark magic, and it took too much technical knowledge to just create what you had in your mind. At that time technology wasn't at a point where there was 3D software available that allowed an artist to come up with an organic idea and run with it. During those years, I studied film animation and art, but I still felt held back somehow. I couldn't visually show people what I really wanted to share.

Then it happened. I was looking around online and saw an image created by the great special effects artist Rick Baker. I was totally blown away by it: a 3D image created in a way that didn't look artificial, had tons of detail, and felt alive! What was this image made with? I tracked the beast down and found its lair in the online forums of ZBrushCentral. A whole new world opened for me as an artist.

I started studying the work of other artists and met many great people who helped me. The more I played with ZBrush, the easier it became. I noticed that technical knowledge wasn't necessary to make the things I wanted to make. All those years of drawing were finally paying off, in a 3D program!

The less you know of other 3D packages, the easier you may find it to learn ZBrush, as it just doesn't resemble anything else on the market. When you are learning, it helps to have a guide that you can quickly open when you want something, because though the internet is great, it is often over-saturated with information and does not always get to the core of your questions. A book like this can help you out, put you on the right track, and enable you to build the career that you always dreamed of.

Maarten Verhoeven
Freelance ZBrush sculptor
mutte.artstation.com

About this book

The huge popularity of Pixologic's ZBrush has changed the landscape of 3D software, giving creators an option that is as close to "hands-on" as digital modeling can get. Nowadays ZBrush is a mainstay of many creative and technical industries, from the ones you would expect (such as animation and video games) to some you might not (such as jewelry design). Artists who would previously stick to the realms of 2D art or traditional clay are increasingly picking up ZBrush as a point of entry into 3D art, as it's a great complement to digital painting or clay modeling.

With *Beginner's Guide to ZBrush*, we have sought to make our most accessible 3D title yet, breaking down the fundamentals of this sometimes dauntingly powerful software so that newcomers and students can start sculpting with ease. The objective of this book is not to go with a fine-tooth comb through all of ZBrush's complex menus and lesser-known functions, but to help you hit the ground running with clear, straightforward 3D workflows that you can start applying to your own projects. The chapters will cover all the commonly used processes and essential tools a ZBrush newcomer needs to know to see a project through from start to finish.

As ZBrush is so widely used in the entertainment industries, and modeling characters and creatures is where it shines the brightest, the tutorials in this book will cover a mix of fantasy and sci-fi concepts from which you will learn a range of approaches to 3D modeling. To get the most out of this book, we recommend following each chapter in sequence, reading each step carefully, and playing around with the tools as you go. ZBrush itself provides many useful, descriptive tool tips, so if you are in doubt or need to refresh your memory, hold the Ctrl key and hover over a tool for a quick pop-up reminder of its keyboard shortcuts and how it works. You will find a handy Glossary at the back of the book. In addition, we have provided a Component Index on pages 258–261 to allow you to quickly check techniques for creating certain elements of a model, as well as to refer to as you work through a project's steps so you can see the component you are focusing on in context. Finally, you will find Key Concepts explained in orange boxes throughout the book, as well as highlighted in the Index; these are tools or ideas that you will encounter frequently, and are worth paying special attention to before you continue.

We hope you enjoy learning from the talented artists in this book and that you will soon be sculpting amazing designs of your own!

Marisa Lewis
Editor, 3dtotal Publishing

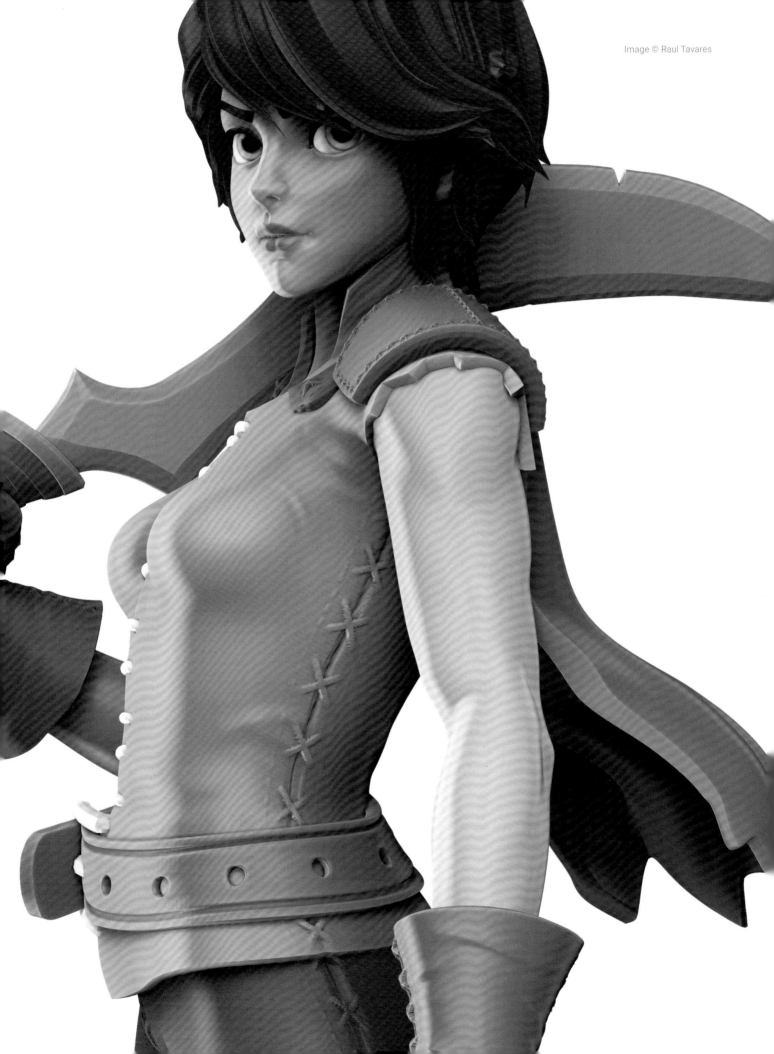

Getting started

Before jumping straight into any projects, it is important to take time to become acquainted with ZBrush's tools and user interface. In these introductory chapters, Pixologic-certified instructor Glen Southern will introduce you to some basic concepts and terminology relating to 3D modeling, before guiding you around the tools and menus that will be essential in this book. The ZBrush workspace can seem like a daunting array of icons, sliders, and menus to a newcomer, but with practice you will soon be able to find your way to all the tools you need.

01
Introduction to ZBrush and 3D

By Glen Southern

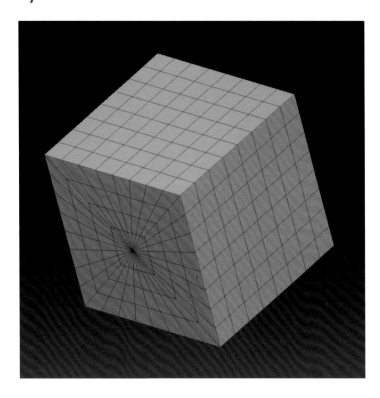

Pixologic's ZBrush offers a unique approach to 3D modeling, allowing artists to manipulate 3D shapes in an organic, spontaneous way. Instead of modeling polygon by polygon like in other 3D packages, ZBrush enables artists to sculpt and carve their model like virtual clay, without being too stifled by technicalities. Now ZBrush is a staple of the 3D industries, used in realizing video games, movies, animations, and physical objects. While ZBrush offers digital artists the nearest feeling to sculpting with clay, it is not quite as simple as playing with a handful of putty – ZBrush is a powerful software with many hidden capabilities and layers of complexity, and can be intimidating to a newcomer. In this introduction we will give you an overview of ZBrush as a whole and the packages available. We will also introduce you to some fundamental concepts that will help you contextualize the tools and methods you will learn throughout the book.

Chapter sections
· The transition to digital sculpting
· Essential tools
· ZBrush versus ZBrushCore

The transition to digital sculpting

01 The benefits of 3D modeling

For many artists, ZBrush can be the first foray into the world of 3D modeling. Whether coming from traditional illustration or physical sculpting, 3D modeling is a fantastic tool to add to your arsenal and allows you to experiment with your designs in new ways. The ability to quickly model and paint a concept and then render it from different angles is often what makes illustrators choose ZBrush, and because it is more organic and less technical, they very often make it their main design tool. There are now lots of concept designers who do as much ZBrush concept work as they do Photoshop. A traditional sculptor who learns ZBrush can try out poses and lay out dynamic scenes without the expense of having to create them physically. Often it offers a way to work out technical issues like proportions and form before committing to real clay.

02 What makes ZBrush different to other 3D packages?

With digital sculpting you very often begin modeling with a primitive shape (see more on

▲ 01 ZBrush is brilliant for artists wanting to test their concepts in 3D. Images © Raul Tavares

page 17) and modify that into your design. This is very different from modeling with a program like Autodesk Maya or Maxon Cinema4D, where you very often start with points, edges, and faces and string these together to make a model. ZBrush very often hides points, edges, and faces from you, which allows you to get on with just being an artist. Generally, ZBrush is better for organic-looking models, including creatures, characters, environments, and jewelry, rather than more technically accurate and harder-edged models like vehicles, buildings, and machine parts. However, this line is becoming blurred as Pixologic adds more and more functionality to ZBrush in every new version release. You may want to learn to model in another package to achieve the accuracy you require and then move that model into ZBrush further down the line. Ultimately, the main advantage with ZBrush is that you can just jump in and sculpt your design without worrying about the underlying structure.

▲ 02 ZBrush can be used for both organic and hard-surface modeling. Images © Carsten Stüben

03 Understanding digital 3D

While ZBrush does offer some simplicity compared to other 3D programs, it is important to understand what is happening underneath the surface, especially if you aim to send your models out to other programs for 3D printing, games, animation, or rendering in another package. If you have come from a 2D or traditional sculpting background, it is important to first realize that the model you are sculpting – often described as a "mesh," "ZTool," or an "asset" – is not a single blob of material like traditional clay but a collection of polygons.

Take a look at the cube in image 03. You can see that it is made up of a number of polygons (the smaller shapes within it marked out by the wireframe). Each polygon consists of vertices (or points), edges, and polygon faces, as shown

and described in image 03. A polygon loop, or poly loop, is a continuous ring of polygon faces that meet back on themselves, like that indicated by the orange polygons in image 03. These help with animation as they deform predictably when moved.

> **KEY CONCEPT**
> **Polygons**
> Familiarize yourself with the concept of vertices, edges, polygon faces, and poly loops now as these terms will come up frequently in the book.

There are different types of polygons you will come across as you read through this book: triangles (or tris), which are polygons made up

of three vertices; quads, which are polygons with exactly four vertices; and n-gons, which are polygons with five or more vertices. ZBrush cannot use n-gons and will convert any model being imported into tris and quads.

04 Primitives

As you learned earlier, the principle behind ZBrush is that you start your modeling with a primitive shape. There are lots of primitives to choose from in ZBrush to get you started, each with different benefits and uses. The images on the next page show a few examples and what they can be used for, and help you to see how complex forms can start as basic shapes.

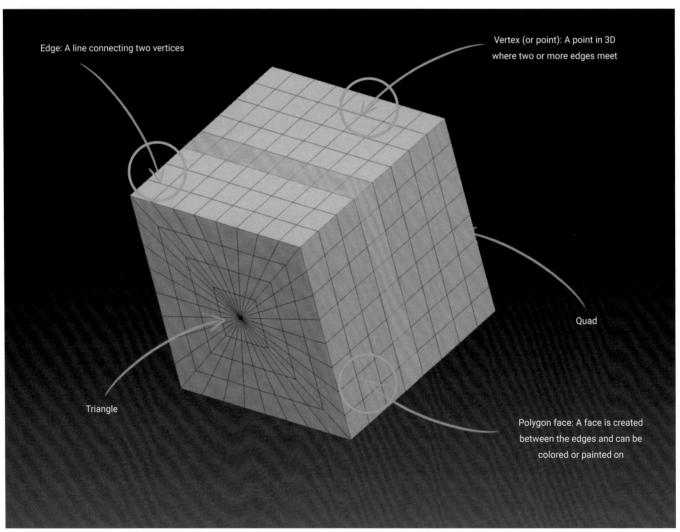

Edge: A line connecting two vertices

Vertex (or point): A point in 3D where two or more edges meet

Quad

Triangle

Polygon face: A face is created between the edges and can be colored or painted on

▲ 03 Ensuring you understand the geometry of polygons will help you as you learn more about ZBrush tools and techniques

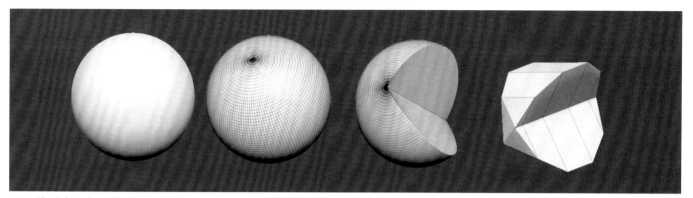

▲ 04a The Sphere3D primitive is probably the most basic one of all and can also provide a wide range of shapes by reducing the polygon count and the coverage (for example see the more angular, far-right example in this image). You can make wedges, slices, character faces, and hemispherical shapes like the top of screws

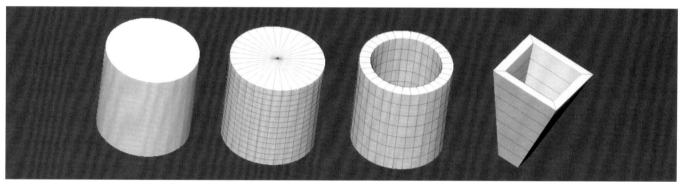

▲ 04b The Cylinder is a great primitive to start making items such as pipes, tubes, rope, and wires. You can hollow out the center to a required dimension

▲ 04c The Ring3D or Torus is perfect for rings, jewelry, and technical parts like O-rings and seals. You can also use it for horns and spikes

▲ 04d The Cube3D is more than just a basic primitive when you start to adjust settings like Twist. By reducing the number of polygons in the X and Y axes you will find all sorts of interesting uses beyond the basic building block

Essential tools

05 Software
ZBrush is a powerful self-contained software package, but is widely used in the industry in conjunction with more traditional modeling programs like 3ds Max and Maya, especially for animation purposes. It is also often used with external rendering software, such as KeyShot (see pages 232–245), to achieve final images of the highest quality. You will not need any software besides ZBrush and an image-editing package such as Photoshop to participate in this book's projects, though you may find the chapter on KeyShot rendering useful if you are aiming to take your renders to a more advanced level.

06 Hardware
It is important to understand that ZBrush is a brush-based program that relies on pressure, and for that reason it is highly recommended you use a graphics tablet for working. It is almost impossible to use all of ZBrush's functions without one. Graphics tablets with interactive displays (such as Wacom's Cintiq range) allow you to work in ZBrush directly on the tablet's pressure-sensitive monitor screen, though having a tablet with a screen is not essential. Note that the instructions in the next chapter are based on someone using default settings and a pressure-sensitive graphics tablet.

ZBrush versus ZBrushCore

07 ZBrushCore features
ZBrush has been around since the late 1990s, and in 2016 was joined by its "lite" version, ZBrushCore. ZBrushCore does exactly what it says on the tin. It has all the core functionality of ZBrush at a significantly lower price point, giving you a good range of tools and features to get up and running with digital sculpting. As it is essentially the same as ZBrush, just with fewer features, none of your learning goes to waste when upgrading to the full version. Pixologic has a fully comprehensive list of the differences between ZBrush and ZBrushCore on their website: zbrushcore.com/features.

08 What's included
There are certain tools that ZBrush is known for and most of those are available in both versions. Some of the hero tools include DynaMesh, which is essential for "remeshing" (or merging) models while in progress and merging meshes together, and the ZSphere function, which allows you to make a fully posable armature from spheres and convert it into a base mesh for further modeling (you will find out more about these tools later). For those who love digital painting, the Polypaint function in both programs allows you to take your characters and creatures to a more finished state. Both programs also offer basic BPR (Best Preview Render) rendering, and can link to the external render engine KeyShot for rendering more complex final pieces.

▲ 05a An overview of the KeyShot workspace

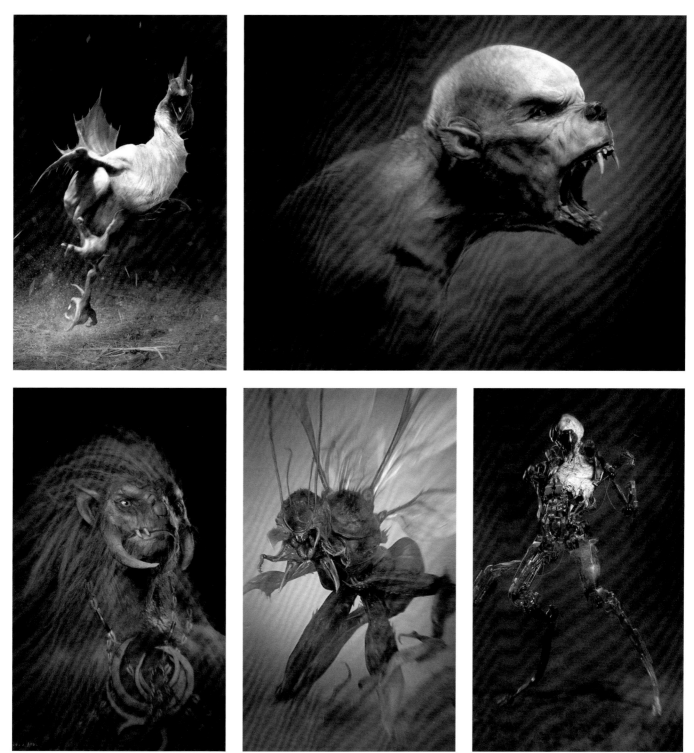

▲ 05b ZBrush, KeyShot, and Photoshop are a powerful combination for finishing portfolio concepts. Images © Ruben Alba

09 What's not included

There are of course some big differences between the two versions and it pays to consider them all before committing to either software. ZBrushCore users are limited to thirty brushes, which may make things difficult if you want to make lots of your own brushes. The document screen size cannot be changed, which means you are not able to render out high-resolution images. There is no support for texture maps, so adding color with Polypaint is as far as you can take a model in ZBrushCore, and there are limited material-editing and import options. In terms of the more advanced features, ZBrushCore does not have ShadowBox, ZSketch, or the ZModeler toolset. Consider these points carefully before you choose the version you use.

02

Introduction to the ZBrush interface

By Glen Southern

This second introductory chapter will help you to get started with both ZBrush and ZBrushCore, and develop a clear understanding of ZBrush's interface, the main toolset, and some basic workflows. We will cover some of the most important things to understand when picking up ZBrush, starting with a general overview of how to move around, manipulate the interface, speed up your work with keyboard shortcuts, and quickly access the tools you need. We will then move on to more specific techniques and tools.

Chapter sections
· Setting up in ZBrush
· Navigating around your model
· Base mesh generation
· Brushes and sculpting tools
· Polypaint
· Texture maps and Spotlight
· Lighting tools
· Rendering tools
· Import and export tools
· The next step

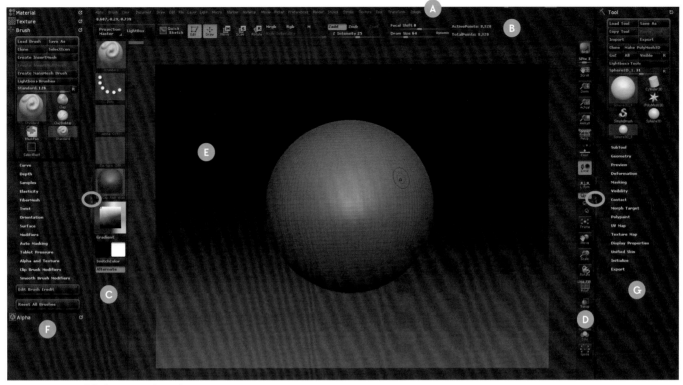

▲ 01 An overview of the basic ZBrush interface

Setting up in ZBrush

01 Understanding the basic interface

The first thing to do when starting out with ZBrush is to learn the overall interface and how you are going to interact with it. ZBrush can be complex for a beginner to navigate, so make sure you familiarize yourself with each component as we discuss them in this chapter.

Image 01 shows an overview of the ZBrush interface. There are a number of panels that can be seen:

A Standard menu list

B Top shelf

C Left shelf

D Right shelf

E Document window

F Left pop-out tray

G Right pop-out tray

The standard menu list and left and right shelves contain many commonly used items. The top shelf also contains a lot of the core tools and features that you will need on a regular basis. They are all available in other menus but it is handy to have them there on the shelf. The document window is the viewport in which your active model is visible. The customizable left and right trays (not to be confused with the shelves) can be opened with the little arrows circled in image 01. If you don't see the trays, click the arrows to reveal them. It is advisable for new users to keep these trays open at all times.

PRO TIP
Hiding the LightBox menu
You may find that when you first open ZBrush, the LightBox browser is open (see page 24), covering a large portion of the document window. To hide this menu and to be able to see the document window in full, simply press the Comma key.

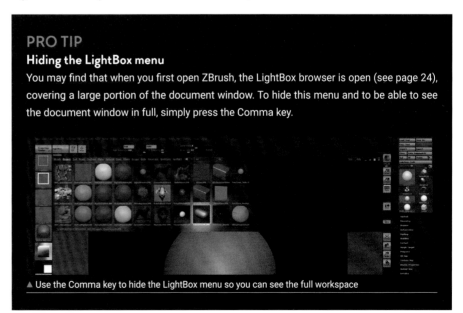

▲ Use the Comma key to hide the LightBox menu so you can see the full workspace

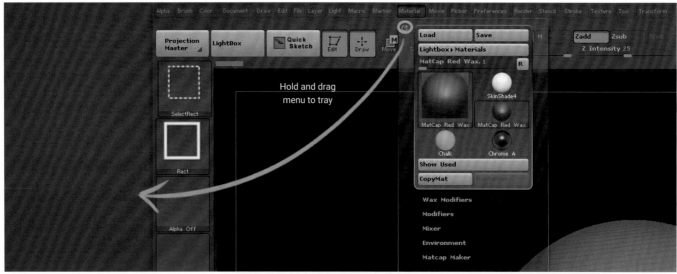

▲ 02 The side trays save time when accessing tools

02 Using the left and right trays

The left and right trays are very convenient because they don't close up when you move away from them (unless you click to close them). You can add any standard menu item to a side tray by simply clicking and holding the icon in the top-left corner and dragging it to the desired tray as shown in image 02. Once there you can roll it closed by clicking on the menu icon in the top-left corner. Once you have dragged the items you want to have in the side tray, you can move up and down by clicking and dragging up or down in between any menu items. If you were to use the same menu item from the standard menu list, it would close after you moved on to your next task, so using the trays instead can save you time. It is useful to add the following menus to each tray:

Left tray
AlphaColor
Material
Stroke
Brush
Texture
ZPlugin

Right tray
Tool
Light
Render

If you are left-handed, use the reverse setup. This matters when using a graphics tablet with an interactive display because it means that your arm does not have to travel too far across

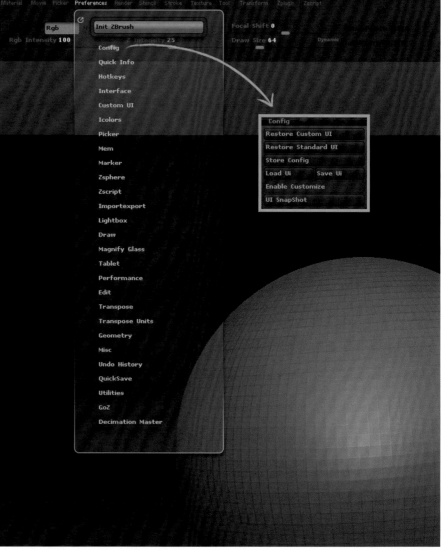

▲ 03 You can save and load custom interface layouts to tailor ZBrush to your workflow

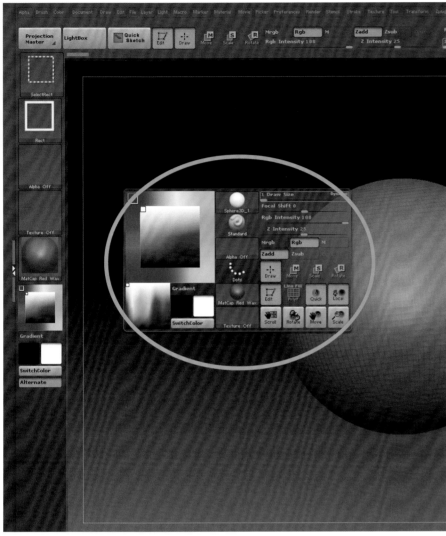

▲ 04 Hold the Space bar to quickly change your tool settings

the screen. This is not so much a problem for standard graphic tablet or mouse users.

03 Saving your interface

Essential for getting to grips with ZBrush is making the interface work for you and your style. Once you have pulled out the basic menu items onto the side trays, you should save the interface. In the standard menu row, go to Preferences > Config > Store Config (Shift + Ctrl + I). From now on, you will find that your new interface layout will be loaded by default when you open ZBrush. You can save this and any other interface you desire by going to Preferences > Config > Save UI; you can reload saved interfaces using Config > Load UI from the same menu.

04 Using the Space bar to access menus

ZBrush offers many ways to access certain tools and features. As you develop as a digital sculptor you will learn the software's keyboard shortcuts and eventually configure your own. For now, one very quick way to access the main tools found in the left and right shelves is to press and hold the Space bar on your keyboard while hovering over the document window. This brings up a pop-up screen located under your cursor (see image 04), giving you a quick way to adjust settings such as Draw Size, Focal Shift, and Rgb and Z Intensity, as well as quick access to the color palette, alphas, brushes, and more.

PRO TIP

Need help? Hover!

Help is built into ZBrush by default. If you hover over most items on the interface for long enough, a dialog box pops up and shows you either a zoomed-in image of the button or some explanatory text. If you hold down Ctrl while hovering you will get a detailed explanation of the tool or feature you are hovering over. There are lots of options to turn these tips on or off in the Preferences menu, but take your time to learn the information shared as it will benefit you in the long term.

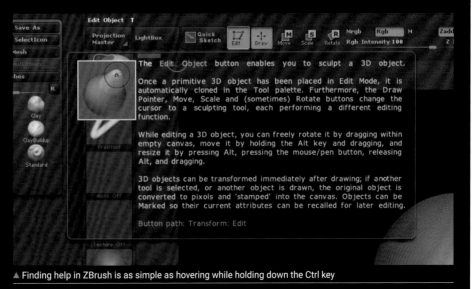

▲ Finding help in ZBrush is as simple as hovering while holding down the Ctrl key

▲ 05 Customize your interface

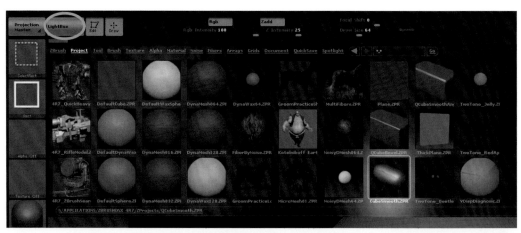

▲ 06 The LightBox palette contains many essential ZBrush resources

▲ 07 The large icons show what tool is currently active, and allow you to access more options

05 Enable Customize

As you learn to use ZBrush you may find that you want to configure the interface even more than we have learned so far. Every item on the interface and within the menus can be moved around to suit your needs. You can bring out the items that you use most and drop them anywhere you like to support your workflow.

To do this, go to Preferences > Config > Enable Customize (image 05). The whole interface will drop slightly, indicating that you are now able to configure it. If you hold the Ctrl + Alt keys you can drag any item around and reposition it. Be sure to turn this feature off once you have finished using it; then save your interface once more as described in step 03 (Preferences > Config > Save UI).

06 LightBox

Image 06 shows the native file browser, LightBox, which can be accessed using the LightBox button as circled. As you learned on page 21, the shortcut to turn it on and off is the Comma key. LightBox gives you access to resources such as default projects and tools that you can use in your own work, including extra alpha brushes, brushes, textures, materials, and grids. We will not look at its functionality now, but later on we will discuss how to save your own items and load them back in from LightBox as needed.

07 Large icon navigation

In most ZBrush menus you will find a large icon representing the currently selected item from that menu, which also provides a way to access other items in the set. Image 07 shows the Texture panel as an example. With a quick glance at the large icon, as circled in part A of image 07, you can see what tool or item you currently have at your disposal. If you need to change it you can simply click that large icon to reveal the full set of items, as seen in part B of image 07.

08 Alphabetical menus

In some areas of ZBrush you will find that you can navigate a menu structure alphabetically. A good example is the Brush menu. (Note that you will need to have carried out steps 10 and 12 in order to access the Brush menu.) Hitting the B key will bring up the full range of brushes currently loaded in ZBrush. To refine this, hitting the C key will reduce the available brushes

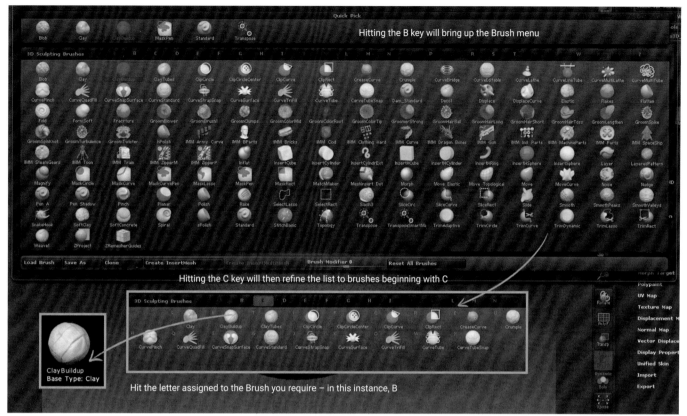

Hitting the B key will bring up the Brush menu

Hitting the C key will then refine the list to brushes beginning with C

ClayBuildup
Base Type: Clay

Hit the letter assigned to the Brush you require – in this instance, B

▲ 08 Brushes are sorted by name, allowing you to navigate to them using your keyboard

down to only those beginning with the letter C. To choose the Clay Buildup brush in this instance, as shown in image 08, hit the B key to select the desired brush. If you look at the large icon in the top left of the Brush panel on your screen, you will see that the Clay Buildup brush is now loaded and ready to use.

09 Floor and Perspective

ZBrush does not have isometric "quad view" windows like a lot of other 3D software, and it does not have a "camera" in the typical 3D sense of the word; in other 3D software you would view your stationary model from different angles, as if through fixed cameras. In ZBrush, the document window is the only view you have and you move your 3D model around in space to view it from different angles. To help you do this, there are a couple of buttons to be aware of before we move on to navigation in the next section. Hitting the P key puts the model into Perspective mode, which allows you to see your model with foreshortening. This is useful for understanding the model in the context of different angles. Shift + P turns on the Floor,

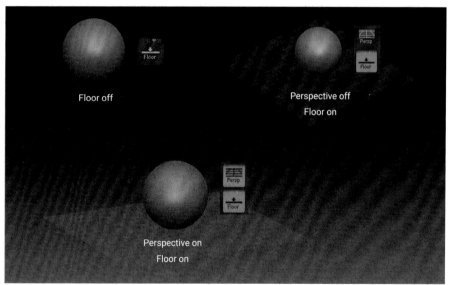

▲ 09 The Floor and Perspective modes offer different views and angles of your model

which produces a green floor grid underneath your model, helping you to check how your creation sits on the ground. You will soon see how important these two features are. The quick access buttons are available on the right shelf in the ZBrush interface and are included for reference in image 09.

You may notice there is also a Local button on the right shelf. This adds symmetry in the local position of the current SubTool, allowing you to work symmetrically on objects that are away from the world center. However, it is more advanced so you will not need it at this stage in your ZBrush journey.

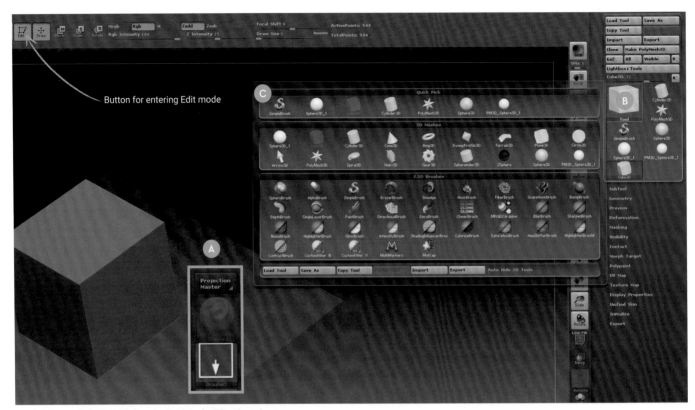

▲ 10 Opening a Cube3D and dragging it out in the ZBrush workspace

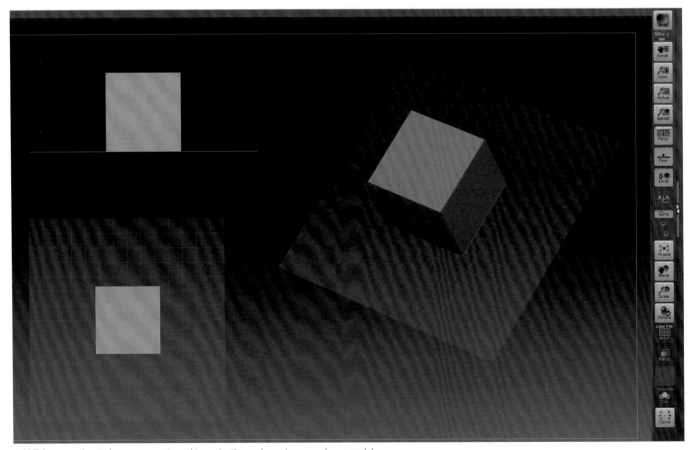

▲ 11 Take some time to become accustomed to navigating and panning around your model

Navigating around your model

10 Opening a model

One essential routine to learn in ZBrush is opening a model. Note that the large Stroke icon in the left shelf needs to indicate that you are in DragRect mode for the following to work (A in image 10). Go to the Tool panel and click on the large icon (B). This will reveal the full set of items available (C). Let's choose to open Cube3D. Click and drag it out in the center of the document window and hit the T key to enter Edit mode. This means the model is now "live" in the window and can be moved, rotated, and scaled, as you will discover in the next step. Now you can turn on the Floor (Shift + P) or activate Perspective (P key) if they help.

11 Moving, rotating, and zooming

We cannot sculpt on this mesh in its current state, however, we can move, rotate, and zoom in and out of the model as needed. To rotate the scene, simply click and hold away from the model and move around. If you are using a tablet stylus, this is as simple as pressing the pen nib down and moving it. If you want to lock your view to a specific axis, hold Shift as you are rotating and it will snap to the closest orientation (top, front, back, or left view). If you have Perspective turned off, this effectively gives you the orthographic views you would find in other 3D programs.

Hold Alt + the left-mouse button (LMB) to move around, and use Alt + LMB then release Alt to zoom in and out. This may be slightly different depending on your setup (mouse or tablet), so adjust your tool's settings if you need to. Take your time learning to rotate, move, and zoom, as this will really help you in the next few sections.

12 Making it editable

To make the model editable so that we can start sculpting on it, go to Tool > Make PolyMesh3D. This converts the model to allow us to sculpt on it. Once Make PolyMesh3D has been selected, you can use the Move, Scale, and Rotate functions in the same way as you learned in the previous step.

At this stage, if you wish, you can just grab a brush and start sculpting on the model. If you accidentally drop unwanted items onto the canvas, you can simply clear the screen with Ctrl + N and start again (you need to have Edit mode turned off for this to work). If you don't make the mistake and "drop to canvas," Ctrl + N does nothing. It is a great shortcut to remember when you are a new user as it can't do any harm just to clear the screen if you get into trouble.

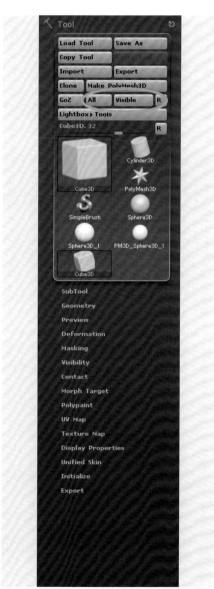

▲ 12 Convert to PolyMesh3D so you can sculpt

PRO TIP
Changing the field of view
You may want to adjust your view to make a model look bigger or smaller in the scene. While there isn't a traditional camera in ZBrush, there is a way to adjust this for your renders. Go to the Draw menu and look for Angle Of View. You can increase or reduce the setting depending on what angle you want to emulate.

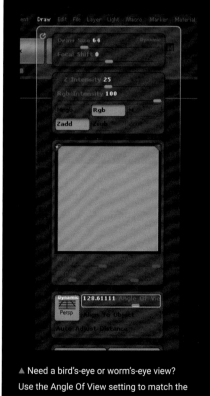

▲ Need a bird's-eye or worm's-eye view? Use the Angle Of View setting to match the camera angle you are hoping to emulate

13 Moving with the Transpose line

What if you want to move your model around independently of the scene (or floor)? This requires the use of the Transpose line. Note that the Transpose line is only available after you have clicked Make PolyMesh3D. To activate the Transpose line, hit the W key or the Move icon on the top shelf. This gives access to a line with three circles on it and marker points in between them. You can click on the model and redraw this line out in a way that makes it easy to see. Use the larger, outer circles to move the points of the Transpose line and the smaller, inner circles to deform the model when in Move mode. The first circle on the Transpose line is essentially a temporary pivot point which is used more in the rotation function (A in image 13). The second circle in the chain is one you can click on to actually move the model around (B). Notice that the floor does not move. The last of the three circles will perform what is called a Move Scale (C). This will increase or decrease the model's scale along the axis you have drawn out. Holding Shift while drawing out the Transpose line will snap it to the relevant axis (D).

14 Using Transpose to scale and rotate

The other two uses for the Transpose line are to scale and rotate an object. They work in the same way as when you are dragging out the Transpose line itself. Use the E key to activate Scale and the R key to activate Rotate (or hit the icons on the top shelf). Here you use the outer circle to control the rotation and scaling functions (image 14a), rather than the middle one, which you used for moving. In either mode, drag the outer circle in the desired direction and the model will follow along (scaling or rotating) independently of the floor/scene. With a combination of Move, Scale, and Rotate you can move your models into any position or orientation as needed.

You can also transform the geometry with this tool. For example, if you start with a sphere you can use the outer circle of the Transpose line in Move mode to flatten it into a disc (image 14b).

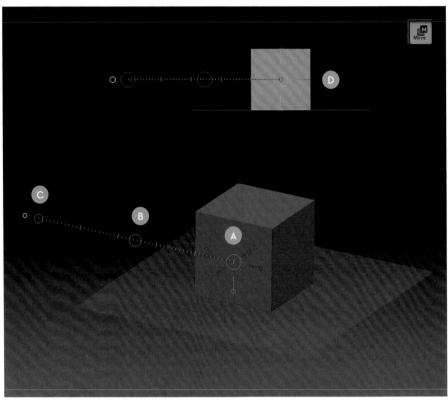

▲ 13 The Transpose line is a complex tool that can be used to move and edit your mesh

PRO TIP
Gizmo 3D

In the newest version of ZBrush when you press the Move, Scale, or Rotate icons (or the W, E, or R keys) the new Gizmo 3D tool will be active instead of the traditional Transpose line tool. You can click on the Gizmo 3D icon on the top shelf to switch back to the Transpose line tool. The Gizmo 3D tool allows you to move, rotate, and scale an object in a similar way to more traditional 3D modeling software. To move the object in a particular direction, click and drag on the cones at the end of the axis lines. Click on the rectangles to scale the model in that direction, or the central square to scale in all directions. To rotate the object, click and drag on the spherical lines.

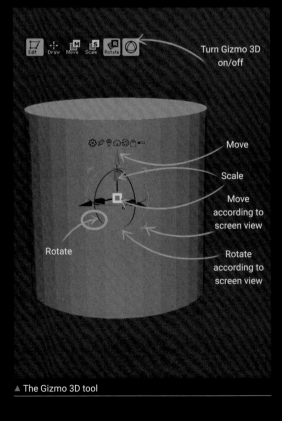

Turn Gizmo 3D on/off

Move

Scale

Move according to screen view

Rotate according to screen view

Rotate

▲ The Gizmo 3D tool

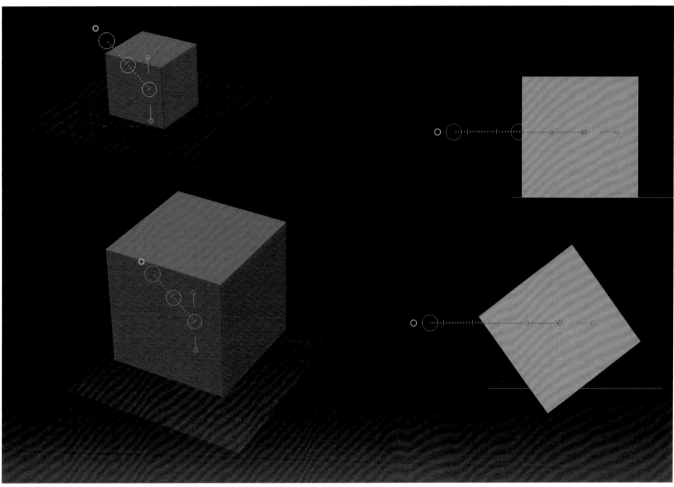

▲ 14a The Transpose line can also be used to rotate and scale your model

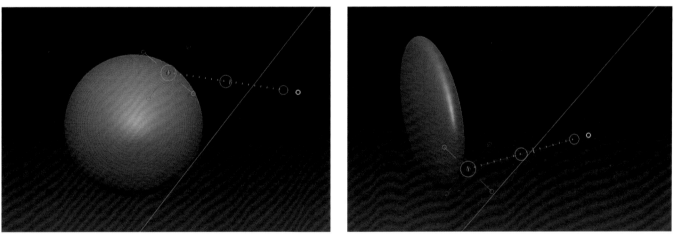

▲ 14b As well as moving and rotating an object, the Transpose line can also be used to change the shape of a mesh

KEY CONCEPT
The Transpose line
Familiarize yourself with this tool now as it will be central to the workflows you will use in this book. You can find some more tips and explanations of the different functions on page 183.

Base mesh generation

15 Basic ZBrush meshes

In ZBrush you have the ability to try out some of the default ZTools and adjust their parameters before making the model a PolyMesh3D object so you can sculpt on it. To try this, go to the Tool panel and select Ring3D (a torus shape) by clicking the large icon to bring up the different shapes available. Note that if you want to do this in a clear document you can go to Document > New Document. Click and drag the Ring3D out on the canvas and hit the T key to activate Edit mode. Open the Material panel and choose a white material (SkinShade4 is best). Hit Shift + F (or the square PolyF icon on the right of the viewport) to enter Polyframe mode and show the object's wireframe so you can see the polygons and how they are affected by the transformation.

If you open Initialize, down at the bottom of the Tool panel, you will find sliders to adjust the torus in different ways, such as changing the radius, radial coverage, and twist. Play around with these, trying some of the settings shown in image 15. When you are happy to use this model and want to sculpt on it, hit Make PolyMesh3D. Try this process with other default ZTools available in the Tool panel. In chapter 05, you will explore using the Quick Mesh options in the Initialize menu, which are especially useful for building up hard-surface meshes.

16 Using DynaMesh

As explained in the Key Concept box on this page, DynaMesh is an essential ZBrush tool that helps to resolve any problematic distortion of your geometry that may occur as you sculpt. To try out DynaMesh, choose a Sphere3D object from the Tool panel, drag it onto the canvas, then enter Edit mode (T key). Go to Tool > Make PolyMesh3D (shape A in image 16). Now select the Move brush (the B, M, and V keys in ZBrush or the B, M, and O keys in ZBrushCore). Hold the Space bar and make your brush Draw Size larger until the ring is bigger than the ZTool

(this is sometimes trial and error so feel free to undo (Ctrl + Z) and try a different Draw Size). Then drag the bottom of the sphere down so it looks like shape B in image 16.

Now go to Tool > Geometry > DynaMesh and activate it by clicking the large DynaMesh button (C). At 128 resolution you will see that the polygons indicated by the wireframe on your model become finer and therefore less distorted than before (D). You can change the DynaMesh resolution if you want it to be more or less dense. With a lower DynaMesh resolution setting, the resulting resolution of the mesh will make it easier to sculpt with.

As you model, you may want to apply DynaMesh again. While the DynaMesh button is activated, simply drag anywhere outside the model while holding Ctrl to repeat the function. You will see the polygons on your model change as a result. You can change the DynaMesh Resolution slider then repeat this process to apply DynaMesh again. Note that the Ctrl + drag function can both remove a mask (see next step) and apply DynaMesh. If you have accidentally drawn a mask, you cannot apply DynaMesh, so the first time you Ctrl + drag it will remove the mask.

KEY CONCEPT
DynaMesh
Digital clay is made up of polygons, which emulate the surface of a clay sculpt in the real world. There are some limitations in how the polygons in a model can be stretched. Elongated or stretched polygons often give bad artifacts that are hard to smooth out and sometimes render in odd ways. This is the same in all 3D modeling and is best avoided. To counter this problem, ZBrush offers DynaMesh, which helps you to keep polygons evenly distributed across a model's surface. Without it, meshes can start to stretch and deform as you sculpt.

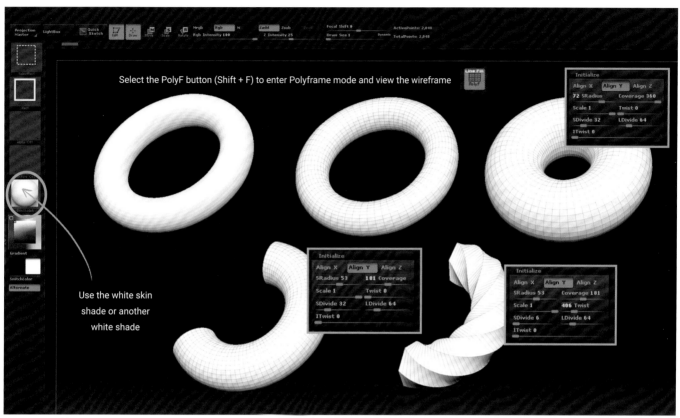

Select the PolyF button (Shift + F) to enter Polyframe mode and view the wireframe

Use the white skin shade or another white shade

▲ 15 ZBrush offers many basic primitive shapes for you to edit and experiment with

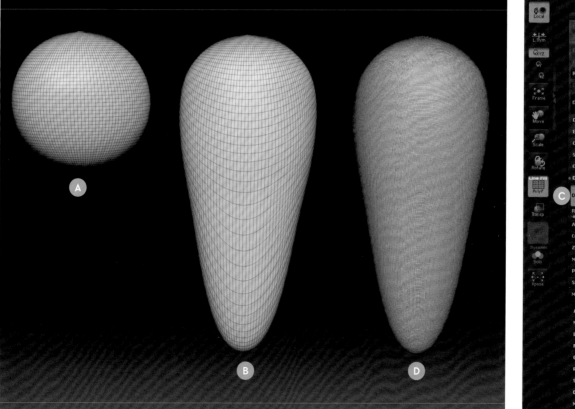

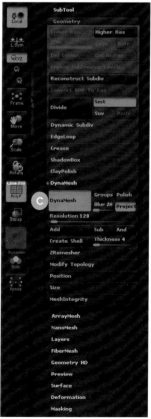

▲ 16 The topology of a mesh can become distorted and difficult to work with (A). These problems can be avoided by applying DynaMesh (D)

17 Masking

To get the most out of ZBrush you will need to be good at masking. Masking temporarily protects an area, allowing you to work nearby without accidentally editing it. It is also useful for making Polygroups, which we will cover in step 49, and hiding or showing parts of a mesh. We can learn the basics of masking an object using the DynaMeshed shape from the previous step. Hold Ctrl and drag a shape onto the model. This gives you a dark masked area wherever you drag. If you drag on the model you automatically use the MaskPen, which is like drawing your mask freehand. We will look into brushes further in steps 22–35, but for now, for the purposes of illustrating how a mask works, select a Clay brush and just click and drag across the model and around the masked area to observe how the mask acts as a buffer against the brush.

For other ways to apply masks, hold Ctrl and click in the Brush window to see more brush options, such as MaskLasso and MaskCircle. To remove parts of the mask, use the Ctrl + Alt keys with any brush. If you are using MaskCircle or MaskLasso, you can move the mask around by holding Ctrl and the Space bar while dragging. As mentioned in step 16, you can also remove a mask by Ctrl + dragging outside the model area. You will notice that in image 17 I have removed the wireframe by hitting Shift + F again.

18 SubTools

At some point you will want more than one object in your scene. Breaking a subject into parts makes it easier to work on, like layers in Photoshop. For example, you may want to make a head with separate eyes, separate glasses, and a hat. For a simpler example, go to the Tool panel and choose the Cube3D object. Drag it out onto the canvas, hit the T key, then Make PolyMesh3D. Now go to Tool > SubTool and note that there is only one layer with a cube on it. In the panel below, click Duplicate and you will now have two cubes in the same space. Select the second layer in the SubTool panel, go to the Move tool (W key), and use the Transpose line as discussed in step 13 to move the second cube away from the first. Repeat this process again and you will have three cubes in one ZTool. Pressing the N key shows you all your SubTools, and clicking Alt + LMB on an object anywhere in the document window will select that SubTool. You can rename any SubTool to better identify it by using the Rename button.

If you want to create a new SubTool with a different shape, use the Append button in the SubTool palette. Append will add a shape to the bottom of the SubTool stack; Insert will add a shape below the one you currently have selected. The SubTool you create will already be PolyMesh3D, so you can move it around using the Transpose line as usual. You will learn more about building up a base mesh using SubTools on pages 56–57.

19 Subdivision levels

To sculpt effectively you will need to use high-resolution polygon models. This is because more polygons means that more surface detail is achievable. A model with fewer polygons is blocky and angular. To increase the polygon count we can use DynaMesh as seen in step 16 and we can also go up subdivision levels. DynaMesh averages out the polygons across the mesh whereas subdivision divides each

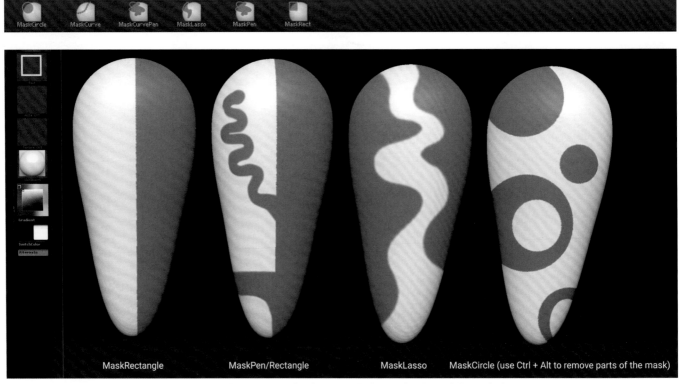

| MaskRectangle | MaskPen/Rectangle | MaskLasso | MaskCircle (use Ctrl + Alt to remove parts of the mask) |

▲ 17 Masking helps to protect areas of a mesh that you do not want to edit. There are multiple Mask brushes to help you do this

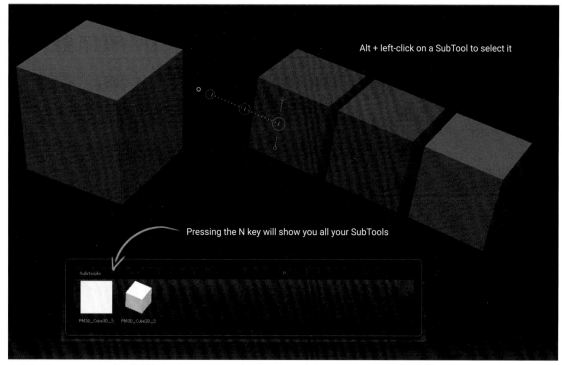

Alt + left-click on a SubTool to select it

Pressing the N key will show you all your SubTools

▲ 18 Splitting your project into SubTools allows you to work with additional shapes and makes the modeling process much easier to manage

polygon by four to give more resolution to work with. Open up a Cube3D and convert it to PolyMesh3D as previously shown. Note the polygon count when you hover over the Cube3D icon in the Tool panel (A in image 19a). Click Tool > Geometry > Divide (B) and the model will go up by one subdivision level to four times the original number of polygons. Now repeat and you will see that the number of polygons is multiplied by four again, and again (see image 19b on the next page). When you sculpt on this

model it will now be smooth and precise. The current subdivision level will be shown near the top of the Geometry menu (C).

To increase the resolution the shortcut is Ctrl + D. You can also go down the subdivision levels if you need to by using Tool > Geometry > Lower Res (D in image 19a). The shortcut to lower the resolution is Shift + D. To go back up again it is the D key. You can also freeze the subdivision levels (Tool > Geometry >

Freeze SubDivision Levels), which some features in ZBrush may ask you to do, or delete them completely (Tool > Geometry > Delete Lower) as some tools, such as ZModeler

KEY CONCEPT
Subdivision

Subdivision levels are like layers which allow you to work on your model in varying levels of complexity. The higher your subdivision level, the higher the resolution of your mesh, allowing you to craft fine details like wrinkles and skin pores. The lower your subdivision level, the more basic your model, allowing you to make broader changes like adjusting poses or proportions.

These changes are not lost as you move back and forth between subdivision levels, allowing you to make global changes to your model with ease. Choose the subdivision level that is the easiest and most efficient to apply the changes you want to make.

▲ 19a Viewing the polygon count and the Geometry menu

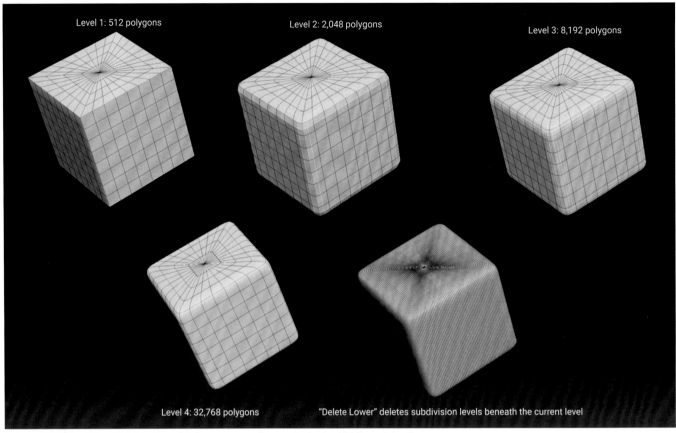

Level 1: 512 polygons

Level 2: 2,048 polygons

Level 3: 8,192 polygons

Level 4: 32,768 polygons

"Delete Lower" deletes subdivision levels beneath the current level

▲ **19b** Adding subdivision levels to your model allows you to work at varying levels of fidelity and detail

(see pages 48–51), will not work on a mesh with more than one subdivision level. Observe the different levels shown in image 19b.

20 Decimation Master

At some stage you may want to lower the polygon count of your model. It might be that it is finished and is a much higher resolution than you need, or that the high polygon count is slowing your program down. Maybe you intend to 3D-print the model and it needs to be a specific number of polygons. To bring the polygon count down, you first need to pre-compute it. Go to the ZPlugin panel, which is a place where Pixologic puts newer or third-party scripts (plug-ins) that have been added to ZBrush. Sometimes these scripts are moved into the main program. Select Decimation Master > Pre-process Current (A in image 20).

Once this has calculated, you can then "decimate" your model to a lower polygon count using Decimate Current. In part B of

image 20, I set the decimation to 2% of the original and, as you can see, it makes a huge difference to the mesh surface and density, but retains the overall shape. Note that it is triangulated; Decimation Master uses triangles whereas DynaMesh uses quads.

21 ZSpheres

ZSpheres are a great way to make complex organic shapes very quickly. They are essentially a shape that represents where geometry is going to be placed, almost like an armature. Once you have made a ZSphere model you can convert it to polygons and sculpt on it. It is also a great way to pose characters and creatures that you create.

Go to the large icon in the Tool panel and select the tool called ZSphere. In Draw mode (Q key), draw out a single ZSphere. Hit the T key to go into Edit mode (there is no need to click Make PolyMesh3D). Now go to Transform on the standard menu list and select Activate Symmetry, making sure the Mirror option

(>M<) is selected (or just press the X key). This will mean we can model both sides of the character at once. Draw out another ZSphere from the original and notice that you have also created a connecting line. Using Move (W key), you can reposition the ZSphere to suit your design. To add another "limb," as in image 21a, simply press the Q key to return to Draw mode and drag a new ZSphere out from where you want on the body. Move the new "limb" as before, and repeat this process until you have something similar to that shown in image 21a. You can use Move (W key), Scale (E key), and Rotate (R key) on the ZSpheres to make sure everything is in proportion.

If you want to see a preview of the model you are making, simply press the A key. Try turning Symmetry off (hit the X key again) and now re-pose your character into a more dynamic shape. This could be done after you have finished the sculpting, but it can help at this stage to ensure that your creation is dynamic.

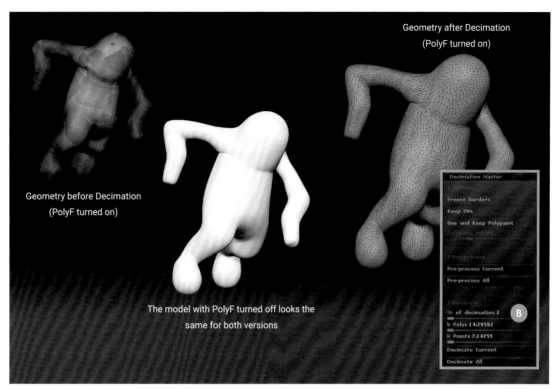

Geometry after Decimation
(PolyF turned on)

Geometry before Decimation
(PolyF turned on)

The model with PolyF turned off looks the
same for both versions

▲ 20 Having a high polygon count is not always ideal. Decimation Master allows you to lower a model's resolution without losing too much sculpted detail

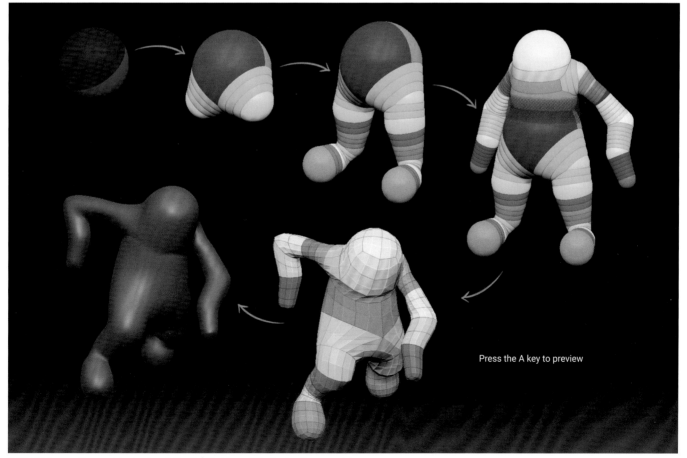

Press the A key to preview

▲ 21a ZSpheres offer a quick, simple solution for blocking out the basis of your model

To make the model into Geometry, select Adaptive Skin > Make Adaptive Skin in the Tool menu. You will notice that a new ZTool is created at the top of the Tool panel. To start sculpting with the new ZTool click on it in the Tool panel (image 21b). To add this to your existing scene click on SubTool > Append and choose the new ZTool. You will now have the ZSphere version of your model and the Adaptive Skin version of your model. You can now start sculpting on the ZTool as normal.

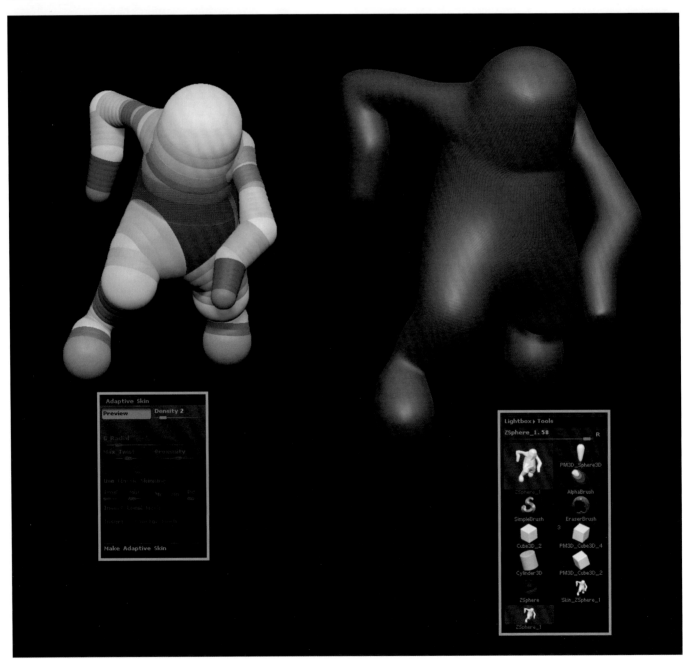

▲ 21b The Make Adaptive Skin option will convert your ZSphere dummy into editable geometry

Brushes and sculpting tools

22 The Brush menu

The workhorse of ZBrush and digital sculpting in general is the Brush system. To access the entire collection of brushes simply press the B key and select the brush you need (A in image 22; note that you need to have an editable mesh in order to access the Brush menu). As mentioned in step 08, you can refine these menus alphabetically. Brushes come in all shapes, sizes, and functions, and they have

evolved and expanded as ZBrush has grown. This section will take us through how to use some of the most common brush types and where we can use them to their best advantage when sculpting.

Make sure you have a solid understanding of changing the Draw Size, Focal Shift, and Z Intensity settings, as they are key. These can be found on the top shelf (B) and in the pop-up menu that appears when you hold down the Space bar on the document window (C). These attributes are particularly important for the Move brush, which you will learn about in step 24.

KEY CONCEPT
Brush settings 01

Draw Size: Adjust this to change the size of the area you want to affect.

Focal Shift: Adjust this to change the curve of the brush profile (imagine a bell curve for intensity if that helps).

Z Intensity: Adjust this to change the intensity of the brush's effect.

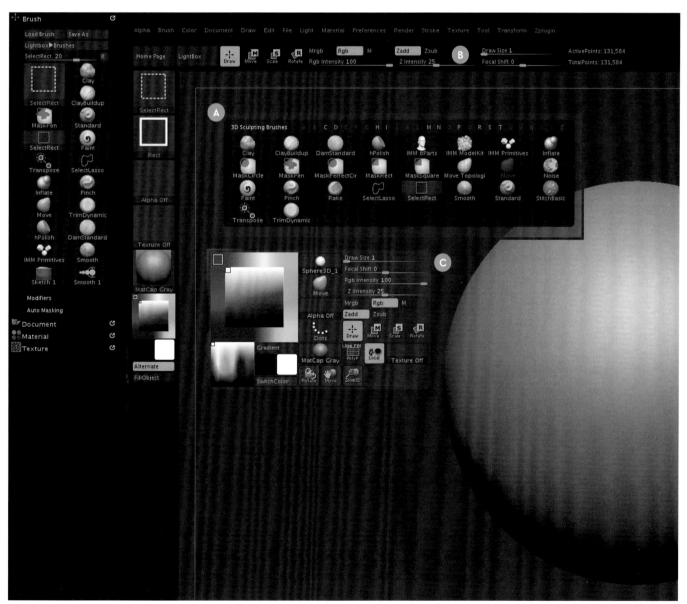

▲ 22 The Brush panel provides access to sculpting tools and more

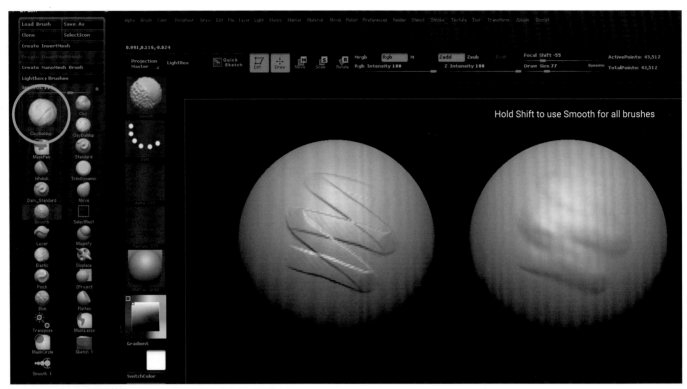

▲ **23a** You will use Clay brushes regularly for digital sculpting in ZBrush

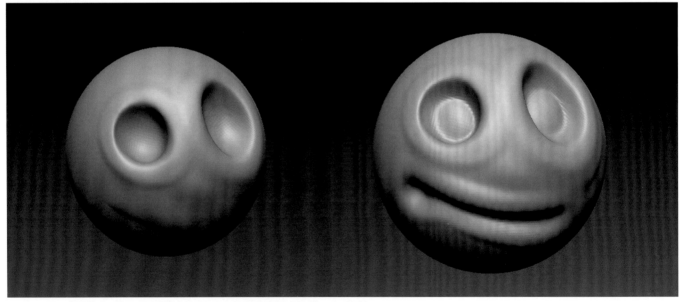

▲ **23b** You can create a simple smiley face just by using the Clay Buildup brush and Smooth

23 Clay brushes

Clay brushes are very versatile brushes for building up volume on a sculpt. The Clay brush itself builds up the surface of the model using an alpha (a texture based on a grayscale image), and there are several versions that use differing alphas to produce different effects. For exploring brushes we will use

a sphere from the Tool menu. Create a clear document layer to work on using Ctrl + N. Draw a sphere out and make it PolyMesh3D. Then apply DynaMesh, and increase the DynaMesh resolution of the model to 512 to enable a more dense mesh (note that you can type this number in rather than just tweaking the slider). Now you have a high-resolution

sphere to work on and it will show your brushstrokes perfectly.

Load the Clay Buildup brush as an example by clicking the large icon in the Brush menu and selecting it from the brushes available (or simply press the B, C, and B keys). Set the Draw Size to 77 and simply drag across the

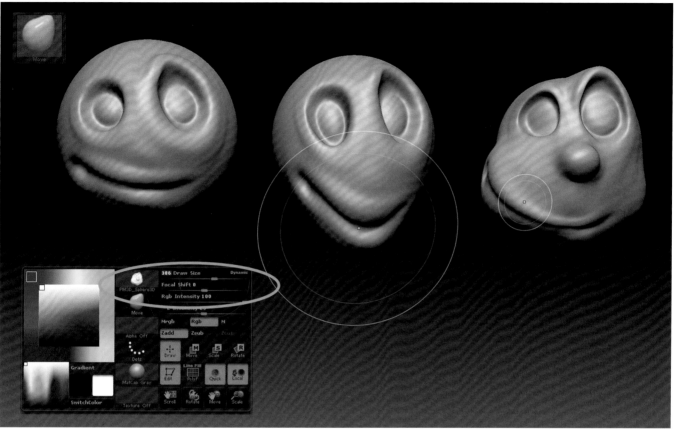

▲ 24 The Move brush can be used to deform and distort your sculpt

sphere you created (image 23a). To use the Smooth function, hold down Shift while you are using most brushes. Pressing Alt while using the brush will allow you to invert the tool and sculpt into the clay. Try making a face with just Clay Buildup and Smooth, as shown in image 23b.

24 The Move brush

The Move brush is used to specifically move areas of the model based on Draw Size, Focal Shift, and Z Intensity. Select this brush and try moving parts of your model around. Observe how adjusting the three sliders changes the effect. Draw Size is simple: the bigger the outer circle of the brush, the greater the area on the model that gets moved. Small numbers for Focal Shift mean sharper edges – not what you want when using Move. Intensity gives you more effect, so the higher the slider, the easier it is to move the area.

This is one of the most-used brushes in ZBrush. Learn it now as it will be used constantly.

KEY CONCEPT
Brush settings 02

Note that each brush in the Brush menu can carry out different tasks depending on certain settings selected. You can select or deselect these options using the buttons on the top shelf.

Zadd: Adds clay
Zsub: Removes clay
Rgb: Adds color
M: Adds material
Mrgb: Adds color and material

Make sure that you check the settings for each brush before you start using it in order to check that the configuration is as you require. A lot of brushes in ZBrush can add color as well as give you the ability to sculpt with them. If the Rgb and Zadd buttons on the top shelf of the ZBrush interface are turned on, then color and volume may be added, and the best brush for painting is the Standard brush because it has very few modifications or settings.

▲ Activate or deactivate the Zadd, Zsub, Rgb, M, and Mrgb options on the top shelf of the interface

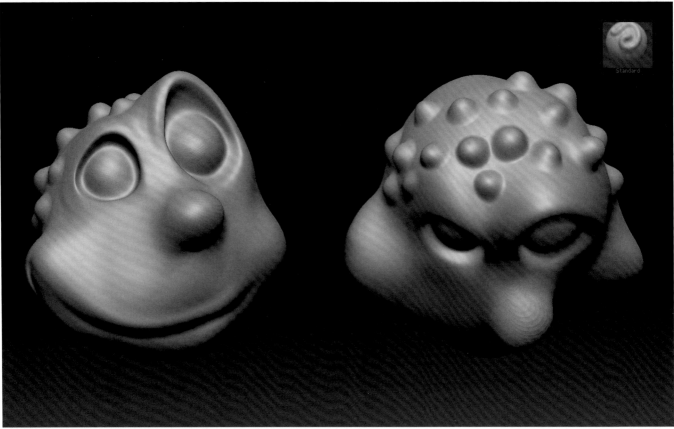

▲ 25 The Standard brush is a plain brush that can be used both for sculpting and painting

25 The Standard brush

The Standard brush works a lot like Clay brushes. In fact, before Clay brushes came along, this was used as the main brush for adding surface volume to a model. One thing you may notice is that this brush is not driven by an alpha map – there is no alpha assigned to this tool by default, which means it is a very basic tool to sculpt with. It is very useful when it comes to painting and using the Rgb (color) rather than the Zadd (sculpting) option. Try this brush on your model and see the difference between this and any of the Clay brushes to see if this works well for you. Don't forget to use Smooth (Shift).

At this point, keep going back over the Clay Buildup, Move, and Standard brushes and continue re-working your test model to understand where to use each brush to best effect. Feel free to use DynaMesh over and over as we are learning these brushes, holding Ctrl while clicking and dragging outside the model area to re-apply it.

26 The Inflate brush

If you have a portion of your model that needs more volume (such as a cheek, nose, or lips), you could of course use the Clay and Standard brushes to build up the area. However, it may be faster to use the Inflate brush (note that on the actual brush in ZBrush this is called "Inflat"). This brush "inflates" the given area out from the surface of the model, based on the angle toward which the surface is pointing (known as the surface normal). If you use it on a simple area like a cheek, it will inflate the cheek out. If you try to inflate a more complex area, such as the nose of a model, you may find that areas of the mesh start to cross over each other. This is not a problem if you are planning to apply DynaMesh again, but it can be an issue if you don't.

27 The Pinch brush

The Pinch brush is probably one of the lesser-used of the brushes discussed here. Its effect is very similar to the Photoshop tool of the same name that pulls a part of an image together. On

a 3D model, the Pinch brush pulls a group of polygons closer to a center based on the brush location. It can be useful to pinch together corners of a mouth, or to tighten a portion of mesh around a join such as an armpit. Go back over the model you have been making and use the brushes covered so far to define the head a little more. Add nostrils, cheek folds, and volume around the cheek. Use the Move brush and the Smooth brush as needed.

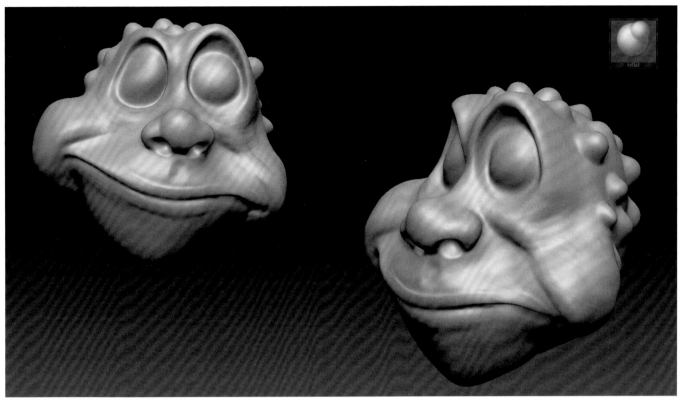

▲ 26 The Inflate brush can be used to quickly add volume to areas of your sculpt

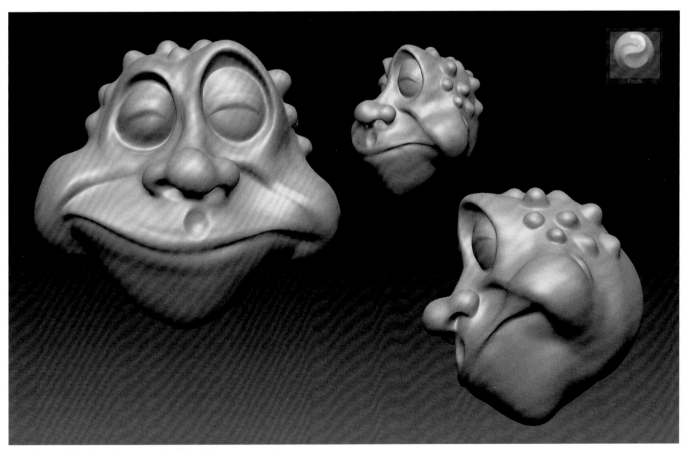

▲ 27 The Pinch brush can be used to "pinch" or tighten up areas of your sculpt

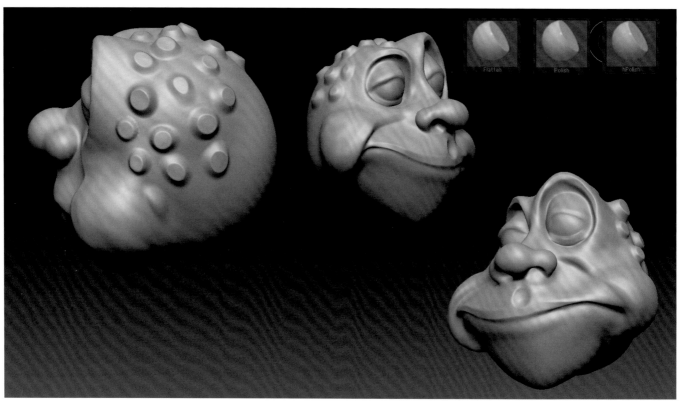

▲ 28 Flatten and Polish can be used to level off any sharp or bumpy areas of your sculpt

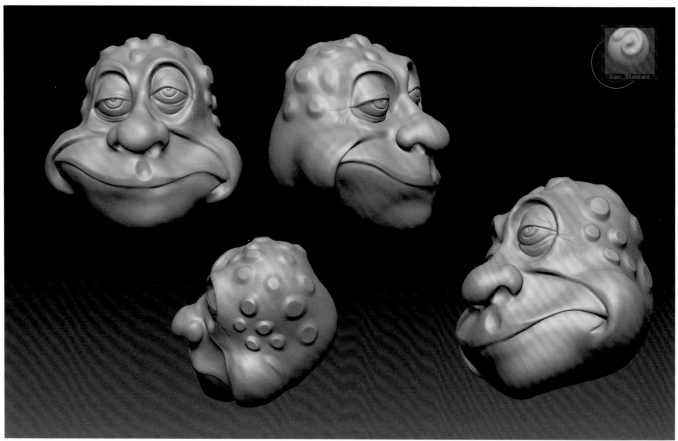

▲ 29 The Dam Standard brush can be used to carve fine details and wrinkles into your sculpt

▲ 30 You can add new shapes to your existing mesh using tools such as InsertCylinder

28 Flatten and Polish

There are a number of brushes that can flatten an area of your model based on certain settings. They include Flatten, Polish, and hPolish. Try using these tools on the head model you have made to see what effects each of them have. I flatten off some of the bumps at the back of the head and some of the lip area.

By now you should be able to find and pick the desired brush using the B key and the first letter of the brush you require. Keep practicing that until it is second nature and all these basic brushes are committed to memory.

29 Dam Standard

This is one of my favorite brushes in ZBrush. The Dam Standard brush is set up to carve into the model rather than add volume to it. It has a very small alpha image, which means if you use it with a very small Draw Size you can carve out thin lines into the surface of your mesh. This is ideal for details such as wrinkles, creases, carve lettering, and scroll work. Try it on your model around the eyes and between the lips.

30 InsertCylinder

There are a range of brushes that allow you to insert a new shape into an existing one and then weld them together with DynaMesh. Let's try this out with InsertCylinder. Use the B and I keys to open the Brush menu and isolate all brushes beginning with "I," including the Insert mesh brushes. Choose InsertCylinder. (Note that in ZBrush R8 you will have to choose IMM Primitives and then press the M key to bring up the Multi Mesh menu, and select InsertCylinder.) Now draw onto your head model and try to make two horn-like structures. This will result in two cylinders that are embedded into the head mesh, but are not yet properly joined at the surface. A mask is created when you insert one mesh into another. Click and drag once away from the model while holding Ctrl to clear the mask, and then again to apply DynaMesh. This will then weld the whole model together.

▲ 31 Once your additional parts have been merged using DynaMesh, you can continue sculpting on your model

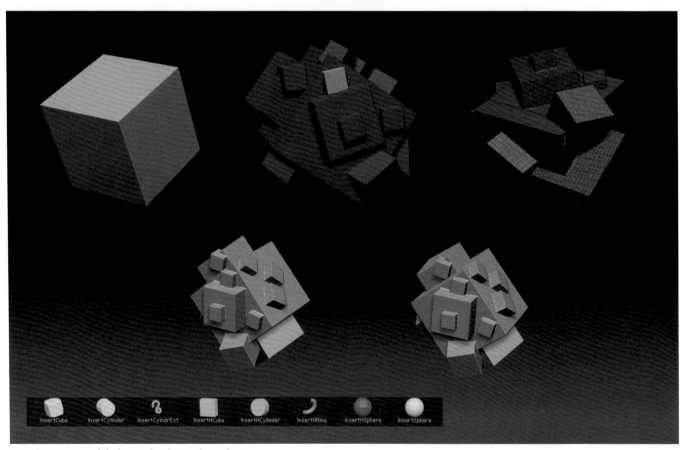

▲ 32 There are many default Insert brushes to choose from

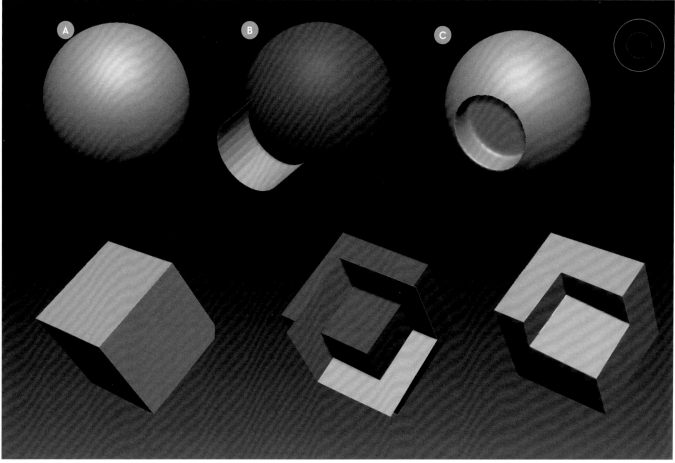

▲ **33** Holding the Alt key will subtract the Insert shape from your model, rather than adding it as before

31 Working with the inserted meshes

Once the cylinders have been melded using DynaMesh, what can you do with them? Now that they are part of the mesh, you can edit them in the same way you have done for the rest of the model. Use the Move brush to pull them around until they look a little like ears. Use the Inflate brush to put some volume back in and the Clay Buildup brush to add detail. This is a very effective way to add predictable pieces of geometry to your models, instead of just adding volume with the buildup tools all the time. Save your head for later use by going to Tool > Save As. You can reload it by going to Tool > Load Tool when needed.

32 Other Insert mesh brushes

Instead of using InsertCylinder, you can use other Insert mesh brushes such as InsertCube and InsertCircle. All of these Insert brushes follow exactly the same process as InsertCylinder, so drag out your shape onto the base shape, then Ctrl + drag twice outside the model. You will now have combined the shapes together with DynaMesh. Try this a few times with all the different Insert brushes you can find in the Brush menu.

KEY CONCEPT

Insert mesh brushes

Insert mesh brushes offer another common technique for building up a base mesh, which you will encounter in chapter 03.

33 Negative DynaMesh

You can use the Insert brush method to actually remove geometry from a model as well. Let's step away from the head model for a second. Make sure you are not in Edit mode, then press Ctrl + N to create a clear layer to work in. Load up a new sphere in the usual way and apply DynaMesh (A in image 33). Select the InsertCylinder brush and this time hold Alt as you drag a cylinder onto the sphere (B). Click and drag once outside the model area while holding Ctrl to remove the mask, then apply DynaMesh to the model (C). Unlike the normal DynaMesh process, holding Alt will make it remove the added shape, almost like a Boolean operation (a way of combining two or more shapes in a particular way using algorithms) in other 3D programs. This is a powerful way to make dramatic changes to your models and enables you to predictably remove inner surfaces. Try it with a cube now as shown in image 33. Make sure you apply DynaMesh before and after using the brush.

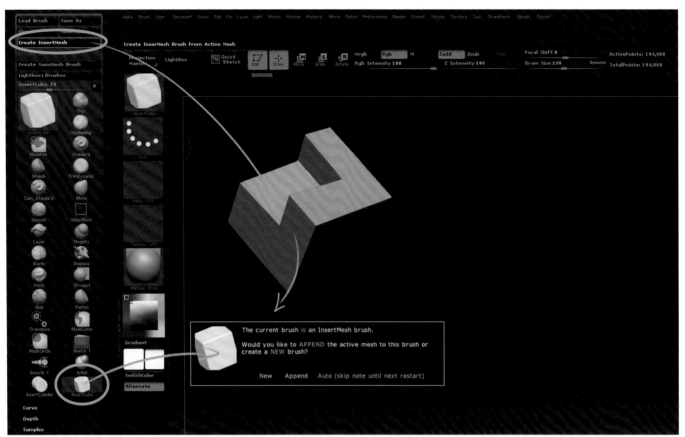

▲ 34a It is possible to create your own Insert mesh brushes

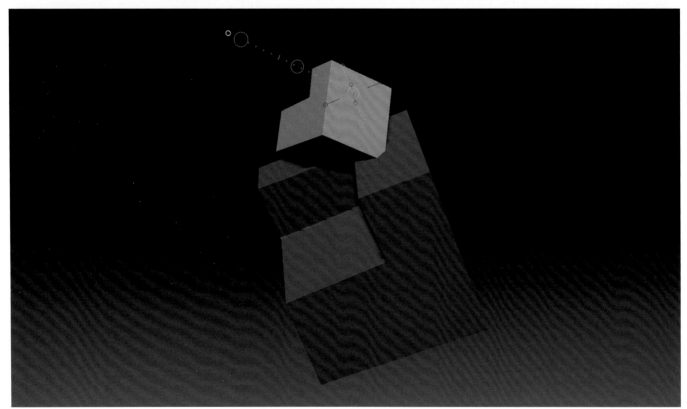

▲ 34b These can then be used in the same way as other Insert brushes

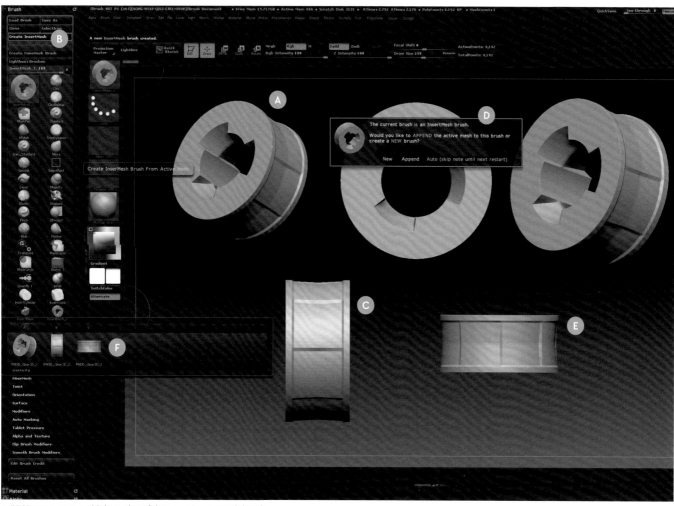

▲ 35 You can save multiple angles of the same Insert mesh brush

34 Creating Insert mesh brushes

While ZBrush's pre-made shapes are very useful, the real power of Insert comes into play when you use your own models as Insert mesh brushes. Start with a cube and use the negative DynaMesh technique shown in step 33 to remove a piece of it. Once you have created a shape that you like, go to the Brush menu and select Create InsertMesh. When the dialog box appears, select New and a new brush will appear at the bottom of the Brush panel. This custom Insert mesh brush can now be used just like the Insert brushes covered previously.

Once you have tested it on a model, you may find that your Insert brush is misaligned and needs to be rotated into a different orientation for DynaMesh to work properly. In this event, use the Transpose line from steps 13 and 14 to make adjustments with Move and Rotate (the W and R keys). To prevent orientation issues like this, you need to make Insert mesh brushes in a certain way; the rotation of the object in the document window when you click Create InsertMesh is how the object will be inserted when you use the new insert brush, so keep in mind where you will be using your brush before you create it in order to save having to recreate it.

35 Creating Insert Multi Mesh brushes

You can also add more than one object to a brush to create an Insert Multi Mesh (IMM) brush. Load up a gear shape from the Tool menu and use the Tool > Initialize panel to change its parameters (try inputting random numbers and seeing what happens) before clicking Make PolyMesh3D, leaving the shape on the screen at an odd angle (A in image 35). Click Create InsertMesh (B). Now rotate the gear until it is flat (C), using Shift to snap it into place. Then use Create InsertMesh again but use Append in the dialog rather than New (D). Rotate the mesh to the side and use the same process again (E; make sure you have the first Insert mesh brush selected before you do this). Now you have made a brush with items at different angles.

Press the M key to see the tools you have made (F). The benefit of IMM brushes is that you can create multiple custom Insert mesh brushes and effectively organize them without overcrowding your Brush palette.

ZModeler

By Ruben Alba

Note that you need ZBrush 4R7 onwards for this section.

36 Testing ZModeler

Let's now take a look at another modeling technique. Alongside the sculpting tools you have learned so far, you can also use a feature called ZModeler. This powerful toolset gives us access to polygon modeling tools that are perfect for a hard-surface subject. Let's examine how this tool works on a simple cube first. In a blank document, create an editable PolyMesh3D cube and select the ZModeler brush from the Brush menu. If you turn on Polyframe mode (Shift + F) you will then be able to see the cube's wireframe geometry. We can now apply certain operations to the components of the cube (its edges, polygons, and points, as discussed on page 16), such as Extrude, Crease, Offset, Bridge, and Divide.

To open the menu containing these options, simply roll your cursor over one of the cube's components and hold the Space bar on your keyboard.

In the next two steps we will work through some of the different actions for polygons, edges, and points to familiarize you with the toolset.

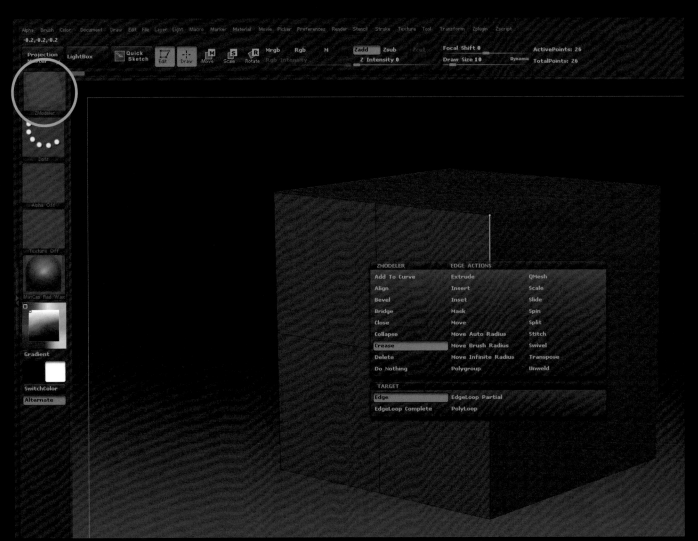

▲ 36 With the ZModeler brush selected, hold your cursor and the Space bar over a polygon, edge, or point to see the ZModeler options

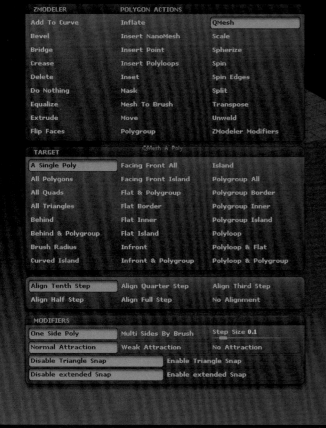

▲ 37a The ZModeler Polygon Actions menus

▲ 37b Select the polygons you want to edit by holding Alt

37 Polygons and ZModeler

To understand the ZModeler menu and options for polygons, try working through the following. Place your cursor over one of the cube's polygons and press the Space bar to open ZModeler's Polygon Actions menus (image 37a). In these menus we can select the action to apply, the target of this action, and adjust the settings and modifiers for the action. Then we just need to click to apply the action to the desired polygons. Many of the options are self-explanatory and will sound familiar to tools and brushes we have used before. For example the Delete action will delete the targeted polygons, the Spherize action will move the targeted polygons into a spherical shape, and the Extrude action will pull out the targeted polygons from the cube.

To extrude faces using ZModeler, first hold the Alt key while clicking the polygons you wish to extrude (image 37b). This will change their color to highlight them. Hover your cursor over

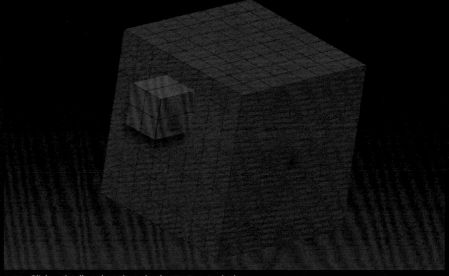

▲ 37c Click and pull on the selected polygons to extrude them

a polygon and hold the Space bar to bring up the ZModeler Polygon Actions menu, then select QMesh (a versatile action capable of both simple extrusions and snapping multiple polygons together) or Extrude as the action,

and A Single Poly as the target. Release the Space bar to close the menu, then click and drag on your selected polygons to extrude them (image 37c).

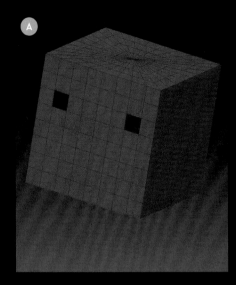

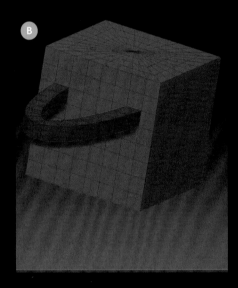

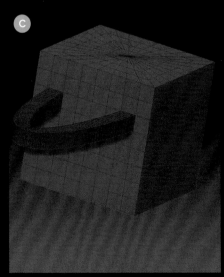

▲ 37d A bridge can easily be created with ZModeler

▲ 37e The orange pins indicate that the object is being previewed in Dynamic Subdivision mode

To create a bridge between polygons, select the polygon you want to start your bridge with. Hold the Space bar and select Delete as the action. Then release the Space bar and delete the polygon by clicking on it. Do the same with the target polygon that will be the end of the bridge (A in image 37d). With your cursor over an edge, hold the Space bar and select Bridge as the action and Two Holes > Spline as the target. Click on any edge where you deleted the start polygon, and then click and drag onto any edge where you deleted the end polygon, to build a bridge between them (B). You can adjust the bridge curvature and subdivisions while you click and drag by moving the mouse back and forth along different axes (C).

The shapes shown in image 37e are the results of playing around with a cube using the Bevel, Crease, Delete, Bridge, and QMesh options, with Single Poly and Polygroups as the targets, slightly adjusting the parameters of each action. As you can see, ZModeler offers many ways of creating unique geometry.

If we press the D key when using ZModeler tools, we can turn on the Dynamic Subdivision version of the geometry (an on-the-fly preview of what the model would look like with more subdivision levels), which is especially useful for viewing creased edges. You can use Shift + D to turn off Dynamic Subdivision mode.

38 Edges and points

As you saw in the bridge example, the same use of ZModeler applies to edges – and points. Hover over an edge or a point and press the Space bar to access the ZModeler options for edges or points, respectively. We can create many interesting details with these tools, such as holes, bevels, and grids. In image 38a you can see the results of using Bevel on an edge. To bevel an edge, hover over an edge with the cursor and press Space bar, then select Bevel as the action and Edge Loop Complete as the target. Release the space bar and click and drag to apply the action to an edge, which will bevel a whole edge loop. You could now

extrude this loop using the Extrude Polygon Action, if you wanted.

Creating hole details like those in image 38b is really simple. Hover over a point and hold the Space bar, then select Split as the action and Point as the target. Release the Space bar and apply the action to create a circle. Select the circle of polygons you just created by using Alt + click; then use Polygon Action Extrude to push them down.

The right side of image 38b shows a cylinder viewed in Dynamic Subdivision mode, with some polygon loops pushed inwards using Extrude, and the Split action applied to some points. You can clearly see which areas have Crease applied to them, as they remain crisp and distinct in Dynamic Subdivision view, while the uncreased areas indicated by yellow pins have become rounded and smoothed over. Take some time to explore the different options the ZModeler toolset offers.

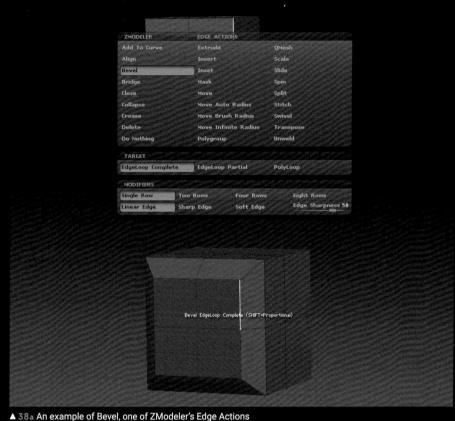

▲ 38a An example of Bevel, one of ZModeler's Edge Actions

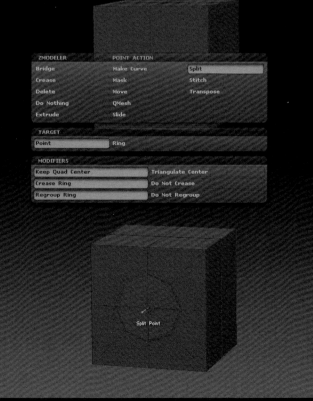

▲ 38b An example of Split, one of ZModeler's Point Actions

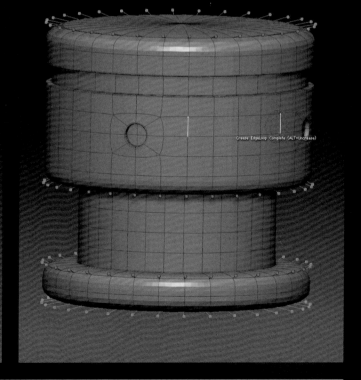

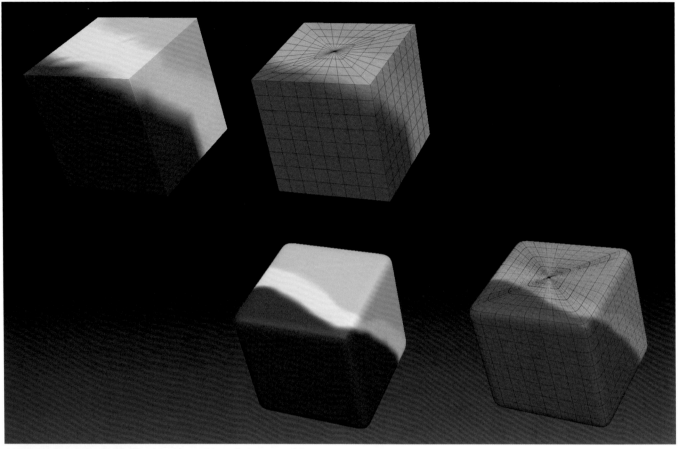

▲ 39 Polypaint is an invaluable ZBrush tool for applying color to your sculpts

Polypaint

39 Polypaint

Moving on to ZBrush's texturing tools, it is essential to understand Polypaint. The name "Polypaint" is actually a misnomer, as it is not painting on polygons but rather giving the vertex points a color (vertex painting). This is a powerful way to apply color to a model, and the higher the polygon count, the better the resolution and clarity of the painting. ZBrush and ZBrushCore both feature Polypaint, but only ZBrush provides Polypaint's full texturing capabilities using UV maps.

40 Starting to paint

Start with a simple shape to try out the basics of Polypaint. Load up a Cube3D, drag it out onto the canvas, press the T key for Edit mode, and make it a PolyMesh3D. Now you need to have a paintbrush, so select the Standard brush from the Brush palette and turn off Zadd (A in image

40a) so that you are only applying the color and material options rather than sculpting. As mentioned on page 39, if Zadd is active it means that a ZTool can be sculpted on. If Zadd is off you cannot sculpt on it. Press Ctrl + D three times, which will increase the resolution of the model. Go to the Tool > Polypaint panel and make sure Colorize is selected (B). The small paintbrush icon in the SubTool menu (C) indicates that Polypaint is active. Change the material to SkinShader in the Material panel to give you a white, basic material. Make sure that you have Rgb selected on the top shelf (D).

Image 40b shows the Color menu. Now you can have some fun painting colors onto the Cube3D model by selecting a color in the color square (E in image 40b). In the Modifiers panel in the Color menu (F), you will find several different ways to pick colors. ZBrush has a few different types of RGB (Red, Green, Blue) palettes and sliders for you to explore. Everyone has a favorite, and as you work through the projects

in this book you will get a feel for what works best for you.

41 FillObject

Let's use our model that we created earlier in this chapter. Load up the head that you made, drag it out onto the canvas, and then hit the T key for Edit mode. The head may still be in your Tool panel but if not use Tool > Load Tool and navigate to wherever you saved your head model. We do not need to use the Make PolyMesh3D button as it is already a polymesh (sculptable) object and, as such, we can sculpt and paint on it.

Firstly let's fill the model with a basic skin color. Go to the Color panel and pick a dark skin color for your base. Lower down in the panel you will see a button called FillObject. When you press this the model is filled with the current color and also the currently selected material. In this case the material is SkinShade4, which is perfect for a creature like the one I work on here.

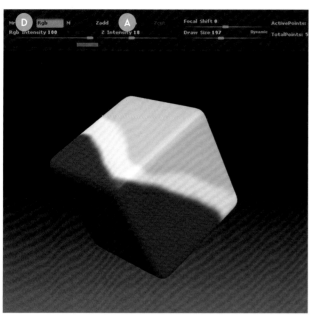

▲ 40a Ensure you have Rgb and Colorize selected and that Zadd is deselected

KEY CONCEPT
Materials versus textures

In 3D modeling, the material applied to a model or parts of it affects how the light reacts to it. The texture is what is added to the surface of the model. For example, you could use a plastic material for an eye to give the eye a shiny appearance in contrast to a less reflective skin material used for the rest of the head. We will use Polypaint and texture maps to give the surface of the model the appearance of skin. However, the material applied to the model will still define how it reacts to lighting.

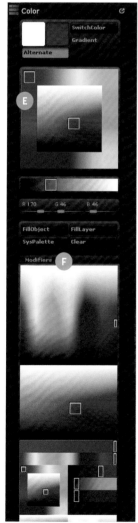

▲ 40b The Color panel

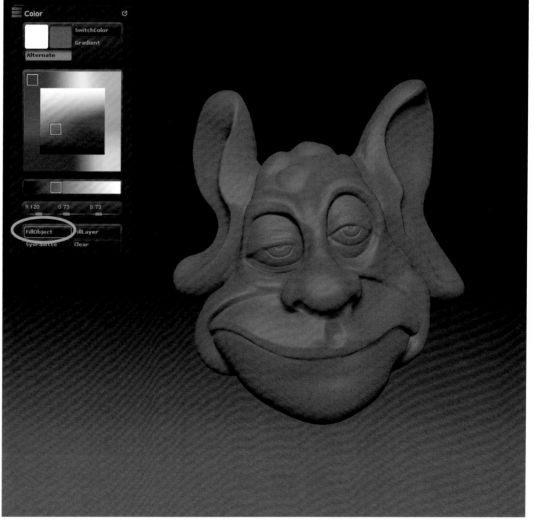

▲ 41 FillObject allows you to fill the object with a single color

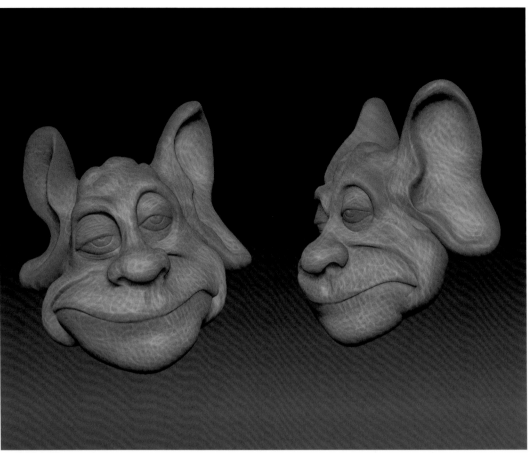

▲ 42a The Alpha panel

▲ 42b Using Alpha 58 to paint the head in a lighter color

42 Using basic alphas to paint

To produce a more detailed paintover you can use alphas. These are grayscale images (black and white) that allow you to paint with a brush shape defined by that image. If you look in the Alpha panel (image 42a) you will see a wide range of alphas already pre-loaded. Select Alpha 58, which looks like vertical lines and is a fantastic alpha to make skin with. Choose a slightly lighter color in the Color panel and start painting the head (make sure you are in Draw mode). Focus on high points rather than the deeper recesses of the head (image 42b). Keep the Rgb Intensity setting low and the Draw Size setting around 187.

43 Painting skin

Painting skin is a skill in itself. Experiment with Alpha 58 and Alpha 62 to see some great skin effects. Always try to lay down the basic colors first. Wherever there are fatty areas on a head, there will be blood nearer the surface, so make those areas redder. Wherever there is thin skin,

like a flat forehead, use a blue/gray color as there is less blood near the surface. Give the character a "five o'clock" shadow by using a gray color around its chin. The ears are very thin and, in reality, would let some light through (sub-surface scattering), but ZBrush does not handle transparent skin, so you can fake the effect instead with a lighter orange color.

44 Painting eyes onto the head

For more complex ZBrush models, it would be common practice to sculpt separate eyes and give them a separate paint job with a highly glossy material, which we will go through in the next step. For beginners making a simple model, it is often easier to paint the eyes directly onto the head, so try this step first. Change your alpha brush to a basic round alpha (Alpha 01 is a good choice), and set the Rgb Intensity setting quite high for this task (I push it right to 100). Now paint the whole eye in white, then add a round black base large enough for the pupil and iris. Paint in a blue ring

for the iris, leaving a black circle for the pupil and a tiny outline in black. You can even paint a fake white highlight for now.

▲ 43 A combination of alphas and Polypaint can achieve a surprising level of painted detail in ZBrush

▲ 44 For some simple models, it is sufficient to paint the eyes directly onto the head mesh

45 Making separate eyes

If you are working on a more complex model, you can very easily make separate eyes in ZBrush by adding them to your model as SubTools. Let's step away from our head model for a moment and start with a simple Sphere3D in a new document. Select Edit mode and the Make PolyMesh3D button. Then activate Symmetry by pressing the X key. This will allow you to create both eye sockets at once. Use the Standard brush while holding Alt to carve out basic eye sockets (A in image 45a).

Next go to Tool > SubTool, select Append, and open a basic Sphere3D. You will see in the SubTool stack that you now have your head with eye sockets as one SubTool and the new sphere as another SubTool underneath (B); this will be your eyeball. Select the eyeball SubTool in the stack and move it into a position where you can clearly see it by pressing the W key and using the central white ring in the middle of the Transpose line. The eyeball needs to be small enough to fit the head, which can be achieved by using the Transpose line in Scale mode. Press the E key and drag the Transpose line out with the large outer circle. Then drag the smaller red circle in towards the center a few times to scale the eyeball down to the correct size. Then use Move to position the eyeball in the socket (C).

Making sure you have the eyeball SubTool selected, with Draw mode and Mrgb selected, and Zadd turned off, choose the Standard brush from the Brush panel and SkinShade4 from the Material panel. In the Color panel, select a color and click FillObject to flood the model with

a white base. Note that in the SubTool panel the paintbrush icon for the eye SubTool will be activated; this indicates that Polypaint and/or material information has been applied to it.

KEY CONCEPT
Using FillObject
You may have noticed that when you selected the material and color for your eye, the head also changed to SkinShade4 and your chosen color. This is because there is currently no Polypaint or material information applied to that SubTool. To change the color and material of the head, simply select the head SubTool, choose your color and material, and hit FillObject in the Color panel. Note that you must have Mrgb selected for both color and material to be applied as you want. The paintbrush icon should now be activated on the head SubTool.

Select the eye SubTool again. Activate Rgb and use the Standard brush to paint the iris and pupil as shown in image 45b (D–G). You may want to experiment with different materials even after applying your Polypaint, but using FillObject in Mrgb mode will replace your painted details with a flat color. To avoid this, turn off Mrgb and turn on M, so FillObject only applies the material without changing the color.

Duplicate the eye SubTool using the Duplicate button in the SubTool panel and move the

second eye into the correct position using the Transpose line (H in image 45c). The eyes should be spaced so they fit in their sockets. Next merge the two eyes into one SubTool by selecting the higher one in the SubTool list and pressing Merge > MergeDown (I). Make sure your eyeballs are spaced correctly before you merge them; it can be a little tricky to achieve this but it will be better to place the eyeballs within the sockets together to ensure one is not positioned higher than the other for example. You may find it useful to snap the head to different orthographic positions by holding Shift while clicking and dragging outside the model in Move mode.

We now need to settle the eyes into their sockets. To do this, it can be useful to lock the Transpose line on an axis so that we only move the eyes in towards the head and not up and down or side to side. In Move mode, click on one of the eyes and drag out the Transpose line. You should see some red, green, and blue markers which indicate the X, Y, and Z axes, respectively. From the angle shown in image 45d, we want to move the eyes out along the blue axis, so click on one of the blue markers. If you then drag the central white circle while holding Shift, you will only move the eyes along this axis. To make it easier to see as you move the eyeballs, go to Transform and click the square "Transp" icon to make the rest of the model semi-transparent (J in image 45d). Move the eyes into position deeper in the sockets as needed. You should now have a head with a separate SubTool for eyes like that shown in image 45e.

▲ 45a Append a sphere and move and scale it into position using the Transpose line

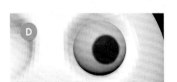
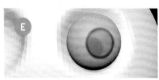
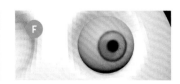

▲ 45b Use the Standard brush to paint the iris and pupil

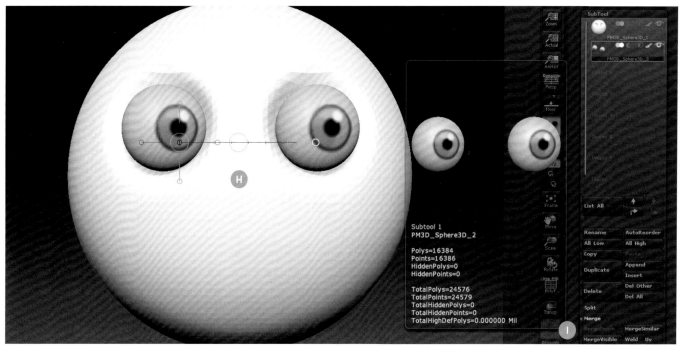

▲ 45c Duplicate the eye and transpose the second one into place. Then merge the eyes into one SubTool

▲ 45d Lock the Transpose line to the desired axis and move the eyes deeper into their sockets

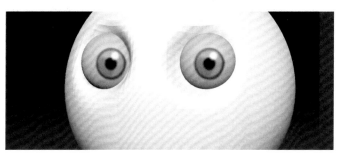

▲ 45e The eyeballs in their sockets

PRO TIP
SubTool visibility

You can use the eye icon above each SubTool to toggle the visibility of SubTools on and off. For example while you are applying Polypaint to the eye in step 45, you may want to hide other SubTools for ease. When positioning the eye in the socket, you will need both the head and the eyeball SubTools visible.

Texture maps and Spotlight

46 ZRemesher and UV unwrapping

At some stage you will want to start using textures. ZBrush allows you to turn your Polypainting into a texture map. To do this we need to give the model some coordinates to allow a texture to accurately wrap around it. Before you create those UV coordinates, however, it is advisable to lower the resolution of the model with ZRemesher. Using a lower resolution mesh means that the computer doesn't have to work as hard to create the texture map but it will look just as good. This is the opposite of Polypainting where you need a high-resolution mesh to paint on.

To lower the poly count we will use ZRemesher. Duplicate the character head you made earlier using Tool > SubTool > Duplicate. Now make sure you are on the lower head in the SubTool stack and go to Tool > Geometry > ZRemesher. Set the Target Polygons Count to 5 (which translates to 5,000 polygons) and hit ZRemesher. After it calculates, you will have a model with a lower polygon count and improved surface quality, which will be useful for projecting details on for our texture map. You will find a useful overview of ZRemesher on pages 109–110.

47 Projecting detail onto the new head

To capture the Polypainting and high detail sculpting, we need to "project" all the detail from the high-poly model onto the low-poly model. First make sure you are on the new lower poly head in the SubTool stack. Make sure both heads are turned on (the eye icon should be highlighted). On the lower head, hit Ctrl + D to subdivide it once. Now use Tool > SubTool > Project > ProjectAll. This will project all the detail onto the lower-poly head at this level of subdivision, but we need more detail so repeat the Ctrl + D and ProjectAll process two more times.

KEY CONCEPT
UV unwrapping

UV unwrapping is a process that allows you to map a texture map onto a 3D object. The letters "U" and "V" denote the axes of the flat texture because X, Y, and Z are being used to denote the axes of the 3D model. You are essentially "unwrapping" a series of coordinates for the surface of your 3D model, which will allow you to make a flat 2D texture that will wrap around the model like a skin.

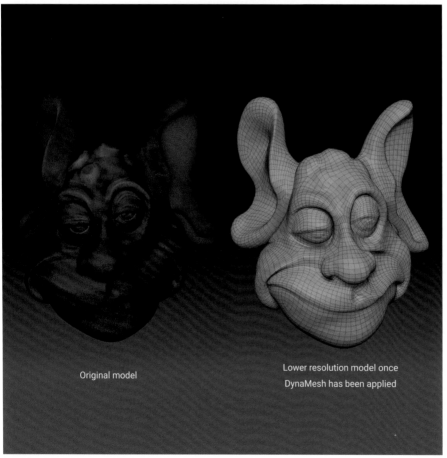

Original model

Lower resolution model once DynaMesh has been applied

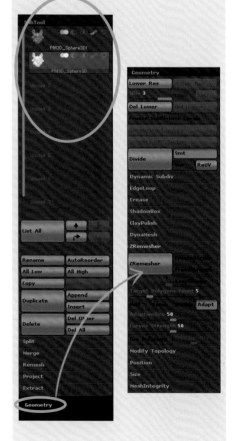

▲ 46 ZRemesher helps when unwrapping a UV from your model

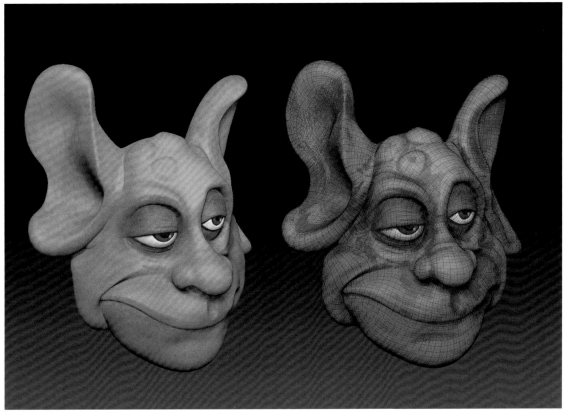

▲ 47 As mentioned, it may sometimes be necessary to create a low-poly version of your detailed sculpt. ProjectAll is essential in this case

KEY CONCEPT
What's the difference between Decimation Master, ZRemesher, and DynaMesh?

Decimation Master: Triangulates a model to bring the polygon count down, but can keep the shape very accurate to the original. It won't combine models together. With this method you specify the poly count you want to achieve and the results are very accurate.

ZRemesher: Will lower the poly count with less accuracy than Decimation Master but it will create a well laid out mesh, using edge loops and quads. This won't retain the shape as well as Decimation Master or DynaMesh but is useful for creating UV maps and projecting details and paint from a higher poly count model.

DynaMesh: Combines models together and redistributes the polygons across the surface. The poly count can be unpredictable sometimes.

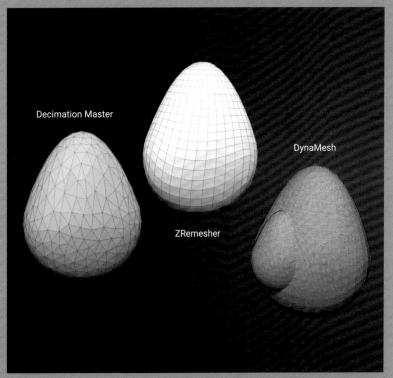

▲ It is essential to learn the difference between Decimation Master, ZRemesher, and DynaMesh, and where to use each one in your modeling

▲ 48 This basic "pelt" unwrap resembles the unfolded skin of your model. From this, you would be able to create textures that wrap back around your model

48 Basic UV unwrap

To make a texture map we then need to unwrap the model. To create a basic "pelt" unwrap is easy. This is a set of UV coordinates that is made by simply unwrapping the model like an animal skin in a single piece. To use this method, lower the subdivision level by pressing Shift + D until the lowest level is reached (or by going to Tool > Geometry > Lower res). Now in the ZPlugin panel (A in image 48) find UV Master. Without changing any settings, just click Unwrap (B). The model will now be unwrapped and can be seen in that state by using Tool > UVMap > Morph UV (C, D). Click Morph UV again to return to the 3D view of the model (E). This is a great way to make quick and dirty UVs.

49 UV with Polygroups

However, we might need more control; for instance you may be making a character for which the position of the seam is really important. Seams should always be hidden where possible and having greater control over these is what makes a model better. To give

more control over the UVs we can use masking and Polygroups. The Polygroup function splits your model into sections with different colors; this does not affect the actual geometry, but is a valuable organizational tool. Select the MaskLasso brush and hold down Ctrl to begin masking. Paint around the areas you want to isolate and Polygroup. With each area that you mask, press Ctrl + W after to make that area a new Polygroup with its own color. Note that you need to be in Polyframe mode (Shift + F) to be able to see the color change. You can also create a new Polygroup by going to Tool > Polygroups > Auto Groups, which assigns a new color every time you use it (image 49a).

Once you have broken the head down into logical groups you can make a new UV set. Go to ZPlugin again but this time make sure Polygroups is selected. Do not use Symmetry as our head is not a symmetrical model. Now hit Unwrap to create a new UV set that is broken down into islands of geometry based on the Polygroups you defined (image 49b).

KEY CONCEPT
Polygroups
Polygroups are a way to break a model down into sets of polygons. In other programs they can be called vertex sets or groups. In ZBrush this allows you to isolate a model by Polygroups, or mask just some of the mesh instead of all of it. ZBrush uses a system where it assigns a color to each Polygroup, which you can see in Polyframe mode (Shift + F).

50 Texture maps

Now that we have a model with Polypaint and UVs, we can look into some ways of displaying a texture. One method is to make a texture map to display on the model. In Tool > UV Map, we must first set the texture map's size to suit our needs: in this case, 2,048 (sometimes called a 2K map, a well-used size in the industry). This will generate a 2,048 × 2,048 pixel image map that is ready for use to apply a texture.

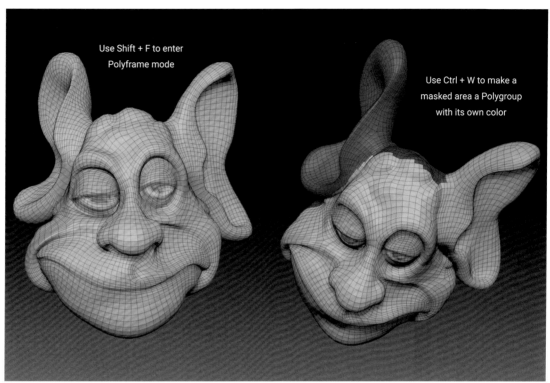

Use Shift + F to enter
Polyframe mode

Use Ctrl + W to make a
masked area a Polygroup
with its own color

▲ 49a Assign Polygroups to your model as a method for organization

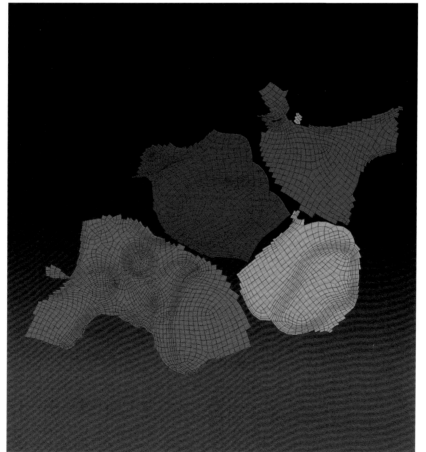

▲ 49b If you choose to unwrap a model by Polygroup, your UV will be split into "islands" for the different pieces

▲ 50 Set the map size first

51 Getting the Polypaint into a texture

As we have already painted a texture using Polypaint, we can grab that painting information and apply it to the texture map created in the previous step. The texture map can be exported and edited in Photoshop as a 2D image and then imported back in to ZBrush. This is useful if you prefer to paint textures in 2D rather than straight onto the model in 3D.

As Polypainting relies on having lots of polygons to create a high-resolution texture, it only works if the model is also high resolution. Make sure the model is set at its highest subdivision level (hit the D key until it is maxed out). Now go to Tool > Texture Map > Create and hit New From Polypaint (A in image 51). Your model may not actually look like it has changed, but if you go to the lowest subdivision level and use UV Map > Morph UV (B) again, you will see that at the lowest subdivision level we now have a fully detailed texture map at our disposal (C). This can be exported and used in other programs as a PSD or JPEG file.

To export the map use Tool > Texture Map > Clone, which sends a copy to the Texture panel. In the Texture panel use the Export button to save your file out as a PSD or JPEG file. After you have edited and saved the image in Photoshop you can import the image back in to ZBrush by clicking on the thumbnail image of the UV map under the Tool > Texture Map menu.

52 Spotlight

Another fantastic way to add textures to a model in ZBrush is to use Spotlight. This is a feature where you can import a series of images and apply them to your 3D model in patches using ZBrush's painting tools. Let's make some skin with Spotlight. Find some images of skin that you may want to use. Go to Texture > Import and select the images you wish to use. This will load the chosen images into your Texture panel. For each image, click the Add To Spotlight button (image 52a). The image will then be loaded into a Spotlight menu on screen (image 52b).

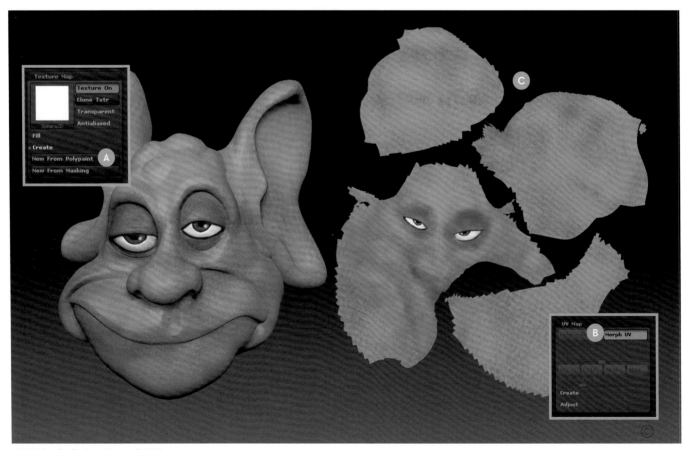

▲ 51 Using the Texture Map and UV Map menus

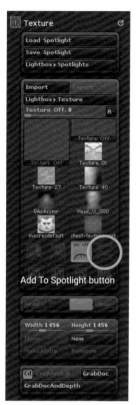

Add To Spotlight button

▲ 52a Use the Texture panel

Photo texture from 3d.sk

▲ 52b An image once it is added to Spotlight

53 Spotlight wheel

To position the image over your model, place the Spotlight wheel over your model by grabbing the small central ring. You can move the image around simply by clicking and dragging it. Use Shift + Z to activate the image; Z will hide and unhide the Spotlight wheel.

Make sure that Zadd is turned off so you don't sculpt by accident, and make sure you are using the Standard brush. The Standard brush is a good brush to use in this case as it has very few modifications or settings. Also make sure that Rgb is turned on. The Spotlight wheel offers options including scaling and rotating, but for now hit the Z key and simply paint onto your model. Your brush will paint through the Spotlight image and add its texture to your model as Polypaint.

Texture by textures.com

▲ 53 Position the image over your model and paint the texture with the Standard brush

Lighting tools

54 Lighting basics

Before starting any rendering in ZBrush, it is useful to take a look at lighting basics. The first step is to build a basic scene. There are two types of materials to consider: MatCaps and the rest! MatCaps have lighting built into them already, which means that ZBrush lighting will not affect the MatCap material, so we will leave those for now and look at how to create lighting for a non-MatCap material.

Select Material > SkinShader4 as it is perfect for our needs and responds to the lighting in the scene. Now select Cube3D from the Tool panel to add it to your scene and then click Make PolyMesh3D. Next click Append under the SubTool menu and select Sphere3D, switch to the Sphere3D SubTool and use Move (W) to position it away from the cube. Repeat this process with a Cone3D. Turn on the Floor

(using Shift + P) and then hit the small BPR (Best Preview Render) button (see icon circled in image 54).

55 Basic shadows

Now you can try to improve the look of the harsh shadows that you have rendered. Open the Render panel, click BPR Shadow, and change Rays to 30 and Angle to 50. Note that you can type in the number you want for each setting as well as adjust the slider. You can of course experiment with the other settings, but to understand the basics we will just change those two parameters. Hit the BPR button again and note how by increasing those two parameters you have softened the shadows and improved the overall look of the render. We will now go back and explore lighting a little more using the settings.

56 Lighting the scene

The scene has only one light for now. Open up the Light panel and you will notice that there

is a sphere icon in the top-left corner. Click and drag the little red icon inside the sphere to move the light around, and it will update in the document window each time you move it. Move it to the front-left of the sphere as if the light is coming in from that position in the scene. Hit the BPR button again to see the render results; you will note that the shadows are now cast backwards into the scene.

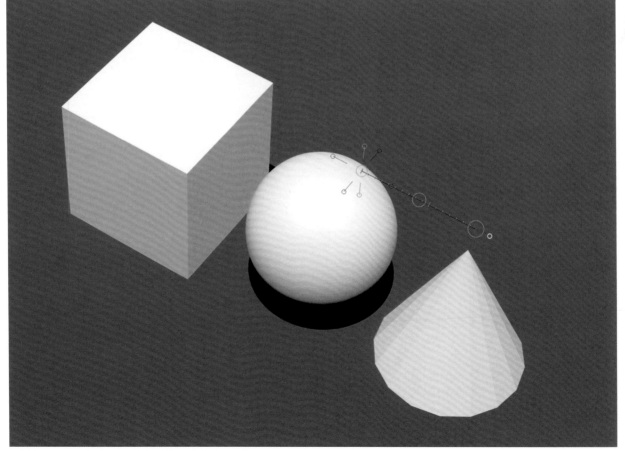

▲ 54 Setting up a simple scene to test ZBrush's lighting options

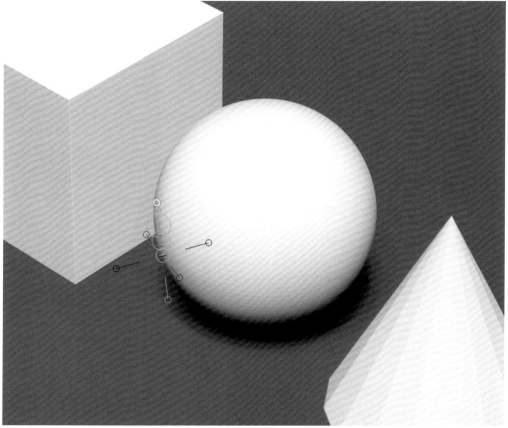

▲ 55 Soften the appearance of the shadows by adjusting settings in the Render panel

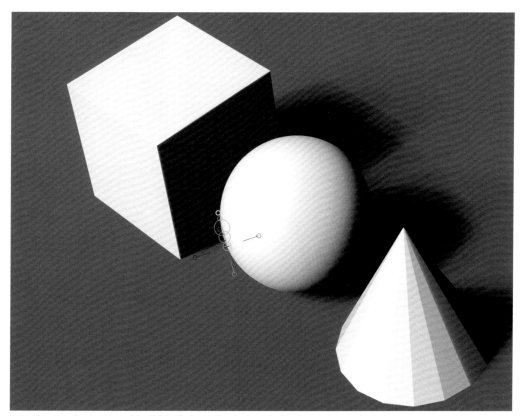

▲ 56 Changing the direction of the light will change the angle of the shadows accordingly

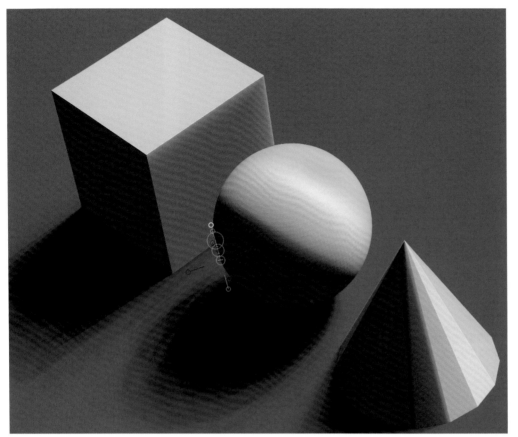

▲ 57 It is also possible to create colored light sources in ZBrush

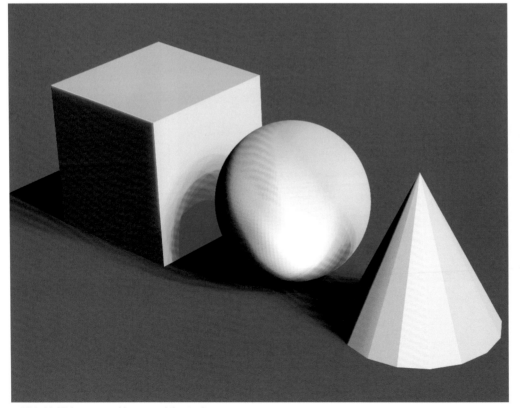

▲ 58 A third light source adds more subtlety to the scene

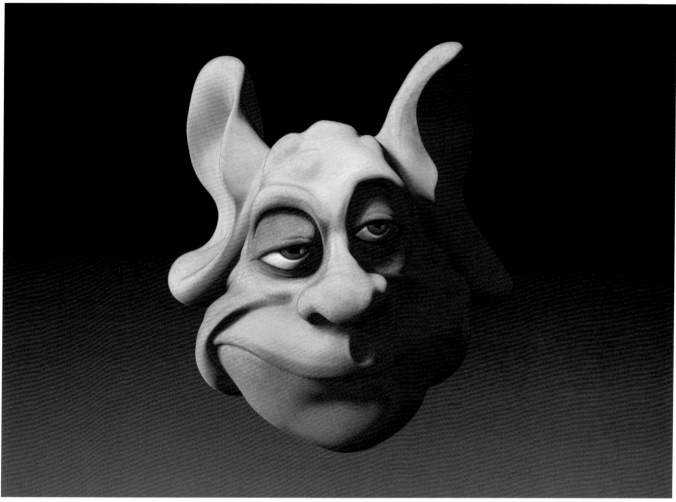

▲ 59 Applying a similar lighting setup to the model created earlier

57 Adding colored light

Let's add more interest to the scene by adding a second light. Click the second light-bulb icon along in the Light panel. It will highlight in orange, meaning that the second light is now turned on. As with the first light, move the little icon inside the sphere around and hit the BPR button until you achieve the desired contrast between the back and front. There is a little color box in the panel with which you can change the light's color. Change this light to red, then select the previous light and change it to blue. You can change the intensity of each light source by adjusting the Intensity slider. Hit the BPR button again to test.

58 More color

The trick to making great renders in ZBrush is understanding the relationship between materials, lighting, and the render settings.

You can adjust global settings like the ambient lighting level by simply using the Ambient slider for each light source, as circled in image 58. If you drop this all the way to its lowest setting, the scene will only be lit by the two lights you have put into the scene. Add a third light by turning on its icon, make it green, and click BPR to test.

59 Set up a model

We will now apply lighting settings to a model. Load up the head you made earlier or any model you have already created. Recreate the three-point lighting setup we made in the previous steps. Try different positions for the lights, aiming for a dynamic lighting setup. Try to keep one of the lights at the back to give a "rim light" effect. Change the colors as needed to affect the mood. By playing around with these settings you will become familiar with how the materials and lighting interact.

▲ 60 LightCaps allows for more dynamic lighting setups within ZBrush

Rendering tools

60 LightCaps

If you want to improve your renders inside ZBrush itself, there is a system called LightCaps that allows you to build a more accurate and responsive lighting environment. Load any model as normal and press Shift + P to show the floor. In the Light panel, open LightCap and click New Light. This will give you a new light which you can move around by clicking and dragging the little red icon on the sphere in the LightCap panel. In the panel you can add lights and accurately manage them into complex lighting setups. These setups can be saved and reused as LightCaps. Try a basic

BPR with these minimal settings and see how the results look. Make sure you adjust the Rays and Angle sliders first under the BPR Shadow section of the Render menu: increasing the number of rays instantly gives you more detail, and increasing the angle can also be a quick way to soften those shadows.

61 Fog

You can add complexity and interest to your renders in other ways within ZBrush. Sometimes a foggy environment can enhance your scenes. In the Render panel, go to Render Properties and enable Fog as shown in image 61. Then go down to the Render > Fog panel and change some of the settings, such as the color and intensity, to suit your needs. In the

example in image 61, I have made the fog a light blue and faded it off around the base of the model.

▲ 61 Fog can add depth to a simple ZBrush scene

▲ 62 Render passes are flat images of your scene that can be edited further in Photoshop

62 Render passes

At some point you may want to save your image out to use in other programs, for example to manipulate it in Photoshop (see the next section about import and export features). ZBrush gives you the option to save out certain maps other than just the image itself. If you look in the Render > BPR RenderPass panel after you have created a render, you will see that it has generated a few other maps. These include a Depth pass, Shadow pass, and even a Mask. These are all very useful if you wish to edit your images further in programs like Photoshop.

69

▲ 63 The External Renderer menu

63 KeyShot button

Although ZBrush has a fully featured render engine built in, there is also the option to send renders out to the popular rendering program KeyShot. You can buy the standard KeyShot software to use with multiple 3D packages, or buy the cut-down version called ZBrush to KeyShot Bridge, which just works with ZBrush. To send the model out for rendering, simply go to the Render panel and activate the KeyShot button under External Renderer. Now when you hit the BPR button, the model will be sent to KeyShot instead of rendering in the document window.

64 KeyShot

Once you have hit the BPR button, KeyShot should open in the background and the model and its textures should all be transferred over. If you have applied Polypaint to the model rather than textured it you will be able to send that out in the same way. Once in KeyShot, you can change the lighting environment, adjust materials, change the camera settings, and even add more objects to the scene. For more

in-depth coverage of KeyShot, and its interface and tools, you can turn to chapter 06.

Import and export tools

65 File formats

There are lots of ways to get assets, models, textures, brushes, and other resources in and out of ZBrush. It is very important to learn about these, otherwise you may inadvertently save an incorrect file type or even lose some work. There are also ways to add files to the Windows or Mac folder structure and have them appear in ZBrush alongside the default tools. In this section we will work through each method and discuss good working practices to adopt.

▲ 64 KeyShot has a simple interface but powerful rendering capacity

▲ 65 There are multiple ways to import and export ZBrush resources

66 Opening and saving ZTools

The first method to learn is how to open and save a basic ZBrush Tool (model) called a ZTool. The file extension is ZTL. Look in the Tool panel and you will see Load Tool and Save As buttons. Any ZTools that you have saved previously can be loaded using the Load Tool button. Likewise, to save a ZTool, you can use Save As. This saves the currently selected ZTool (the tool that is the large icon in the Tool panel) and all of the SubTools that are in the layers below it – for example, you might have a head model with eyes and glasses. This is the most common way of saving a ZTool, and it also saves the model's color data if you have done any Polypainting.

▲ 66 You can save your project as a ZTool (ZTL file), including any SubTools and Polypaint information with it

▲ 67 You can also import and export the widely used OBJ format

▲ 68 Saving ZProjects is thorough but can occupy a large amount of space

▲ 69 Don't forget to QuickSave!

67 Importing and exporting OBJ files

Sometimes you may need to export a different file format to send out to another program. More advanced users can use a script called GoZ to transfer between different programs, but a very simple way to get the common OBJ format is to use the Tool > Export button. OBJ is a very popular modeling format and is used widely in the industry, and in many 3D modeling programs. One reason it is popular is that it carries UV coordinates allowing texturing.

Once your model is prepared and ready to export, use Tool > Export and choose OBJ from the dropdown menu (you will see there are also options such as MA for Maya, X3D for Web standard, and the GoZ options). Please note that this will export and save only the SubTool layer that you are currently on, not the entire ZTool. To export the whole model, go to Tool > SubTool > Merge > Merge Visible and this will combine the parts into a new single ZTool that you can export.

68 ZProjects

Sometimes you may want to save out all the ZTools you have currently got loaded in the Tool panel. This is a great way to save your entire project but can result in very large file sizes on bigger projects. To use this method, select File > Save As from the Standard menu, make sure the file type is ZBrush Project, then click Save. To reload a ZProject, simply go to File > Open and search for the ZPR file you saved. It is sometimes best to only save a limited amount of ZProjects per session, as they can create a lot of duplication and wasted space if not managed efficiently.

69 LightBox and QuickSave

Sometimes we need a get-out-of-jail-free card and require an emergency Save button at hand. ZBrush delivers on this front by giving you a QuickSave button in the top right of the ZBrush interface. If you use this button, ZBrush will save your work into a folder as a ZProject. To reload it, open LightBox with the Comma key, or use the LightBox button on the interface. With LightBox open, click on QuickSave and you will see the last ten ZProjects that have been saved. This is also where to look if ZBrush crashes and saves a version for you. The default save limit is ten, and they are overwritten after that, so don't rely on QuickSave for anything other than emergency saves.

▲ 70 Export Image offers a quick solution for saving out views of your ZBrush workspace

▲ 71 Resizing the document window can help you to capture more of your workspace

70 Exporting an image

On some occasions you may want to save out your screen document as an image. This can be after a BPR render or to save out a series of turnaround images to quickly composite into a set for a client. Once you are happy with the image you have created on screen, use Document > Export on the Standard menu. You can save out your image in a variety of formats including PSD, JPEG, PNG, BMP, and 16-bit TIFF. Choose the format that best suits your needs and click Save.

71 Increasing window size

If the image you are wanting to work on needs to be saved at a higher resolution, you will need to increase the document window size before rendering and saving. Go to the Document menu again and look down to the Width and Height settings. There is a Pro button to the left which allows you to constrain proportions if you wish. Change the dimensions to suit your project and hit Resize. The document window will change to reflect your new dimensions. If the pixel dimension is greater than the size of

your monitor resolution, some of the window will be hidden.

72 Document window zoom

To zoom in on the document canvas, use the Zoom button on the right-hand shelf. You can revert back to 100% size at any time by using the Actual button below it, and there is also an AAHalf button that will give you an image at 50% size. This is useful if you want to render out a huge image but need to zoom out on the entire canvas to see how to place the model.

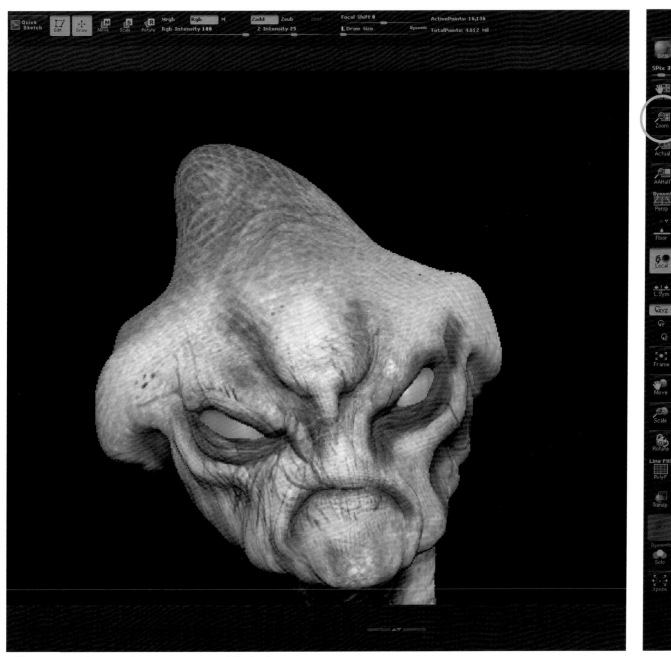

▲ 72 You can zoom in or out to better capture your model in the viewport

73 Saving brushes

As you develop your ZBrush skills you will want to make new brushes with the right settings for you. You can change things like depth into a mesh, surface noise, and even how the brush affects the model. As with most things in ZBrush, your brushes can be saved. If you have a brush that works well for you but want to make a slight change to its settings, simply use Brush > Clone to create a duplicate that you can modify as needed.

Any brushes you create will be lost once you restart the computer unless you save them. To save a brush variant, go to Brush > Save As and save your brush as a ZBP file. Then the next time you open ZBrush go to Brush > Load Brush to load the saved brush.

74 Import and export for 3D printing

Sometimes you may want to export a model for use in 3D printing (see more in chapter 07). You can of course export the model as an OBJ as described in step 67, but you may need to use a more common file format called STL. This format is used widely for most 3D printers and in additive manufacturing in general. This method of exporting is executed using the ZPlugin menu at the top of the screen. With your model selected, go to ZPlugin > 3D Print Exporter, and select the default format of STL. Then click Save. You can also use this panel to import an STL using the STL Import button.

75 LightBox files

We have already talked about using LightBox briefly. LightBox is a great way to keep your ZBrush ZTools and Projects organized. Navigate to the route installation folder for

Pixologic. In there you will find lots of folders relating to projects, brushes, alphas, and so on. You can start saving your own custom items into these folders and they will appear in the corresponding folders in LightBox.

▲ 73 Your custom brushes can be saved as ZBP files

▲ 74 The STL file format is often used for 3D printing

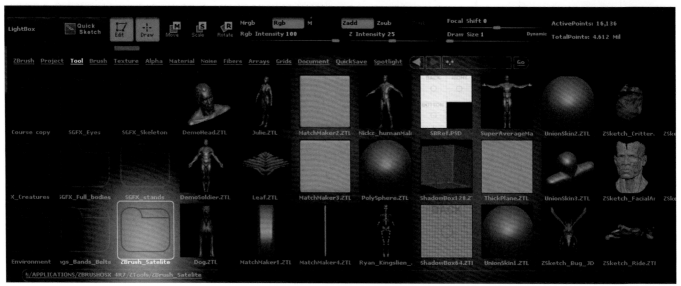

▲ 75 You can use LightBox to organize your ZTools and ZProjects

The next step

76 Exploration

You should now have enough information to start working through the projects that follow in order to learn how to use ZBrush tools and techniques in the context of a workflow. The key to ZBrush is familiarity with the toolset and interface, so make sure you explore and practice at every opportunity. This will help you to pick up the software and workflows much quicker.

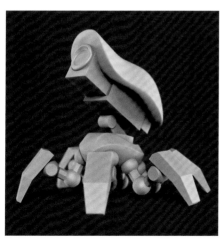
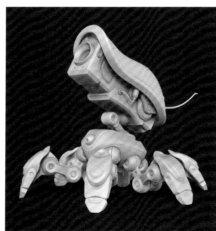
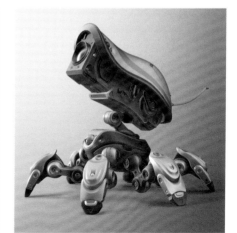

▲ 76 Top row images by Raul Tavares; middle row images by Ruben Alba; bottom row images by Carsten Stüben. Final artwork © the artist

DOWNLOADABLE
RESOURCES
3dtotalpublishing.com

Each artist in this section has provided the sketch they based their model on as a downloadable resource, so you can quickly get started sculpting for each project. These are available at **3dtotalpublishing.com/resources**

Projects

To give you a well-rounded guide through ZBrush, we have provided three step-by-step projects that cover organic, mixed-surface, and hard-surface sculpting. The ability to easily sculpt organic subject matter, such as characters, creatures, and monsters, is one of the great freedoms ZBrush offers to an artist. In the first project of this book, Raul Tavares will guide you through a straightforward character project that focuses on moving and shaping pieces of digital "clay." By the end of this project, you should be confident in manipulating geometry with brushes and managing the parts and sections of a full-body character.

Meanwhile, "hard-surface" is used to refer to metal or artificial structures like robots, vehicles, mechanical props, and industrial objects. Due to their precise nature, these objects are usually crafted with a more geometric polygon-modeling approach, which is not necessarily what first springs to mind when thinking of ZBrush. However, newer versions of ZBrush now include the ZModeler toolkit, which allows you to create hard surfaces with incredible control and ease of use. We touched on ZModeler's capabilities briefly in chapter 02, but in the second project of the book Ruben Alba will delve into them more deeply, blending organic and hard-surface elements to create a bionic character that combines not only different genres but different modeling techniques. Please note that ZModeler is not available in ZBrushCore.

For the third and final project, Carsten Stüben will show you how to model a fully hard-surface sci-fi design, creating smooth mechanical elements with a combination of ZModeler, hand-topologized geometry, and custom-made alphas. If you haven't already, we advise that you tackle the first two projects before starting this one, as they will help to familiarize you with the tools and techniques required. You may find the Component Index at the back of this book useful as you work through each project as it will help you to see each element you are constructing in context.

At the end of each chapter each artist will share some KeyShot renders of their final project to give you an idea of how to take your model's presentation to a more advanced level. We have provided an introduction to KeyShot in chapter 06 of this book, if you are keen to experiment with a new rendering option for your projects.

03
Organic sculpting

By Raul Tavares

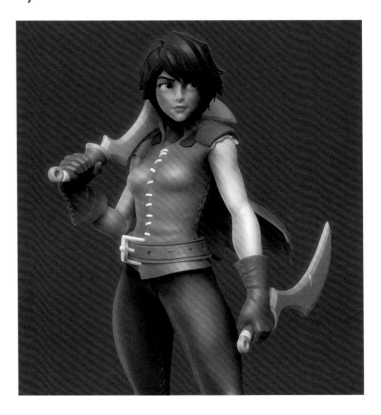

This first project will guide you through the creation of a stylized fantasy character called Kyra. ZBrush sculpting is renowned for its resemblance to clay modeling, and that is the type of quintessential ZBrush process we will be learning here: building up the design piece by piece, with a focus on sculpting simple shapes informed by strong core principles of character design. Though the emphasis will be on creating an "organic" subject, the project will also introduce you to some "hard-surface" modeling techniques to create weapons and accessories, which will prime your skills for creating more pronounced hard-surface elements in the next chapter.

To help you get started with your first major ZBrush project, the artist has also provided ZBrush files, extra brushes, and videos with audio commentary as downloadable resources for this book. You can find them online at: 3dtotalpublishing.com/resources.

Chapter sections
· Creating the base model
· Detailed sculpting
· Coloring, posing, and rendering

Creating the base model

01 The concept

Image 01a shows the 2D concept we will work from in this project – a brave dragon slayer named Kyra. As this is the first project in the book, we will work with a design that is simple to translate into 3D, with a focus on anatomy and readability.

Our objective will be to sculpt a female character with a distinctive and appealing design that tells a story. Sculpting is exciting, but understanding design principles and fundamentals is also valuable, because ultimately it is our mindset that will allow us to create characters no matter what software we use. With that in mind, image 01b shows the key design choices considered in the concept so you can take these forward when you move on to creating your own character at a later stage. The line of action shown in green indicates the gesture of the pose and distribution of the character's weight. Straight versus curved lines,

and complex versus simple lines, are indicated in orange and red, respectively; using contrast between areas of "visual rest" versus "visual interest" creates a stronger design. Thick to thin lines are shown in blue. Tapered shapes as opposed to parallel lines add interest and direct the viewer's gaze; parallels are boring to the human eye.

02 Anatomy breakdown

To help us visualize what we will be building in ZBrush, it is useful to identify the character's anatomy in an image-editing software such as Photoshop by separating it with different colors for the different parts. We will be building everything with primitive shapes, especially the base mesh, so this stage helps us to separate the main elements and keep an eye on proportions. It is not necessary to do this every time but, especially when starting out, it helps to visualize things much more clearly before jumping into ZBrush.

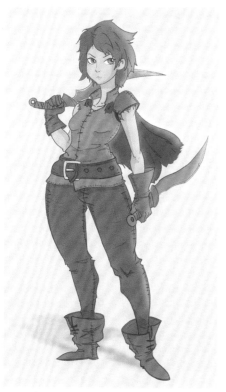

▲ 01a The 2D concept for the character

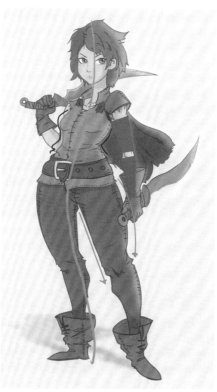

▲ 01b Some key visual markers to pay attention to

▲ 02 Break down the anatomy into parts

03 SubTools breakdown

Another thing that is useful to do before we start sculpting is to separate the concept into parts – different colors – to help us see what we will end up with as a final result in terms of SubTools inside ZBrush. For example the hair will be a single SubTool, the jacket will be another, and so on. Planning things ahead and separating the parts with different colors means that when we begin sculpting, we know that we will have X number of parts to take care of, and we can address them in an orderly fashion. This will help to keep us focused, as we will know exactly what we are going to build and in what order.

04 Starting the base mesh

Now we can open ZBrush and start building our base mesh. We will start with the torso and keep things simple, so we do not have to worry about exact proportions straight away. Instead, our concern at this stage is to get something on the screen so that we can then address the character in individual parts (according to our concept and references) once we have built the entire base mesh. Drag a 3D sphere (A in image 04a) out into the workspace by going to the Tool menu, clicking the large icon, and selecting Sphere3D from the list. To make the sphere sculptable, check that you are in Edit mode and click Tool > Make PolyMesh3D.

Press the X key to turn on Symmetry, then select the Move brush from the Brush menu. Make sure the Draw Size is bigger than the sphere, and make sure you can see the two red symmetry markers on opposite sides of the sphere. Start pushing the clay inwards with the Move brush to produce the shape shown in part B of image 04a. Left-clicking will allow you to drag the geometry around; Alt + LMB will move the geometry straight up or straight down from the surface of the object; Shift + LMB will smooth over any rough edges. There will be plenty of opportunity for you to become familiar with this sequence of tools, as we will be using it to build up the whole base of the body. We can also use the hPolish brush to establish flatter planes where the other body parts will connect (C).

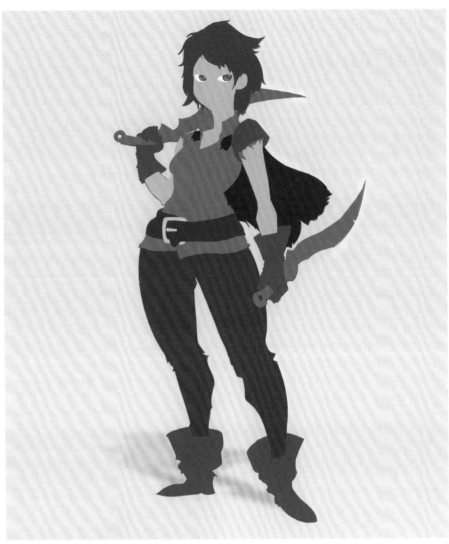

▲ 03 Plan separate SubTools ahead of time

In image 04b you can see an additional three-quarter, profile, and back views of the rib cage. I will show you as many views as possible of each part in this project, because it is only through constant rotation and evaluation of your model that you will start to memorize shapes, see irregularities on the form, and keep yourself honest about your object of study. Use Move and Rotate modes with the Transpose line to view your mesh as you shape it. You can use the W and Q keys to quickly switch between Move and Draw modes. Don't focus solely on one angle or view – by the time you rotate it, the chances are it will look nothing like what you are trying to sculpt. It helps to visualize the rib cage as more or less a bean-like shape in profile, and closer to an egg shape when viewed from the front.

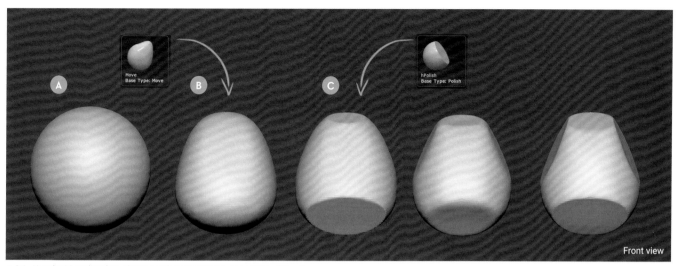

▲ 04a Use the Move brush to shape a Sphere3D into the base form of the rib cage

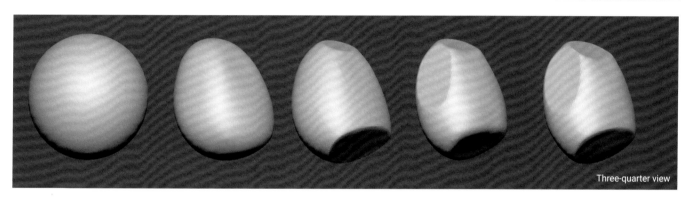

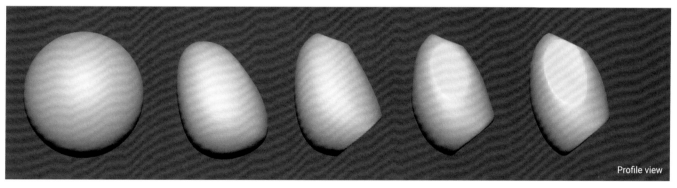

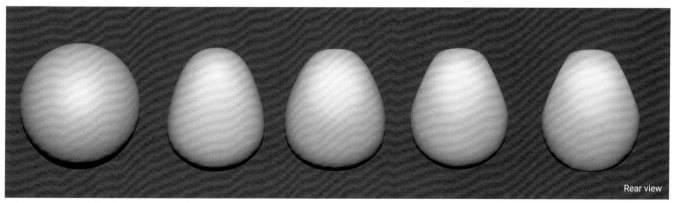

▲ 04b An overview of developing the rib cage from different angles

05 The pelvis

The rest of the base mesh will be added to this SubTool using mainly the Insert mesh brushes and Transpose tool. I use the InsertSphere brush for the pelvis, though you could also use InsertCube; I just prefer the sphere since it has a bit more topology to move around and it deforms slightly better. Reduce the Draw Size and select the InsertSphere brush from the Brush menu. Drag the sphere out from the bottom of the rib cage.

After inserting the primitive shape, the rib cage will automatically be masked off (A in image 05a), allowing you to position the pelvis easily: enter Move mode to activate the Transpose line, then use the central white ring to move the pelvis into place (B). Then use the Move and hPolish brushes to shape it into the slightly deformed box shape that the pelvis resembles in its simplest form (C).

In images 05a–05d you can see front, three-quarter, profile, and back views of the pelvis being placed and sculpted. You will notice in the profile and back views that I have created a hint of the gluteus and its placement. There are also flatter planes on the sides of the pelvis, to suggest where we will insert the thighs later. Even though we are just blocking out the really basic shapes, it is fine to give a hint of other forms here and there where you see fit. This is where a familiarity with anatomy is useful.

KEY CONCEPT

Topology

"Topology" refers to the surface geometry of a 3D mesh, consisting of a layout of edges and points that create polygons. Good topology (or "clean" topology) should capture the desired shapes as consistently and effectively as possible, without odd-shaped polygons or flaws that cause problems when deforming or dividing the mesh. We will come across ways to improve topology later on.

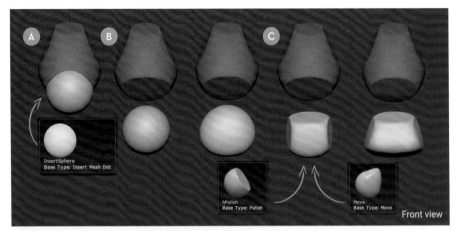

▲ 05a An overview of placing and sculpting the pelvis from a front view

▲ 05b Do not forget to rotate your mesh to ensure it is placed and shaped correctly

▲ 05c Note that the rough shape of the gluteus has been blocked out

▲ 05d A rear view of the pelvis being placed and sculpted

▲ 06a Use the same process as before to insert and shape the mid-section of the torso

▲ 06b Note how this mid-section flows between the forms of the rib cage and the pelvis

▲ 06c Check in a profile view to ensure that this part has an organic, appealing flow

▲ 06d From behind, you can clearly see where the pelvis has been moved upwards

06 Completing the torso

Now let's introduce the big mass that connects the rib cage and the pelvis, using the same techniques as before: adding new geometry with the InsertSphere brush, and then using the Move brush to attain the right shape. Again, you will find that the rest of the SubTool will be safely masked off when we place a new InsertSphere, allowing us to move and sculpt it without disturbing the other parts we have made so far. As you can see in images 06a–06d, we can start from a smaller sphere and then stretch it out to fill the space between the rib cage and pelvis.

This particular mass will include both the abdominal muscles as well as some of the back muscles, so getting it right is a big step in creating a well-designed torso for our character. You can see where I have selected the pelvis again (see how to do this in the Pro Tip below) and moved it up slightly to create a stronger form.

PRO TIP
Masking shortcuts

When we add a new shape to this SubTool with an Insert mesh brush, it will temporarily mask out the rest of the geometry until we unmask everything by holding Ctrl and clicking and dragging in an empty space. The mask function is useful for moving a new piece into place and starting to shape it without disturbing the other parts we have made. Even when parts have been unmasked, you can easily reselect specific pieces by switching to Move mode and clicking on them while holding Ctrl + Shift. This selection can then be inverted with Ctrl + I, or by clicking in empty space while holding Ctrl. Use these shortcuts to switch between body parts when sculpting. Ctrl + clicking and dragging in an empty space will cancel the whole masking area.

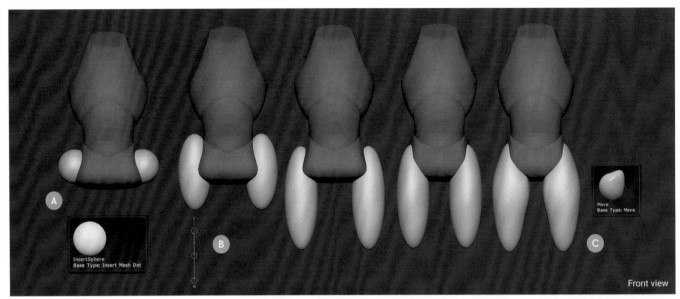

▲ 07a Use Symmetry to place identical thighs

07 The thighs

The thighs will sit on the side planes of the pelvis that were carved previously using the hPolish brush. Both the thigh and the lower leg are two large masses that are useful to add in as fast as possible in order to have a clear view of the size of the character. We are still using the same techniques: adding with the InsertSphere brush, moving things into place with the Transpose tool, and creating shape with the Move brush. This time, however, activate Symmetry with the X key to place two spheres at the same time (A in image 07a). In Move mode, use the red inner ring at the end of the Transpose line to stretch the spheres into two ovals (B). Then adjust their placement with the white central ring. Use the Move brush to add some hints of shape to the thighs, but not detailed anatomy (C). The major masses should be our focus at this stage.

08 Lower legs

Looking at anatomy references can be intimidating because they have so much detail, but any complex shape can be broken down into simplified ones. To block out the lower legs as shown in images 08a–08d, simply use the Transpose tool to duplicate the thighs (hold Ctrl while dragging on one of the smaller inner rings), and then move them into place with the central white ring. Then use the Move brush to shape the legs accordingly.

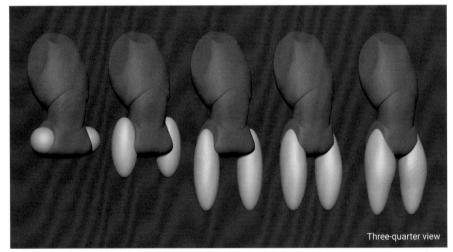

▲ 07b A three-quarter view of the thighs being placed and sculpted. Note the subtle final shape

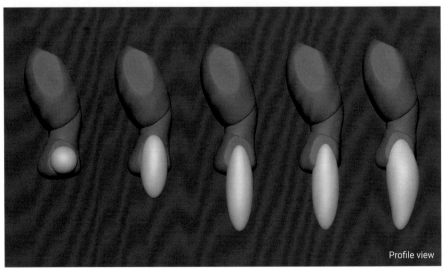

▲ 07c A profile view of the thighs being placed and sculpted

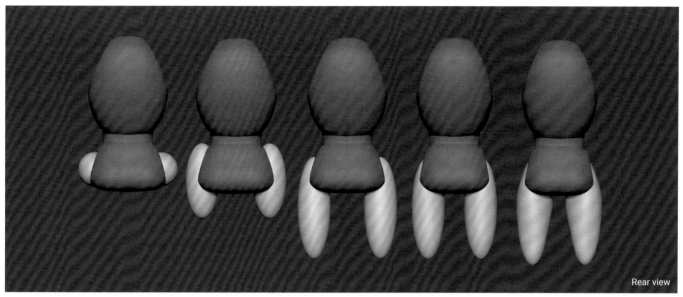

▲ 07d A rear view of the thighs being placed and sculpted

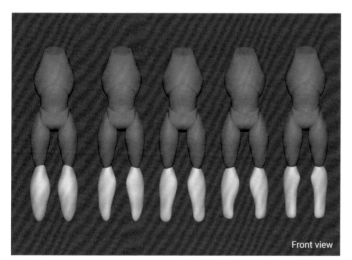

Front view

▲ 08a Duplicate the thighs with Transpose to quickly block out the lower legs

Three-quarter view

▲ 08b Sculpt the lower legs into a more suitable shape with the Move brush

Profile view

▲ 08c A profile view of the lower legs being placed and sculpted

Rear view

▲ 08d A rear view of the legs. Note the subtle sculpted shapes of the calves

09 The shoulders

The form of the shoulder is basically created by the deltoid muscle, which is roughly heart- or triangle-shaped. The broad side of the shape is facing up and out (towards the neck) and its narrow edge points down (towards the arm). Its purpose is to serve as a union of the arm with the torso.

As we did for the thighs, activate Symmetry with the X key, use the InsertSphere brush, and then use the Transpose tool and Move brush to place and sculpt the triangular deltoid shape.

Front view

▲ 09a Add two more spheres and use the Move brush to form them into the shoulders

Three-quarter view

▲ 09b A three-quarter view of the shoulders being placed and sculpted

Profile view

▲ 09c In this profile view, you can easily make out the rough teardrop shape of the simplified deltoid muscle

Rear view

▲ 09d A rear view of the shoulders being placed and sculpted

▲ 10a Place spheres underneath the deltoids and stretch them with Transpose to form the base upper arms

10 Upper arms

Use the same process as we did for the thighs to create the upper arms. Activate Symmetry, use the InsertSphere brush to block out the upper part of the arm, and then use the Transpose tool in Move and Rotate mode to elongate them into more or less cylindrical shapes that are positioned underneath the deltoids we made in the previous step. The upper arms should taper slightly towards the forearm and have more volume in the triceps and biceps area, but again, this should only be a simple block-out. We will move on to anatomy, proper volumes, and plane breaks later.

▲ 10b In this three-quarter view, you can more clearly see how the deltoid and upper arm fit neatly together when moved into place

▲ 10c Use the Transpose tool in Rotate mode to achieve a better placement of the cylinders we stretched out

▲ 10d A back view of the upper arms and how they fit together with the deltoids

11 The forearms

In its most simplistic form, the forearm can be considered as two boxes. However, when connected and with all the other layers that go on top (muscle, fat, and so on) it almost resembles a cylinder. So, as we did with the thighs and lower legs, we are going to use the recently created form of the upper arm to create the lower arm. Press the X key for Symmetry. Use the Transpose tool with Move selected, and press Ctrl while dragging one of the smaller inner rings to duplicate the upper arms. Then move these into place with the white central ring.

It is not necessary to sculpt and edit the forearms very much. For now, and until we finish the base mesh, it is all about having the basic shapes in place to start working.

▲ 11a Use the Transpose line to duplicate the upper arms and move them into place as the forearms

▲ 11b The duplicated arm meshes will need to be moved forward slightly

▲ 11c Moving the arms into place

▲ 11d A rear view of the arms being duplicated and moved into position

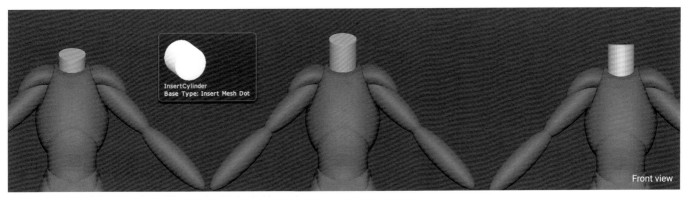

▲ 12a Use the InsertCylinder brush to add a very simple placeholder neck

▲ 12b Use the Transpose tools to adjust the length and angle of the neck to something more natural

▲ 12c Create a more upright posture for the neck with Transpose

▲ 12d A rear view of the neck being placed and adjusted

12 The neck

This stage is very simple and scarcely requires any editing. The base neck mesh is made with an InsertCylinder brush, which can be accessed through the Brush menu like the InsertSphere brush we have been using so far. Place this cylinder, adjust its length with the Transpose tool in Move mode if needed, then adjust its angle slightly using Rotate mode to make it more upright.

▲ **13a** Shape the base mesh of the head from a simple sphere

▲ **13b** Here you can see how some planes of the skull are suggested with the Move brush

▲ **13c** The Move brush is used to pull down the shape of the lower jaw

▲ **13d** The back of the skull is not adjusted very much, apart from some subtle flattening at the sides

13 The head

The head is complex because it has many plane breaks and very precise proportions. We spend most of our time looking at other people's heads, so it is very easy to look at a sculpt and "feel" that something is not quite right. Look for additional references to solidify your knowledge here. Place a sphere on top of the neck using the InsertSphere brush, then turn on Symmetry and carefully use the Move brush to sculpt the rough forms of the head. Keep the back of the skull as round as possible, with only some minor adjustments, and use the Move brush to pull down the jaw and define some of the basic planes of the face. You may find it helpful to use a planar reference for this task.

14 The feet

Our feet have the difficult function of bearing the weight of our bodies. As such, the foot has the same structure for everyone but has a great variety of subtle forms that vary from person to person, especially when it is settled on the ground. If you look up George Bridgman's illustrations of the foot, he deconstructs the complex forms into a couple of basic shapes we can recreate inside ZBrush. Again, find additional references – even take pictures of your own feet – to aid you during sculpting. Although Bridgman divides the foot into two rough shapes, we can simply turn on Symmetry and use the InsertSphere brush to add a sphere. Then use the Move brush to roughly achieve the intended shape. I also like to flatten the sole of the foot (although it is definitely not flat in reality) during the initial sculpting stages. You can use the ClipCurve brush to do this, holding Ctrl + Shift and dragging the line over the area you would like to delete. The angle of the line indicates in which direction the mesh will be clipped, and depends on whether you drag the line from the left or right.

▲ 14a Use the Move brush to pull out the spheres of the feet, and optionally the ClipCurve brush to flatten the sole

▲ 14b A three-quarter view of the feet being sculpted into position

▲ 14c In this profile view, you can more clearly see how the side and heel of the foot are shaped

▲ 14d This rear view of the foot shows the heel being shaped, and the results of flattening the soles with the ClipCurve brush

15 The hands

Hands are probably every artist's Achilles' heel. It is so easy to get them wrong! It helps to imagine them as simple cubes (or cubes and cylinders), but at this point we are only going to add a simple sphere using the InsertSphere brush. Do this with Symmetry turned on to create both hands, and then use the Move

brush to shape the masses of the hand and add the hint of a thumb.

16 Preparing for detail

It is now time to start tweaking proportions and adding the final elements to our base mesh. We will use masking tools and Transpose to isolate and adjust the proportions to match the concept. Make the rib cage smaller and the legs and head larger to create a more appealing silhouette. You can Ctrl + click on a Polygroup to isolate it easily (thanks to the Polygroup mechanic, which we will learn about in step 20), and Ctrl + click in empty space to invert the masked selection and make it

quicker to isolate specific parts. Once the proportions are adjusted, use the Smooth brush to smooth out the planes of the head. Add the breasts using the InsertSphere and Move brushes, then add the fingers as a series of cylinders (three for each finger, two for the thumb) using the InsertCylinder brush and the Transpose line to move and rotate them into place. We can roughly add some kneecaps with the InsertCube brush, again making small adjustments to their shape with the Move brush. Use the hPolish brush to lightly establish some planes on the arms, suggesting some bone and muscle structure, and the Standard brush to sculpt a hint of the clavicle.

Front view

▲ 15a The hands start as simple spheres

Three-quarter view

▲ 15b The Move brush is used to flatten the hand slightly and add the suggestion of a thumb

Profile view

▲ 15c A profile view of the hand being placed and shaped with the Move brush

Rear view

▲ 15d Note the very simple flattened and curved shapes of the resulting base hands

Front view

▲ 16a Here you can see the final base mesh after the proportions are tweaked with masks and some last details are added

▲ 16b The InsertCylinder brush is used to create placeholder fingers, and the InsertCube brush to create the knees

▲ 16c The final tweaked base mesh (on the far right) has stronger proportions than our previous version (on the far left)

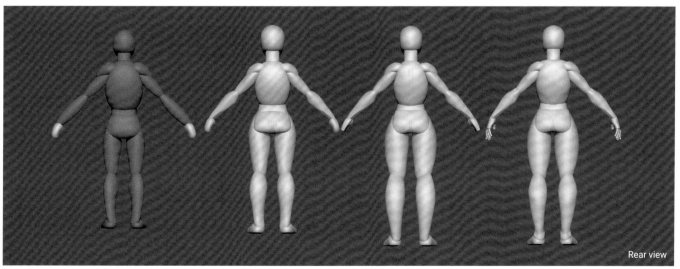

▲ 16d The back view of the final base mesh. Here you can see how some extra definition has been sculpted into the arms and legs

17 Placeholder eyes and ears

Next use the InsertSphere brush and Symmetry to add the eyes, just as placeholders. You can use the Move brush first to push two rough eye sockets into the front of the head mesh for them. It is useful to have all the features in place, even if we end up remaking them, as it helps us to see not only the character's overall proportions, but how the parts look in relation to each other. The eyelids are not essential at this point but

can be added following the steps in the Pro Tip on the next page. The ears can be created using cylinders that are flattened and shaped with the Transpose tool and the Move brush.

18 Placeholder nose and mouth

Use the same techniques as before to place the nose, which we can represent with four parts made from spheres: one sculpted out for the bridge of the nose, one for the tip of the nose,

and two for the wings of the nostrils. These are all shaped with the Move brush.

We can also use the Move brush to roughly define the cheekbones and mouth, though our geometry is too low poly to go into much detail at this stage. It will nonetheless help us to visualize our character later.

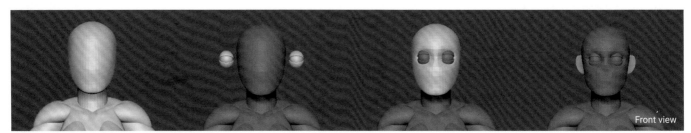

▲ 17a Use the InsertSphere brush for the eyes

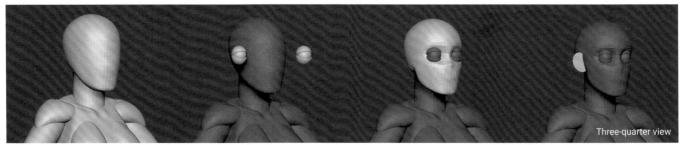

▲ 17b See the Pro Tip on the next page for how to create basic eyelids

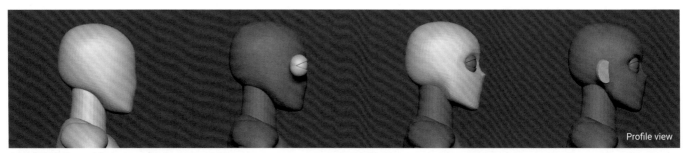

▲ 17c Use the InsertCylinder brush for the ears

▲ 18 After adding the eyes and ears, add a placeholder nose using four spheres and the Move brush

PRO TIP

Creating the eyelids

To create placeholder eyes with eyelids, turn on Symmetry and use the InsertSphere brush to place two spheres. Ctrl + Shift + click on these to temporarily isolate them so they are easier to see. Use the ClipCurve brush (hold Ctrl + Shift and drag the line from right to left) in Draw mode to delete the lower halves of the spheres, leaving two upper "lids." Switch to Move mode and use one of the smaller inner rings of the Transpose line while holding Ctrl to drag out two duplicate lids. Don't forget that holding Shift at the same time will help to Transpose in a fixed direction.

Open Tool > Deformation > Mirror and activate only the small letter Y in the top right of the Mirror button, indicating that we want to mirror these lids along the Y axis. Click Mirror to confirm and the duplicate lids will be flipped upside down to create the lower lids. Use the Transpose line in Move mode to move the lower lids closer to the upper lids, then adjust their angle with Rotate mode (so that the eyelids seem open). It helps to Ctrl + click on the background to switch between the upper and lower lids. Finally, use the InsertSphere brush to insert two eyeballs between the newly made eyelids.

Ctrl + click and drag on the background to clear all selections, allowing you to select or mask one eye or the other and adjust their spacing individually. Finally, move the eyes into place with Transpose.

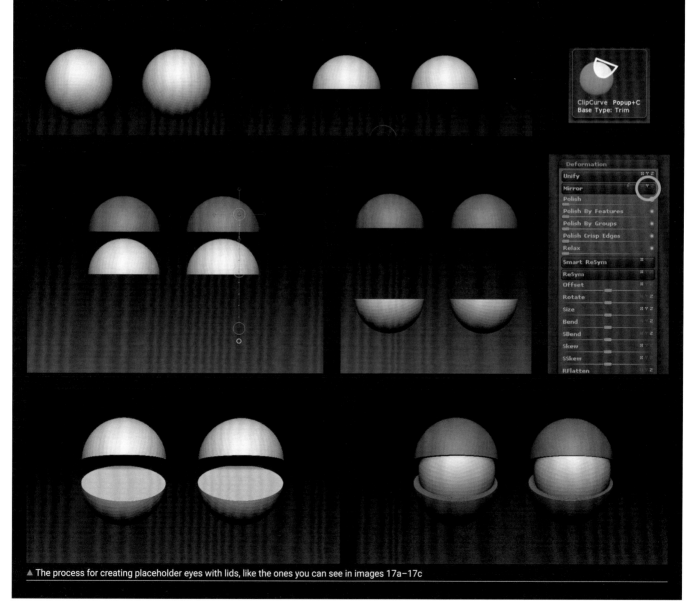

▲ The process for creating placeholder eyes with lids, like the ones you can see in images 17a–17c

Detailed sculpting

19 Final base mesh

The base mesh is now looking well developed in terms of proportions and silhouette, so it is almost time to move on to refining the anatomy. Before we start that, take a moment to compare and measure the model against the concept. Find some key reference points (like the width of the shoulders and hips) to judge the proportions of the base mesh against the concept. Check that the character's silhouette is clear from different angles, and consider the "S"-shaped curves that naturally occur on the body.

It is likely that some of the character's overall proportions need tweaking to get them as close as possible to the concept, so we can use the Polygroup mechanic mentioned in step 16 to select areas to edit. We may need to select more than one area to edit, which is not initially straightforward to do. To select multiple parts of the mesh, start by using Ctrl + Shift + click to select one Polygroup. This will initially isolate that Polygroup and hide the rest of the mesh (like the arms, as shown in part A of image 19). We still need to select more parts of the body though, so Ctrl + Shift + click on the same piece to invert the selection. Now we can continue using Ctrl + Shift + click to isolate other areas (B). If we need to start over, simply Ctrl + Shift + click in empty space to reveal the full mesh. When you are happy with the parts you have isolated, use Ctrl + click in empty space to mask the visible remainder of the mesh, then Ctrl + Shift + click to reveal the isolated groups again.

Now we can use the Transpose tools to tweak the sizes and proportions as desired, without affecting the rest of the body. Once we have finished making changes, we can clear the mask by holding Ctrl and dragging in empty space. You can also mask multiple parts of the mesh by clicking and dragging on the mesh with the Transpose line active (C) while holding Ctrl. This will select areas and mask others, depending on where you drag the tool. To add

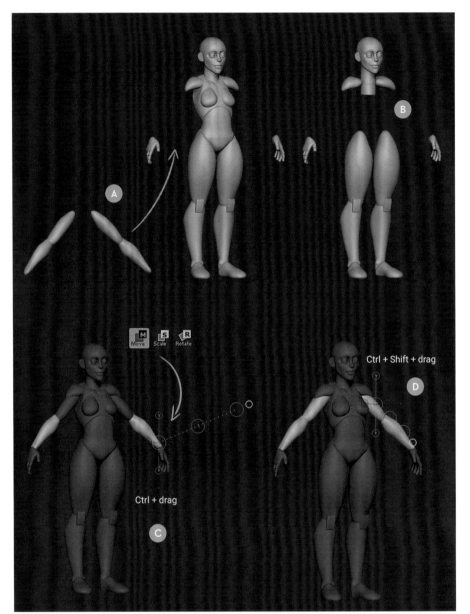

▲ 19 You can use masking to isolate body parts if you need to adjust their anatomy

more parts to the selection, just hold Ctrl + Shift and drag on a new area (D). This will also reverse the mask, so Ctrl + click in empty space to flip the selection back. Try to judge which selection method is most appropriate for the adjustment you are trying to make.

20 Assigning new Polygroups

In order for this next stage to work, we need to assign some new Polygroups to our model. Each time we added a sphere using the InsertSphere brush as we built the model, the new sphere was automatically given its own Polygroup. However, it will be more useful

and practical to consolidate some of the larger body parts together. In image 20 you can see how the upper and lower legs now share a Polygroup, as do the arms. To assign new Polygroups to your model, select parts using the masking techniques described in the previous step, and press Ctrl + W or use Polygroups > Group Masked. Note that you will need to be in Polyframe mode (Shift + F) to see the Polygroups as you create them. Try using these techniques to put the legs and feet in the same Polygroup, as well as the breasts and torso, as you can see by the color grouping in the next step.

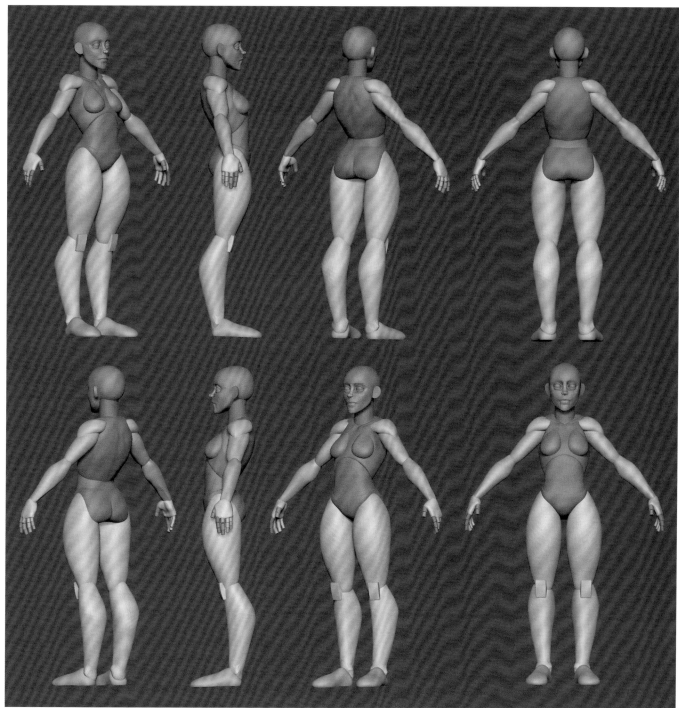

▲ 20 Consolidate your Polygroups into more useful groups

PRO TIP

Turning off the wireframe

In the images above I have turned off the wireframe but left the coloring of the Polygroups visible in order to illustrate this step more clearly. You can do this by checking the small letters shown inside the PolyF button once it is activated (in ZBrush 4R7 onwards). "Line" refers to the wireframe and "Fill" refers to the color. Click "Line" to turn off the wireframe and view your Polygroup colors only.

21 DynaMesh with Groups

Now that we have different Polygroups for the parts we will work on, it is time to apply DynaMesh to the model to give ourselves better geometry to work with. First make sure you have the wireframe turned on. Under Tool > Geometry > DynaMesh, there is a Groups button. If we switch this on, it allows us to apply DynaMesh to parts that belong to the same Polygroup. This means that we could apply DynaMesh to a Polygroup such as the torso or the arm, merging the sculpted pieces into a single form, while still keeping them separate from other Polygroups that have different colors. This is helpful because we want our base mesh to be a single SubTool, but also need the ability to select and isolate individual parts to work on.

After turning on the Groups button, set the resolution slider to 96, and press the DynaMesh button. DynaMesh will even out the distribution of polygons all over the mesh, making the topology a consistent resolution to sculpt with.

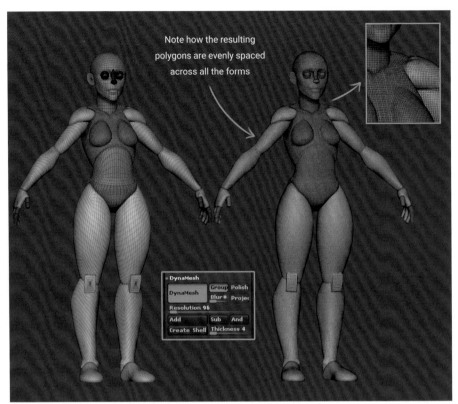

▲ 21a The mesh topology before and after applying a DynaMesh resolution of 96

▲ 21b An overview of the model now that DynaMesh has been applied

Geometry within the same Polygroup will be slightly smoothed together, while the transitions between different Polygroups will be kept distinct. At this stage, it is important to keep a low resolution so that we can manipulate the mesh without struggling. The higher the resolution, the less effective our sculpting brushes will be on the mesh, so at this point an overall resolution of 96 will suffice.

22 Smoothing the base mesh: part 1

Because our DynaMeshed sculpt has retained its Polygroups, we can work on one section of the body at a time by clicking on a Polygroup while holding Ctrl + Shift. Now we have enough resolution to start smoothing transitions, adding some subtle mass, and creating plane changes or plane breaks. By "plane changes," I mean where the surface naturally changes angle, creating subtle harder edges: for example from the eyebrow line to the eye sockets, and from there to the eyelids. DynaMesh may have introduced some crude transitions where meshes were joined together, so smooth and refine them with your sculpting brushes.

I use the Clay and Clay Buildup brushes to add mass, for example for the abdominal muscles. I also use one of my favorite brushes, the "MAHcut Mech A" brush. This brush does not come with ZBrush by default, but can be downloaded for free online or with the downloadable resources of this book, courtesy of artist Michael Angelo Hernandez (MAHstudios on Facebook). Make sure Symmetry is activated so you can adjust both sides of the mesh at the same time. Take a look through the different stages shown in image 22 to see which brush can be used to polish the mesh and add hints of anatomical structure.

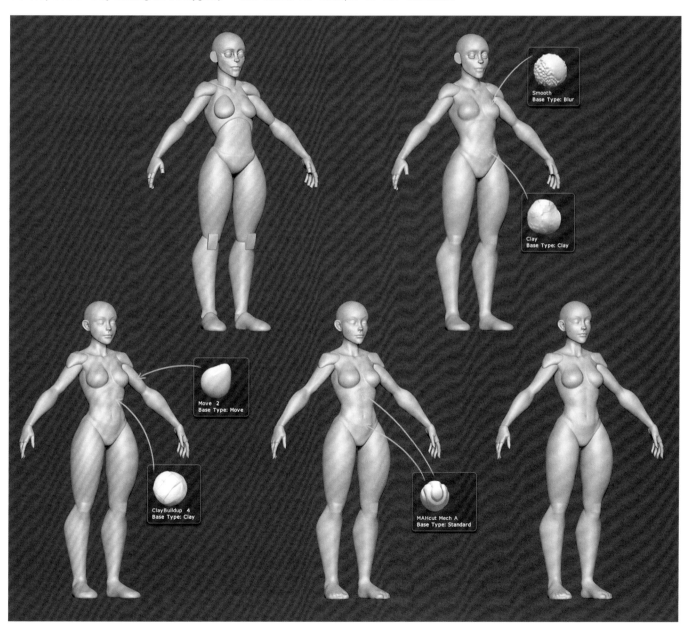

▲ 22 Now that DynaMesh has been applied, we can begin to smooth and refine the sculpt

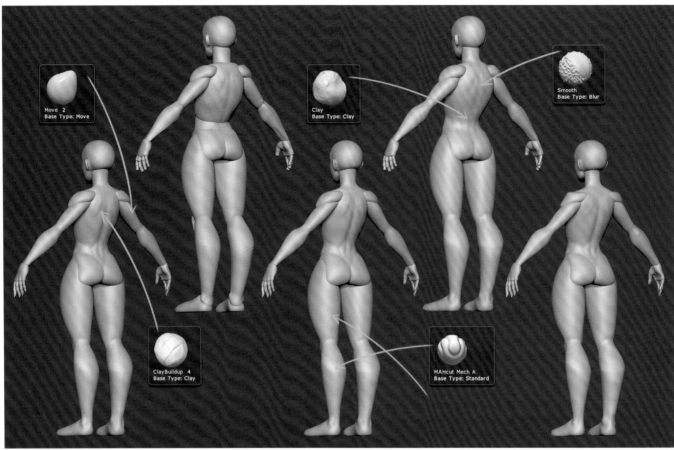

▲ 23 The back view of the mesh as it is smoothed and sculpted

23 Smoothing the base mesh: part 2

The same thing goes for the back view of the character, where we can gradually smooth over the parts (Smooth brush), add mass (Clay and Clay Buildup brushes), and then smooth again. Think of it as if you are building the forms in layers: making adjustments with the Move brush, creating crisp lines with the MAHcut Mech A brush to give some anatomy hints, then smoothing over the results where necessary to make them softer and more natural. Examine image 23 to see how each brush can be used.

24 Split Hidden

Now we can start focusing on the anatomy a bit more, but still not too drastically. To do this, we need to start by splitting some parts (like the head and arms) in order to increase the DynaMesh resolution and focus on the connections of the main body. To do this, select and hide the arms and head using the techniques covered in step 19, then go to Tool > SubTool > Split > Split Hidden (A in image 24). This will split the arms and head off into their own separate SubTools, allowing us to focus on detailing the body parts separately. Now we can increase the DynaMesh resolution of the torso and legs (which are still in the same SubTool) to 160 (B), allowing us to sculpt in greater detail. Continue to refine the mesh using the same techniques as before: smoothing the surface (Smooth brush), adding mass (Clay and Clay Buildup brushes), adjusting geometry as needed (Move brush), and creating plane breaks and hints of anatomical structure (MAHcut Mech A brush).

25 Mirroring the legs

Symmetry is very helpful for sculpting, but sometimes makes it harder to visualize areas of the model that are close together, such as the legs. Let's break away from symmetry by pressing the X key and just working on one

KEY CONCEPT
Polygroups and SubTools

SubTools are individual meshes that can be moved, edited, or deleted more easily. Polygroups are not separate meshes, but are a useful way to organize a mesh visually and create useful selection areas that you can easily come back to. Use a combination of SubTools and Polygroups for the best possible organization of your project. Creating the rough base mesh in one SubTool was sufficient for that rough level of sculpting, but we are now going to split that SubTool into smaller pieces that we can edit and detail more easily. Many of these SubTools will be organized into Polygroups for better control while sculpting.

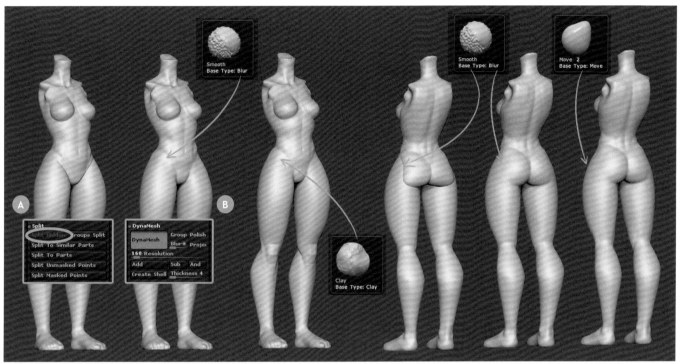

▲ 24 Use the Split Hidden function to assign separate SubTools to the head and arms

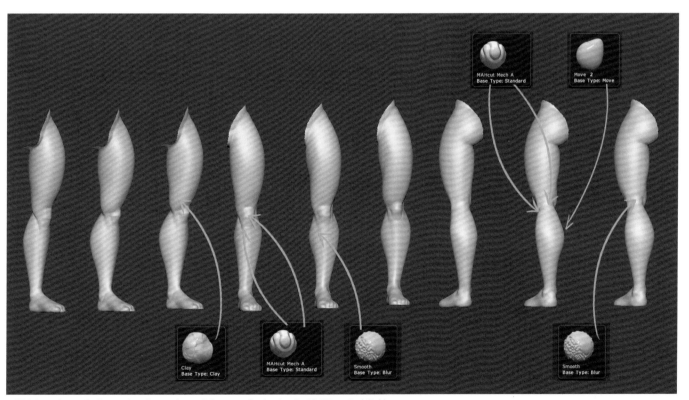

▲ 25 It is easiest to isolate and sculpt one leg and then transfer the detail with Mirror And Weld

leg. To show only one leg, use SelectLasso or SelectRect to select around one leg. Simply choose one of these brushes from the Brush menu, and click and drag around the area you want to isolate while holding Ctrl + Shift. This will temporarily hide the rest of the mesh until you Ctrl + Shift + click in empty space to clear the selection. After you have sculpted details onto the single leg, go to Tool > Geometry > Modify Topology > Mirror And Weld, which will mirror all the sculpting you have done to the other leg.

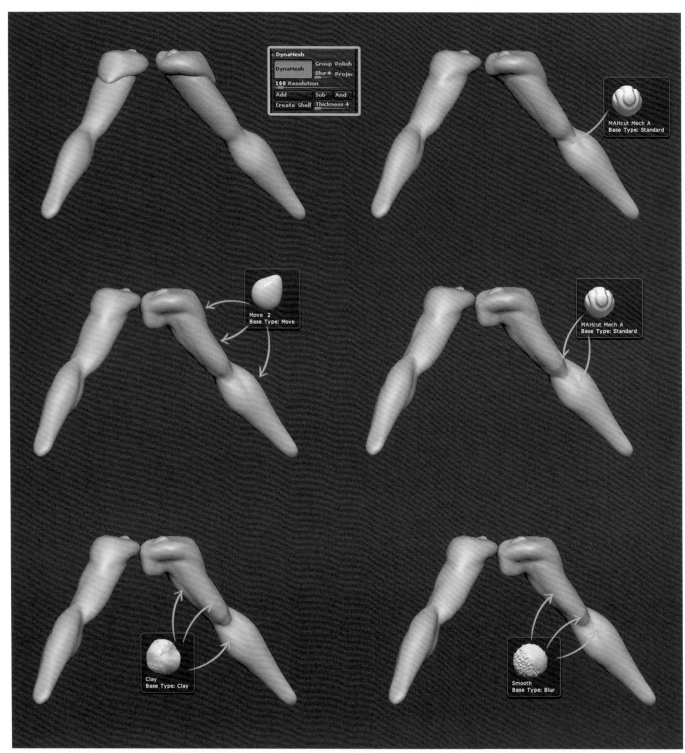

▲ 26a Increase the DynaMesh resolution of the arms SubTool and start sculpting details

26 Sculpting the arms

Now use Alt + click to select the arms SubTool that we separated from the body earlier, and increase the DynaMesh resolution to 160. The arms are far enough apart that we can sculpt them with symmetry and not encounter any problems, so activate Symmetry with the X key. You can see both arms and hide the torso by clicking the eye icon on the torso SubTool in the SubTool stack. Use the brushes shown in images 26a and 26b to sculpt the arms in more detail. Pay special attention to the way in which the upper arm connects to the forearm, and how the biceps end with a plane break before "sliding" into the forearm.

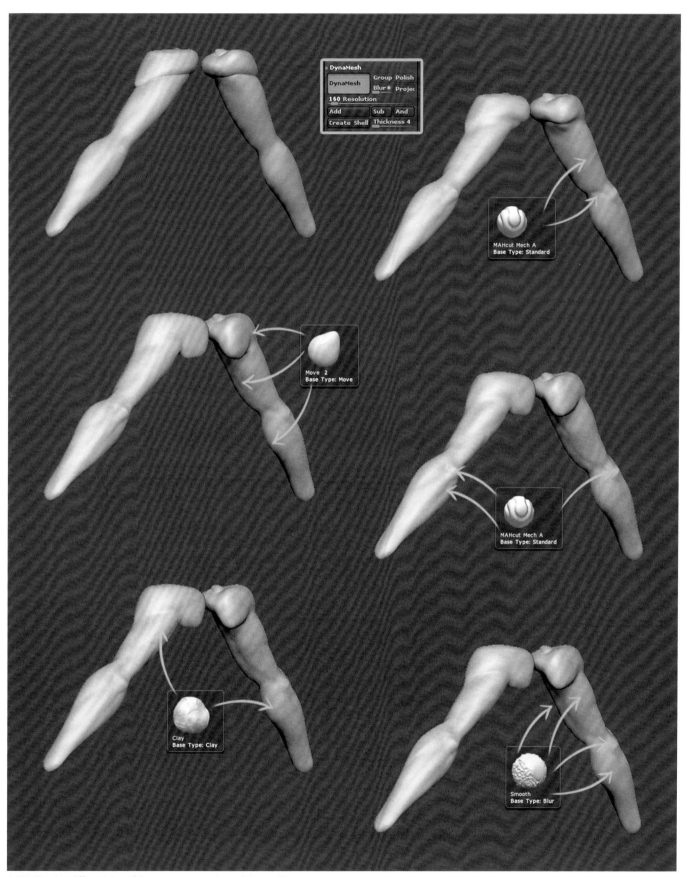

▲ 26b Here is a different view of the same process shown in image 26a

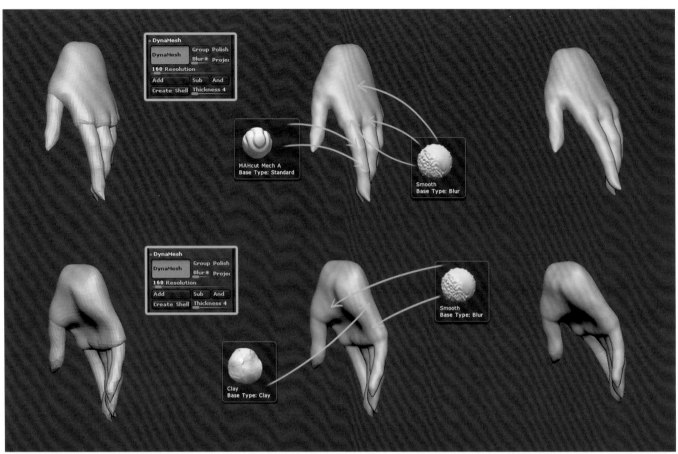

▲ 27 Increase the DynaMesh resolution of the hands and start to sculpt them

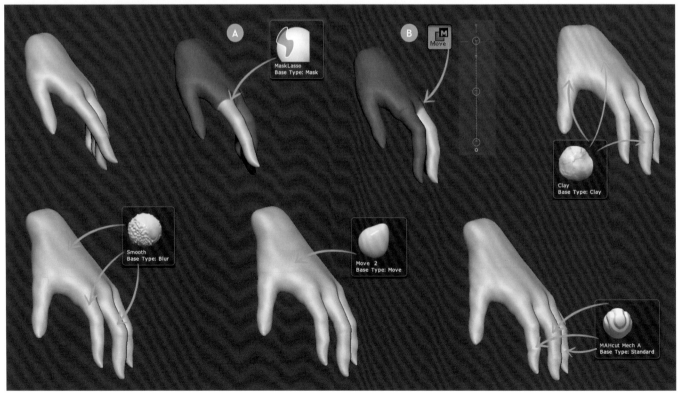

▲ 28 We need to allow space between the fingers to extract the gloves later on. Use masking and the Transpose line in Move mode to space the fingers out in preparation

27 Sculpting the hands

Use Tool > SubTool > Split > Split Hidden as we did in step 24 to split the hands away from the arms and into their own SubTool. It is important to collect additional references or even take pictures of a female friend's hands in order to sculpt these. Hands are a character in themselves – they seem so graceful and simple, and yet they are very complex to sculpt. The techniques are the same as before (working on both hands as one SubTool and using Symmetry).

In this case, I increase the DynaMesh resolution to 160, same as the other parts; however, you may find that you have to increase the DynaMesh resolution a bit more because the ideal DynaMesh resolution depends on the scale of your SubTool and model. Experiment to see what works best; being able to use your judgment will come with experience.

Use the Clay and Smooth brushes to sculpt the forms of the hand, and the MAHcut Mech A brush to add subtle bony landmarks such as the knuckles.

28 Preparing the hands for extracting geometry

Now we need to change the pose of the hands slightly. They will look less graceful, but it will make the next steps much easier. We are going to be "extracting" gloves and other pieces of clothing directly from the base mesh later, and if the fingers (or any other parts) are too cramped together, they might give us trouble when we start extracting thicker geometry. To prepare for this, use the MaskLasso tool to select an individual finger (A in image 30), then use the Transpose tool to change its position (B).

Repeat this for each finger until they are all spread slightly apart. When you are happy with the new pose, you can start to go back over the hand with the Smooth, Clay, and MAHcut Mech A brushes to finish refining the anatomy and re-establish any lost details.

29 Sculpting the head

As the previous head and facial features were placeholders, if you are not happy with your head it can be easier to start from scratch rather than refining the existing anatomy. I append a new Sphere3D SubTool and then use masking and the Move brush to pull out the chin area (A in image 29a). I use the Move brush to establish the overall shape of the skull, and the hPolish brush to introduce some plane changes where the eyes and mouth will fall (B). I use the InsertSphere brush to add the nose and ears (C and D in image 29b), and the Move brush to shape them.

▲ 29a Remake a detailed head using various sculpting techniques

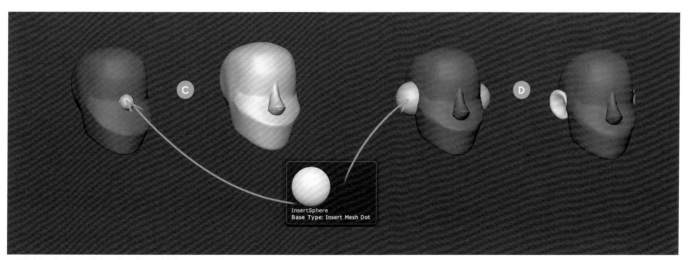

▲ 29b Use the InsertSphere brush to add the nose and ears

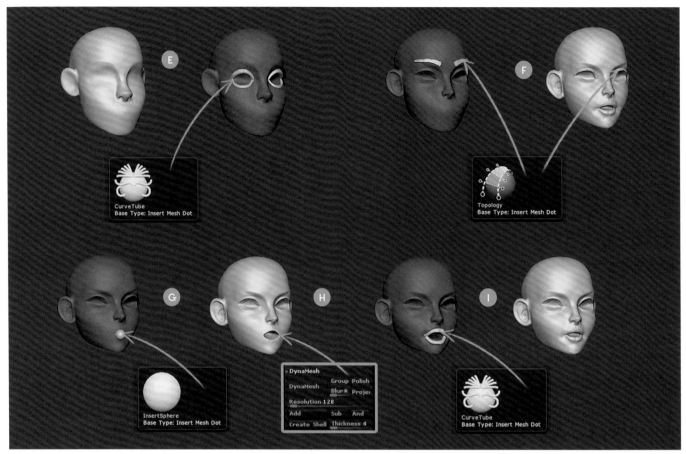

▲ 29c You can use the Topology brush for the eyebrows and eyelashes, and subtraction to create the mouth

I use the CurveTube brush to add the eyelids (E in image 29c), shaping them with the MAHcut Mech A brush.

We will use the Topology brush to draw the geometry of the eyebrows and eyelashes. The Topology brush enables you to outline the polygons of a new piece of geometry, click by click, which is very useful for adding small accessories or flat surface details such as these stylized eyebrows. Geometry created with the Topology brush is not created as its own SubTool, so we will need to separate them into SubTools afterwards to preserve their shape while we continue to work on the head. Use the brush to outline the polygons of the piece you would like to create, then left-click on the result to confirm the new shape (F). Set these parts to become new SubTools while they are active by going to Tool > SubTool > Split > Split Unmasked Points. We don't currently need them to be attached to the head mesh.

To create a hole for the mouth, hold Alt while using the InsertSphere brush (G). ZBrush will invert the view of the sphere as you are placing it, which can make it difficult to see; in order to view it as normal, go to Tool > Display Properties and click Double. Now you can sculpt the sphere into a flattened oval shape that will subtract a mouth-shaped cavity. Unmask the selection and apply DynaMesh (H). DynaMesh will recognize the inverted geometry as a subtraction operation, and remove that shape from the head. Use the CurveTube brush to create the lips (I), and shape them with the Move brush. You can also place two spheres for the eyeballs, and keep them as a separate SubTool; they are not needed yet.

30 Preparing for ZRemesher

After sculpting and cleaning up all the different parts of the body, it is time to combine them back together (except for the eyes, eyebrows, and eyelashes). To do this, use Tool > SubTool > Merge > MergeDown (A in image 30a) to

merge a SubTool with the one directly below, using the curved arrow icons to move the SubTools up and down the list as needed (B). Next apply DynaMesh to them again at a higher resolution (I choose 1,392) in order to preserve detail.

Now we are going to use ZRemesher to reduce the polygon count, and start using subdivision levels with some cleaner sculpting topology. ZBrush is capable of handling models with massive numbers of polygons, but if we wanted to use this model in another software or a different context – such as making a 3D print or animating it for a video game – we would need to streamline the topology to a far more manageable level, preferably without losing our carefully crafted details. This "retopology" process can be done manually, which will be covered in chapter 04 briefly, and in more detail in chapter 05, or automated using ZRemesher, ZBrush's powerful automatic retopology tool. The result will be a nearly identical character

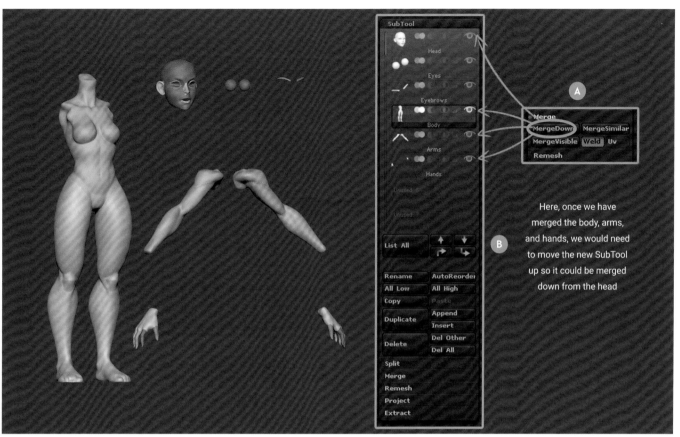

Here, once we have merged the body, arms, and hands, we would need to move the new SubTool up so it could be merged down from the head

▲ 30a Join the SubTools together using the Merge options. Creating a duplicate body means we will not lose our original sculpted details after using ZRemesher

model that is simpler and more efficient, saving a lot of potential labor in the future.

Before we start, duplicate the body SubTool so that we have a spare (C in image 30b). We will use this original model to "project" our sculpted details back onto the mesh if any are lost or smoothed out during the ZRemesher process.

KEY CONCEPT
ZRemesher
ZRemesher is a very powerful automatic retopology tool that can create good sculpting topology with a single click. However, it is very unpredictable in how it distributes the polygons, unless we give it some guidance. We can do this by creating Polygroups and then using the KeepGroups option when using ZRemesher, but before we do, let's take a look at an overview of the whole process and what results we will get out of it.

▲ 30b The duplicate body SubTool

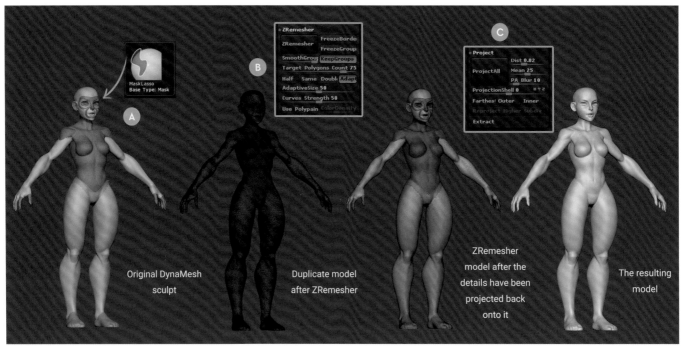

▲ 31 An overview of the ZRemesher process

31 The ZRemesher process

ZRemesher will create a cleaner, simpler version of our mesh, with a more manageable polygon count. However, this automatic process will reduce our original details, which is why we will work on a duplicate. The process may also overlook some nuances of the mesh, especially in subtle areas where good sculpting topology is important, such as the face. We will help to guide ZRemesher by using the MaskLasso tool (or any other masking option) to draw masks that follow the natural flow around the face, for example the round loops we would want around the eyes and mouth (A in image 31). We will establish different Polygroups for these masks, which will aid ZRemesher in recognizing that we want particular edge loops and edge flow in those areas. When we apply ZRemesher with the KeepGroups button activated (B), it will organize the topology while taking into account our desired loops. Finally, we will recover any detail lost during the process by using the SubTool > Project > ProjectAll button to carry the details of our original SubTool back over to our clean new mesh (C).

32 Using ZRemesher

To clarify the previous step, image 32 shows a close-up view of the workflow for the face,

which is the main part that needs special preparation. Use the MaskLasso or MaskPen brushes to mask the preferred loops on the face of the duplicate DynaMesh sculpt (A in image 32). Pay special attention to areas where we want the polygons to be flowing in circular directions, such as around the eyes and mouth. These areas would be awkward to sculpt if the topology just flowed straight across them without following the structure of the face. Use Polygroup > Group Masked (or Ctrl + W) to make a Polygroup from your masked selection, then go to Tool > Geometry > ZRemesher, turn on KeepGroups (B), and click ZRemesher (I set it to a Target Polygons Count of 50). You may need to allow the process a few minutes to complete. Now you can see how the resulting mesh is much less dense than our DynaMesh sculpt, but has lost some clarity, especially around the mouth. We will rectify this later. If you are otherwise happy with the results, click Divide in the Geometry menu a couple of times to add more resolution to your ZRemesher sculpt.

Now we need to recover the details lost in the ZRemesher process, which is why we kept a copy of the high-resolution sculpt earlier. In the SubTool menu, make sure you have the ZRemesher sculpt selected. Check that the

original DynaMesh sculpt is visible, then click Project > ProjectAll (C), which will "project" the details of all the visible SubTools (the DynaMesh sculpt) onto your selected SubTool (the ZRemesher model). If you have subdivided the ZRemesher geometry enough, there should be enough resolution to re-capture all the details of the original sculpt. You can always divide again and project again, if the projection does not turn out quite right the first time. Once the details of the ZRemesher mesh bear as close a resemblance as possible to the original SubTool, the original SubTool can be deleted.

For future projects, it can help to have the head in a separate SubTool from the body, as it is quite a task for ZRemesher to follow our loops while also trying to reach the target polygon count. Here, we have kept the head connected to the body for simplicity's sake.

33 Starting the clothing

For projects demanding more realistic and complex clothing, the software package Marvelous Designer has quickly replaced hand-sculpted clothing, enabling artists to create clothing meshes based on patterns like virtual tailors. However, for the purposes of this stylized character, we will be sculpting

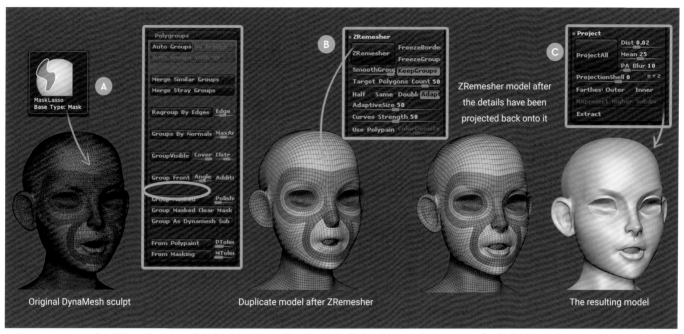

Original DynaMesh sculpt Duplicate model after ZRemesher

ZRemesher model after the details have been projected back onto it

The resulting model

▲ 32 Here you can see how ZRemesher streamlines topology. It sometimes loses details, but these can be recovered using ProjectAll

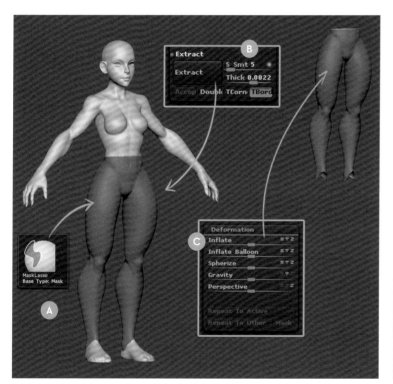

▲ 33a Extracting a mesh for the trousers using a mask

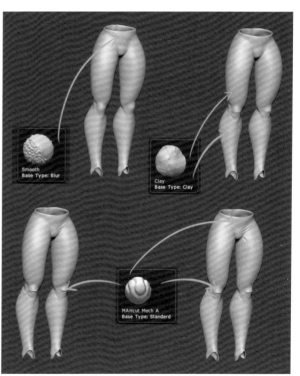

▲ 33b Create folds using reference

simple clothing in ZBrush using the body as a base from which to extract pieces of clothing. First we need to mask the desired part of the body – in this case, masking the legs to create the desired shape of the trousers (A in image 33a). Once you have done this, go to SubTool > Extract, set the Thickness to a low amount

(as the trousers in the concept are quite snug; B), then press Extract and Accept. Now you can select the newly made trousers SubTool from the list. Make sure you have the trousers SubTool selected and go to Tool > Deformation and increase the Inflate slider slightly, which will give the trousers a bit more

thickness (C). Next go over the trousers with the Clay and Smooth brushes to shape and smooth them, and then create some folds with the MAHcut Mech A brush as shown in image 33b.

KEY CONCEPT
Using the Deformation panel

There are lots of ways to manipulate and change your geometry in ZBrush, but one of the most powerful sets of tools lies in the Deformation panel. This panel has a set of modifiers that are activated as sliders. The modifiers include Inflate, Twist, Taper, Rotate, Flatten, Skew, and many more. For example, rather than using the Transpose line for scaling, you could just change a model's size by increasing the slider by a given number, making it very predictable and repeatable. Here we are using the Inflate slider to add thickness to each item of clothing we extract. Don't forget you can configure your interface by pulling out the sliders you use the most.

▲ The Deformation modifiers offer many useful ways to manipulate your model

34 Finishing the trousers

In image 34 you can see the back view of the sculpted trousers. Note how the material is creased and bunched in areas like the backs of the knees. Use the MAHcut Mech A brush to achieve this. Even though we are aiming for a stylized character, using research and collecting additional references of clothing, as well as looking at how other artists sculpt folds, is key.

The techniques for making the costume will be the same for each garment, and quite simple, because all we are aiming for at this stage is to have everything blocked out. The most important aim, at least for me, is to see the same level of finish and overall progression through the entire character. Having everything blocked out ensures that we can see how the whole character is looking and how all the elements relate to each other. It can also help to keep us motivated as we can clearly see our progress.

35 Sculpting the jacket

The same workflow applies to the jacket. The only difference is the addition of some IMM brushes to create the belt. After masking (A in image 35), extracting (B) and inflating (C) the jacket to the size you want, use the SnakeHook brush to

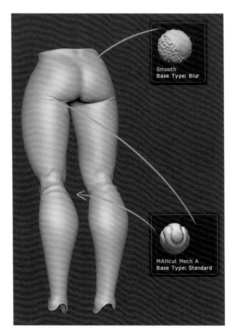

▲ 34 The back view of sculpting the trousers

create some of the torn fabric of the shoulders (D). Turn off Symmetry and create a mask down one side of the jacket's front (E), then use the Move brush to adjust the other half, creating an overlapping seam down the front of the jacket. Smooth over the results if needed (F).

Go to the Brush menu, select IMM Curve, and then tap the M key. Select the Strap option, and use it to sculpt the main shape of the belt (G). If the belt is too thick or thin, just make your brush size smaller or larger. Then select IMM Clothing HardW, tap M again, and use Buckle to add a buckle to the belt (H). You may need to mask and move the buckle and ends of the belt into the desired positions.

36 Extracting the gloves

We will continue using the same workflow as before, this time on the gloves. With Symmetry activated to make both gloves, mask out the hand and some of the forearm, as far up as you would like the gloves to go (A in image 36). Use Extract to create the gloves (B), then use Inflate to give them extra thickness, enough that they look like a leather material in which the hands would fit (C). We should encounter no problems extracting the gloves because we spread the fingers apart in step 28. Finish the gloves with some extra smoothing and sculpting as shown in image 36.

PRO TIP
Insert Multi Mesh brushes

Brushes marked as IMM in the Brush menu contain additional brushes within them, which you can view by selecting the IMM brush and tapping the M key. ZBrush comes with many useful IMM brush sets by default, including objects such as zippers, buttons, cogs, and rocks. Have a browse through them now and see what useful meshes you can find. We will be using some brushes from the IMM Curve and IMM Clothing HardW sets to create the character's accessories.

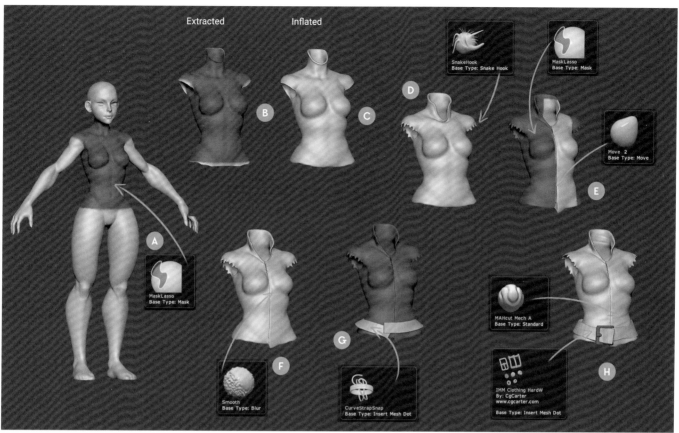

▲ 35 Extract the jacket and add frayed sleeves (SnakeHook brush) and a belt (IMM Curve Strap brush)

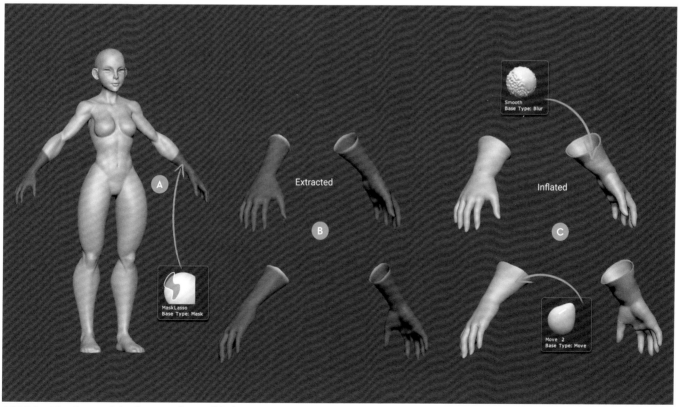

▲ 36 Extract the gloves and give them extra form and thickness

37 Extracting the cloak

To create Kyra's short cloak, just repeat the same process, but this time try masking out the ragged edge of the fabric before extraction, rather than creating the effect with the SnakeHook brush as

we did for the jacket (A in image 37). Use Extract to create the cloak as a new SubTool (B), use the Inflate slider to make the material thicker (C), then use the Move brush to make the cloak hang more naturally (D).

38 Extracting the boots

Repeat the same masking (A in image 38) and extraction (B) process for the boots, then inflate them and sculpt them into a longer shape that looks like it could accommodate the

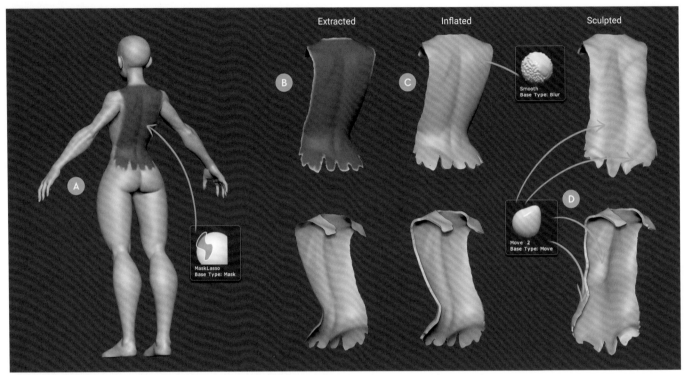

▲ 37 Extract a short cloak with a ragged edge

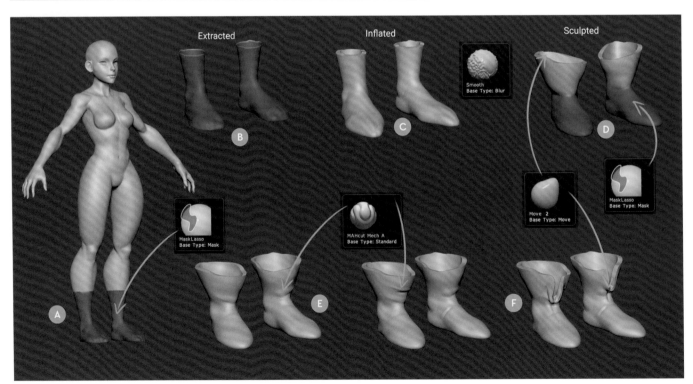

▲ 38 Extract the boots and mask them to sculpt the desired shape

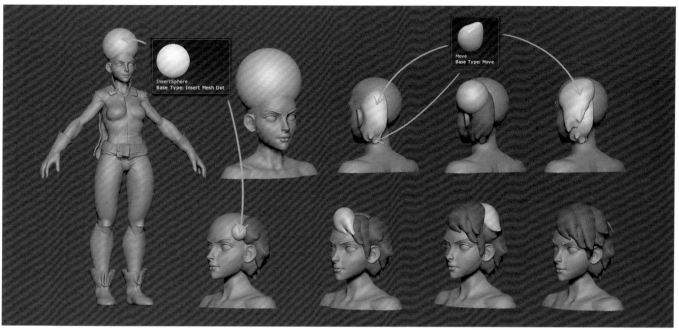

▲ 39a Create the hair using the InsertSphere and Move brushes, visualizing it as large pieces rather than small strands

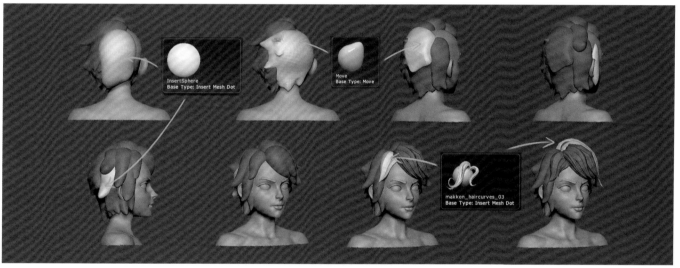

▲ 39b Add hair to the rest of the head and give it some detail with the Makkon Haircurves 03 brush

character's feet (C). The boots will be looser at the top, so use the MaskLasso tool to mask off the foot of the boot before spreading out the top with the Move brush (D). Use the MAHcut Mech A brush to add leathery creases to the boots (E), and finally the Move brush again to create a split at the front (F).

39 Sculpting the hair

Try to visualize the hair in blocks. Hair grows in all directions but appears to fall and overlap in layers due to gravity. I can't stress enough the importance of gathering reference images and looking at how other artists build hair; I like to look on Pinterest for this. Use the InsertSphere brush to add chunks of hair, one piece at a time, shaping the spheres with the Move brush as shown in image 39a.

At the start of image 39b you can see the head with all the shaped spheres in place. It is only when we are happy with how the overall hair and silhouette are looking that we can start adding finer variations. We can do this using the Makkon Haircurves 03 custom brush created by Ben Hale, also known as Makkon (makkon.artstation.com), and Chris Whitaker (funkybunnies.artstation.com). The brush can be found for free online and is included as a downloadable resource with this project. It is a simple Insert brush with some strand variations ideal for stylized hair. The hair we have made from spheres is now a useful base for placing these chunks of hair. With some patience and fine-tuning the pieces into shape, the end result should look quite appealing.

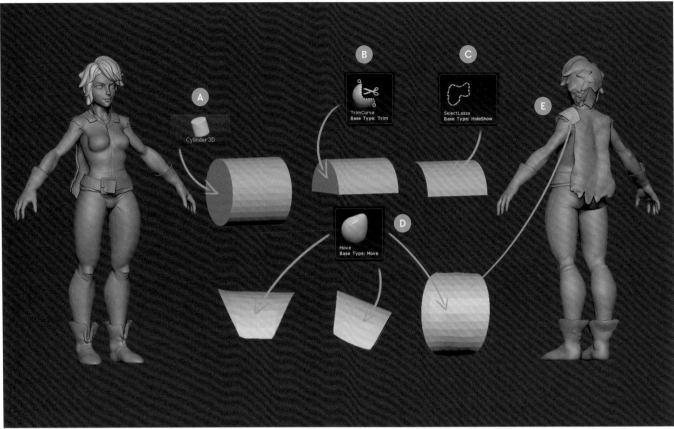

▲ 40 Use a cylinder to make a piece of shoulder armor

40 Shoulder armor

Kyra's shoulder pad is made by appending a Cylinder3D SubTool (A in image 40). Turn off Perspective (the P key) if it is active, then use the TrimCurve brush to slice the cylinder in half lengthwise (B). Now use the SelectLasso brush and hold Ctrl + Shift + Alt to hide both ends of the cylinder as well as the underside. This can be made easier by rotating the object while holding Shift to snap its orientation to the viewport. Then click Tool > Geometry > Modify Topology > Del Hidden to preserve just the outside polygons (C). The cylinder can be an awkward shape to navigate around, so keep checking it from all angles to make sure you haven't accidentally deleted a part you wanted to keep, or left some floating polygons behind after deleting a selection.

You can now turn Perspective back on if you wish. Use the Move brush to sculpt the armor roughly into shape (D), and then the Transpose tool to move it over the shoulder and give us a sense of how it will look once we give it some thickness (E). There is no need for great precision here – this accessory is probably handmade, and should show some imperfections. When you are happy with how the piece looks, apply Geometry > EdgeLoop > Panel Loops with a Thickness value of 0.1 or more, which will add an inside and extra thickness to the armor piece.

41 Starting the weapon

We are going to briefly touch on ZBrush's hard-surface ZModeler toolset to make Kyra's weapons (refer back to pages 48–51 if needed). This will allow us to use a more controlled polygon-modeling approach for a couple of components that would benefit from it. For the blade's handle, append a Cylinder3D SubTool (A in image 41), rotate it to face you, then use the Transpose line in Scale mode to make the cylinder fatter and then to reduce it into more of a squat disk shape (B). Now turn on the wireframe view by clicking the PolyF icon, so we can see where to apply our ZModeler actions.

Go to the Brush menu and select the ZModeler tool. Hover the cursor over one of the cylinder's edges and press the Space bar to bring up ZModeler's Edge Actions menu. Select Delete as the action and EdgeLoop Complete as the target, and use this to delete every other edge loop until the cylinder is much simpler, as shown (note the number of edge loops around cylinder C compared to cylinder B). Bring up the Edge Actions menu again and select Bevel, and use this to add bevels to the outer edges of the cylinder (shown in green).

After you have performed any ZModeler action you can simply click once to repeat it on another edge, point, or polygon; so now, just click on an edge on the opposite side of the cylinder to repeat the bevel. Under the Edge Actions menu again, select Insert with Target as Single EdgeLoop, and use it on one of the inner spoke-like edges on the flat face of the cylinder to insert a new loop (C). Do this for the opposite end of the cylinder too.

Hold down the Alt key and drag over the inner circle on the flat face of the cylinder to highlight all of its polygons, then hover over a polygon and hold the Space bar to bring up the Polygon Actions menu. Select QMesh with the default target of a Single Polygon, then use this to drag your group of highlighted polygons inwards into the cylinder, until it connects straight through to the other side and creates a hole. Bevel the edge of this hole too (D). Now we can append another Cylinder3D SubTool (E), stretch it out to form a long handle with the Transpose line in Move mode (F), and simply shape it with the Move brush (G). Again, we are not striving for perfection here, but imagining these as handmade objects with some degree of imperfection.

With the long handle in place next to the round hilt, we need to create a connection between the two pieces. Hold Alt to select some polygons from the side of the ring-shaped piece, and extrude them using Extrude in the Polygon Actions menu (H) so that the handle appears joined together.

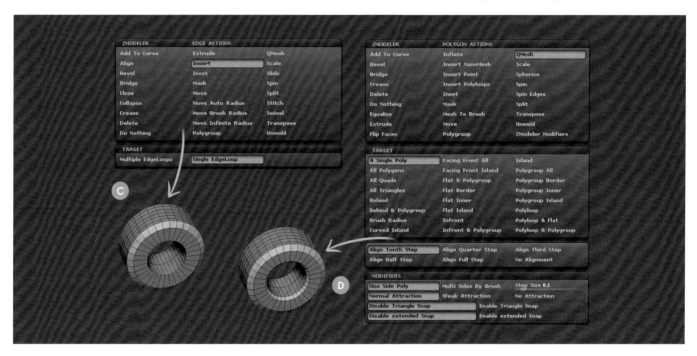

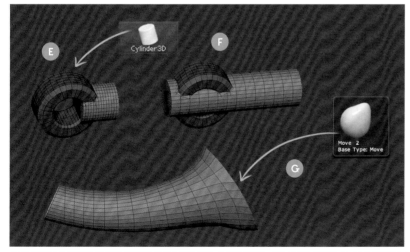

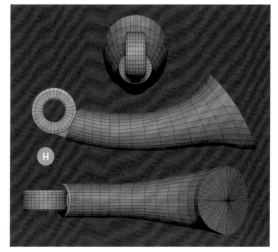

▲ 41 Create a handle for the dagger using cylinders, a few simple ZModeler functions, and the Move brush

42 Adding straps to the handle

In the original concept, the handles of Kyra's daggers are bound with leathery straps. To create this effect, let's start by duplicating the SubTool of the long handle (not the ring) that we just made (A in image 42). Leaving some space at each end for the underlying handle to show through, use the SliceCurve brush to cut different diagonal shapes along the handle, which creates some interesting cuts that will serve as a base for the straps (B).

With Polyframe mode turned on, you will see that each time you create a new shape it becomes a new Polygroup. Now use SelectLasso brush to select around the Polygroups that will form the straps, as we want to apply Panel Loops to them all together, giving them thickness. Then go to Tool > Geometry > EdgeLoop. You can tweak the settings in this menu to your taste, but I set the Loops quantity to 3, increase Thickness, reduce Polish to 5, reduce Bevel, and set Elevation to 0 (C). Click Panel Loops, and this will apply extra thickness to the Polygroups we just made, creating thick straps which we can refine with the Move brush to add variation (D). You can then merge it back with the handle to see the result (E): use the curved arrow buttons below the SubTool list to move the leather straps SubTool above the

SubTool of the bare handle, then use Merge > MergeDown to merge the two SubTools into a single finished handle.

43 Sculpting the blade

To avoid this project becoming too complex, we will create the sword blade without using ZModeler. Append a Cube3D SubTool (A in image 43) and use the Transpose tool in Move mode to make it about the size and thickness you want for the blade (B). Apply DynaMesh to give us more resolution to work with.

Use the MaskLasso brush to roughly mask the shape that will become the blade (C). Then invert the selection by Ctrl + clicking in empty space, and use the Move brush if necessary to shape the blade (for example filling out the areas where the mask did not fit within the cube). Go to Visibility > HidePt, which will hide the unmasked areas, then simply invert the isolation (Ctrl + Shift + drag in empty space) so that only the cut-out shape of the blade is visible. Now go to Tool > Geometry > Modify Topology > Del Hidden to delete all the unwanted areas we have just hidden.

Repeat this masking and deletion process to hide and delete the remaining sides and back side of the "cube," leaving only one flat blade

shape behind (D). This part can be a little fiddly to master, but persist with masking areas, inverting them, hiding the unmasked areas with HidePt, then using Del Hidden to delete the unwanted geometry until you have only your desired blade shape. You can also use SelectLasso to isolate areas you want to keep and then use Del Hidden, without having to mask and invert sections.

Apply ZRemesher to the flat blade (E in image 43b) by going to Tool > Geometry > ZRemesher, setting the Target Polygons Count, and hitting ZRemesher. Then go to Geometry > EdgeLoop and click Group Loops to insert an edge loop around the geometry (F). Apply ZRemesher again to improve the flow of the blade's topology (it should now somewhat follow the blade's shape; G). Use the Move brush to adjust the shape if needed. Finally, return to Geometry > EdgeLoop and click Panel Loops with some medium Thickness, high Bevel, and low Elevation, which will give you the finished blade (H). Then move the blade into position next to the handle to see how it looks (I). Merge the blade and handle SubTools together when you are satisfied with them.

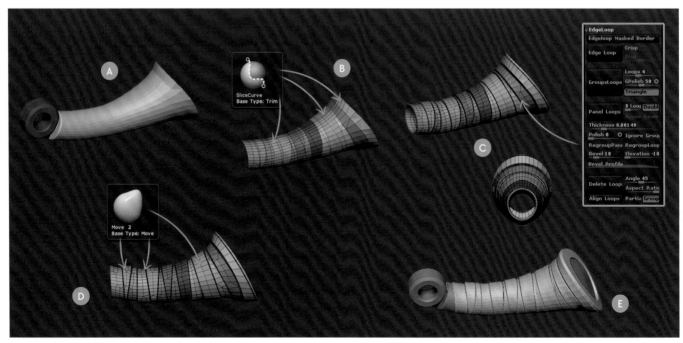

▲ 42 The SliceCurve brush can create the diagonal Polygroups needed to add straps around the handle

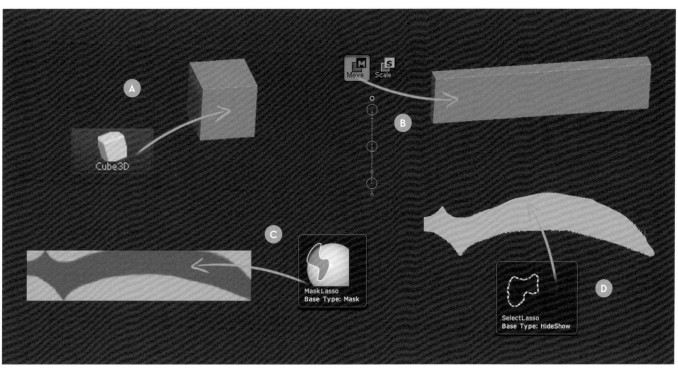

▲ 43a Create the blade by masking out the desired shape and deleting the excess geometry

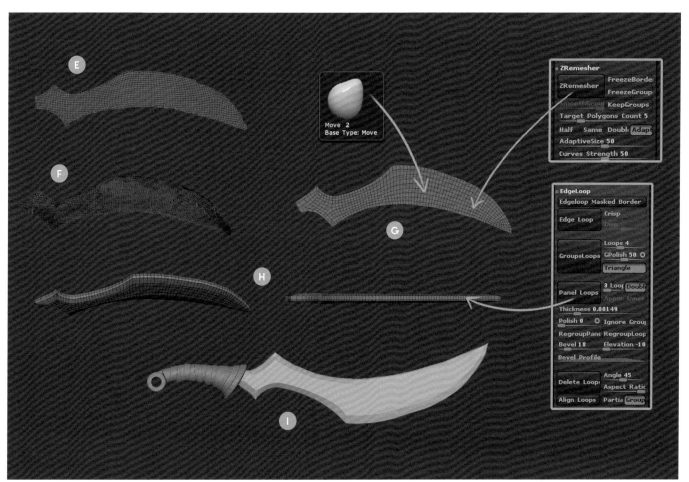

▲ 43b Then apply Panel Loops to add thickness

44 Detailing the trousers: part 1

In order to finalize each accessory, we are going to retopologize it with ZRemesher, creating a cleaner and simpler topology like we did for the body earlier, then increase the subdivision levels for sculpting the final details. The workflow for this is really simple. Let's start with the legs as an example.

When we used Extract to create the clothing, it will have assigned Polygroups for the inside and outside of the mesh. Select only the outside faces of the trousers SubTool by holding Ctrl + Shift and clicking on the outer Polygroups until they are all hidden, then inverting the selection by holding Ctrl + Shift and dragging the mouse outside the model. Then go to Geometry > Modify Topology > Del Hidden to delete the rest (A in image 47). Now, with only the outside selected, apply ZRemesher at its lowest Target Polygons Count. This will make a clean, simple version of the trousers, with few polygons and neat topology (B). Apply Panel Loops to add thickness and an inside to this new shell (C). Notice how Panel Loops also

assigns automatic Polygroups to the inside, outside, and borders, which will make sculpting easier. To add a guide for some seams down the outside of the trousers, use ZModeler to insert an extra edge loop (D).

45 Detailing the trousers: part 2

We now have clean topology thanks to ZRemesher, so let's add subdivision levels to give us more geometry for sculpting as shown in part A of image 45 (Polyframe mode has been turned off again here). Then we can use the same techniques we have used for sculpting before: use the MAHcut Mech A brush to go over the seams we added at the end of the previous step (B), then continue sculpting the new trousers to add creases and final details. Add mass with the Clay brush, use Smooth to build up details in a subtle manner, and use the MAHcut Mech A brush for crisp seams and folds (C).

46 Detailing the boots

I have included another example of detailing here – the boots – just to solidify the idea.

With the exception of the sole, which is made by simply using the IMM CurveStrapSnap (and then shaped into position with the Move Brush), the entire workflow is the same as before. Take the extracted mesh and select only the outer faces, this time by using the SelectLasso tool (A in image 46). Apply ZRemesher at the lowest Target Polygons Count to create new topology (B), which you can start to shape with the Move and Smooth brushes (C). Use Panel Loops to add thickness to the boots (D).

Use the CurveStrapSnap brush to create narrow strips under the boots for the soles. The larger the Draw Size of your brush, the wider the strap; the higher the Z Intensity of the brush, the thicker the strap. Next use the Transpose tools and Move brush to widen them and shape them into place (E). You can use ZModeler tools to add additional edge loops, as we did in step 41, for more control over shaping the soles. Finally, add some subdivision levels (F) and sculpt the details back into the boots using the Clay, Smooth, and MAHcut Mech A brushes (G).

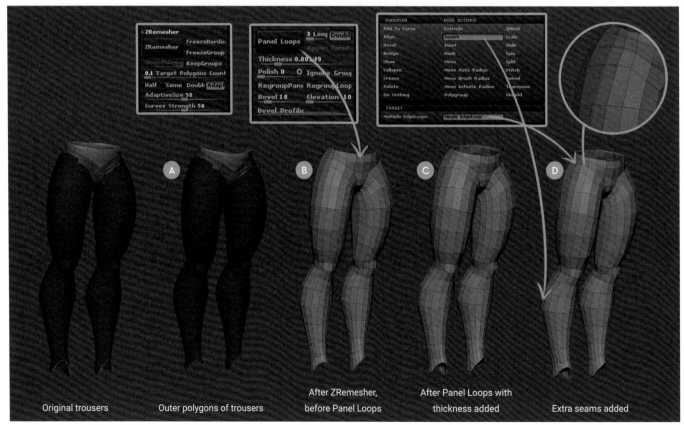

Original trousers

Outer polygons of trousers

After ZRemesher, before Panel Loops

After Panel Loops with thickness added

Extra seams added

▲ 44 Create improved, simplified geometry for the trousers using ZRemesher

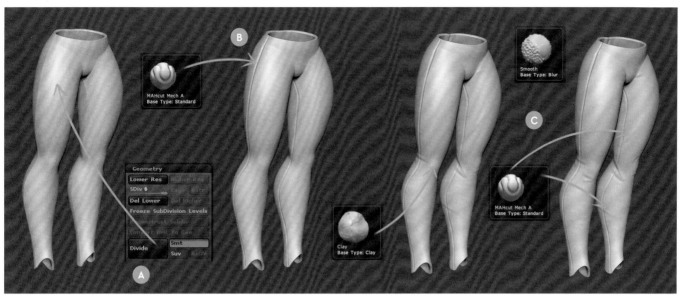

▲ 45 Add creases and seams on the new trousers mesh using MAHcut and the other sculpting brushes

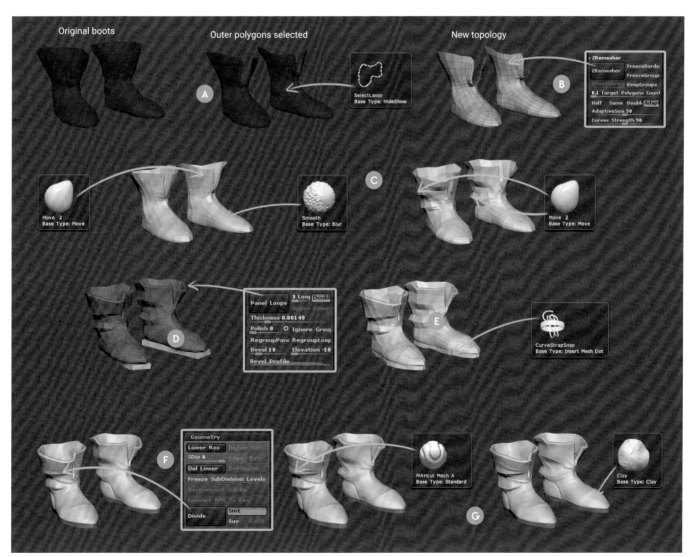

▲ 46 Add sculpted details and simple soles to the boots

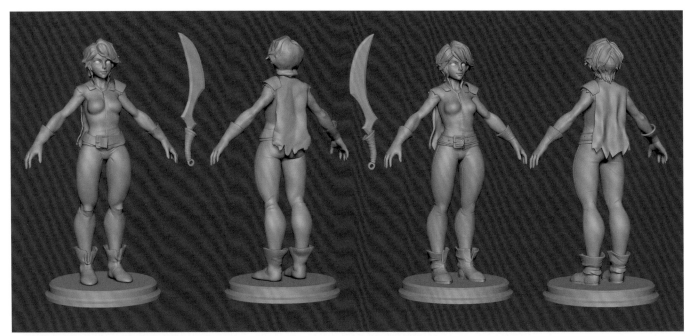

▲ 47 The model before and after adding extra details and refinements, as well as a simple presentation base that we will add later

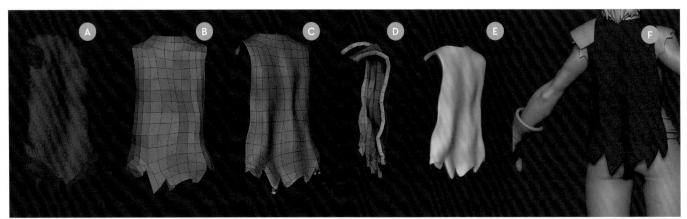

▲ 48 Refining the cloak

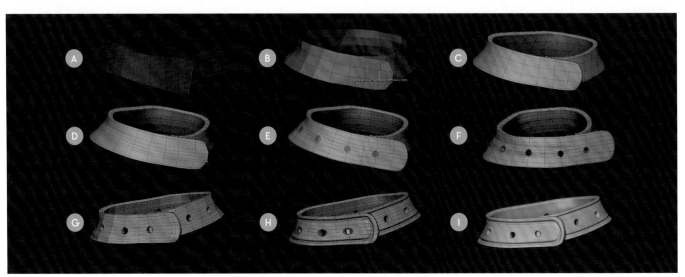

▲ 49 Detailing the belt with the help of ZModeler

47 Detailing the other accessories

In image 47 you can see the front and back view of the blocked-out (rough) mesh on the left, and the front and back view of the final detailed mesh on the right. As I have mentioned before, by building things up as a whole, pushing for overall progression and the same level of finish on all the parts, we are able to constantly be on the lookout for silhouettes and relationships between shapes. This makes for solid, faster progress. The process for retopologizing and detailing each accessory is very similar to the previous steps, so now let's look at the remaining accessories.

48 Revising the cloak

To refine the cloak, isolate the outer side of the cloak and click Del Hidden to delete the rest, leaving a thin shell (A in image 48). Apply ZRemesher set to the lowest possible polygon count to make the mesh as clean and simple as possible (B), though it may need some tweaks with the Move brush to recover its shape.

Finally, apply Panel Loops with the Loops quantity set to 3, increased Thickness, Polish set to 0, Elevation set to −100, and reduced Bevel. You can preview how it will look by turning on Dynamic Subdivision (press the D key to turn it on and Shift + D to turn it off; C in image 48).

Part D in image 48 shows a clearer view of the cloak's thickness from the side; part E shows the cloak with the wireframe turned off; part F shows the final retopologized cloak in context on the character's back.

49 Revising the belt

For the belt, use the SelectLasso tool to select only the outer shell again (A), apply ZRemesher at the lowest polygon count (B), then continue smoothing and shaping the geometry into place. Apply Panel Loops as we did in the previous step (C). Use ZModeler to insert extra edge loops along the middle of the belt, to create points for placing belt holes (D). Apply ZModeler's Split action (see page 51) to some of these points, creating circular holes (E). Add these around the outside of the belt, as well as on the inside in the corresponding positions, so that we can push holes through the belt. Select QMesh from the ZModeler Polygon Actions menu with Target as Polygroup All, and push each circle through the belt until it connects at the other side to make a hole (F). Add a slight Bevel action to the inside of each hole.

To make a debossed hem effect around the edges of the belt, use Polygroup in the Polygon Actions menu with Target set to Polyloop to assign Polygroups along the borders of the belt (G). Then use Inflate in the Polygon Actions

menu with Target set to Polygroup All, and drag the groups inwards to make a groove (H). You can see the final belt in part I of image 49.

50 Revising the jacket

The process should be quite familiar to you now. Again, select the outer shell of the jacket (A in image 50), but leave a slight extra gap down the seam at the front by using Ctrl + Shift and clicking on the edge of a polygon to hide the strip of polygons. Then apply ZRemesher. Use the Move tool to adjust one side of the front seam so that it will give an impression of thickness later (B). Apply Panel Loops to give a realistic amount of thickness to the garment (C). Add seams and resculpt wrinkles using the MAHcut Mech A and Smooth brushes (D). You can see the updated jacket in part E of image 50.

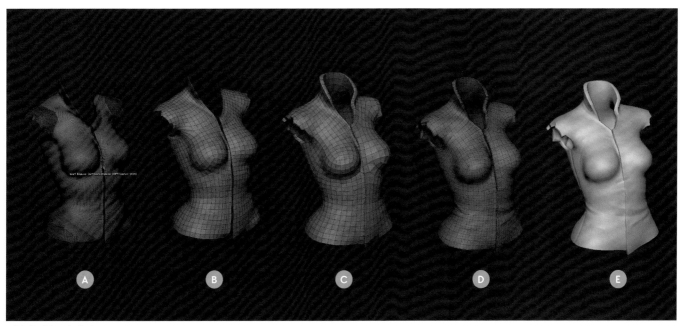

▲ 50 Revising the jacket

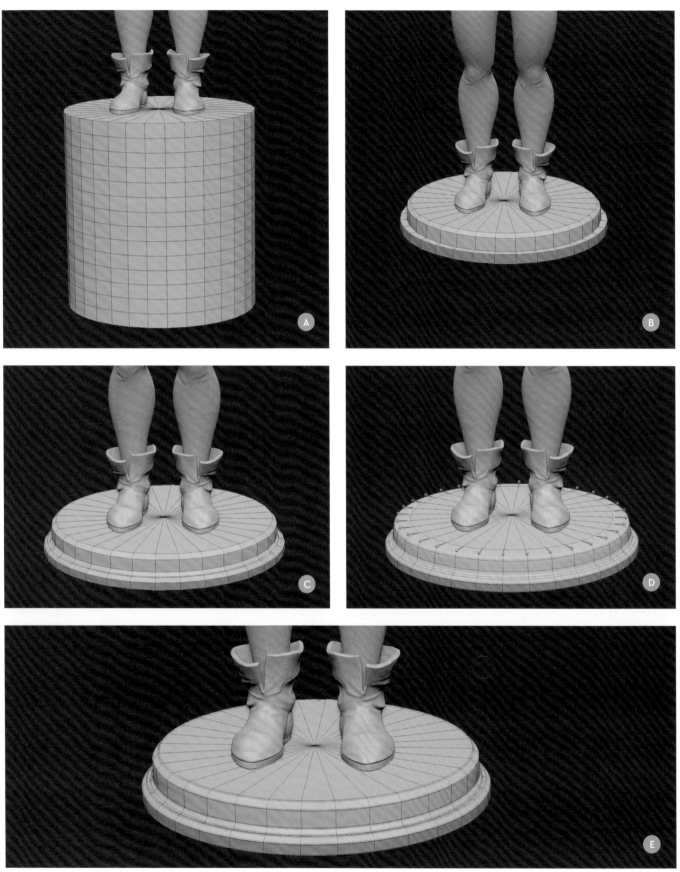

▲ 51 Creating a base for the model

51 Creating the base

Giving the character a base to stand on is not essential, but can add an extra layer of presentation and polish to your design, giving it the appearance of a figurine or miniature. To add a base, append a Cylinder3D and move it beneath the character's feet (A). Use the Transpose line in Move mode to trim the cylinder into a flat disk (by dragging the red circle at the inner end of the line), leaving only two polygon loops around the outside. Use ZModeler's Polygon Actions > Extrude (set to Polyloop target) to extrude the lower polygon loop (shown in orange), creating a tiered effect around the base (B). Use Edge Actions > Bevel to apply bevels to the outer edges (C), which is a simple but effective way to refine the base and make it look polished. Apply Edge Actions > Crease (set Target to EdgeLoop Complete) to crease the rims of the base and keep them crisp. Check your results with Dynamic Subdivision view (D).

PRO TIP
Adding stitching

Adding stitches and laces will help tie the costume together. I add them later on, but you can add these when you feel it is appropriate: for thick laces down the front of Kyra's jacket, for example, use the InsertHRing brush to insert a half-torus shape. Then simply sculpt it into place with the Move brush, and repeat the process to continue adding laces. Don't forget to adjust the underlying jacket mesh as well, to add some tension created by the laces. Use the same process to add laces to the fronts of the boots we shaped earlier.

We can also add crossed stitches using the Stitch brush from the IMM Curve brush set. To apply these to the seams of Kyra's clothing, simply drag a line following the seam and the crossed stitches will be added according to the size of your brush.

▲ Creating stitches

▲ Creating crossed stitches

Coloring, posing, and rendering

52 Loading the concept art

The saying that "less is more" is true of many things, including this character. This is to say that, especially for stylized character work, Polypaint can be as simple as getting the right tone and then filling the object with the color – which is exactly what we will do here. Import the concept art into Spotlight (Texture > Import), select the thumbnail of your texture when it appears, then press the square +/− button just below it (circled in image 52a) to load the texture into Spotlight. Now you can activate and deactivate Spotlight using Shift + Z, and toggle the Spotlight wheel on and off using Z.

53 Color-picking and Polypaint

Press the Z key to activate the Spotlight wheel, and then use the C key while hovering over an area of the image to color-pick from the image. Hit Z again to exit the wheel and return to your model, then go to the Color menu and use FillObject to fill each SubTool with its respective color. If the colors do not seem quite right, simply tweak them using the Color palette. You may have to change the current Material to something plain and white, or it may clash with the colors you are trying to apply. There are many suitable plain materials to choose from, and more are available to download.

You may now find that manual painting with brushes no longer works with an image active in Spotlight, so go to Brush > Samples and turn off Spotlight Projection. Now use the Standard brush with a low Rgb intensity to add a subtle red blush to the cheeks, lips, forehead, and ears, which will make the face look more natural. As with sculpting, you can hold the Shift key to smooth the transitions between colors (don't forget to make sure the brush is only in Rgb mode). Smoothing colors is more effective at lower subdivision levels. Apart from some minor hand-painted details that add life to the face and eyes, each SubTool is simply filled with a plain color.

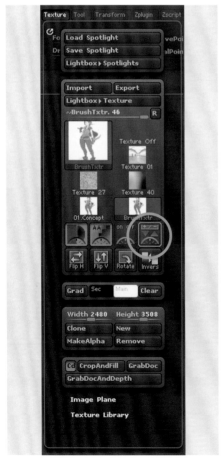

▲ 52a Load the concept art into Spotlight

▲ 52b The Spotlight image and wheel

▲ 53 Pick colors from the concept art and apply them to the various SubTools with FillObject

PRO TIP
Using alphas for the eyes
We can use alphas to make painting the eyes quicker and easier. Fill the eyeballs with a white color, then hit the X key to turn on Symmetry. Select a black color and use Alpha 09 in DragRect mode to draw the outlines of the irises. If you press 1 on your keyboard, it will repeat your last action, so tap this key a few times to create a darker, more intense outline. Select Alpha 14 (a circular alpha), pick a blue-green color, and use this to fill in the irises. Use Alpha 14 again in a smaller size, with a black color, to fill in the pupils. Finally, return to the Standard brush in Dots mode to paint some brighter tones and white reflections onto the eyes.

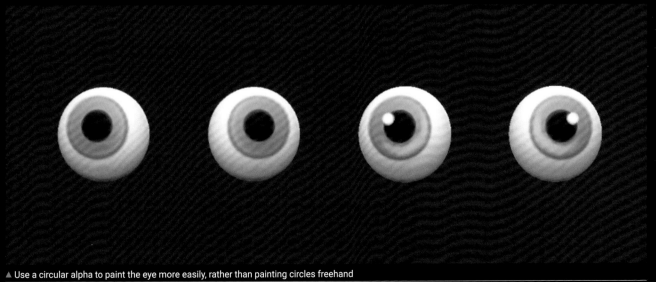

▲ Use a circular alpha to paint the eye more easily, rather than painting circles freehand

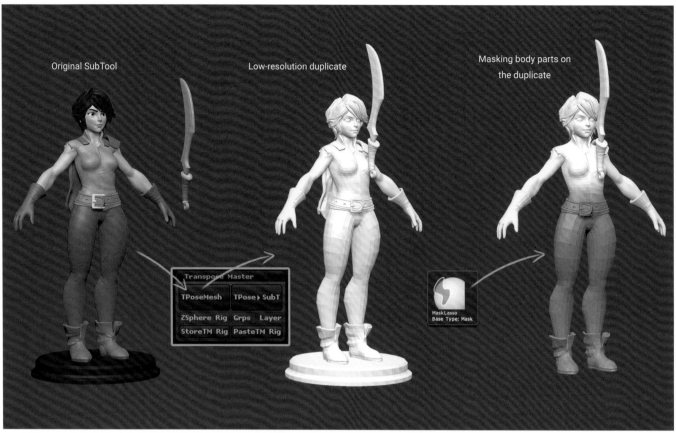

Original SubTool

Low-resolution duplicate

Masking body parts on the duplicate

▲ 54 Transpose Master will make a low-resolution duplicate of the entire character that we can use for creating a pose

54 Transpose Master

Another advantage of having low-poly topology (by using the workflow of ZRemeshing our extracted parts) is that the model is much easier to handle at the posing stage. The body itself still has quite a high polygon count, but we need it to retain the details of the face and costume; it will not have a negative effect on the posing part of the process, which is what we will move on to now. For this character, we will create quite a classically feminine pose with an edge of aggression.

Go to ZPlugin > Transpose Master and press TPoseMesh. ZBrush will take all our SubTools and create a merged duplicate of them at their lowest subdivision level. We will use this low-resolution mesh to create our pose, then "transpose" it back onto our original model. Now we can switch to this low-resolution SubTool and simply mask the body parts with MaskLasso and move them into position with the Transpose tools. Work slowly and keep checking your references.

KEY CONCEPT
Transpose Master
Transpose Master allows you to pose your model by creating a low-resolution copy of the whole character, which you can pose, and then transferring the pose back to the individual SubTools of your model.

55 Posing the character: part 1

In image 55 you can see the breakdown of how to move the character into place, starting with the legs and the trunk of the body, and working up to the arms, accessories, and hands. First mask out the upper body in order to pose the legs, tilting the pelvis one way to achieve a natural hip angle (A in image 55), then moving the legs back into position individually (B and C). One leg is straight to support Kyra's body weight (D), while the other leg is stretched slightly forward. To pose this latter leg, it is necessary to work our way down the leg,

posing it from the hip, the knee, and finally from the ankle, so that each section is rotated and angled correctly and the foot is standing flat (E).

Lower Kyra's left arm (on our right) and move her weapon into position (F and G). Again, this requires masking out the rest of the body a few times, so that we can Transpose the arm from the shoulder, elbow, and finally the wrist (but not the fingers yet).

PRO TIP
Posing
Posing is all about tilting the masses of the body, using plenty of reference, masking, more masking, and lots of patience! I urge you to get yourself in the pose of your character so that you can feel the weight of it. Weight is a very important part of posing and should not be neglected.

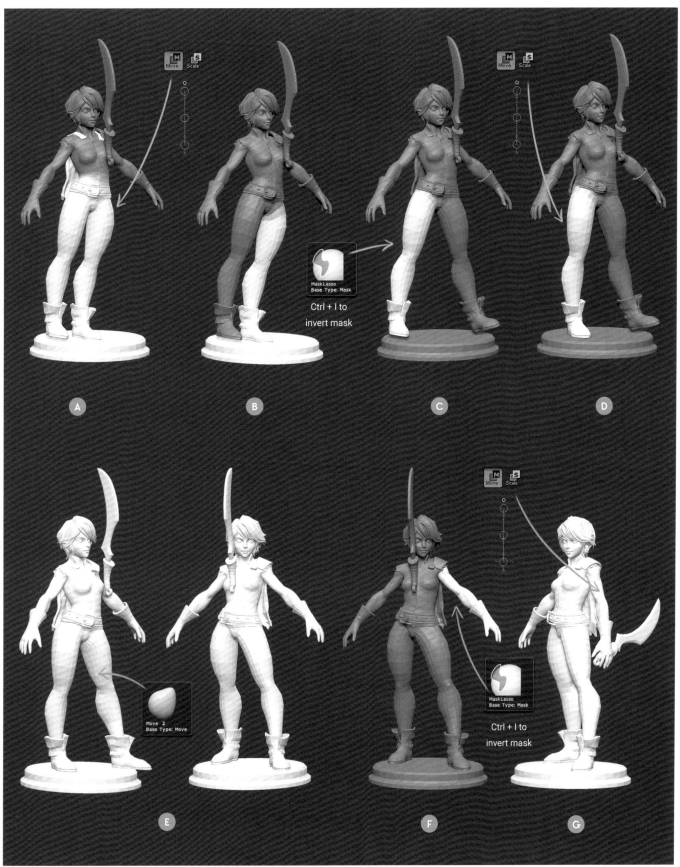

Ctrl + I to
invert mask

Ctrl + I to
invert mask

▲ 55 Starting to move the character into place

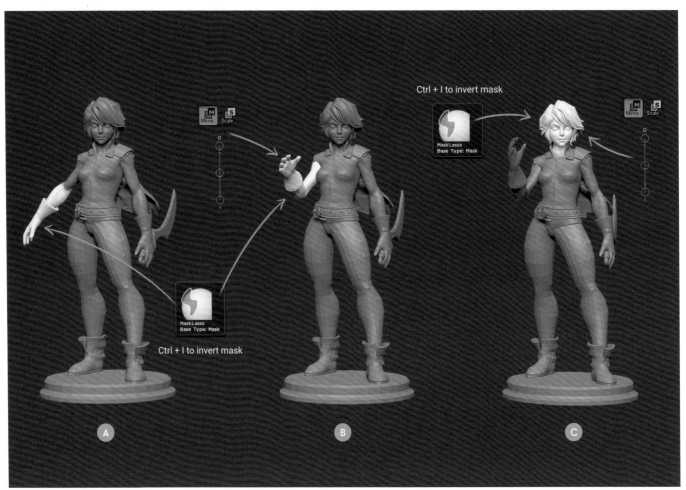

▲ 56 Posing the character's right arm and head

56 Posing the character: part 2

The other arm can be raised and bent at the elbow by masking out the rest of the body (A in image 56) and using the Transpose line to move and rotate the lower arm into place (B).

I also pose her cloak at this stage. A slight motion to her cape will really add some extra life to the whole model (B). Pose the head by slightly rotating the neck. Finally, select only the head, and turn it slightly to face the right (Kyra's left) for a more natural pose (C).

57 Transposing our progress

The pose is not finished yet, but let's move our progress back over onto our original model to check it. To do this, return to the ZPlugin menu and click the TPose > SubT button. Now you will see our pose has been transferred to our character's individual SubTools. We still need to create a second dagger to match the

concept, so duplicate the dagger SubTool and move it into place with the Transpose line. If needed, you can return to Transpose Master > TPoseMesh to refine the placement of the second dagger, then transfer it back using TPose > SubT.

58 Moving the fingers

Now all we have to do is move the character's fingers into place. We are going to explore a different method of posing for this. Instead of using Transpose Master to pose the hands, we will work directly with the model, but *only* on the gloves SubTool. It is only really necessary to pose the gloves, as they are the part we see, so select the main body SubTool and hide Kyra's hands by holding Ctrl + Shift + Alt and dragging red selections around them. This will allow us to pose the gloves SubTool without exposing the body mesh's unposed hands underneath (A in image 58).

A naturalistic hand pose is challenging to achieve, so do not forget to consult reference images and look at your own hands constantly as you work. Simply mask each finger and use the Transpose line to move and rotate it into position (B), working from the base of each finger to the tip. You can also hide and unhide the weapons using the eye icon in the SubTool menu, to check that the hands have an appropriate pose and grip.

When the fingers have been posed, you may find that some of the sculpted details have been lost in the process or are no longer appropriate, so take a moment to refresh them with the MAHcut Mech A and sculpting brushes (C).

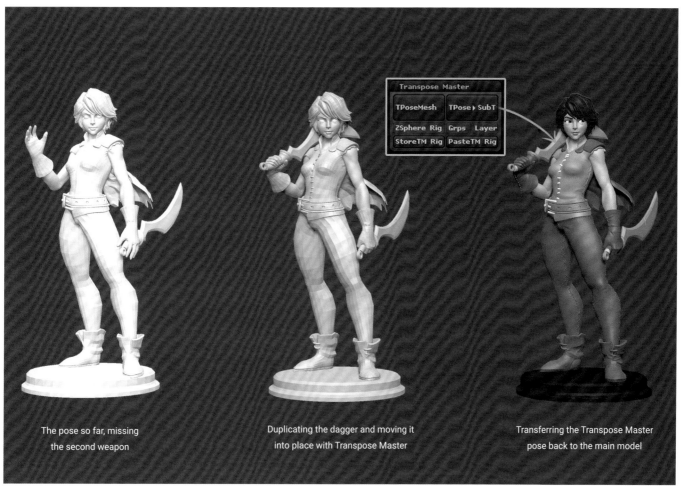

The pose so far, missing
the second weapon

Duplicating the dagger and moving it
into place with Transpose Master

Transferring the Transpose Master
pose back to the main model

▲ 57 Adding the second dagger

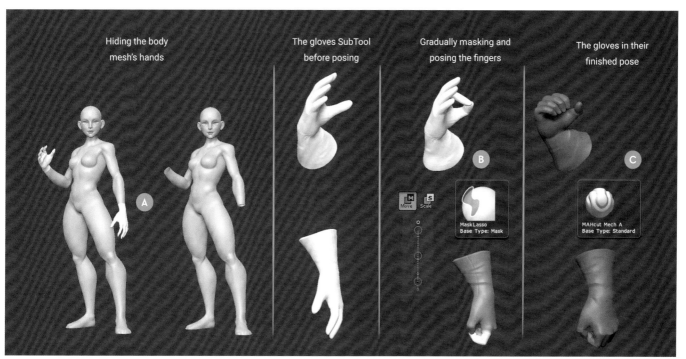

Hiding the body
mesh's hands

The gloves SubTool
before posing

Gradually masking and
posing the fingers

The gloves in their
finished pose

▲ 58 This process will take some patience, but simply mask off the fingers, joint by joint if necessary

59 Rendering in ZBrush

Although KeyShot has almost entirely replaced it, ZBrush's native renderer (BPR or "Best Preview Render") is still very useful for making quick presentation shots. We will add some simple light and shadow to our model and render with BPR now. These are some of the basic definitions I use to get good-quality, fast renders.

Go to the Light menu and double-click a second light-bulb icon (image 59a) to add an additional rim light. This will make the character's pose and silhouette "pop." Now go to the Render > BPR Shadow and increase the Angle, Rays, and Blur sliders as pictured in image 59b, to soften the transitions.

Under Render > BPR Filters, activate a filter by clicking on one of the numbered F buttons (image 59c), and check that the button below is set to Filter > Sharpen (F3 is set to this filter by default). You can edit the various sliders to suit your taste, but I leave them as they are. Now click the square BPR icon on the top right of the document window and wait for ZBrush to complete the BPR render. An orange bar will load across the top of the window, indicating the render's progress.

Now open Render > BPR RenderPass (image 59d) and you will see the various render "passes" that have been saved. Each one

contains a layer of information that will help us to composite the final image (to "composite" an image means to edit together your final piece in an image-editing program such as Photoshop, merging the multiple render passes to make a finished piece). You can save the passes you want by clicking on them, and then open the files in Photoshop to edit the final image to your taste. For example you could use the Shadow pass in Multiply mode to apply darker shadows to your Shaded pass, and use the Mask pass if you would like to easily select around your character and cut them out to place them on a different background.

60 Final images

In image 60a you can see a "clay render" version of the character, which uses only a plain clay-colored material rather than full color. Clay renders are a great option for showcasing the forms of your sculpt. It is always worth creating some versions like this to show your creations in a different light. Image 60b shows the final rendered version of the character in ZBrush. Image 60c shows a KeyShot render of the character. You can learn more about KeyShot and how to apply different effects to your final image in chapter 06.

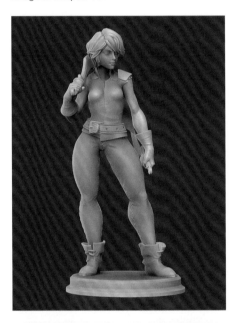

▲ 59a Create light sources using the bulb icons

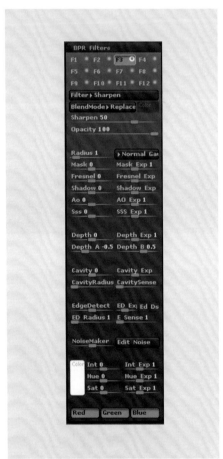

▲ 59c Apply a BPR filter that will sharpen the image

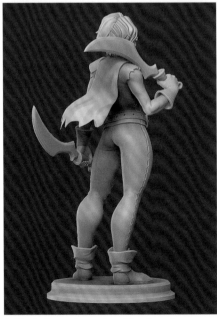

▲ 59b Set the desired shadows using these sliders

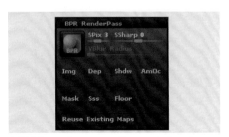

▲ 59d The render passes will appear in these boxes

▲ 60a A clay render version of the character

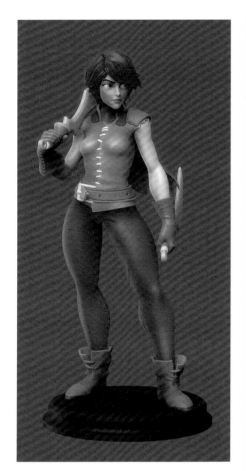

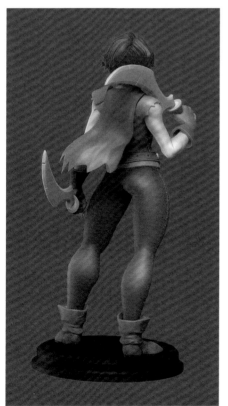

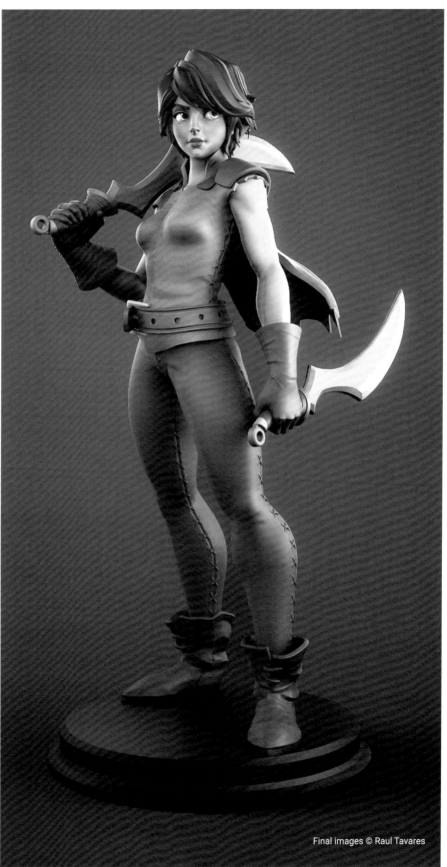

Final images © Raul Tavares

▲ 60b The final rendered character

▲ 60c The final character rendered in KeyShot

04
Mixed–surface sculpting

By Ruben Alba

This chapter will guide you step by step through the design of a cyborg goblin character, mixing sci-fi and fantasy genres as well as organic and hard-surface sculpting. We will incorporate tools and workflows discussed in previous chapters to create a more advanced character, so if you haven't already, it is advisable to tackle chapters 02 and 03 before jumping into this one. By the end of this project, you should be able to create a complete rendered character with ZBrush.

Chapter sections
- 2D sketching in ZBrush
- Sculpting
- Hard-surface modeling
- Texturing and posing
- Rendering

2D sketching in ZBrush

01 Creating a 3D plane

The first step is to create a 3D plane, which we will use to paint on and sketch out a blueprint for our creature. Right-click on the SimpleBrush icon in the Tool panel and select the Plane3D object. You can now click and drag on the canvas to create a plane of your desired size. If you hold Shift while dragging out the plane, it will snap to right angles, so you can position it squarely head-on in the canvas. If the plane is not positioned correctly, click the Move icon to activate the Gizmo 3D or Transpose line, which you can use to move the plane into place. You can press the F key to center it, or press Ctrl + N to clear the canvas and start again. Do not worry if the size of your plane seems too small.

▲ 01 Create a 2D plane to sketch on

02 Subdividing the plane

We will need to subdivide the plane's geometry in order to have enough polygons to accurately sketch on. Press the T key to go into Edit mode, then go to the Tool menu and click the Make

PolyMesh3D button. Subdivide the geometry by going to the Tool > Geometry tab and clicking Divide a few times. The plane should now have enough high-resolution geometry for us to start sketching on.

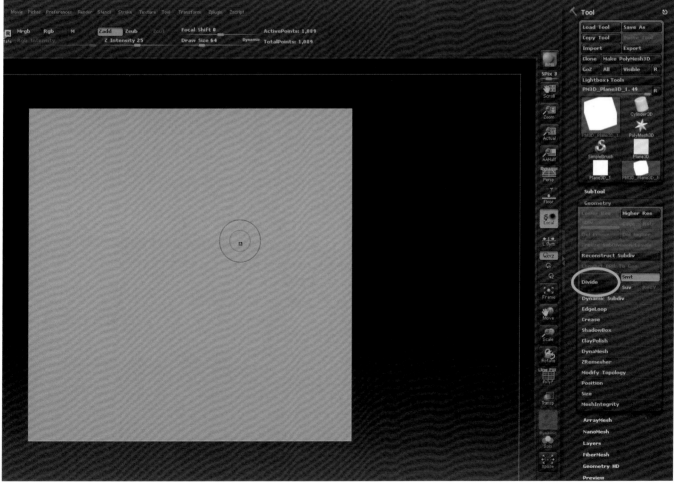

▲ 02 Subdivide the plane so it has sufficient resolution to draw a fairly detailed sketch on

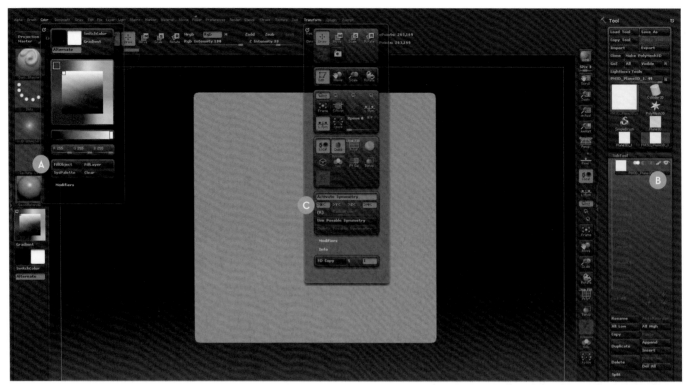

▲ 03 Apply a plain material and color to the 2D plane

03 Preparing to sketch

Change the plane's material to BasicMaterial2
to give us a plain base that is not too bright, and
set the current color to white. To fill the whole
plane with the color we have selected, go to
the Color menu and click FillObject (A in image
03). You may notice that the material color is
gray, and the plane will remain slightly gray
even when you fill the plane with white. This is
because ZBrush takes into account both the
selected color and the material's color.

In the SubTool menu we can see all the
SubTools we have in the scene – currently, we
just have the plane. We can see the little brush
icon is active (B in image 03), meaning that
Polypaint is active for this SubTool and we are
able to start drawing on it. To make our sketch
symmetrical, which will save time and help us
when creating our character in a simple A-pose,
go to the Transform menu and click Activate
Symmetry on the X axis (C in image 03).

04 Sketching tools

Time to start painting. If you are in Move mode,
click the Draw icon, then open the Brush menu
and select a brush to sketch with – I chose the

▲ 04 Brushes will only apply color when Rgb is enabled, which is perfect for sketching in ZBrush

▲ 05a Sketch out a flat blueprint for your character design

Dam Standard brush. Remember that each brush has its own configuration regarding Zadd, Zsub, M, and Rgb actions, so if you change your brush, be aware of its behavior and check or uncheck the desired options. Activate the Rgb button and deselect Zadd, Zsub, M, and Mrgb; this will allow us to draw on the plane, as if with a brush in Photoshop. Change the selected color to black. We can now start to paint on the plane.

05 Sketching the design

Time to sketch! Press and hold the Space bar to change the size of the brush and other parameters in the menu that pops up (image 05a). Pressing the C key while you are painting selects the color from where your cursor is currently located, so you can color-pick without needing to click the mouse. Take some time to

explore which brush setup feels best for you to sketch with, then start sketching the outline of your character. This flat blueprint will help us to sculpt a 3D model later. Use Ctrl + Z to undo any unwanted strokes. If you want to start over again, select white from the color palette and go to Color > Fill Object. The whole plane will be repainted, providing a fresh blank canvas.

The easiest way to save a version of our sketch is to just take a screenshot. We could also render the image by clicking on the BPR button or by going to Render > BPR RenderPass, then clicking BPR. When the render is complete, go to Render > BPR RenderPass, click on the image's icon (image 05b), and save it as a PSD file. Either way, once we are happy with our sketch, it is time to open a new document and start sculpting.

▲ 05b Saving the sketch as a PSD file

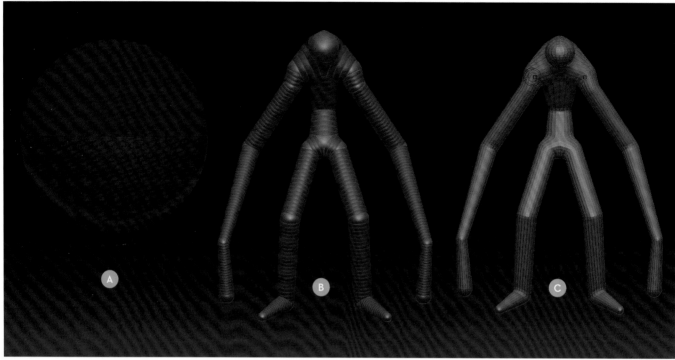

▲ 06 The base for your character can be quickly generated using ZSpheres

Sculpting

06 Option 1: ZSpheres

We will now start to block in the design for the character. One approach is to use ZSpheres. Create a ZSphere in the same way that we created the plane previously, with Symmetry in the X axis activated (A in image 06). Click and drag over the ZSphere and you will begin to make a skeleton consisting of ZSpheres (B in image 06). Activate the Move button to stretch out lines of ZSpheres to make limbs, and build up a rough dummy of the body. Change to Scale or Rotate mode to adjust the size and position of the ZSpheres, and to resume adding new ZSpheres, click the Draw button.

PRO TIP
Activate Symmetry
Whenever you start modeling with a new object, it is useful to push the X key to activate Symmetry. This way you only have to construct one half of the model; the other half will be mirrored automatically as you sculpt.

Pressing the A key enables you to preview the actual geometry that the ZSphere skeleton will create (C in image 06). Pressing A again will return you to the ZSphere view. Once you are happy with the shapes you have made, visualize the geometry by pressing A, then go to the Tool panel and select Make PolyMesh3D to turn the geometry into a sculptable mesh.

07 Option 2: mannequins

Another way to create a base mesh to start sculpting is to use mannequins, which are preset ZSphere skeletons. Go to LightBox > Project and double-click on the Mannequin folder. You will see options like those shown in image 07a. Double-click a preset that fits best with your character or creature. Adjust the

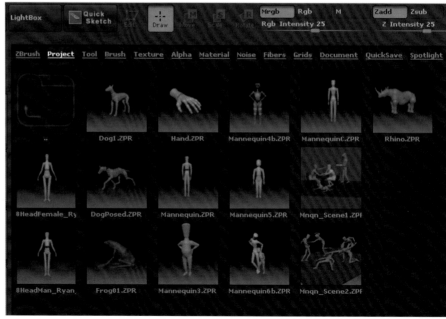

▲ 07a The Mannequin folder in LightBox

mannequin the same way you would adjust the ZSphere skeleton, using the Move, Scale, and Rotate modes. When you are ready, press the A key to view the geometry, and then go to Tool > Make PolyMesh3D to make a sculptable mesh. This method can save you a lot of time if you struggle with ZSpheres (image 07b).

08 Roughing out the figure

Activate DynaMesh and start sculpting with a DynaMesh resolution of 64. Gradually build up the shapes using brushes such as Move and Clay Buildup, but only work on general shapes, don't worry about details yet. Alternate between Draw mode (the Q key) and Rotate mode (R) to work your way around the model with your sculpting brush. Press Shift to smooth over the geometry as you go along. Treat the "clay" with care and don't push or pull too harshly. Click and drag in empty space while holding Ctrl to apply DynaMesh whenever your geometry becomes too distorted. It can be useful to activate the Perspective button so you can model in perspective, and click on Floor to see the ground plane on the canvas.

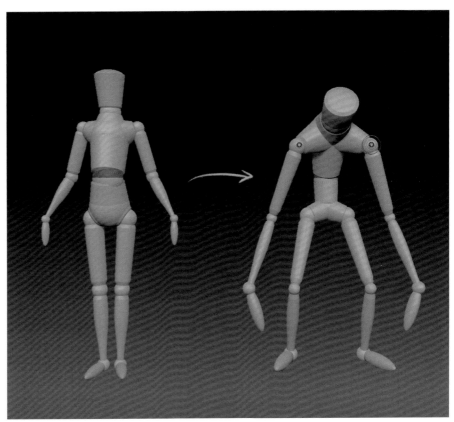

▲ 07b You can edit the proportions of a ZBrush mannequin to make a base for your sculpt

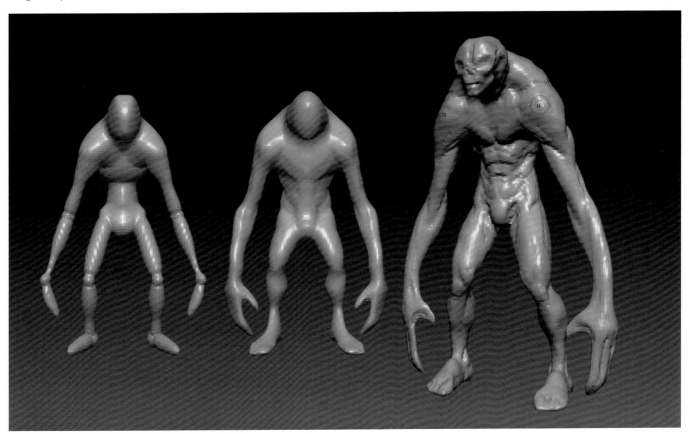

▲ 08 Gradually rough out the anatomy using sculpting brushes

09 Masking geometry

In addition to adding, subtracting, or smoothing the clay, we can also mask it. Masking isolates certain parts that we want to focus on without affecting other parts of the geometry, and is very useful for sculpting difficult areas. For example I would like to focus on building up the shoulder muscles of the character.

Press Ctrl while sculpting, and the cursor changes color to yellow, enabling us to draw a mask. We can choose the type of selection effect we want to use with the mask: for example Ctrl + LMB will invert the mask and clicking and dragging in empty space while holding Ctrl will cancel the whole masking area.

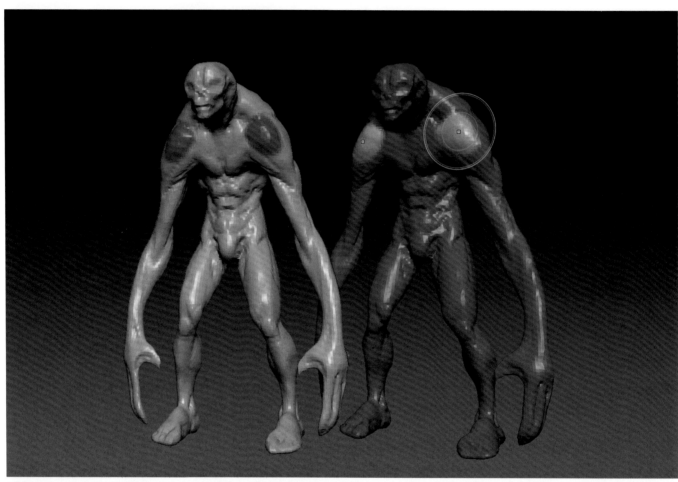

▲ 09 Masking is valuable for protecting areas that you don't want to edit by mistake

PRO TIP
Undo History
Instead of using Ctrl + Z to undo an operation, you can click on different stages of the Undo History bar above the canvas at any point in your modeling.

▲ The Undo History bar can be found above the canvas

10 Hiding geometry

Similar to masking, we can also hide geometry to help us focus on specific areas of our model. Left-click and drag while holding Ctrl + Shift, and a green box will appear on the canvas (A in image 10a). Select the area you want to isolate and the rest of the mesh will be hidden (B in image 10a). Hold Ctrl + Shift and left-click on the Stroke menu (image 10b) to choose a selection method. If you left-click and drag while holding Ctrl + Shift + Alt, the area that appears will be red, which will hide the selected area instead. Click on the empty canvas while holding Ctrl + Shift to unhide all the geometry. Left-click and drag while holding Ctrl + Shift to invert the hidden selection. Use a combination of masking and hiding geometry to help you sculpt without getting distracted or confused.

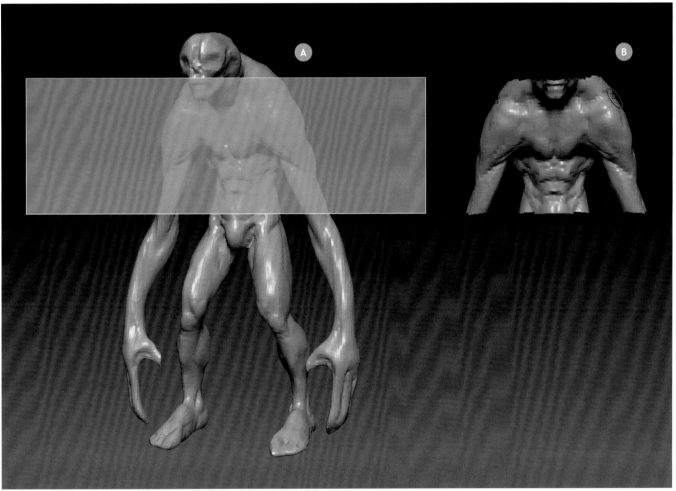

▲ 10a Hide parts of your mesh so you can help yourself focus on specific areas of the sculpt

▲ 10b Hold Ctrl + Shift and then left-click on the Stroke menu to bring up additional selection options

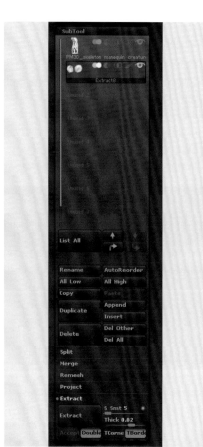

▲ 11 Masking can also be used to help make more complex extractions

11 Extracting geometry with masks

Masking is also useful for extracting elements of geometry from our model, such as this character's ears. To make the ears, we must first mask the area of the head where we want to create them using Ctrl + MaskPen. Then go to Tool > SubTool > Extract. Control the thickness of the geometry you want to extract using the Thick slider at the bottom of the SubTool menu, and then click the Extract button (you may need to experiment with the slider to see the effect of different thicknesses). If you are happy with the extraction, click Accept. If you move the camera without clicking Accept, the mesh extraction disappears, so you can try again with a different thickness.

The extracted geometry will appear as a new SubTool, listed below our main mesh under the SubTool menu. Activate Symmetry and start sculpting the ears.

12 Appending the eyes

We can also add new geometry by going to the SubTool menu and clicking the Insert or Append buttons. If we insert a Sphere3D, we

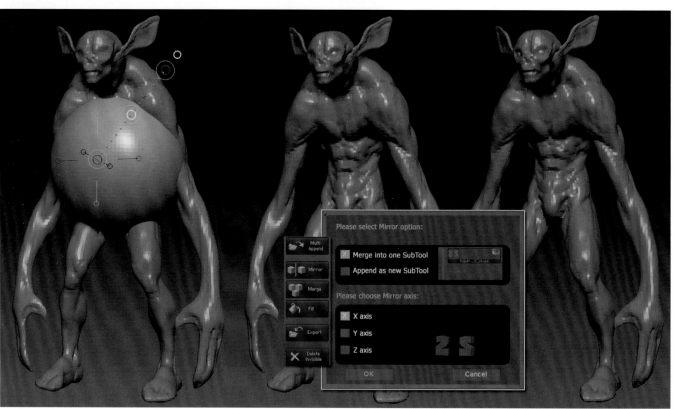

▲ 12 Make one eye from a new sphere and mirror it to create two eyes within the same SubTool

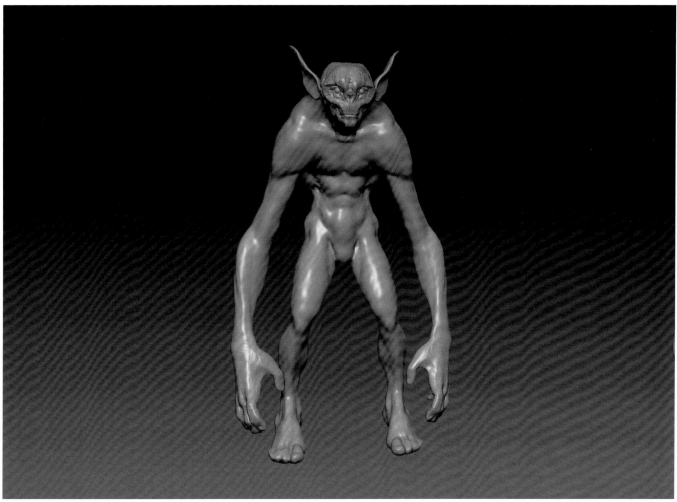

▲ 13 Gradually increase the DynaMesh resolution to sculpt more anatomical detail

can see that the sphere is now a new SubTool listed below the ears and body. Position this sphere in one of the character's eye sockets using Move, Scale, and Rotate. Once you are happy with its placement, you can click the Draw button to resume sculpting.

To make a pair of eyes, we need to mirror the eye we have just made. Go to ZPlugin > SubTool Master > Mirror, select Merge Into One SubTool, and click OK. This will mirror the first eye and add its duplicate to the same SubTool. Remember to select the correct SubTool before mirroring it.

13 Increasing detail levels

Now we can add more detail to the sculpture. Increase the DynaMesh resolution to 128 and continue sculpting, focusing on general proportions and overall anatomy and muscle,

like the creature pictured in image 13. When the main masses of the body and muscles have been established, increase the DynaMesh resolution again to 256 to sculpt even smaller details, such as wrinkles on the face and hands. Remember to smooth (hold the Shift key) your sculpt constantly, as it will help you to control the process more easily, without adding too many exaggerated details. It is easy to become excited while sculpting, but be patient!

Once we have sculpted a moderate amount of detail, it is time to add the character's armor. There are two ways we can approach this, which you will discover on the following pages.

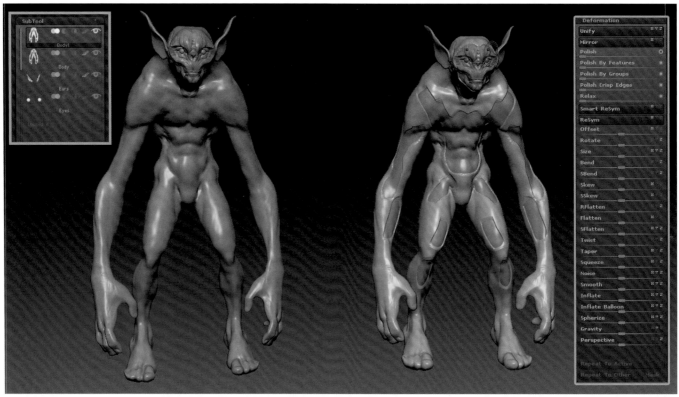

▲ **14** Create the base armor by duplicating the body, making the copy slightly thicker, and carving out the design

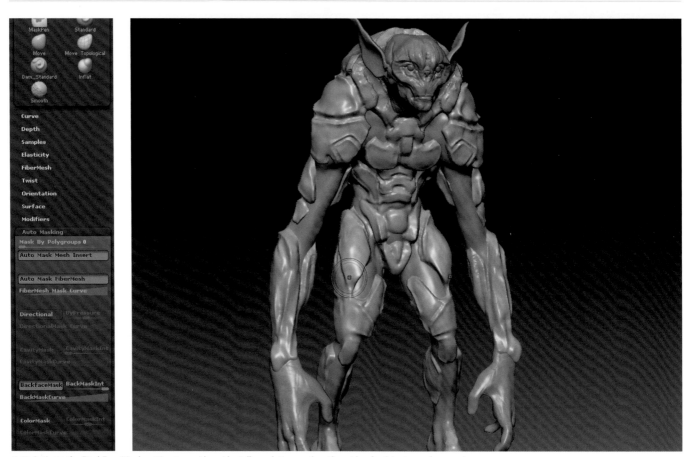

▲ **15** Activate the BackFaceMask setting to avoid accidentally sculpting on the other side of a thin piece of geometry

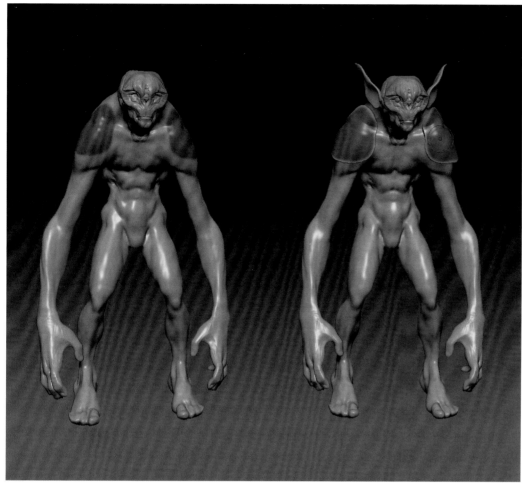 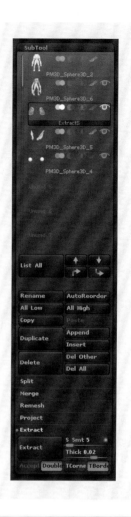

▲ 16 You may also wish to extract smaller pieces of geometry directly from the model

14 Option 1: duplicating the body

Select the SubTool of the character's body and click the Duplicate button, under the SubTool menu. This will create a copy of the body which we can use to rough out the armor. In order to easily distinguish the armor, activate the Brush icon for the body in the SubTool stack, select a color (I chose green), and go to Color > FillObject to fill the body with it. Then go to the armor SubTool, select the Brush icon, and fill the armor with a white color.

Now we need to make the armor layer slightly larger and thicker than the body. Open the Deformation palette and use the Inflate slider on the armor to add some thickness. You can increase or decrease this to suit your taste. Now we can start carving away the armor, revealing the body of the character underneath. Activate Symmetry with the X key to make this process easier. Use the Clay Buildup brush

while holding the Alt key (or just activate Zsub mode) to remove pieces of the armor layer and establish a basic design.

15 Building up the armor

Now start using the sculpting brushes to build up the forms of the armor plating itself. Activate DynaMesh and start sculpting the different parts of the armor. Sometimes when you sculpt, especially on a thin piece of geometry, adding clay will accidentally modify the back face of the area you are sculpting (the side facing away from you, which you can't see). To prevent this, go to Brush > Auto Masking and activate BackFaceMask.

16 Option 2: extracting armor directly

It is also possible to extract pieces of armor directly from the body mesh. You can mask and extract geometry using the method described in step 11. Select the body of your

character and hold Ctrl to mask the areas you want to extract, then add some thickness using SubTool > Extract. Don't make it too thick.

To help you mask and extract the geometry properly, you can isolate the SubTool using the Solo button. This is situated in the shelf to the right of the main canvas. When activated it will hide all SubTools except the one selected in the SubTool palette, enabling you to work on each one individually without distraction.

As soon as you click Accept for the area you want to extract, you will create a new SubTool in a separate layer. You can use this instead of, or alongside, the Duplicate method described in step 14.

▲ 17 Separate the intended robotic arm into its own SubTool

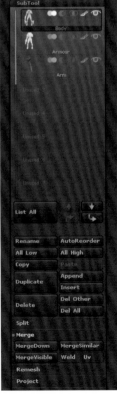

▲ 18 Merging SubTools is useful to keep your model from becoming overwhelming

17 The robotic arm

One major part of this character is its robotic arm. To create this, we need to separate one of the character's arms into a new SubTool. Isolate the body as described in step 10, then hide the arm by clicking and dragging while holding Ctrl + Alt + Shift. It may be easier to change the selection method to Lasso while holding these keys, so you can draw the selection freehand. Duplicate the SubTool and select the new copy, then invert the hidden parts by clicking and dragging on the SubTool while holding Ctrl + Shift. Go to Geometry > Modify Topology > Del Hidden to delete the rest of the body, leaving the arm behind. Now we have the body in one SubTool and a copy of the arm in another SubTool. Use the sculpting brushes and Insert Mesh brushes to fill out a rough robotic arm.

Remember that using an Insert Mesh brush will temporarily mask out the rest of the arm, so click and drag anywhere in empty space while holding Ctrl to confirm the additions and return to your modeling. Lastly, you can use Modify Topology > Close Holes to close any holes in the arm geometry.

18 Merging SubTools

In image 18 you can see my rough draft of the robotic arm, and the progress made sculpting the face and head. ZBrush enables us to constantly push our design, but let's try to stick to the sketch or we could become lost making changes. As we build up the sculpt, we should be constantly hiding and unhiding geometry, extracting, using DynaMesh, and splitting geometry to find the shapes we need and adjusting proportions that we are not happy with. You may find it useful to Merge Down your SubTools, which groups your geometry into fewer parts, and apply DynaMesh to continue sculpting. When you do this, the SubTools attach together and the whole geometry density is recalculated so you don't have to worry about topology. Do this with the ears, merging them down into the body.

19 Isolating body parts

It is also useful to work on parts of the character (hands, head, feet) by isolating them,

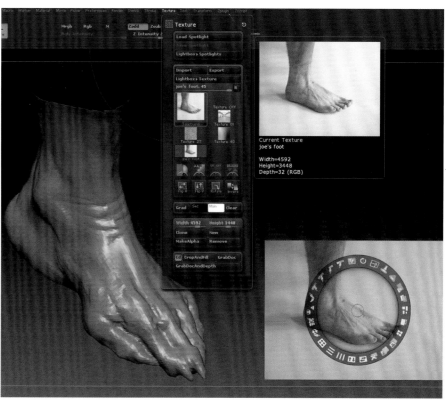

▲ 19 When adding detail, try isolating areas and loading up more specific references

as we did with the arm earlier. This allows us to focus on the details of a specific area, and is an ideal time to load up some reference images. You can load references into ZBrush using Spotlight. Go to the Texture menu, click Import, and choose the image file. Then select the reference and click Add To Spotlight. The image will appear on the screen along with the Spotlight menu controls. I used reference photos to help me sculpt the feet.

20 Spotlight tips

We will use Spotlight to texture the model later in this tutorial, but for now, it can help us with image references during the sculpting process. Shift + Z closes and opens Spotlight. To enable sculpting again after adding an image to Spotlight, just press the Z key. To modify or move the reference image around the canvas, press Z again and use the Scale, Rotate, and Opacity icons to make adjustments. You can also move the image simply by clicking and dragging it. You can load more than one image with Spotlight and modify or place each one just by clicking on an image while Spotlight is activated.

▲ 20 I sculpt the foot with the help of reference

21 Polygroups

Before we start to refine the armor, it is important to talk about Polygroups. As you will already have learned, Polygroups are a powerful ZBrush feature that make it much easier to select, mask, and hide sections of a SubTool as you sculpt. Unlike SubTools, Polygroups do not split your mesh into separate geometry, just into visually distinct selections for ease of use.

To see a model's Polygroups, click the PolyF icon in the right-hand shelf. Press Ctrl + W to create one Polygroup for the whole mesh, then hold Ctrl to mask a part of the geometry. Press Ctrl + W again to make another Polygroup from that mask. You will see that the geometry you have masked changes color, making the different Polygroups easier to distinguish. You can press the X key to activate Symmetry for this stage, if needed. In image 21, you can see that I have applied Polygroups to the model using large anatomical areas that I may want to return to later.

▲ 21 Applying Polygroups to a SubTool make it easier to control specific selections

22 Cleaning up and adding more detail

To start refining our model, we have to upgrade it from a rough sculpt to clean geometry. It is necessary to add subdivision levels to the model, as up until now it has only been DynaMeshed geometry suitable for quick sketching. To start this process, select the body SubTool and duplicate it. Hide the other SubTools for now and just keep the original and duplicated bodies visible. Select the copy, and go to Geometry > ZRemesher and click the ZRemesher button to quickly retopologize the DynaMesh. We can always adjust the ZRemesher settings, but for now the most important value is the amount of polygons for the first subdivision level of our model. Check that it is set to 5 – a limit of 5,000 polygons.

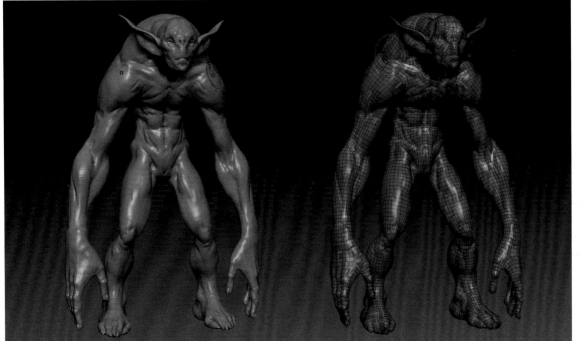

▲ 22 Add more subdivision levels to the model so that you can increase its detail level

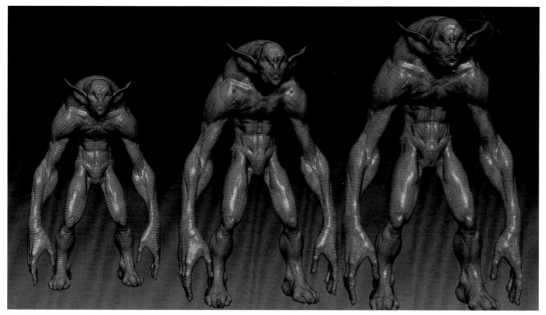

▲ 23 You can transfer the high-resolution details that you sculpted on the DynaMesh model to the clean, retopologized copy

23 Projecting sculpting details

We don't want to lose the details we added on the original DynaMeshed model so, after using ZRemesher on the copy of the body, select it and go to SubTool > Project. Clicking the ProjectAll button will transfer – or "project" – the details of our visible SubTools (the DynaMeshed body, in this case) onto the ZRemeshed geometry we have selected.

Press Ctrl + D to increase the subdivision level and click ProjectAll again. Repeat this process until we have five subdivision levels (indicated by the number 5 on the SDiv slider in the Geometry menu). We now have a model with much higher subdivision levels and all the

sculpted details of our original sketch. We can now delete our old DynaMesh sketch.

24 Changing subdivision levels

Under the Geometry menu, we can now use the SDiv slider to slide back and forth between our model's different subdivision levels. As we switch between them, the ActivePoints and TotalPoints values shown above the document window indicate how many vertices (or "points") are currently present in the active SubTool and all SubTools, respectively.

Our model now has enough subdivision levels to detail it, texture it, and afterwards, pose it. Each level is suited to a particular stage of the

process. For example it will be much easier for us to pose and create UVs for the character using subdivision level 1 (basic geometry) than subdivision level 5 (with high-resolution details like skin pores). Subdivision level 4 will be where we start adding sculpted details, and 5 will be for higher-level textures and details made with alpha maps.

We can now draw crisp, high-resolution details straight onto our model. You can test how this works right now: move the SDiv slider to subdivision level 5 and select the Standard brush. Go to LightBox and click on Alpha. If you double-click on an alpha map, it will become the alpha assigned to the Standard brush, enabling you to "paint" surface detail onto your model. You can download extra alphas online, or create your own in Photoshop. I chose a speckled alpha that is useful for adding skin pores. Select a Stroke setting for your brush in the second square icon underneath your chosen brush in the left-hand shelf; this changes the way your alpha will be "stamped" onto the model. I selected the Dots setting for this; you can see the effect in image 24. Continue working around your model adding details such as wrinkles and pores. After we have detailed the organic sections of the character, we can move on to creating the sci-fi armor.

▲ 24 The highest subdivision level of your model is ideal for adding fine details like pores and wrinkles

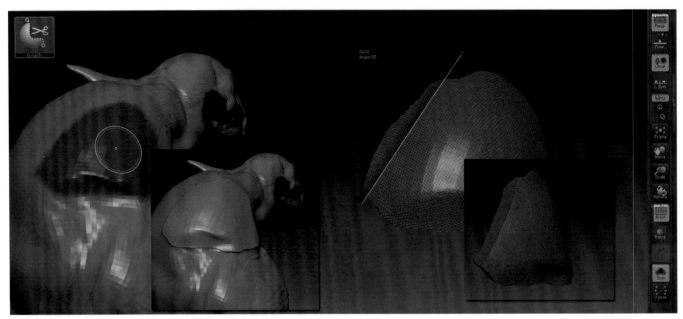

▲ 25 You can use the Extract function to create a new SubTool, then slice it with TrimCurve to create a piece of armor

Hard-surface modeling

25 Extracting armor

There are a number of different tools and techniques that we can use for working on the armor, including Extract, Slice, and Trim for simple shapes, plus Panel Loops, and retopology tools. Let's start by looking at Extract, and testing it out on our mesh.

To create a plate of armor that follows the form of the model, we simply mask the desired area and use SubTool > Extract as we did in steps 11 and 16 of this chapter. Apply DynaMesh to the new SubTool with a resolution of 512. Hold Ctrl + Shift and left-click on the Brush icon, then select the TrimCurve brush, which we will use to shape this new armor piece. Left-click and drag while holding Ctrl + Shift to trim the edges off the armor geometry. Note that TrimCurve trims off the section facing the gradient side of the line you drag out.

26 Slicing armor

Return to the Brush menu and select SliceCurve. This brush will cut the geometry into separate pieces rather than trimming pieces off as TrimCurve does. Press Ctrl + W to make the armor geometry into a single Polygroup, then apply the SliceCurve tool. Now we need to separate the mesh, so go to the DynaMesh options, activate Groups and click DynaMesh. The geometry should now be divided into two parts, which we can move independently. With the Move tool active, use Ctrl + Shift to select the part you want to move.

27 Panel Loops

Panel Loops is another useful tool for creating hard-surface geometry, used in conjunction with Polygroups. Let's explore how we can use Panel Loops on a simple sphere, creating some individual "panels" with beveled borders. Create a sphere, then mask an area to create a Polygroup. Create a few more Polygroups around this Polygroup (as in image 27), then go to Geometry > EdgeLoop and click Panel Loops. Every Polygroup will be transformed into a beveled panel with the number of surrounding polygon loops indicated by the Loops slider in the EdgeLoop palette. Edges will be jagged or smooth depending on the value in the Polish slider. Now mask the panel you want to keep, hide the surrounding unmasked areas by clicking on the masked piece while holding Ctrl + Alt + Shift, and then click Geometry > Modify Topology > Del Hidden.

PRO TIP
Mask By Polygroups
If you go to Brush > Auto Masking and set the Mask By Polygroups slider to 100, you will be able to create more accurate Polygroups. The higher this setting, the more focused the brush effect, so you can work on a Polygroup individually without modifying nearby Polygroups. Lowering the setting will allow the effect to carry over slightly onto other Polygroups.

▲ You can alter the accuracy of your masking

 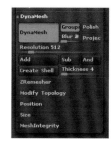

▲ 26 Unlike TrimCurve, SliceCurve will chop your armor into separate pieces of geometry

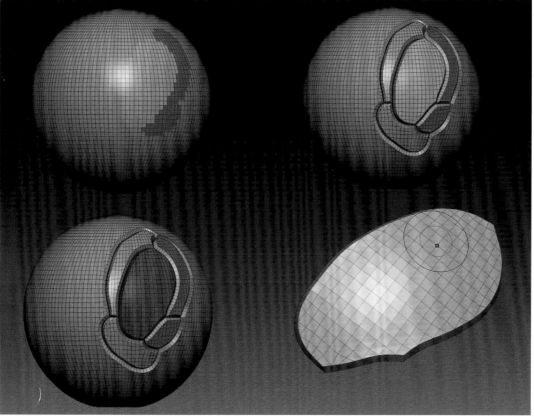

▲ 27 Similar to step 25, you can use Panel Loops and masks to create armor pieces with thickness and neat, beveled edges

▲ 28 Use the Crease function to sharpen edges that you want to give a clean, hard-surface look to

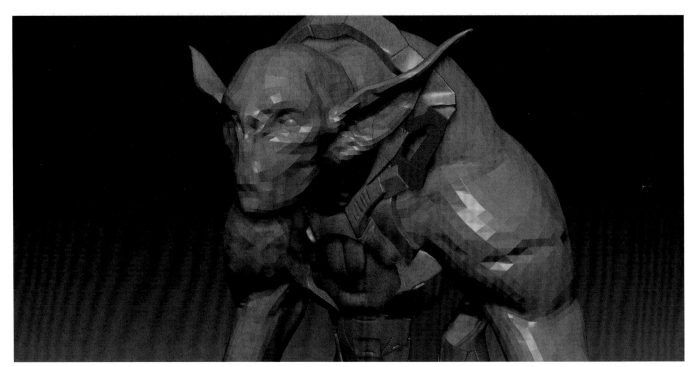

▲ 29 Sculpt the armor using the techniques covered in previous steps

28 Creasing the edges

We can crease the edges of our newly made panels to create sharper edges on the corners. Mask the Polygroup you want to crease and hide the other parts. ZBrush lets you do this by holding Ctrl + Shift in Draw mode and simply clicking on a Polygroup; the other Polygroups will automatically become hidden (hold Ctrl + Shift and click in an empty space to unhide them). Go to Geometry > Crease. After clicking Crease, you will see a dotted line around the borders of the selected geometry. This indicates that those edges have now been creased. Use Deformation > Polish By Crisp Edges to smooth the geometry where there are no creased edges present. The creased edges will stay crisp and retain their shape. Now you have all the control you need to start creating hard surfaces.

29 Refining the body armor

We can now start building the armor (excluding the bionic arm) with the techniques from the previous steps, using our rough sculpt as a guide. Using cut, move, and trim functions, Polygroups and Panel Loops, and hide and unhide options, we can gradually build up the layers of armor. We can still explore new shapes and add details using regular sculpting brushes, but should increase the subdivision levels to do so. However, don't go over the top with subdividing the geometry – four or five levels are enough for adding details.

30 Retopology with a ZSphere

Retopology is also useful and important for creating hard surfaces. When we retopologize a mesh, we essentially reconstruct its shape with a cleaner flow of polygons and contours, ensuring that our model stays organized and efficient. To retopologize part of the armor, start by selecting the SubTool of the rough armor sculpt and hiding all of the other SubTools. Append a ZSphere and select it from the SubTools list in order to access the extra topology tool palettes that we need. Go to Tool > Rigging > Select Mesh and select the armor mesh from the list that appears. Click Tool > Topology > Edit Topology. The ZSphere will vanish and we will be able to "draw" geometry following our armor sculpt by clicking to create new polygon shapes. The new topology will automatically snap to the forms of the original mesh; the red circle indicates the point from which the line will originate. We can delete points by clicking on them while holding Alt, and also use the Edit or Move tools to adjust the topology as we go along.

▲ 30a Retopologize the armor to keep the flow of your model clean and consistent

▲ 30b Uneven topology can cause setbacks in your process later, so it is good to adjust it now

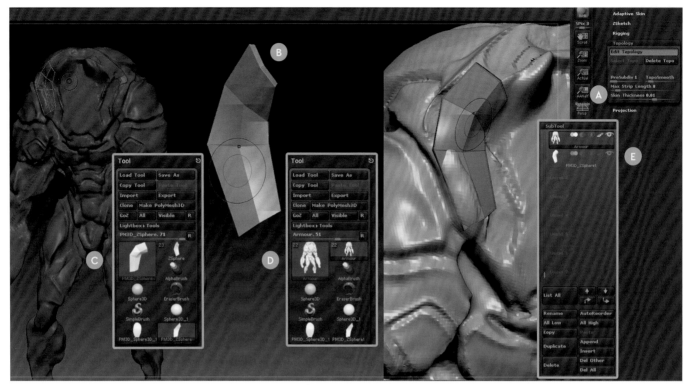

▲ 31 When you are happy with the newly retopologized armor pieces, click Make Adaptive Skin to add them as SubTools

31 Adding the new geometry

After drawing out the geometry as described in the previous step, press the A key to toggle a preview of the results. We want to make this piece thick and double-sided, which we can do by moving the Skin Thickness slider under the Topology menu (A in image 31). After moving the slider, turn off the Edit Topology button to view the results, and continue trying different thicknesses until you are happy. After finishing the desired shape (B), click Tool > Make Adaptive Skin; the geometry will be added to the project as a new SubTool (C). However, it is not yet a part of the character. Select the main armor under the Tool menu (D), then go to SubTool > Append and append the geometry we have just retopologized. It will appear as a new SubTool in the list (E).

32 Applying DynaMesh

Select the main armor SubTool and use sculpting brushes to carve away any clay that overlaps or sticks through the new armor plate. Crease the edges of the new armor piece, as shown in step 28, so that it will retain its hard-surface look. Once you are happy with the shape, increase the subdivision level and apply

▲ 32 Clean up the armor by carving away any old pieces of the sculpt that clip through the new armor plates

DynaMesh with a resolution of 1,024. Now you can add details to this new piece of armor, such as the cut lines shown in image 32, or you can slice, extract, or trim sections of it.

33 Merging SubTools

Continue using the techniques from steps

30–32 to create a clean, retopologized version of your rough armor sculpt. As you finish each section, it is helpful to merge together meshes and SubTools that belong to specific parts of the character, such as the front neck and chest plates shown in image 33. To do this, you will need to organize the SubTools that you want

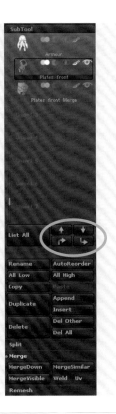

▲ 33 When you are happy with the armor SubTools in one section, consider merging them together

▲ 34 I hide the left "robotic" arm, which will be created with different modeling tools later on

to merge in descending order, so go to the SubTool menu and click on the arrow icons to shuffle each SubTool up or down (circled in image 33). After that, select the first SubTool you want to merge downwards from, and open the SubTool > Merge menu. Click Merge Down; the SubTools will join into one, just like merging layers in Photoshop. Now it will be easier to work with this armor SubTool and the whole model will be more organized.

34 Keep practicing

The modeling process takes time in the beginning, but you will speed up as you get used to using the previous techniques. As you gain confidence, you can add more complexity to your models, and your designs will start to gain originality and richness in detail.

You can see how the overall details of my character and his armor are coming together in the image on the left here. You can also see that I am not currently working on the goblin's left arm, as this will be a mechanical arm that I intend to create with different techniques. I have hidden the left arm for now, with the intention of working on it later.

▲ 35a This simple custom alpha will be used for adding some small armor details

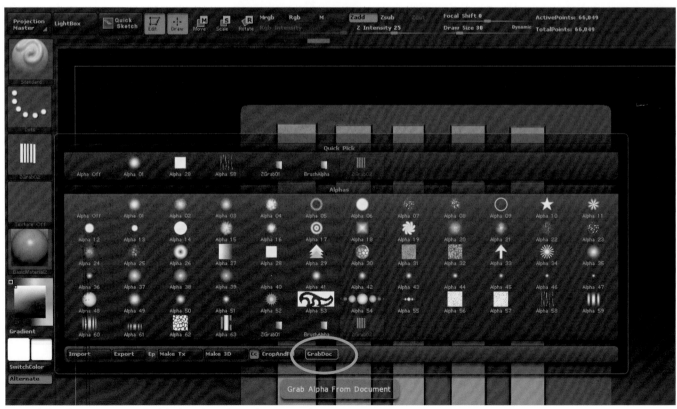

▲ 35b Click GrabDoc to create a new alpha from the sculpt you have just made

35 Creating armor alphas

When the main surfaces of the armor are all sculpted to our satisfaction, we can start adding finer mechanical details using alpha maps. There are many preset alphas in the LightBox > Alphas panel, but we will create one of our own instead.

To start, open a new document (Document > NewDocument), making sure you have saved your current document first. Then create a plane and subdivide it, as we did in the first two steps of this project. Now we can mask and sculpt the shape we would like to use as an alpha. In this case, we are creating a simple grille: use the MaskRect brush to make the selection, invert it, then extrude the pieces using Move mode (image 35a).

Now select the Alpha icon and click GrabDoc (image 35b). ZBrush will create a new custom alpha based on our document. Turn off the Perspective camera and center the 3D panel on the canvas for better results when capturing the alpha.

36 Applying the alpha

To apply the alpha we just created, start by selecting the piece of armor you would like to sculpt on. Select the Standard brush, set the Stroke to DragRect, then select the alpha we just made. Click and drag over the armor geometry and you will see how the alpha easily applies 3D detail. If there is not enough resolution on our mesh, the alpha may apply poorly; if this happens, we just need to subdivide the geometry and try applying the alpha again. Learn more about creating and applying alphas on pages 214–217.

37 Starting the mechanical arm

To begin constructing the mechanical arm, we will create some hydraulic parts that serve as the goblin's arm "muscles." Start by creating a cylinder, making it a PolyMesh3D, and stretching it out using the Transpose tool (in the latest versions of ZBrush this is handled using the Move tool's 3D gizmo). Select the ZModeler brush and use the Inset and Extrude options to create a simple hydraulic part with some wide sections and some narrow

▲ 36 Now you can apply your new alpha to the model to create quick 3D details

▲ 37 This hydraulic piece, based on a cylinder, will form the basis for the mechanical arm

sections. If needed, use Insert to create more edge loops, or Delete to remove edge loops. Remember that you can use the Spotlight tool to load up some reference photos if you need to (refer back to steps 19 and 20 if needed). Once you are happy with the overall shape and

details, append this SubTool to your character and place it in the arm. Now we can move on to creating the other parts of the mechanical limb.

38 The lower arm

To model the main part of the forearm, we can start from a cylinder again. It is important to achieve a logical, mechanical feel for the whole arm, so we must keep this in mind as we create the shapes and joints. Use the ZModeler options to trim, move, mask, and slice parts of the geometry as necessary. You can also append new geometry to achieve the desired shapes, and activate Symmetry in order to speed up the modeling process.

39 Dynamic Subdivision

If you are using subdivided geometry with ZModeler, you have to "freeze" the geometry to check that all the creased edges and details remain in place. In image 39 I have made a random shape to demonstrate this. Go to SubTool > Dynamic Subdivision, and press Apply. This provides a visual preview of the subdivided mesh, but does not actually subdivide the geometry of our model. However, it is very useful for reference, with the edges of the underlying original ZModeler

mesh indicated by the orange pins. Remember to save a version of this SubTool as dynamic subdivision geometry, in case you want to add some more details in the future. Now append the SubTool to the character and place the geometry where you want it.

40 Hand and fingers

For the hand, let's start by creating a single finger first, using a mixture of cylinders and cubes, and the modeling techniques you have learned in previous chapters. We will duplicate the finished finger to save time. Now append a cube and use ZModeler tools to flatten and shape it into the palm section of the hand, following a human hand reference if needed.

Now we need to Polygroup the parts of the hand that we wish to pose later. We can do this by moving all of the fingers into place, merging the SubTools of the hand, then Polygrouping the whole hand (Polygroup > Group Visible) before applying Polygroups to each finger by

masking each one and then hitting Ctrl + W. Alternatively, we could apply Polygroups to one section at a time (for example, merging and grouping each finger) before merging the SubTools of the whole hand together. It is only really necessary to Polygroup the areas that we want to pose; the idea is to group those parts together now so that, when we want to pose the hands and fingers later on, the selection process is easier.

You can see how I have grouped each section of the hand and fingers in image 40. We can use these groups to pose the hand now, though you could also do this in step 42 when you come to posing the whole arm, now that the Polygroups are in place. I choose to pose the hand at this point, to check that the overall design is working. To do this, I use the Transpose tool to push the palm forward and make the fingers hang more naturally. When we properly group the SubTools in step 42, posing becomes very simple, and we can easily focus on placing everything correctly.

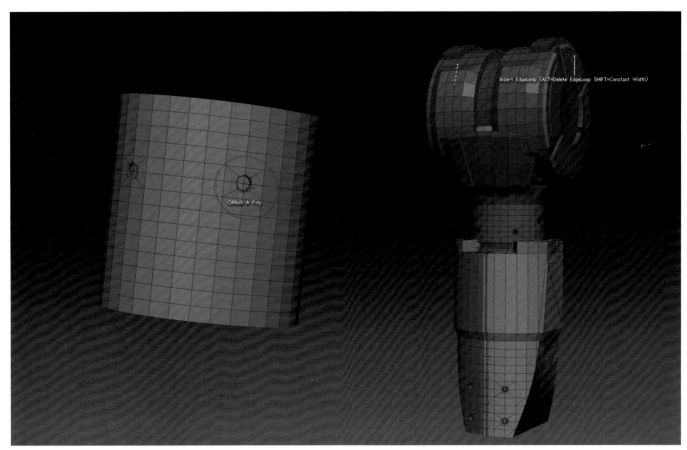

▲ 38 Model the parts of the forearm with cylinders and ZModeler tools, with Symmetry active to save time

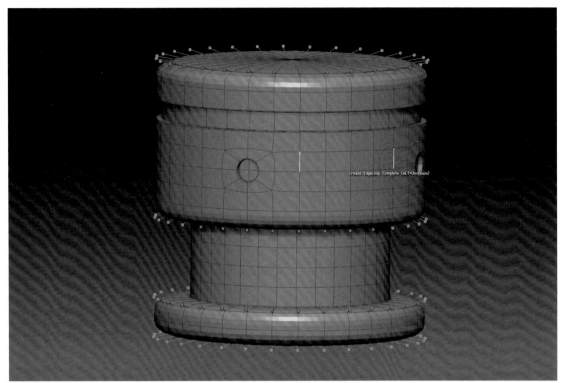

▲ 39 When in Dynamic Subdivision view, the orange markers indicate the actual outline of the unsubdivided geometry

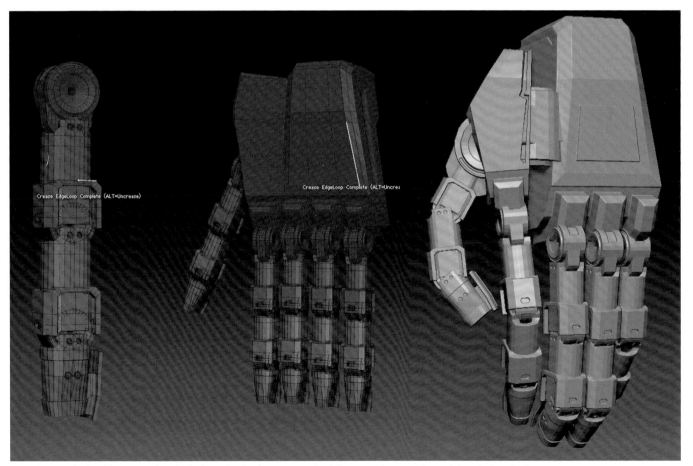

▲ 40 I build up the hand from a number of cylinder and cube shapes, group the different sections together, and then give it a simple pose

41 Insert meshes

Using Insert meshes is a great option for adding details to our model. Like alphas, we can create our own Insert meshes if we don't want to use the available presets. To create an Insert mesh, we can sculpt any shape we want – in this case, a multi-purpose cylinder which can serve as a rivet, piston, or tank on the goblin's back – then go to Brush > Create > InsertMesh, and click New. To use this new mesh, simply select it from the Brush menu, and click and drag over where you want to apply the geometry (use the Ctrl key to constrain it to its original size). You can then adjust the size and placement if needed. We can use this Insert mesh in different sizes and positions to fill out the upper and lower arm with mechanical detail.

42 Grouping the arm

Once we have created the whole structure of the arm, it is important that we group the upper arm parts, the lower arm parts, and the hand independently. To do this, merge all of the individual parts of the upper arm together, and then click Polygroups > GroupVisible to create a Polygroup from that section. Repeat this for the SubTools of the lower arm and the hand, and finally merge all three SubTools together. Now the entire arm is in one SubTool, but each section still has its independent Polygroup. This will make our life easier later on, when we come to posing the character. Posing requires a lot of masking, moving, and rotating geometry, so these groups will enable us to pose the arm without any problems.

43 The finished arm

Now that the arm is complete, save it as a SubTool and open the character file. Import the arm SubTool and append it to the character. If the arm is out of scale with the body, just select the arm SubTool and go to Deform > Unify. This will scale the arm in proportion to the character so that you can position it properly. We can now add some extra plates to the shoulder and upper arm to fit the style of the rest of the armor. These metal plates could be some kind of protection for the mechanical structures of the arm.

▲ 41 This custom Insert mesh looks simple but will be useful for adding detail in various areas of the model

▲ **42** Group the different sections of the arm so that they are ready to pose later

▲ **43** Append the bionic arm SubTool to the character, moving and scaling it into place as appropriate

Texturing and posing

44 Preparing for texturing

Now it is time to start texturing our model. We will start with the organic part of our character,

which is the body. To create the texture, we first have to generate UVs – the coordinates that help to "wrap" the texture around our model. Go to the Texture menu and set a texture height and width of 2,048 × 2,048, then select the body mesh and lower the subdivision down to 1, which is a sufficient level of detail for this stage. Go to ZPlugin > UV Master and click

Work On Clone. This will create a copy of the body SubTool at its lowest subdivision level, which we will use to create the UVs. A new document with a copy of the body will open up.

45 Unwrapping the UV

Click on Unwrap and wait for ZBrush to process the action. Once the UVs have been generated,

▲ 44 Create a clone of the body from which to extract UVs

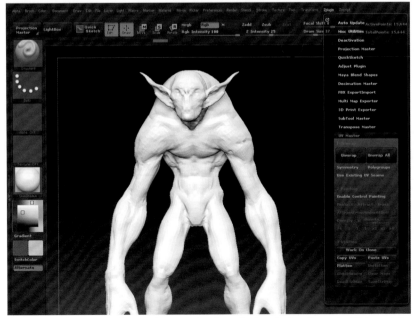

▲ 45 Unwrap the UVs of the low-resolution mesh and transfer them back to the original high-resolution model

you will need to transfer them back to the original character, as we are currently working on the clone. Click Copy UVs and open the original body – it should be stored in the Tool palette, just click on it. Return to ZPlugin > UV

Master and click Paste UVs. Now the UVs have been assigned and you are ready to texture the skin of the character. Select a neutral material and fill the object with a suitable color (I chose pale green to start with).

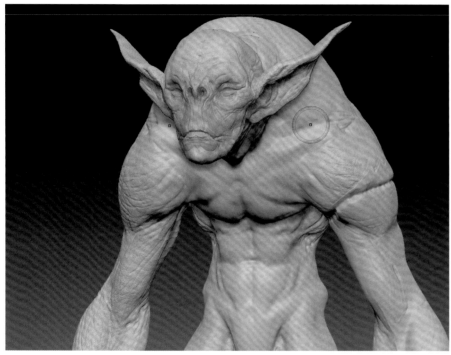

▲ 46 Start painting the character's body using brushes set to Rgb mode

46 Starting to paint

Select the Standard brush, Color Spray or Spray, and an alpha. I usually like to create skin textures with a speckled alpha. Remember to turn on Rgb and turn off the other options so that we are working only in color. Activate Symmetry and start painting over the character. Use warm tones in skin areas where there is more blood and thinner skin (such as the eye sockets, mouth, and ears). You can always fill the object with flat color to start again. Vary the brushes, alphas, and colors you use to add interest and achieve your desired look.

47 Transferring the painting

Now we need to apply our Polypainting to a texture map. Go to the Texture Map tab and click Create > New From Polypaint. The color info will be transferred to the texture using the UVs we generated. Now we won't see any change when we try to paint, because what we are currently looking at is the model with the texture map applied. If we turn off the Texture Map > Texture On button, we will be able to continue painting. Every time we want to transfer color from our Polypainted model to the texture map, just repeat this step.

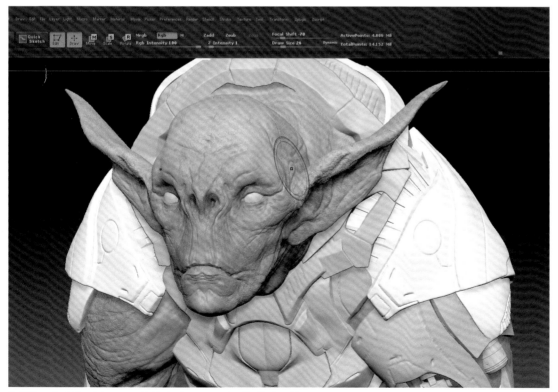

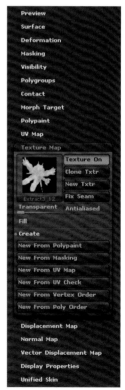

▲ 47 Transfer Polypaint progress to the texture map using the Texture Map menu

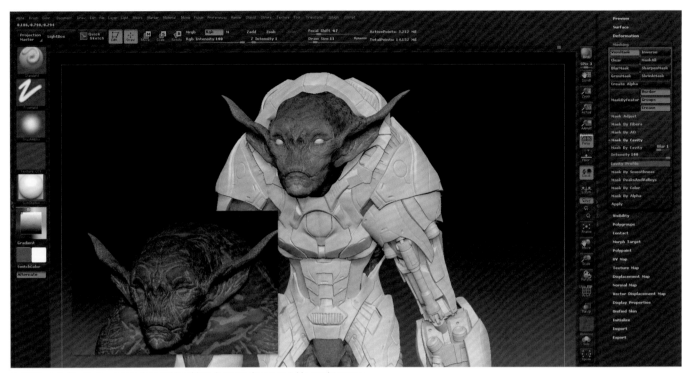

▲ 48 Mask By Cavity is valuable for quickly adding deeper colors to wrinkles and creases

48 Texturing with Mask By Cavity

We can paint skin details such as deep wrinkles by applying masks to our model. Go to the Masking tab and click on Mask By Cavity. Now invert the mask, select a darker color, and apply it to the character. You will find that you are now Polypainting only in the recessed parts of the wrinkles, giving them a deeper, more natural feel. To apply the color more clearly, turn off View Mask. We can also mask by the other parameters available in the Masking menu – feel free to explore them – but this option is especially suitable for the skin of this character. Remember to transfer the color to the texture map after finishing.

49 Painting the eyes

Let's apply both a color and a material to the eyes, making them glossy and shiny. Select the eyes from the SubTool palette, turn on Mrgb (to apply a material *and* color at the same time) and select the Toy Plastic material from the Material menu. Select a color for the eyes and go to Color > FillObject. This will apply both the material and the chosen color. You can then turn off Mrgb and return to working in Rgb, so the material will remain and you can Polypaint detail onto the eyes.

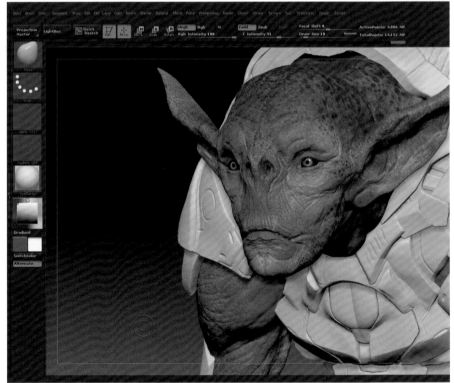

▲ 49 Add both color and a glossy material to the eyes to give them life

50 Texturing the armor

The same process from steps 44 to 47 applies to painting the armor. You can use Spotlight by importing a texture into it, scaling it as desired, and pressing the Z key; this will fix the texture on the canvas while you move the character. Place the character where you want the texture to be added – to the armor plates, in this case

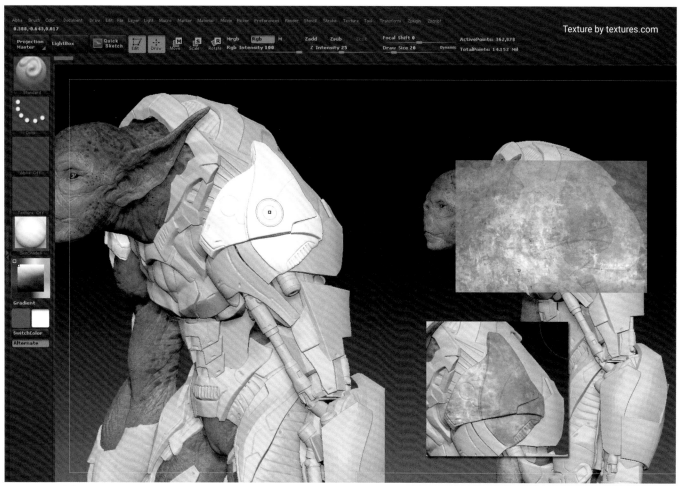

▲ 50 Use Spotlight to paint textures onto the armor. The texture used here is MetalBare0100, available to download from textures.com

– and paint over the texture as a stamp. The texture I use is called MetalBare0100 and can be freely downloaded from textures.com, though you can choose whichever you prefer or even photograph your own. Shift + Z hides Spotlight so that you can continue to Polypaint as usual. Try to use different metal textures to give a more varied, realistic look.

51 Armor material

To make the armor look more metallic, we will also add a material to it. Select a suitable material and turn on the M button. Now fill the armor with color, which will transfer the material to the armor without losing our texture. Turn off M and return to Rgb mode to continue adding color without changing the material. Return to using the plain SkinShade4 material to resume adding color and texture to the other parts of the armor, then add the metallic armor material last, as described in this step.

▲ 51 Adding a chrome material to the armor gives it a realistic, metallic look

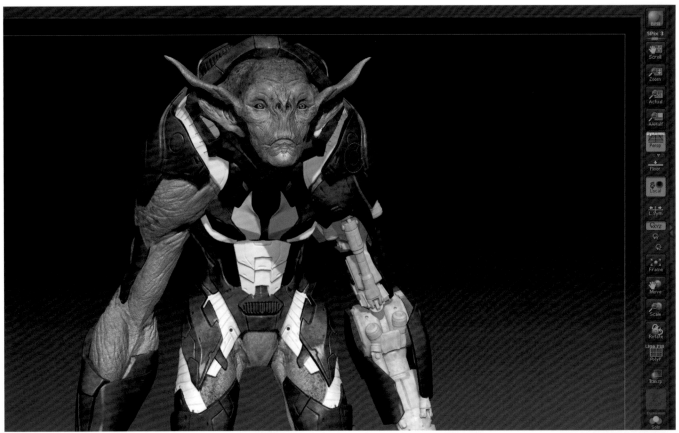

▲ 52 Use BPR to create quick renders of your model so far

52 Testing with Best Preview Render

It is useful to check the appearance of our sculpture by clicking the BPR button to get an idea of how the finished render might look. Note that BPR will only work in Edit mode. It is important for this character to have a good balance between organic and hard-surface parts, so use BPR to help you decide how to tailor your textures and Polypainting towards the desired final look.

53 More arm and armor textures

Use a range of textures and materials for the robotic arm, as variety adds interest and keeps the different parts of the model visually distinct. Mask By Cavity can be used again here to darken recesses and give the feel of rusty metal. For the brown parts, apply a leather texture as a complement to the metallic areas.

54 NoiseMaker

Another of ZBrush's many useful plug-ins is NoiseMaker, which creates surface noise to make a model more interesting and detailed.

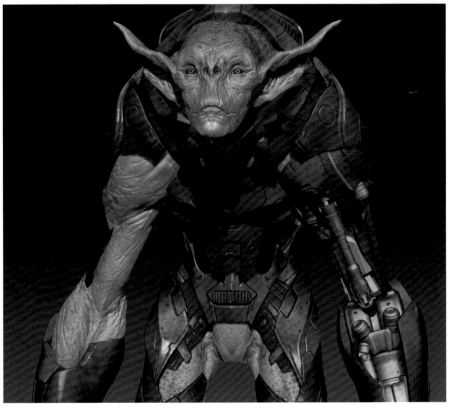

▲ 53 Apply a more leathery color and material to some parts of the armor

▲ 54 Generate noise with NoiseMaker to add extra texture to the leather surfaces

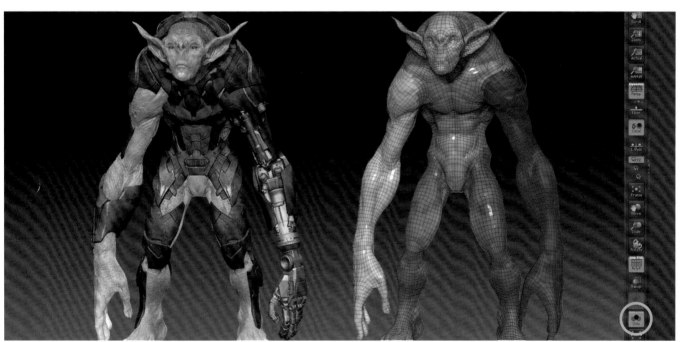

▲ 55 The character's body will be posed first, then the armor will be positioned manually on top

If we go to Surface > Noise, an editor opens up giving us options for this feature. Explore the sliders on this menu to vary the scale and strength of the surface noise and preview how it affects the mesh. Clicking the Edit button brings up a second panel with additional controls. Apply noise to the brown parts of the armor to enhance their leathery grain.

55 Transpose Master

With the texturing complete, our character is now ready to pose! We will use another ZPlugin called Transpose Master to pose the character. To use Transpose Master, first Polygroup the arms, legs, and face of the character so that you can select and mask them easily. We will create the pose with just the body mesh, then

move the armor manually over the posed figure afterwards. Click the Solo button on the bottom right of the viewport to isolate the body and make the Polygroups.

167

56 Posing the character

Go to ZPlugin > Transpose Master and turn on the Grps option, then click TPoseMesh. The program will merge all SubTools at the lowest subdivision level and we can now treat the character as a whole, using the Transpose tool with masking to rotate and move any part of it to find the pose we want. We will take advantage of the Polygroups we created before to modify the whole pose. It is amazing to see how the character starts to come alive just by posing the head. Turn the goblin's head slightly and give his feet a more natural stance. The mechanical arm will be posed separately – we don't need Transpose Master for that.

57 Transferring the pose

After posing the body, return to ZPlugin > Transpose Master and click TPose SubT. This will transfer the low-resolution pose we just created back to our original SubTools. Now we can see the textured model in its new pose. I grouped and Polygrouped the different sections of the mechanical arm separately in step 42, but if you missed that, you can always do it now.

▲ 56 Pose the character using Transpose Master and the Grps option

▲ 57 Transfer the pose from Transpose Master back to your high-resolution model

To pose the armor, start by merging the geometry that belongs to certain parts of the armor: for example, merge all the armor plates of the shoulder. Now we should have our armor organized by parts, with each part a SubTool, and can simply select each SubTool and use Transpose to place it on the posed body. You could also merge all the armor into a single SubTool, then organize it into Polygroups and move those, but this method is more complex and takes more time.

58 Posing the mechanical arm

We can use the Polygroups to our advantage when posing the robotic arm by moving the arm as a hierarchy. Use the Transpose tool to pose the upper arm without masking any other parts, and the whole arm will move with it. Then mask the upper arm to keep it in place and move the lower part, which will pose the lower arm and hand together. Finally, mask both the lower and upper arm and pose the hand separately. If you applied Polygroups to the fingers, you can also mask and move or rotate them individually into different positions.

59 Adding curved tubes

Now that the pose is complete, we can add some finishing details to the character such as cables or a few more Insert meshes. Go to the Brush tab and select CurveMultiTube. Click and drag over the geometry to draw out the path of the tube, then click and move the end points around to adapt the curve into a suitable shape.

We can also break the symmetry of the character to make him more interesting by adding mechanical parts, such as a tank on the goblin's back, using the Insert mesh we created in step 41.

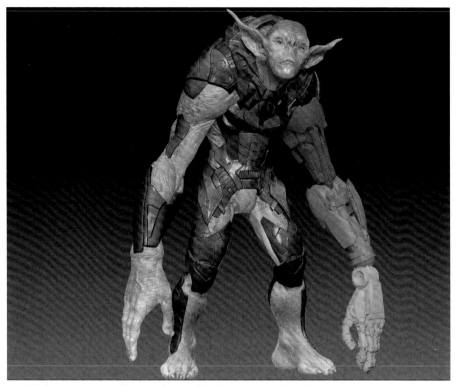

▲ 58 The bionic arm is posed separately using the Polygroups created earlier

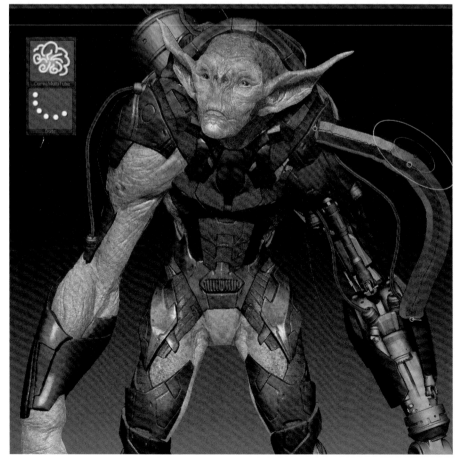

▲ 59 The CurveMultiTube can be used to easily add pipes and tubes to the mechanical parts

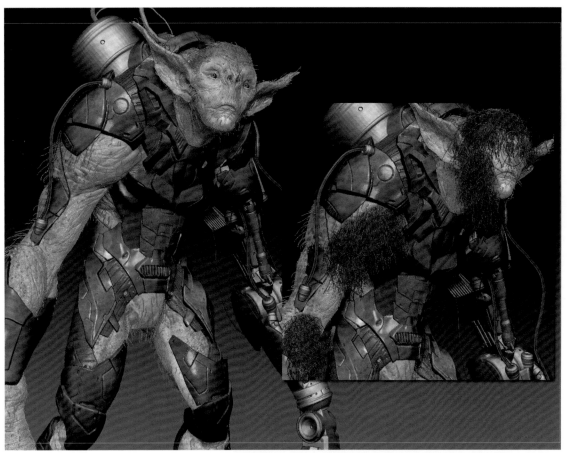

▲ 60 FiberMesh is used to add fine hair to the goblin's skin

▲ 61 The hair can be groomed into place with the GroomHair brushes

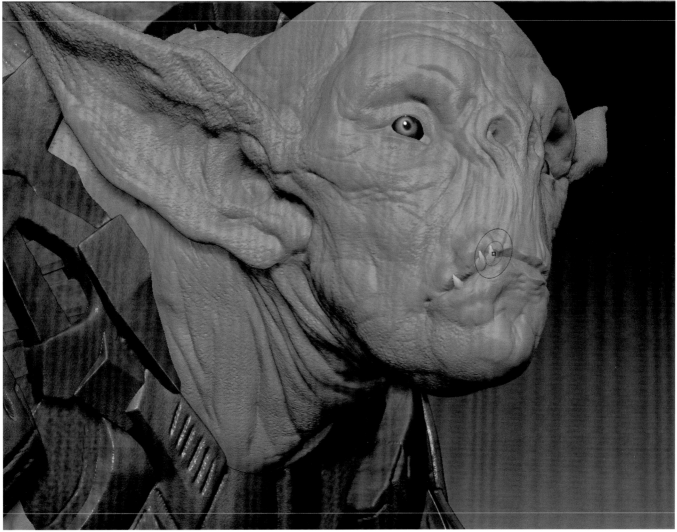

▲ 62 Add a few pointy teeth as a final extra detail

60 FiberMesh hair

Let's add some hair to the model to give him more realism. To do so, mask the areas where you want the hair to appear, then go to FiberMesh and click LightBox > Fibers. Select a hair type when it opens up, then click FiberMesh > Modifiers to adjust the parameters. The main settings to consider are Length and MaxFibers, but we can also change the color of the hair and add texture to it. When you are satisfied with the hair, press Accept. The hair will be added as a new SubTool and we can click BPR for a clearer preview of how it looks.

61 Modifying the hair

We can also modify the hair with some special brushes. Go to the Brush menu and choose GroomHairShort or GroomHairLong. You can use these brushes to groom the hair SubTool and improve its shape. The hair that ZBrush creates is geometry, so we can always hide, delete, or move it, and can also change its materials and texture. In this case, we just want some natural-looking body hair to give our character additional detail.

62 Adding teeth

ZBrush's versatility allows us to keep polishing our design at any stage in the process, so, before rendering, one last touch we can add to the character is some teeth! Append a 3D sphere and sculpt it into a tooth, then use the Transpose tool to move it into place. If you hold Ctrl while doing so, you will duplicate the geometry and create another tooth. Do this a couple of times and place the resulting teeth.

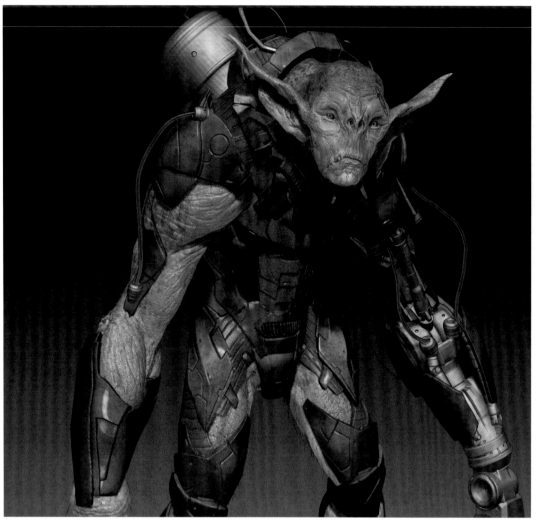

▲ 63 Create a simple lighting setup in preparation for rendering

Rendering

63 Lighting the scene

Our character is now ready to render! To start this process, we will add some light to the scene. Open the Light menu and check that one light is active. We can turn the light-bulb icon on and off to activate or deactivate the light, and also adjust its intensity and ambient color. Place the light by moving the point on the sphere that represents its position. A little later, we will render several passes with different light placements and composite them together in Photoshop.

64 Framing the character

We need to prepare our document a little more to achieve a well-composed render. Go to the Document menu and select the width and height for our image. We can now adjust the angle of our camera by going to Draw > Angle Of View. Frame the character as you wish and save the file after framing it. This is the best way to save our camera view, in case we move it accidentally.

65 Main render passes

We will render main render passes first: Diffuse (which in ZBrush is called the Shaded pass), Shadow, Depth, and Mask. We will deactivate Shadows first, though, as we want a single pass with just the shadows so we can modify it independently in Photoshop. To do this, go to Render > Render Properties and deactivate Shadows. Click BPR and save the Diffuse (or Shaded), Depth, and Mask passes by going to Render > BPR Renderpass and clicking on the

thumbnail of each pass you want to save as an image. When those are saved, re-activate Shadows, then click BPR and save the Shadow pass. Note that if you have the Floor activated, you will also have a ground shadow in the shadow pass if you want it.

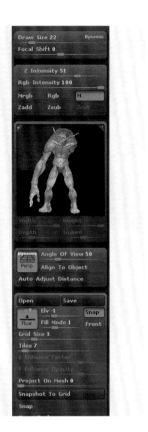

▲ 64 Frame the finished character into a more appealing composition

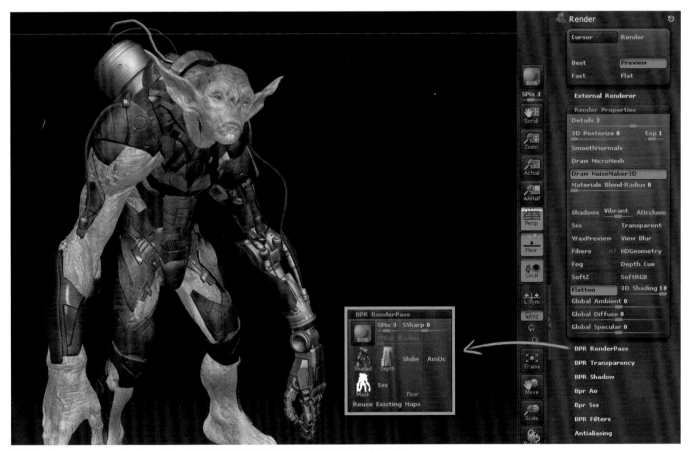

▲ 65 The first passes you should render out are Shaded, Depth, Mask, and a separate Shadow layer

▲ 66 Save out several light passes with the light source in different positions

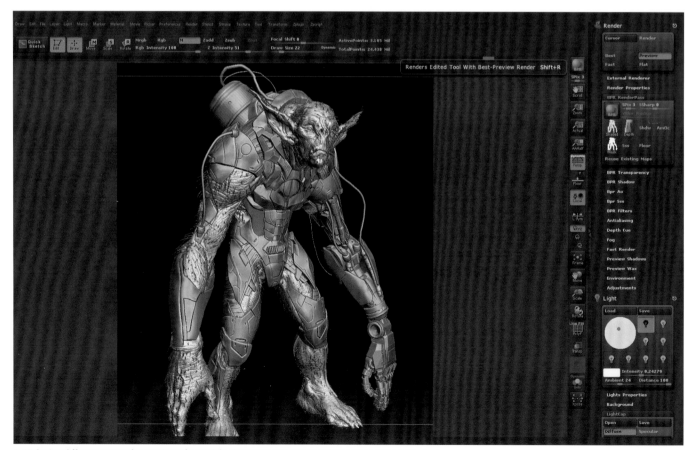

▲ 67 Saving different passes for a variety of materials gives you more options when compositing in Photoshop

66 Saving the light passes

Now we will save out passes for the lighting that we created earlier. Turn off the brush icon in all the SubTools in order to visualize the model with just the material that is selected – in this case, BasicMaterial2. Turn off Shadows in the Render Properties menu. Select a black color and modify the light by moving it around the sphere. The plain black model should make it easy to see where the light falls. Click BPR each time you modify the light to save light passes at a few different angles. Saving different variations will ensure that the final image is well lit, and that we have a number of lighting options to experiment with.

67 Material passes

Now we can start to select materials and apply them to the whole model. Pieces of each material pass will be used for compositing the final image in Photoshop. You can use BPR for as many material renders as you want, with different colors and properties, and you can always come back to ZBrush and render other materials that you might need. In image 67 you can see I have chosen to save out a shiny metallic material that will help with compositing the mechanical parts. Again, save each pass by clicking on them under Render > BPR Renderpasses.

68 Clown pass

Clown pass will render an image with flat colors assigned to each material. This will be very useful for selecting each part when we are in Photoshop, in order to adjust or mask them.

▲ 68 Make a Clown pass with flat color to assist with Photoshop selections later

To create a Clown pass, select the Flat Color material and fill every similar part of the model (for example the skin, armor, and eyes) with a different color. Once this is complete, hit BPR and save the pass.

69 Main passes in Photoshop

The main render passes should look something like this: Diffuse, Shadow, Mask, and Depth.

When you open them in Photoshop, place the Diffuse pass as the bottom layer and place Shadow and Depth over it. A basic rule of thumb is to apply Shadow and Depth layers in Multiply or Overlay blending mode, while leaving the Diffuse pass in Normal mode. Layer by layer our image is coming together.

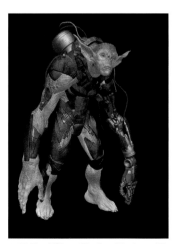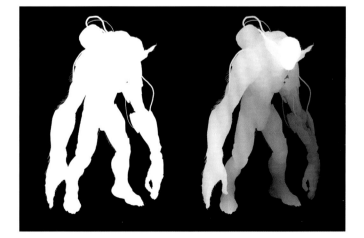

▲ 69 The Diffuse, Shadow, Mask, and Depth passes in Photoshop

▲ 70 The lighting passes illuminate the model at different angles and intensities

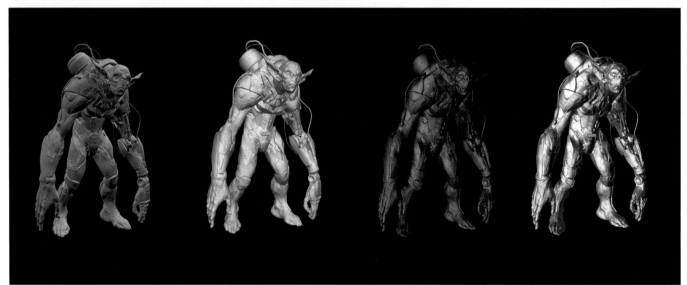

▲ 71 The various material passes, in conjunction with the clown pass, will help to add effects to different sections of the character

70 Light passes in Photoshop

The light passes should look as shown in image 70. Every light pass we composite in Photoshop should be in Screen or Color Dodge blending modes, so that they light up the layers beneath. Of course, this is a basic approach to compositing the image – feel free to mix and match the various blending modes in Photoshop, and experiment by adjusting the hue and saturation of the lights.

71 Material passes in Photoshop

Material passes should look like those pictured in image 71. There are no special rules to rendering and compositing specific materials, but I find that using the Lighter Color or Overlay blending modes works well. At this point, your own artistic point of view comes into play when adjusting the material passes for your image. Remember that you can use your clown pass to isolate those areas to which you would like to apply specific materials, such as skin or metal. You can skip ahead to step 75 to see my final Photoshop result, but for now, let's go back into ZBrush to explore some other options for presentation.

72 Clay render

Just to wrap up this project, let's cover a different style of presentation render: a render with a "clay" look, which we can just make within ZBrush. We can do this by selecting the Clay material preset from the Materials tab, but Pixologic's Download Center also offers many other materials suitable for producing clay renders: pixologic.com/zbrush/downloadcenter/library. If you choose to download one, add it to ZBrush by going to the Materials tab and clicking Load.

73 Rendering a clay BPR

Now we can see how this clay material looks on our model. If you are happy with the result, render the "clay" version of the sculpture by clicking BPR. We will be finishing this version in ZBrush, but don't forget that we could still use this material as a pass if we were finishing our image in Photoshop.

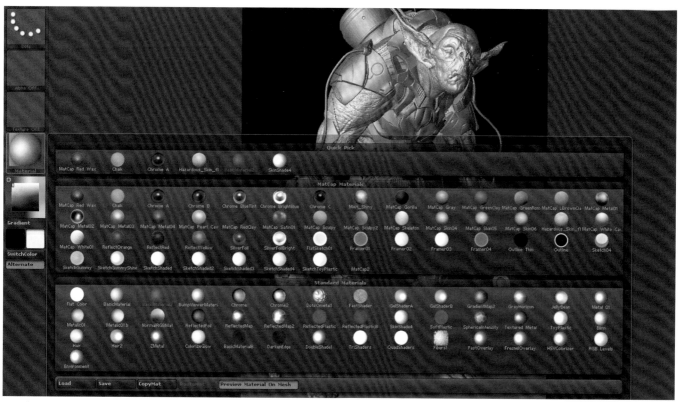

▲ 72 If you want to keep things simple with a clay render, you can find many extra options for clay materials on Pixologic's website

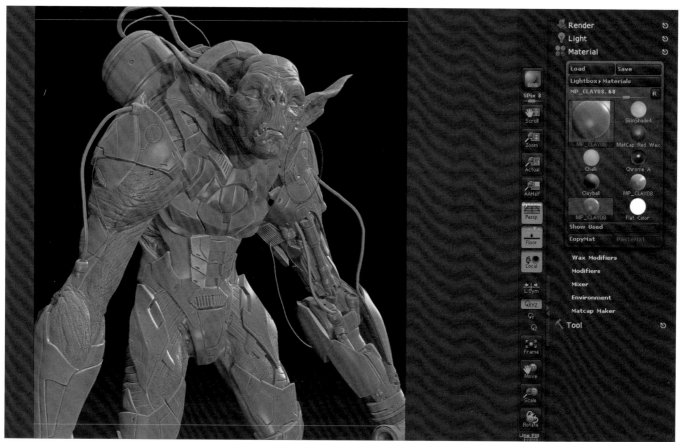

▲ 73 When you have chosen your clay material, hit the BPR button as before

▲ 74 You can add many filters, shading, and color tweaks to your clay render using the Render options

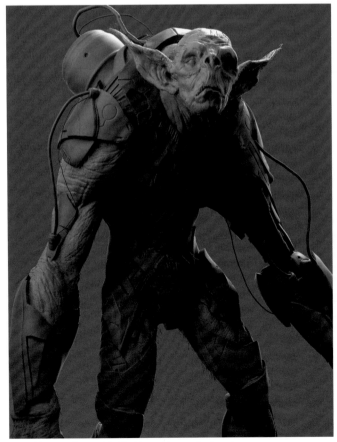

▲ 75a You can also use KeyShot to create your final renders

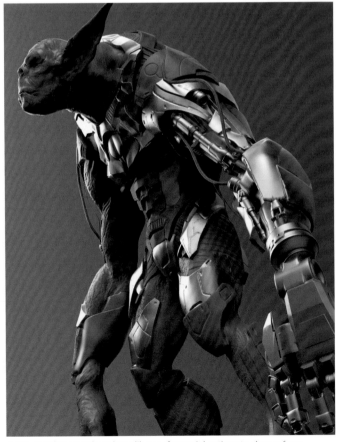

▲ 75b KeyShot provides a huge library of material options to choose from

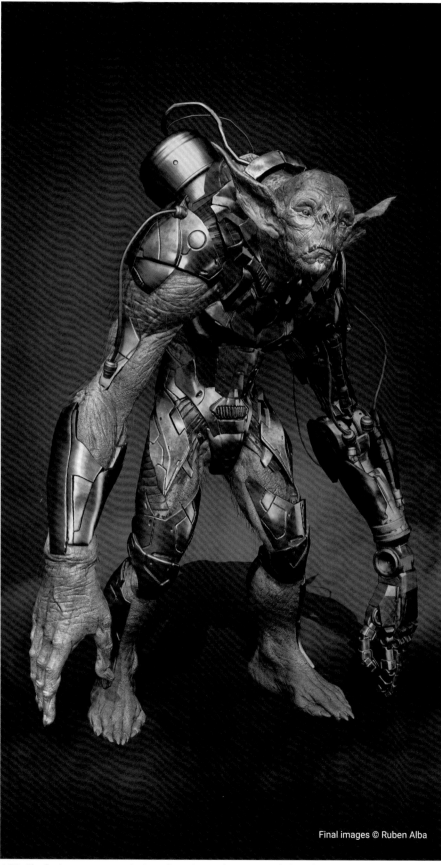

Final images © Ruben Alba

▲ 75c The final concept composited together using render passes and Photoshop

74 Editing the clay render

Now we will apply filters under Render > BPR Filters. We can activate and deactivate filters by clicking the small circles in each button. If the circle is open, the filter is on. Here we can add noise, change the hue and saturation, or add different effects to the render. Finishing a render this way is useful if you are looking for a quick, simple result that has more polish but does not require Photoshop.

75 Final renders

After compositing the image in Photoshop, the character is ready to work as a new portfolio piece. On the previous page you can also see some versions that I rendered using the external program KeyShot, creating some very different looks. You can use KeyShot to apply materials, set lights, and play with camera settings, creating amazing renders with just basic materials and slight color variations. In the KeyShot renders shown, I applied "metal" materials to the mechanical parts of the character, and "clay" materials to the organic parts. KeyShot uses HDRIs to illuminate your model, but you can also create geometry to act as lights in the scene, adding dramatic lighting. Turn to chapter 06 to learn more about finishing images with KeyShot.

05
Hard-surface sculpting

By Carsten Stüben

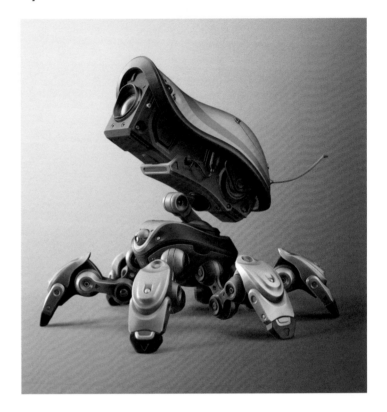

This chapter will show you the step-by-step process for creating a futuristic robot called *Nosy-N-42*. ZBrush offers an array of magnificent tools for hard-surface modeling, which this project will shed light on, teaching you different methods to help you realize your own visions. As you will now realize, hard-surface modeling differs from the more organic sculpting you saw in chapter 03, in that it uses ZModeler. As you follow this project, it is strongly recommended that you take extra time to experiment with the tools presented; it will help you to learn more about their different facets, quirks, and strengths.

Please note that this project relies on the ZModeler toolset, which was introduced in ZBrush 4R7 and is not available to users of ZBrushCore.

Chapter sections
- Base model
- Hard-surface modeling
- Advanced modeling
- Detailing
- Rendering

Base model

01 The concept sketch

ZBrush offers the possibility of starting with a basic shape, such as a sphere, and discovering where your mind will take you. It can be very liberating when the shape-finding takes place directly in 3D in this way, but for this project we will start with the more traditional method of making some quick 2D sketches to work from. Since we are the only ones who will be using these sketches – not a team of other artists or sculptors – we do not need to go to the extent of drawing each angle and lots of detail. These sketches just capture the idea and serve as a guide for proportions, as shown in image 01.

02 Loading the sketch

I decide that I like the second concept sketch shown in image 01 the best, and choose to move forward with that one. In this step we will transfer the sketch to ZBrush and use it as a guide for roughly defining the basic shapes. As we haven't sketched a front or a top view, we will define the width and depth of the design within ZBrush.

You have two options when it comes to loading your sketch into the background of ZBrush for a direct reference comparison. The first option is in the Texture panel, where you can load your image into ZBrush's Spotlight and lay it over your model transparently. To do this, use the Import button to add an image to the Texture panel (image 02a). Select the image in the panel, then click the Add To Spotlight button (the last of four orange buttons circled in image 02a). You can then use the Spotlight wheel (image 02b) to change the opacity of the image by clicking and dragging the Opacity button around the wheel. Press the Z key to close the wheel and you can then start sculpting your model "through" the image. You can close Spotlight with Shift + Z.

Alternatively, you can open the image in another program, such as Photoshop, and make the entire ZBrush interface transparent using the See-through slider at the top right of the interface (image 02c). You can then effectively sculpt on top of your reference image.

▲ 01 The second 2D concept sketch will be the basis for this design

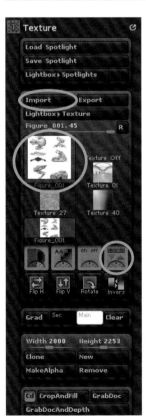

▲ 02a Add an image to Spotlight

▲ 02b Alter the opacity of your image using the Spotlight wheel

▲ 02c The See-through slider makes the ZBrush interface transparent

PRO TIP

Save your camera angles

To store the current view of your mesh, go to Document > ZAppLink Properties panel, where you will find two buttons, labelled Cust1 and Cust2. These can be used to store two custom views of your model. This enables you to move your model around as you wish – clicking the button again will return you to your stored viewpoint.

You can also store Front, Back, Right, Left, Top, and Bottom views for quick navigation. Set your model up facing the camera head-on and click Front; ZBrush automatically stores the Back view for you. Likewise, if you set up a Right view and click the button, the Left is also recorded. Now, if you ever become disoriented while modeling, simply click a button to return to one of these six standard projections.

▲ Use ZAppLink to store views of your mesh

In the Document menu you will find the ZAppLink Properties panel (image on the left), where you can click Cust1 or Cust2 to save the current view of your model. Clicking the same button will snap the view back to the saved one again. These saved camera angles will disappear when you close ZBrush, but you can easily save and load them from the same menu. This function will save you the trouble of arranging the model and the sketch again.

03 Making a base shape

For the creation of the first basic shapes, this project will cover two possible methods: sculpting and ZModeler. First we will look at sculpting, which, as you saw in chapter 02, is perfectly suited for flowing and organic shapes. Sculpting allows us to play around with initial shapes without having to worry about topology. As with drawing, the leading principle is to start with a rough shape and go into further detail gradually.

Open up a Sphere3D, and press the T key followed by the Make PolyMesh3D button. Apply DynaMesh to it (A in image 03). The appropriate DynaMesh resolution will depend on the size of your model, but you will get a feel for this as you use it. Try starting with a low resolution and increasing it when the shapes

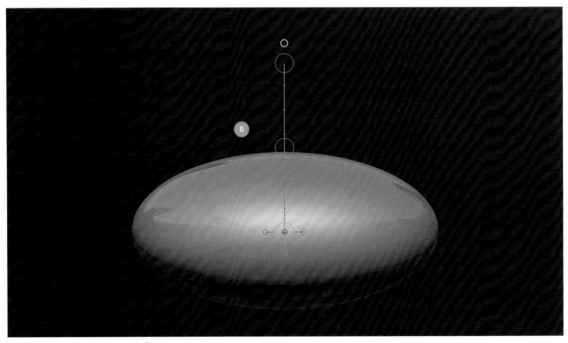

▲ 03 Use the Transpose line to squash the sphere into an oval shape

require greater detail. Don't forget that you can hold Ctrl and swipe with the mouse or pen in an empty section of the canvas to apply a new DynaMesh resolution.

We now need to use the Transpose line to reduce the sphere's height and width to get a base shape for our sculpt. Select the Move option, draw out the Transpose line, and use

the inside ring at the outer end of the line to flatten the sphere into an oval like that shown in image 03 (B). See the Pro Tip box below for tips on manipulating this tool.

PRO TIP
The Transpose line

As you know, you can access the Transpose tool by pressing the W (Move), E (Scale), or R (Rotate) keys. Click on your model to bring the Transpose line out at a 90° angle from a point on the surface, or click and drag to span the Transpose line between two points. The start and end points of the line can be set freely or snapped to vertices on your model. You can snap the start just by clicking a vertex with the Transpose line selected. Now you can drag the endpoint by clicking and holding the outer (yellow) circle. It will snap to any vertex you lead it to. While drawing the line, you can hold Shift to align it orthogonally to your viewing direction and rotate it in 22.5° steps.

Each of the three lines (Move, Scale, Rotate) has different modes depending on which part you click and whether you press Alt. See the image on the right here for an overview. It is best to test these modes on an object to get a feel for how they work. If you hold Shift while editing with the Transpose line, it will keep your changes locked straight along your chosen axis so that you do not accidentally skew your model in 3D space.

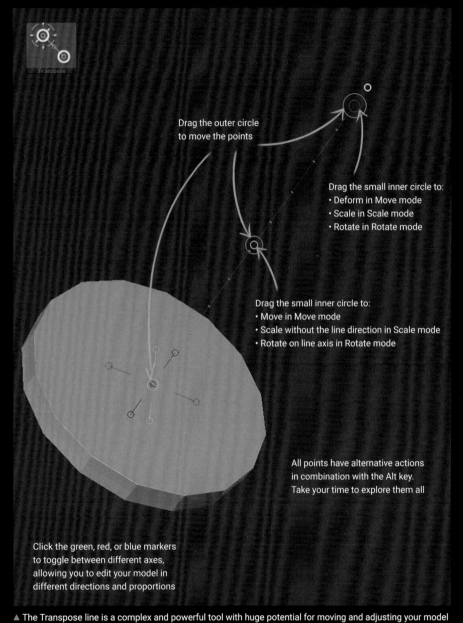

Drag the outer circle to move the points

Drag the small inner circle to:
• Deform in Move mode
• Scale in Scale mode
• Rotate in Rotate mode

Drag the small inner circle to:
• Move in Move mode
• Scale without the line direction in Scale mode
• Rotate on line axis in Rotate mode

All points have alternative actions in combination with the Alt key. Take your time to explore them all

Click the green, red, or blue markers to toggle between different axes, allowing you to edit your model in different directions and proportions

▲ The Transpose line is a complex and powerful tool with huge potential for moving and adjusting your model

04 Starting the model

We will now start sculpting the basic shape of the robot's curved cap, using brushes with a large Draw Size setting to reach our goal in as few steps as possible. If you try to drag the shape back and forth with small brushes for too long, you will lose the soft flow needed for this design.

In image 04 you can see the process steps and their corresponding tools. The Move brush brings the flat sphere seen in image 03 to the first form shown in step A of image 04. The Dam Standard brush is used to define the edge of the cap (step B), with the ClipCurve brush being used to clip the bottom of the model. The Pinch and hPolish brushes help to really make the sculpting look "hard surface" (step C). Pinch can be used to contract the polygons together along an edge, making a sharper ridge. hPolish polishes the surfaces and helps to create soft transitions. Use the Transpose tool to rotate the model in the direction required (step D). Keep checking the shape against the original sketch repeatedly, using the Move brush to correct any errors (steps D and E).

We can also create the robot's body using the same techniques (step F). If you look in the SubTool menu, you will see the cap you have created. Select Insert to create a new SubTool, and select a sphere once again (note that because this sphere has been inserted from the SubTool menu, it will already be PolyMesh3D). Use the Transpose line and various brushes as we did for the cap. My shape differs from the sketch, but I take this liberty because I think it fits the cap better. To go back and edit the cap at any point, select it in the SubTool stack.

05 Blocking out the head, neck, and legs

Now we can fill out the remaining parts of our design with simple forms, just by making an arrangement of cubes, tubes, and spheres that have been slightly re-shaped. Part A in image 05a shows the geometrical construction we are aiming for. We will use Initialize's Quick Mesh function to create some of the body parts using primitives that are quick to create and ZModeler-friendly. The Initialize menu can be found under the Tool menu when you are adding a new

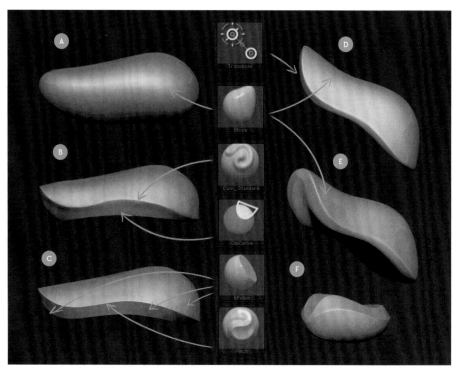

▲ 04 The brushes and tools used to sculpt the robot's curved cap (steps A to E) and body (step F)

primitive shape, and its parameters change depending on the primitive you have chosen. To access the Initialize settings we need, select the PolyMesh3D Star; the QCube, QSphere, and QCyl (cylinder) options will then become available in the Initialize menu (B). If they do not initially appear, you may have to draw out the star first.

If you click one of these Quick Mesh options now, you will be able to draw out a QCube or QCyl, with the number of polygons indicated by the X Res, Y Res, and Z Res sliders, and useful Polygroups already assigned. As you can see in part C of image 05a, the head is created from two QCubes with X, Y, and Z Res sliders set to 2, creating cubes with four polygons on each side (2 × 2 × 2, in height, width, and depth). These parts can be converted into editable meshes with the Make PolyMesh3D button, then stretched or scaled out using the Transpose tools and MaskLasso brush to restrict the effect to selected polys. The same goes for the two QCubes and two QCyl pieces of the neck, which are squashed or stretched from their original dimensions (D). There are a couple of ways to change the width and thickness of each part. One way is to scale or re-shape the parts

using ZModeler, which we will look at later in this chapter. The other option is to isolate the vertices with MaskLasso and adjust them with the Transpose line. You access the masking tools by pressing and holding Ctrl, and can use them to protect areas of the model that you do not want to edit by mistake. To delete a mask afterwards, just hold Ctrl and swipe your cursor in an empty space on your canvas.

KEY CONCEPT
Quick Mesh
Using the Quick Mesh options in the Initialize menu is a useful way to sculpt hard surfaces because it offer more control over basic pieces of geometry in a model.

Our robot is a hexapod, but it isn't necessary to model all six legs from scratch. Instead, we will just model the pieces of one leg as separate SubTools, merge them into one SubTool, then duplicate it. The two cylindrical parts of the leg are made with QCyl, and the foot is a QCube stretched with Transpose and MaskLasso. Go to Tool > SubTool, where you will see your body

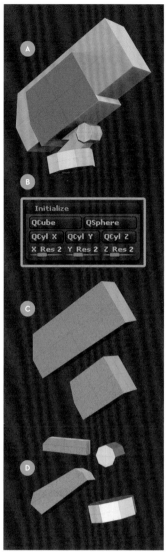

▲ 05a Block out the head neck

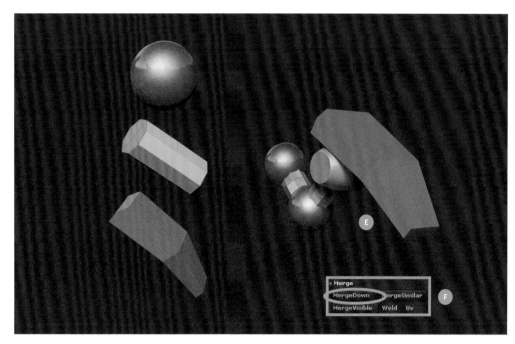

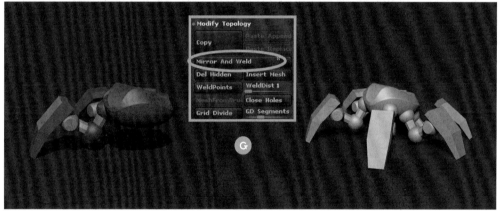

▲ 05b Duplicate and mirror the single leg SubTool to create six legs

and cap, and any other body parts you have created as SubTools. Click Insert in the Tool menu to create a sphere, then duplicate it twice so you have three sphere SubTools in total. Use the Transpose line to move the spheres around, placing them into a similar position as shown in the leg in part E of image 05b.

Next, click the PolyMesh3D Star tool, enabling you to open up the Initialize palette. Select one of the QCyl options (the QCyl X, QCyl Y, and QCyl Z options just mean the cylinder will be drawn on different axes) and drag this out on the canvas. You can then adjust the sliders to add as many vertical polygons as you wish. In Edit mode, click Make PolyMesh3D. You can then use Append in the SubTool menu to append

the cylinder you have just made to the SubTool stack. Duplicate this cylinder so you have two. The foot can be created using a QCube and holding Alt while using the Move tool.

Once you have all the leg parts you need, use the Transpose line to move them into place, starting from the top joint. When the first two parts are positioned next to each other, use the up and down arrows beneath the SubTool list to ensure that the first cylinder is underneath the first sphere, then click the first sphere of the leg in the SubTool stack and hit MergeDown (F). This will merge it with the cylinder piece below, turning them into one SubTool. Follow this procedure for the rest of the leg components, putting them in the

appropriate order and merging them until they are joined in the positions shown.

Now we can duplicate the whole leg as a single object, until we have three identical legs. Bring each of the duplicates into position using the Transpose tool and mirror them with Tool > Geometry > Modify Topology > Mirror and Weld, creating three paired sets of legs (G). Now that we have our base model, we do not need the 2D sketch overlay any more. At this point, you can move the SubTools of the head into place using the Transpose tools, but don't merge them together yet.

06 The eye lens

Here we will model a rough version of the robot's "eye." Don't worry about making it precise – it is just a placeholder to ensure that the lens sits on the head correctly. Use the InsertCylinder brush to generate a cylinder directly on the head. Subdivide this cylinder several times (Ctrl + D) and apply DynaMesh to it. I use the MaskPen to protect some areas while I transform others, such as masking over most of the cylinder's front so that I can Transpose out the small hood at the top. For the recessed middle part, I use the Clay brush with a negative Focal Shift.

07 The finished base

In image 07 you can see the basic shapes are all defined. This is a good time to check whether we are happy with the anatomy of the robot, because it is easier to make big changes now than later. Using this base model, we can begin to edit each specific component without

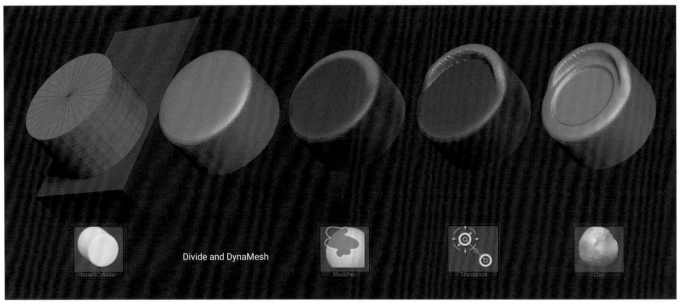

Divide and DynaMesh

▲ 06 Using a cylinder as the basis for the robot's eye

▲ 07 The initial rough model, based on the shapes and proportions of the 2D sketch

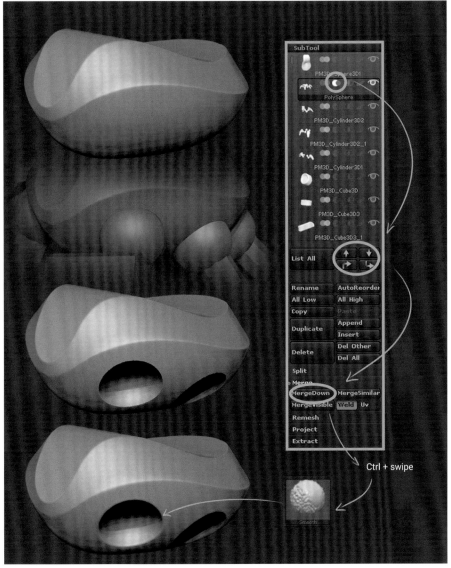

▲ 08 Use MergeDown with subtraction selected to create sockets for the robot's legs

▲ 09 Use Lazy Mouse to cut some clean sci-fi detailing into the robot's surface

running the risk of messing up the overall proportions of the design. I will expand on each component in the following steps.

08 Adding leg sockets

We will start by refining the body, as it offers a good example of how to perform Boolean operations in ZBrush. Note that the body has to have DynaMesh applied for this to work. Duplicate the SubTool containing the legs, then press the little subtraction icon shown in the SubTool menu (circled at the top of image 08). Use the arrows to move the merged legs directly underneath the body in the SubTool list, then select the body SubTool from the list and press MergeDown to merge the parts.

As mentioned before, holding Ctrl and swiping in empty space will delete masks, but if there are no masks, the shortcut will trigger a remesh on a DynaMeshed sculpt. So if we hold Ctrl and swipe now, the legs will be incorporated into the remesh, but *subtracted* because we clicked the subtraction icon. This leaves six round sockets that will perfectly fit the robot's leg joints. If we had not clicked the subtraction icon, the legs would just have been merged with the body. The edges of these new holes are quite sharp, so smooth them a little with the Smooth brush before moving on.

09 Lazy Mouse

Another important feature for hard-surface modeling is Lazy Mouse. Lazy Mouse draws a red line that follows behind your brushstrokes, and any light trembles or wobbles will no longer affect your stroke. So, whenever you need an especially exact or straight line, you should try Lazy Mouse. In image 09 you can see my settings for the Slash3 brush, which I use to make gaps and grooves in my sculpts. These grooves mark where different components will join later on, giving the robot a sleek sci-fi look. Lazy Mouse helps me to draw these effects as precisely as possible, which is important for hard surfaces where the lines must be clean and accurate.

10 Modeling with masks

Masks offer many interesting possibilities for shaping a sculpt. In this instance, we want to create some raised ridge effects at the front of the robot's body. Take the masking tools, in this case MaskPen or MaskLasso, and draw the desired shape onto the body (part A in image 10). Then invert the selection (Ctrl + click in an empty space) so that your specific shape is active but the rest of the body is masked.

Use Move or Transpose to pull and scale the unmasked part out of the body (B), then delete the mask afterwards by holding Ctrl and swiping in empty space. Use the hPolish brush to polish and sharpen the result (C), then use Slash3 to draw the rest of the sharp groove around the body that we began in the previous step. The last stage in image 10 (D) shows the ridge reduced slightly, plus two more shapes which can be created in a similar way, by pushing in and pulling out areas selected using masks.

11 The rest of the body

The remaining features of the body follow the same procedures. To deduct a sphere from the body like you can see in image 11, take an InsertSphere brush and hold the Alt key to insert a negative shape, then hold Ctrl and swipe in an empty space to apply DynaMesh and subtract. For the cylindrical hole in the robot's back, repeat the same process with an InsertCylinder. Use Slash3 and Lazy Mouse again to draw another groove around these new areas. I choose to add a little tab detail by masking, transforming, and sharpening as I did in the previous step.

12 Refining details

For now, the last detail we will add to the body is a raised edge around the rear. After making the groove using the Slash3 brush, use the Dam Standard brush to elevate a ridge, then the Clay brush to apply some substance. As before, polish the new shape with hPolish, then use Pinch to attain a crisp, clean edge.

For now, the body is finished. Depending on how you want to use the model later, you can go into further detail at this point or work on the topology first, but more on that in a while.

▲ 10 Use masks to make precise changes without accidentally editing your mesh

Mask,
transform,
and sharpen.

▲ 11 Adding geometry to the rest of the body

▲ 12 Sculpting some details and surface shapes to add interest to the model

Hard-surface modeling

13 ZModeler tools

The remaining shapes will be more angular, so we will switch to using ZModeler, ZBrush's very useful hard-surface modeling toolset. Load any new object into your scene, choosing which basic shape you want under Tool > Initialize as described in step 05. The different colors of the cube you can see in image 13 are Polygroups, which you can show and hide with Shift + F, and which are helpful for a number of functions in ZBrush that we will come to later.

To access ZModeler's different actions, press and hold the Space bar while hovering over a polygon (for Polygon Actions), an edge (for Edge Actions), or vertex (for Point Actions), and choose from the toolbox what you want to apply. In the second panel, you can define which target the chosen action will be applied to. The third window offers more options depending on the choice of action.

The default Polygon Action is QMesh, which can be used to easily extrude or subtract polygons from your model. To create extra polygons in order to extract different shapes, you can use the default Edge Action, which will insert an edge loop. It is well worth taking some time to test these basic functions out on a cube and become comfortable with them.

14 The middle neck joint

Once you are familiar with ZModeler's functionality, we can move on to building a series of components with it, to further acquaint you with this very intuitive toolset. The robot's neck consists of three parts, as roughly blocked out in step 07. We will now recreate this in detail.

For the middle section, we will create a cylinder using Initialize, then edit its properties. To do this, insert (rather than append) a Cylinder3D SubTool and open the Initialize menu, which gives us options for editing primitives. We need to shrink the cylinder and simplify it

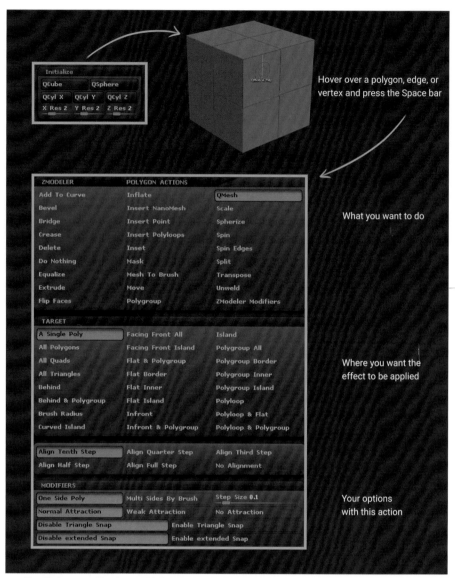

▲ 13 Familiarize yourself with ZModeler's options by working on a simple cube

into an octagonal shape, which we can do by lowering the X, Y, and Z Sizes to 60, HDivide to 8, and VDivide to 5 (A in image 14). When your cylinder resembles the one pictured, click Make PolyMesh3D. Now select ZModeler from the Brush menu and apply a bevel to the ends of the cylinder using Edge Actions > Bevel > Edge Loop Complete (B). Add an extra edge loop in the middle of the cylinder by using Edge Action > Insert > Single EdgeLoop. Also add an extra circular loop to the flat ends, as shown in part C of image 14, by selecting one of the triangular inner edges, and dragging towards the center of the circle. Use Geometry > Divide (or Ctrl + D) to subdivide the model once, then click Del Lower (otherwise we could not continue to use

ZModeler). Mark the polygons shown in gray in part C of image 14 by pressing the Alt key, as we are going to extend these two sections to make the arms of a pivoting joint.

Use Polygon Actions > QMesh on these gray sections to pull new geometry out of the cylinder several times, bringing them into position with ZModeler's Transpose option. Now remove the middle part of the cylinder by masking the central two polygon loops (with a tool such as MaskRect) and using Tool > SubTool > Split > Split Masked Points (D). The ring-shaped section we have removed will now be a separate SubTool, which is how we will make the corresponding middle joint later.

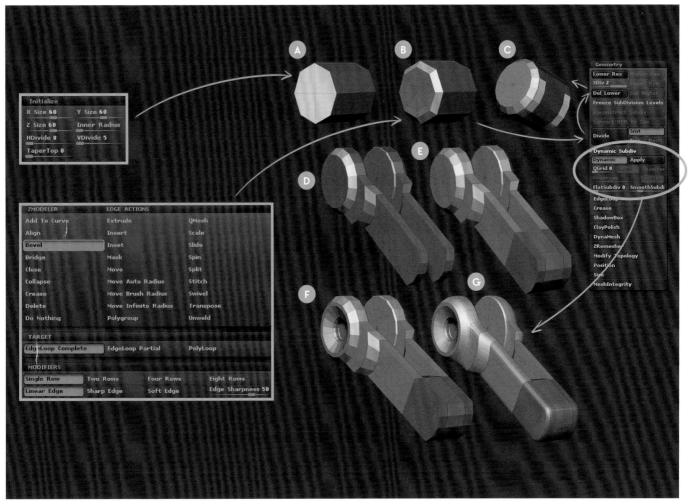

▲ 14 Creating the middle section of the robot's articulated neck with ZModeler

Add more edge loops to the arms (E) with Edge Actions > Insert and then fuse the lower parts together with QMesh. Make the hole in the upper part (F) using Polygon Actions > Inset, QMesh, and Transpose. Try different effects, such as making an Alt selection and then using Inset with the "Center and Border" and "Inset Region" modifiers activated.

At this point it is a good idea to look at the model by turning on Tool > Geometry > Dynamic Subdiv > Dynamic, which serves as a preview for the "real" subdivision. It can also be toggled on and off with the D key and Shift + D. This view is very useful for quickly judging the hypothetical subdivided look of an object while still maintaining simple geometry. If our object looks correct in Dynamic Subdivision mode, it should look correct when we subdivide the geometry later.

Right now, you may be surprised to see that our mechanical joint looks too smooth and shapeless in Dynamic Subdivision mode. To fix this, we will apply Crease to the edges that we want to keep sharp, such as the inside of the ring, the bevels, and the tops of the arms. To do this, use Edge Actions > Crease on the desired edges. You will see an extra dotted line is added, indicating that the edge has been creased. Now these edges will stay sharp when subdividing the model or using Dynamic Subdivision, and will not get lost or softened later. You can see in step G of image 14 how some areas have become smoothed and rounded, in contrast to the areas with creased edges. We will be using Crease a lot in this modeling process to create crisp plane breaks that fit our sci-fi subject.

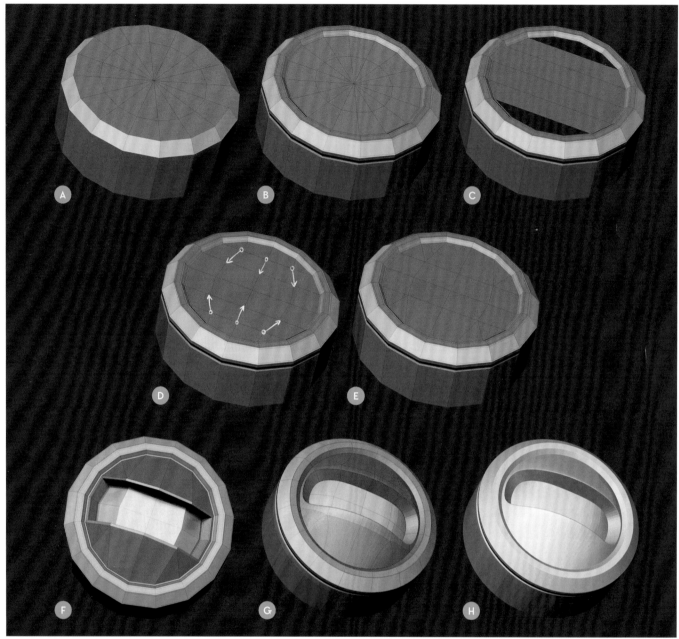

▲ 15 The base on which the neck will be attached

15 The base joint

Now we will make the base joint that connects the neck to the body. The initial process is similar to that of the previous step: creating a new Cylinder3D SubTool and editing its properties with Initialize. In this case, set HDivide to 16 to simplify the cylinder's edges, VDivide to 3, and Z Size to about 35 (A in image 15).

Add three bevels to the top edge, then hold Alt to select the inner circle of polygons and push them down with Polygon Actions > Inflate,

creating the raised lip effect shown in part B of image 15. Apply Crease to the bevels we just created.

The polygons in the center (shown in red) are currently not the right shape for what we want to model, so select them all with Alt again, and delete them using Polygon Actions > Delete. Fill the resulting hole with Edge Actions > Bridge, clicking across from one edge to the opposite edge to create new polygons, but

leave two ends open with four outer edges each. Use Edge Actions > Insert to insert three edge loops into the new middle polygons. Now use Edge Actions > Bridge again to seal the remaining holes, as the new loops will have created enough edges for you to do so (C).

Now the central polygons are almost the correct shape. Use Point Actions > Stitch to "sew" the points marked in part D of image 15 to the points indicated by the arrows. We can

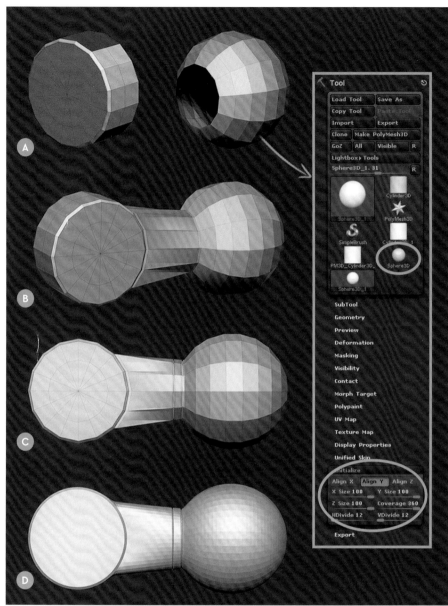

▲ 16 The ball joint that will form the top part of the neck

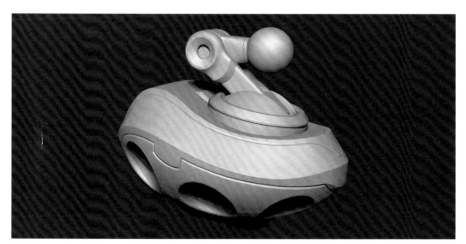

▲ 17 The neck and body when viewed together

now arch the four middle polygons upward by marking them with Alt and using Polygon Actions > Transpose (F). Use Insert to give the middle rows a border, then press them into the object with QMesh to create a groove for the joint arm to sit in (G). Lastly, as we did in the previous step, apply Crease to the edges that you want to keep sharp (H).

16 The ball joint

Let's make the last part of the neck. Start with the cylinder that we removed from the joint in step 14, use Alt to select eight polygons on the side (A in image 16, shown in gray), and delete them with Polygon Action > Delete. The resulting hole has twelve edges, so open a Sphere3D, go to Initialize, and reduce HDivide and VDivide to 12 to give it twelve sides. Delete the lower polygon loops to create a hole in one end of the sphere. Hit the Make PolyMesh3D button. Use Edge Actions > Bridge > Two Holes to bridge together the hole in the cylinder and the hole in the sphere (B).

The narrow groove details around this central join (C) are formed with Edge Actions > Insert, and Polygon Actions > QMesh > Polyloop, just to add some extra interest to the piece. As before, finish off the piece by sharpening the edges with Crease and checking the results with Dynamic Subdivision (D).

17 Evaluating the results

Now let's take a short pause and look at our progress. When you have moved the various SubTools into position, the parts from the previous steps should look something like that shown in image 17. Later on we will add a few minor details and refine the edges, but for now all of the parts are close to their final shape. I find it useful to work on finishing the design in its entirety, to restrain myself from becoming lost working on the details of a single component.

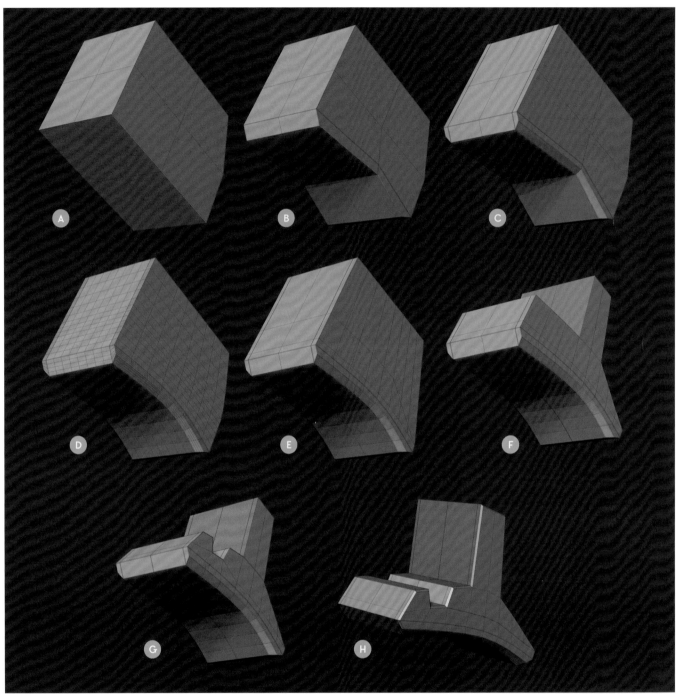

▲ **18** Forming the bracket that will connect the head to the neck

18 Starting the head

We need to develop the piece that connects the head to the neck, still mostly sticking to our original sketch. We will return to the central cube component of the head that we made in step 05 (A in image 18) and add shape to it.

Add two new edge loops with the Insert command (B), and curve the edges slightly inward (C). Divide the mesh twice (Geometry > Divide) to add more polygons, which will also result in the curved geometry on the underside (D). All the additional loops that are not needed to create the curve can be deleted, except for the two loops shown here (E). Use QMesh to push down a series of polygons from the top to form the stem (F), then use Insert to create a new edge loop and push down a small notch with QMesh (G). Use the Transpose tool to adjust its shape.

Use Edge Actions > Bevel to apply a bevel to the edges of the purple sides (H). Any points which do not seem like they are in the correct position yet can be corrected with Point Actions > Slide.

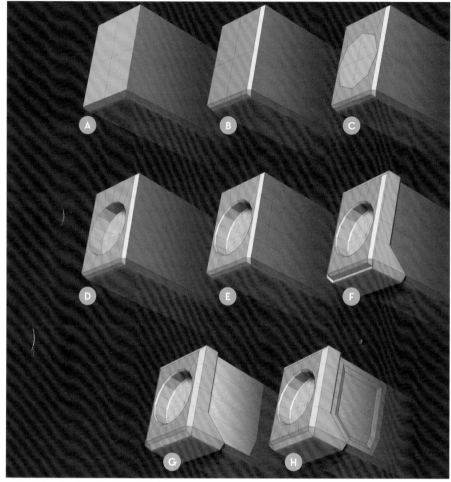

▲ **19** Adding details to the front of the head

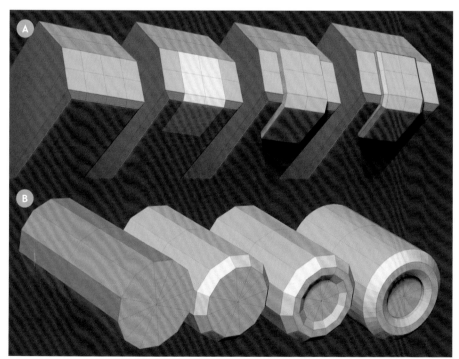

▲ **20** These extra details can be seen at the rear and on the side of the robot's head in image 22

19 The main head section

The next part is the main section head, which will sit under the cap and house the lens. Again, select the rough shape that we made in step 05, then bevel the front and underbelly (A and B in image 19). Use Point Actions > Split to form a ring around the middle vertex of the front side (C). Divide the object once, then delete all the edge loops which are irrelevant for the rounded area. Use QMesh to create a hole where the lens will go later (D), setting the target to Polygroup Island to save the labor of selecting single polygons, as the circle was assigned its own Polygroup when it was created.

To extrude an angular border shape around the front of the head, as shown on the left, start by adding a new edge loop (Insert), then use masking and Transpose to move it into the desired position (E). Next, use QMesh set to Polyloop, which extrudes the green shape as shown (F). Remove the new edge loop that appears between (F) and (G) by using Insert and pressing Alt. The yellow shape in part H is created by making a new edge loop, marking the four lateral polygons, applying Inset twice (Polygon Actions > Inset > A Single Poly > Inset Region), and finally using Transpose.

20 Back of the head

Let's add some detail to the back of the head, still working on the same geometry as the previous step. Add a new edge loop, mark the shape you want to edit, use QMesh to pull it out slightly, then apply Bevel to create the shapes shown in part A of image 20. The tools should be familiar to you by this point.

My simple sketch doesn't offer any further elements, but I would still like to add more detail to the head, so let's add a new component (B). Start with a simple cylinder (using Initialize) as the basis for a joint which might move the robot's cap later. As before, use Bevel, QMesh, Scale, and Crease, and finally apply Dynamic Subdivision to see a smoother view.

21 Curved tank component

The next component is going to serve as a basis for a little tank that we will attach to the side of the head later on. Start with a Cube3D again, make it a PolyMesh3D, then open Initialize. Set the X Res, Y Res, and Z Res values to 2, then press QCube, which replaces the current mesh with a cube that has four polygons on each side, as shown in part A of image 21. Use the Transpose line in Move and Scale mode to shape it out into an oblong (B), and remove a segment with the QMesh Polygon Action (C). Create a curvature (D) using Polygon Actions > Bridge > Connected Polys, with Specified Curvature set to 50 and Specified Resolution set to 4 under the Modifiers section. When using this tool, a little yellow line appears when hovering over a polygon, which changes direction depending on which quarter of the polygon the cursor is located on. Click when it is pointing at the desired target polygon, and a bridge between both polygons will be formed, the curve of which you can adjust by moving the cursor in and out. Repeat this QMesh and Bridge process for the other side, creating a semicircle (E).

As we did with the cylinder in the previous step, use Bevel, QMesh, Scale, and Crease to add some finishing details to your liking (F). For example: to attain a bevel effect like the one shown in parts G and H of image 21, hold Alt to select all the polygons on one side, apply the Bevel Edge Action a couple of times, and then indent the inner polygons using QMesh.

22 The updated head

In image 22 you can see where the new parts are placed and what the head looks like after applying Crease and Dynamic Subdivision. The fine grooves on the cap are made using the Slash3 brush with Lazy Mouse activated, following the design of the sketch. The model is beginning to take shape.

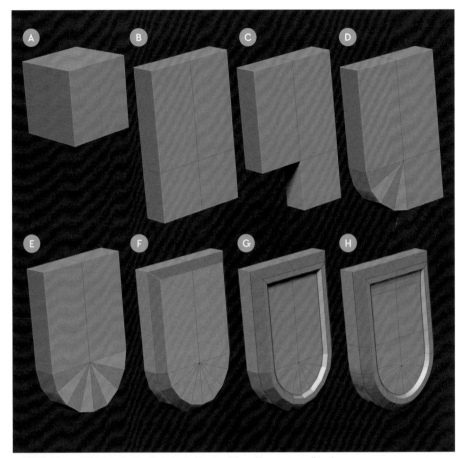

▲ 21 This plate will fit onto the bracket created in step 18, and house a small tank

▲ 22 In this side view, you can see how all the previous details fit together

Advanced modeling

23 Retopology

Now let's move on to retopology. This particular project will be built, rendered, and painted within ZBrush, which handles huge amounts of polygons well. But let's assume that this model may leave ZBrush and be integrated into a bigger scene – maybe for an animation, or even a game. In that case you would need the option of making a low-poly model that other programs would be able to handle. For the parts made with ZModeler, this is no problem, because no matter how often we subdivide a mesh, we will still have access to the low-poly version in the first subdivision level. However, the sculpted parts don't have the appropriate topology – they have very high polygon counts and no subdivision levels. In the following steps, I will discuss retopology in ZBrush, using the robot's cap as an example.

24 Retopologizing with a ZSphere

One retopology method involves the use of a ZSphere. Add a ZSphere to the scene using SubTool > Append, select it in the SubTool list, and press the X key to activate Symmetry. We don't have to do anything to the ZSphere itself – it just has to be present to make the Tool > Topology palette available. Just move or scale the ZSphere with Transpose if it is in the way.

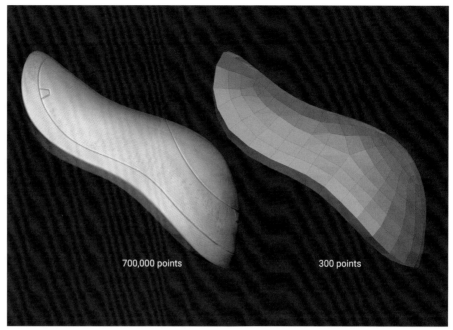
▲ 23 The high-poly cap (left) is not compatible with other 3D software, so we will make a low-poly version

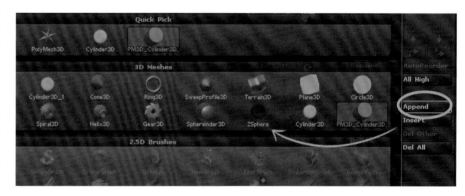

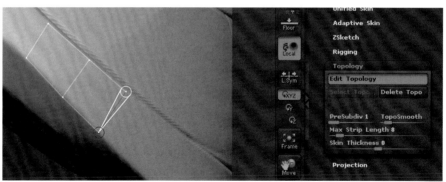
▲ 24 Add a ZSphere to your scene – not for sculpting, but to activate the topology tools you need

> ## KEY CONCEPT
> ### Retopology
> The objective here is to make a simpler version of the high-resolution sculpt, using fewer points to achieve the same overall shape. This will make our model more clean and efficient in general, and also much more versatile if we wanted to use it in other software or projects in the future. In previous chapters, we already touched upon automated retopology using ZRemesher (pages 108–110), and some manual retopology (page 153), which is the approach employed here

Click Edit Topology and set the brush tip as small as possible to be able to work precisely. The Q key activates Draw mode, enabling us to define what the topology looks like by placing points on the mesh. Simply click from one point to another to plot out the vertices and edges of the new simplified topology,

which will automatically follow the forms of the underlying high-resolution mesh. These points can be removed with Alt + LMB, or easily adjusted if they are not in the desired position by activating Move mode (the W key).

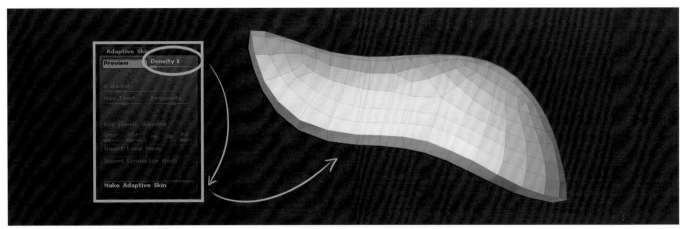

▲ 25 Once the new topology has been created, clicking Make Adaptive Skin will add it to your SubTools as a new object

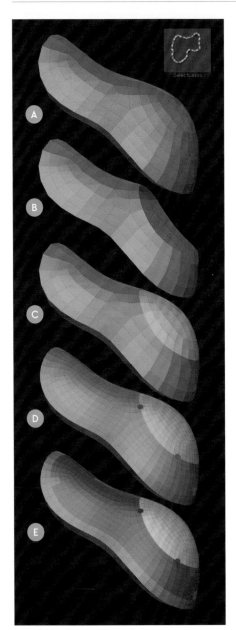

▲ 26 Assign Polygroups to help manage a mesh

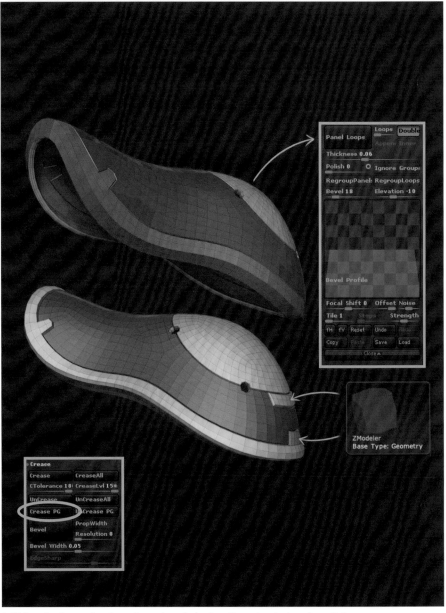

▲ 27 Creasing these edges is made much easier by Panel Loops' assigning of new Polygroups

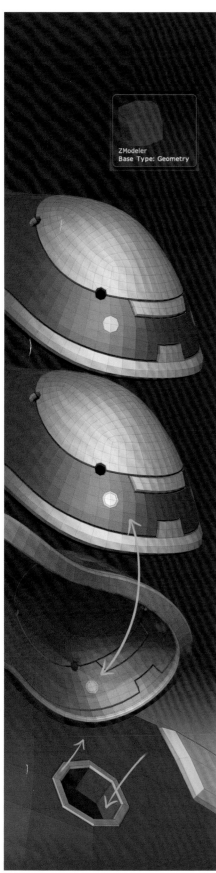

▲ 28 Pushing a hole through the cap

25 New topology

We have to work precisely here: it is easy to put points next to each other instead of combining them, only noticing this mistake much later. At first it can be difficult to judge how fine the new mesh should be; we should use as few points as possible, but we still need enough of them to recreate the shape (as shown in image 23). It is a matter of practice, and is a time-consuming process, but one well worth learning for use with future projects.

Try to limit yourself to just making quads (four-sided polygons), because triangles can cause undesirable shapes when subdividing the mesh. When you are happy with the new topology, go to Tool > Adaptive Skin, set the Density to 1, and press Make Adaptive Skin. This creates a new model of the cap in the Tool menu, which we need to add as a SubTool in our scene by using Append and selecting it from the list.

26 Polygroups

Next we need to assign different Polygroups to the new mesh (A in image 26) to mark where the robot's components should be separated (visually, not literally). To do this, take the SelectLasso and select all the polygons you want to hide by holding the Ctrl + Shift + Alt keys together.

When only the desired polygons are visible (B), press Ctrl + W to assign them a new Polygroup. Holding Ctrl + Shift while swiping in empty space will invert the selection, while holding Ctrl + Shift and clicking in an empty space will negate the selection and make everything visible again. Repeat this step until all the polygons of the cap are marked out, following the grooves in the sculpt (C).

Divide the model once and add holes with ZModeler (Split and Delete) as shown in part D of image 26. These holes are where the screws will go later. The Split action creates a new Polygroup around the holes (visible in part D), which we should remove in preparation for the following step. In part E you can see where I have made the holes a single Polygroup again.

27 Panel Loops

ZBrush's Panel Loops function, found under the Tool > Geometry > EdgeLoop palette, offers terrific potential for separating geometry by Polygroups while giving the mesh a geometric thickness at the same time. In image 27 you can see the settings I use. Use ZModeler to extrude the edge of the cap and the little shape on the back outwards slightly. All the newly created geometry will be given the same Polygroup, which enables us to use the Crease PG option (Tool > Geometry > Crease) to crease the edges of all Polygroups automatically.

28 Holes for the antennae

Before adding some antennae to the back of the cap, we first need to create two new holes for them to sit in using ZModeler. Use the Split Point Action to make two circles where the antennae will go. We also need corresponding circles on the opposite inner surface, which will enable us to make a hole all the way through the cap. To do this, just click the opposite vertex with Split and a circle with the same size will appear. Repeat this on both sides with a second, smaller circle, so that the holes will have a border. Push the polygons of the small circle into the body with QMesh until ZBrush connects them together and converts them into a hole. Lastly, pull the outer rings outward slightly with QMesh (set to Polyloop target), just to add definition to the hole.

29 The antennae

To make the antennae, begin with a Sphere3D, and set its HDivide and VDivide values to 16 in the Initialize tab. Select ZModeler, use Alt to highlight the upper polygons, then use the Delete action to create a hole (A in image 29). Close this hole with Edge Actions > Close > Convex Hole, dragging the cursor in and out to reduce the number of loops as shown in part B of image 29. Highlight this new section and use QMesh to "pull" it out of the sphere to create a long tube for the antenna (C). You may need to zoom out for a better view.

Use Slide (Edge Actions > Slide > EdgeLoop Complete) on the edge where the sphere meets the antenna, just to make the transition smoother (D). Divide two of the edge loops with Bevel (E), then do the same with the new bevels (F) to make narrow strips inside them. Then extrude the middle polygon loops of the bevels into the model with QMesh > Polyloop, creating a groove detail (G). Use Edge Actions > Insert to divide the long antenna several times.

We will give the antenna a curved shape using the Transpose line in Move mode. Draw out the line from the sphere to the end of the antenna, and pull the last "handle" (the inner circle at the end of the line) upwards while holding Alt to make the curve (H).

To make the antenna's horizontal tip (I in image 29), open a Cylinder3D SubTool, set HDivide to 16 to match the sphere, lower VDivide, and use the TaperTop slider to narrow one end. Insert a circular edge loop at the opposite end and delete the polygons to make a round hole where the antenna will join. Append the cylinder SubTool to the rest of the antenna, Transpose it into place, then merge the two SubTools together with MergeDown. Delete the polygons from the end of the antenna and use Edge Actions > Bridge to join the two pieces together. Duplicate the finished antenna to make a pair.

30 Creating screws

Now we will make the screws that we planned to add to the cap in step 26. Start with a simple Cylinder3D, with HDivide set to 8 and VDivide to

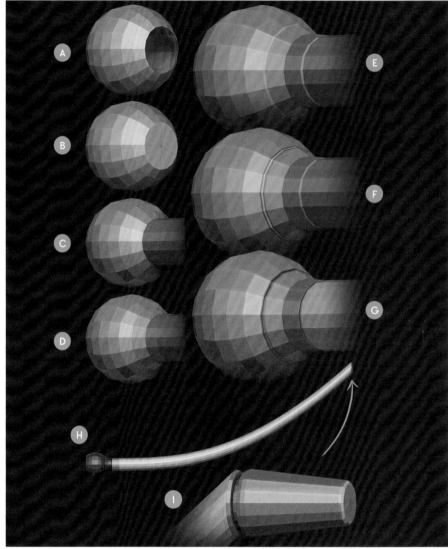

▲ **29** QMesh is used to stretch out the antenna, and the Transpose line is used to curve it

5. Insert a smaller edge loop at one end and use Edge Action > Delete to delete the individual edges as pictured in yellow in image 30a (A). Use Point Action > Split to define the size of the hole, then use QMesh (with a Polygroup Island target) to form the hole itself (B). Create a bevel around the inner and outer edges using Edge Action > Bevel > EdgeLoopComplete (C).

We now need to subdivide the mesh for some extra geometry, but first, in order to keep the hard edges of the inner octagon when subdividing, apply Edge Action > Crease, using a combination of EdgeLoop Complete and Edge target modes. Divide the model once (Geometry > Divide), then click Del Lower so we can return to using the ZModeler tools. You

will find that the cylinder has been smoothed into a rounded barrel shape, which we do not actually want, so delete all the edge loops from the side of the cylinder, until only the two loops shown in (D) remain – one near the top end of the cylinder, and one near the bottom. Use Slide plus EdgeLoop Complete to push one of the remaining loops into a higher position, which we will use to create the outer details of the screw. Mark alternate pairs of polygons around the cylinder (D) and extrude them with Extrude or QMesh, then shape these new polygons with Polygon Action > Transpose (E). The last image (F) shows the model with Dynamic Subdivision activated, which helps to identify which edges are creased. In image 30b you can see where the new parts have been moved into place.

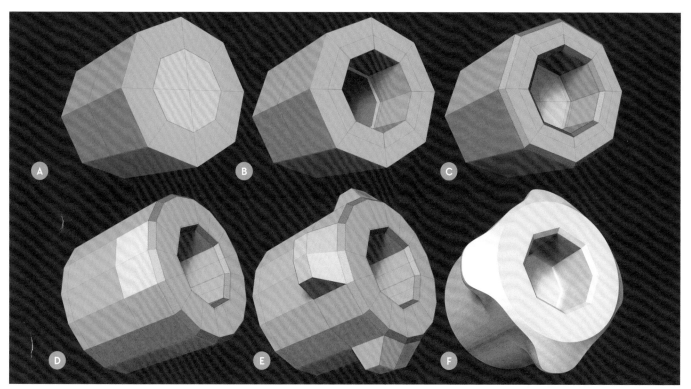

▲ **30a** Applying Crease to the screw's inner hole ensures that it stays sharp and angular, and won't get softened into a circle when it is divided

31 Creating an "eye socket"

In this step, we will copy the inside wall of the hole we created in step 19 and use it as a base for a new cylinder, which will be the right size and sit in the right place inside the hole as the barrel ("eye socket") of the lens. We will then create a round glass lens ("eye") to place in the barrel later (step 41). First copy the inner wall of the hole at the front of the head that we created in step 19: take QMesh set to Polyloop target, and while you are applying this action (not before), press Ctrl to separate the new Polyloop. Repeat this without holding Ctrl to get the base of the socket. Mask the new mesh with ZModeler (Polygon Actions > Mask > Island) and create a new SubTool from it by using SubTool > Split > Split Masked Points.

▲ **30b** The head with screws and antenna

▲ **31** The recessed hole for the lens

▲ 32 The robot's camera-like lens is built from geometry based on the hole in the previous step

32 Developing the eye socket

Now we have a base from which to form the barrel of the lens: part A in image 32 shows the cylinder we just copied from the inside of the eye hole in step 31. Image 32 shows the process of developing it further, in which ZModeler undertakes all the work. Select four polygons along the top edge (A in image 32) and use Polygon Actions > Inflate to drag out the lens hood (B). Divide the mesh once and click Del Lower before resuming modeling (C).

All the tools used here should be more familiar now – use a combination of Alt-selections, QMesh, Insert, and Bevel to add the extruded layers to the inside (D and E). The notches on the inner walls (F) serve as sockets for the lens, and the lens itself will just be a part of a sphere. The final stage (G) shows the Dynamic Subdivision version with creases applied.

33 Connecting pieces

Now we will make the connecting plate that joins the robot's cap to the underlying parts

▲ 33 This fan-shaped plate will fit into the cylinder on the robot's head, connecting it to the cap

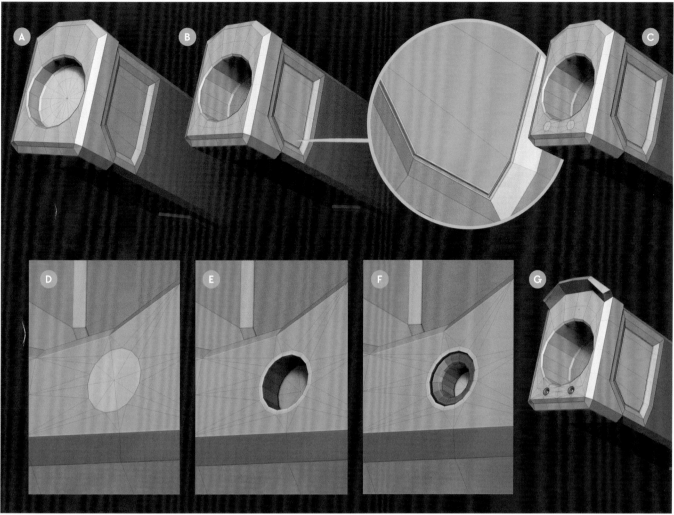

▲ 34 Adding some holes to the front of the head for variety

of its head. We don't need to overwork this detail, as it is purely functional and will always be in shadow. Start with a round disc SubTool, extracted from the existing cylinder part of the robot's head using Split (as used in step 31). Apply an Inset to the area with Polygon Actions > Inset > Polygon Island > Inset Region (A). Now we can deform the outer ring with MaskLasso and Transpose (B), and reduce the size of the inner circle to create a flat fan shape using Polygon Actions > Scale > Polygroup Island > Polygon Center (C).

Apply a bevel to the new outer shape (D), and an indentation to the inner circle (QMesh, Scale). Extrude the back side of the circle to create a flat cylinder shape, so that this piece will appear to slot into the joint of the head. If you wish, you can add some extra details to

the inner circle (E) using the QMesh, Bevel, or Insert tools. You can see how the new piece sits on the head, underneath the cap (F).

34 Further head detail

Let's keep working on the head to add in some additional details. Start by changing the upper front area from a rectangle to a more rounded arch, to fit the cap better (A and B in image 34). Apply a groove to the recessed area on the side using Inset and QMesh, to make it seem more like a distinct piece (C). Now let's add two small hole details below the orifice for the camera lens. Create an edge loop (Edge Actions > Insert) to provide the necessary points for a Split using Point Actions (C). After the first Split, select Ring as a target to divide the circle and give it a smoother edge (D). Push the holes into the mesh (E) and create extra details inside,

using a mixture of Inset, QMesh, and Bevel (F). To finish off the upper edge of the front (G), use QMesh to pull out a piece which will later serve as a better-looking connection to the cap.

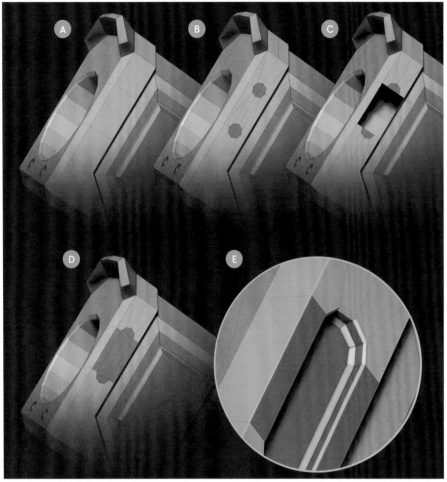

▲ **35** Adding more detailing and visual interest to the head

35 Side plate detail

To make the side of the head (A in image 35) more visually interesting, let's add a long indented groove design. Add an edge loop around the green section of the head, which creates the necessary points for two Splits of the same size (B). Use Polygon Actions > Delete (C) to delete the mid-section between the two circles, then connect them again using Edge Actions > Bridge to create straight polygons (D). Create the groove details using Inset, QMesh, and Bevel, as before (E).

36 Custom Insert mesh brush

At this point we will look at how to make an Insert mesh brush (image 36). As you learned on pages 43–45, this is a brush which inserts a pre-made 3D object onto the surface of a SubTool, which is especially helpful for technical parts that we want to place on a model again and again.

Take the screw head from step 30 as an example (A in image 36), making sure that you look at it from the exact top view (B). To do this, use Document > ZAppLink Properties and click the Front button. This alignment is very important because the model will be saved as an Insert brush exactly like this, and will be

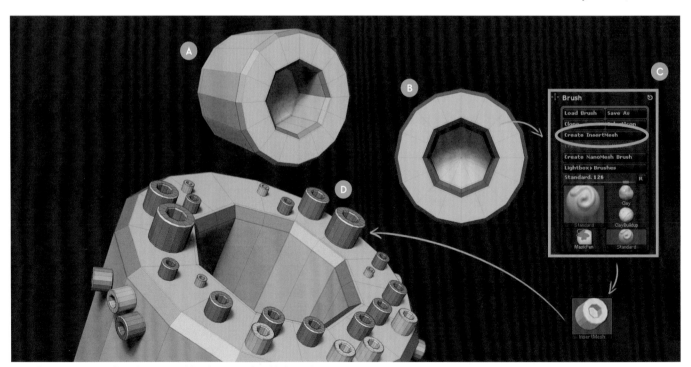

▲ **36** This custom screw-shaped Insert mesh brush can now be added anywhere!

▲ 37 Creating the ventilation grid

inserted directly onto the model's surface in this orientation.

In the Brush tab, click Create InsertMesh (C), then New in the subsequent dialog box. Now you can place the screw head as often as desired in any size, on any surface (D). If you want them all in the same size, hold the Ctrl key while pulling and the screw head will become as big as the tip of the brush. Now save the new brush (Brush > Save As) for later use.

37 Ventilation

For the connecting piece of the head and neck, let's create a ventilation slot with a perforated plate. First create the recessed slot with Inset, QMesh, and Bevel (A). Adding two new edge loops ensures that the slot retains the right shape when viewed in Dynamic Subdivision mode. Duplicate the rear wall of the slot with QMesh (B) and make a separate SubTool out of it (as explained in step 31), resulting in a piece that is the perfect size to cover the ventilation hole.

Divide this new piece of geometry into four nearly square segments (Insert > Multiple EdgeLoops), subdivide it twice (Geometry > Divide) (C), and apply a subdivision level to round off the edges (D). Click Del Lower, then apply an Inset to the entire shape (using Island target mode; E) and arrange circles of the same size on the surface (F). Don't forget: you just have to define the size for the first circle, then simply click for every other one. Delete the inner surfaces of the circles, then extrude the entire shape with QMesh (Island target) to add thickness to the ventilation plate (G). Apply Bevel to all the edges, then an automatic crease with Geometry > Crease > Crease PG (H).

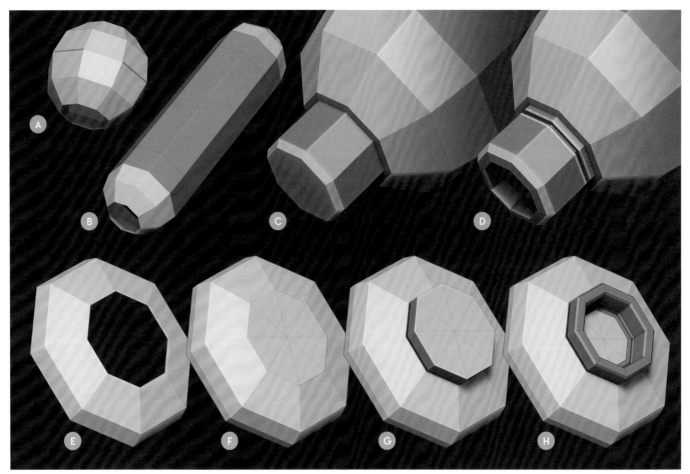

▲ 38 This tank will fit onto the curved plate we made in step 21

38 The head tank

Next let's make the little tank which fits under the robot's hood. Start with a sphere using HDivide 8 and VDivide 7 settings. Delete the tips and bevel the middle edge loop (A in image 38). Mask the lower part of the sphere and pull the upper part up to the desired length with Transpose, making a long tube shape with rounded ends. Add two edge loops using Insert (B) to this new mid-section to support the shape of the eventual Dynamic Subdiv (if we don't do this, the tube will probably lose its shape or be rounded off too much when viewed in Dynamic Subdiv mode). Two extra loops is all that is needed to maintain the correct shape. Close the hole using Close (Edge Actions > Close > Convex Hole) and model the adapter for the tube with Inset, QMesh, Bevel, and Insert (C and D). This same sphere serves as a basis for the smaller adapter that will connect the tank's tube to the robot's head. Duplicate the sphere, hide all but two of the polygon loops, and

apply Modify Topology > Del Hidden. Now use Transpose to scale them into a flat sleeve (E). Model the rest of the adapter using the same tools we used for the rest of the tank: Close, QMesh, and Bevel (F, G, and H).

39 Placing the tank

Place the tank and small adapter on the side of the head (A in image 39), on the curved component that we made in step 21. Delete the polygons on the inside of each adapter, creating holes that we will connect together with a bendy tube.

To make the tube, use Edge Actions > Bridge with the settings Two Holes > Spline > Optimal Curvature > Optimal Resolution selected (B). If the ends of the tube don't sit perfectly in the adapters, correct them using the Move brush and masks where necessary. If you find that the tube is slightly too thin in the middle, you can correct it with the Inflate brush (C).

40 Adjusting the model

In image 40 you can see a preliminary result of the model, with some little design adjustments to surfaces that looked too plain. As mentioned previously, it can be useful to look at and work on a model in its entirety before going into too much detail – that is why some of the parts are revisited during the process. In part A of image 40 a simple cube has been added with Crease and Dynamic Subdiv. In part B the InsertMesh brush that we made in step 36 is used to add a bolt detail. In part C, an extra bit of extrusion is created using Inset, QMesh, Scale, and Slide.

41 Creating the lens

Up next we will make the spherical "eye" lens. This time let's start with a sphere with HDivide 16 and VDivide 13 settings. Delete the tip, close the hole (A), and use QMesh (Polygroup Island target) (B). Divide the innermost polygon loop with another edge loop (visible in B), enabling

▲ 39 Placing and attaching the tank

▲ 40 A few small refinements add more interest to the model

us to indent the front of the lens. Push this
edge loop a little inwards (C) with Transpose
(Edge Actions > Transpose > EdgeLoop
Complete). Use Bevel and QMesh to create
some groove detailing around the "eye" of
the lens (D), and a further recess to make the
shape more interesting, creating the illusion of
having different components.

On the side of the sphere, let's add another
rounded groove detail, similar to the one we
made in step 35. Again, use Split to create
circles centered around two points (E), divide
the middle polygons with Insert, and delete the
surfaces shown in (F). Now we have enough
edges to connect everything again, using Edge
Actions > Bridge > Edges. Finally the new form
is extruded inward with QMesh and scaled
smaller with Transpose (G).

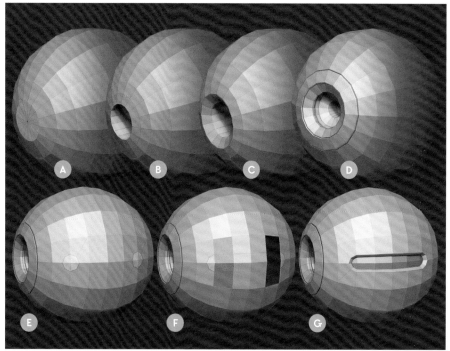

▲ 41 Modeling the spherical "eye" and adding some surface detail with QMesh

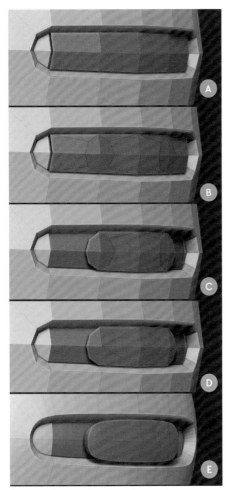

▲ 42 The detail on the side of the robot's eye

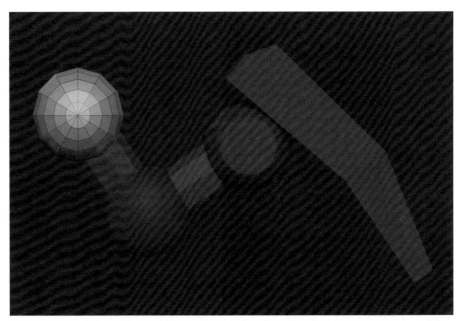

▲ 43 The new detailed leg will be built over a screenshot of the rough leg to keep it in proportion

42 Extra lens detail

Let's add one more little detail to the groove on the side of the lens. Duplicate the polygons marked in red in part A of image 42 with QMesh, then add circles which take up almost their complete height, using Split (B). Delete the outer polygons (C) to create a shape like a sliding tab or button, and use Point Actions > Stitch to reduce the points we don't need (D). If you are unable to get rid of the last diagonal with Stitch, remove it with Edge Actions > Delete. Give this resulting oval shape some extra thickness with QMesh. The final stage (E) shows the completed shape with added Crease and Dynamic Subdiv turned on.

43 Starting the legs

The legs have not been touched until this point – they still have the shape seen in step 05. To be able to work with symmetry along the X axis, we will build the leg in a new SubTool. There are

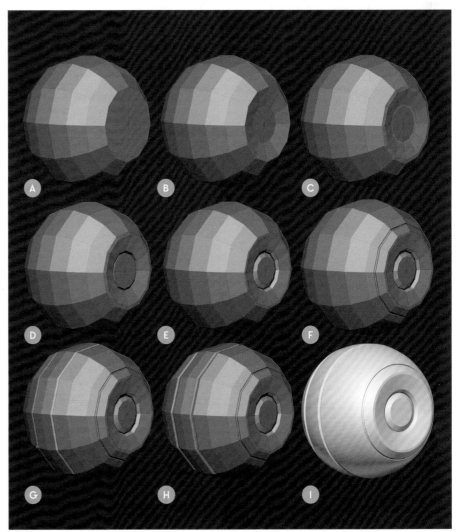

▲ 44 This first leg joint will be duplicated and joined together in step 45

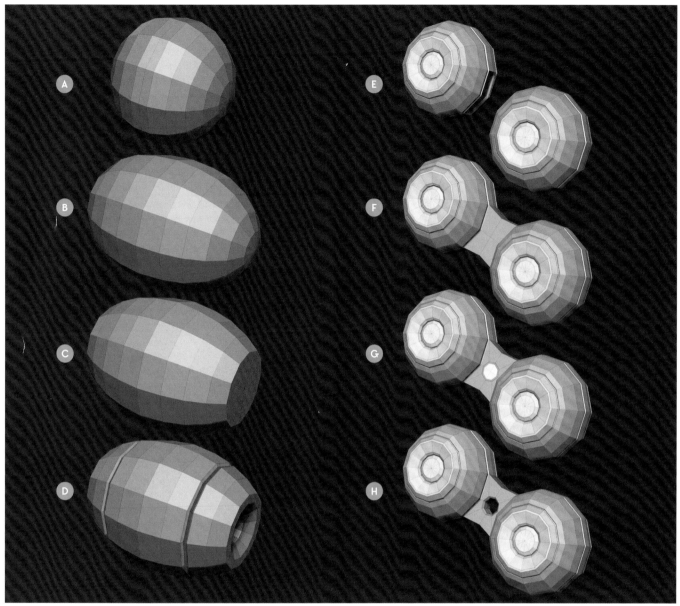

▲ 45 The joints in the robot's legs are made from simple spheres, using QMesh and Bevel to create a more interesting form

several different ways to ensure that we get the proportions right: we could copy one of the legs and put it in the middle of the world center (the very center of the area you are modeling in) as a reference point, or we could take a screenshot (from step 05, for example) and put it into Spotlight or behind the ZBrush window using the See-through slider. In this case, I use the latter option and start building the new leg with a simple Sphere3D (HDivide 12, VDivide 12).

44 First leg joint

Out from this sphere arises one of the three joints of the leg. Cut off the sides of the sphere

and fill the resulting holes (A). Use Inset or Split to create a smaller circle, push it inward a little (B), and apply Bevel to the new edges (C). Use QMesh to create a groove around this inner circle to visually separate it (D). Apply Bevel to this new groove (E), and create a second groove (F) a bit further outside. In the middle there is also a separation (G and H) which will be mobile later.

45 Second leg joint

Now we will create a second joint shape. Create a sphere (A in image 45) and pull it into an oval shape with Transpose (B), then delete

the tips and the first polygon loop, and fill the resulting holes with Close (C). Then sever the four middle polygon loops so that we will be able to move the parts independently later (D). The lateral surfaces are shaped with QMesh and Transpose again.

On the right-hand side of image 45 you can see how I duplicate the joint that we made in step 44 (E), delete four polygons from the middle of each, and connect them with Bridge (F). I then punch a hole into the connecting piece with two Splits and QMesh (G and H). These two different shapes will be the basis for our robot's legs.

46 Third leg joint

Now we need to connect the two leg joints with a third piece. The two joints are still two separate SubTools, so combine them into one (Merge Down). Delete four polygons (two pairs of two) from each joint where we would like the two to connect together (A in image 46).

Use Bridge to connect the joints, creating the two "arms" as shown (B). Use QMesh (Polyloop target) to extrude the inner ring of the blue joint (C and D), then form it into a connecting piece for the foot using SelectLasso and Transpose. Dynamic Subdiv mode helps to show which edges require Crease (E).

47 Sculpting the foot

The shape of the foot (A in image 47) itself has not been defined, so now we will sculpt it into shape. Divide the placeholder repeatedly (B) and apply DynaMesh (C). Then cut off some of the bottom side of the foot with the ClipCurve brush to fit around the round leg joint (D). Start designing the surface with the Clay brush, adding some raised shapes.

The sides and the toe are shaped and sharpened with hPolish and the other brushes pictured (E). Define where single components meet with the ClipCurve brush and Slash3. The area colored turquoise in parts F and G is the first to receive new topology (see steps 24 to 25), turning it into a new piece (H and I).

48 Connecting the leg and foot

In this step we will connect the third joint of the leg to the previously built component of the foot. To do this, delete polygons from both parts until there are no longer any polygons overlapping (A in image 48). To connect the

▲ 46 Extruding two "arms" to connect the joints

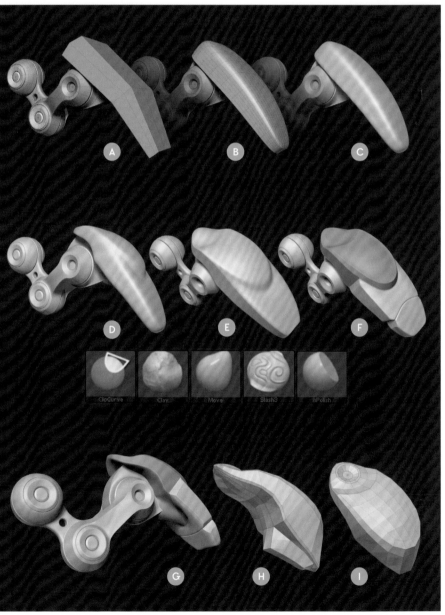

▲ 47 Sculpting the new foot and building clean topology for the top half of it, resulting in a new mesh

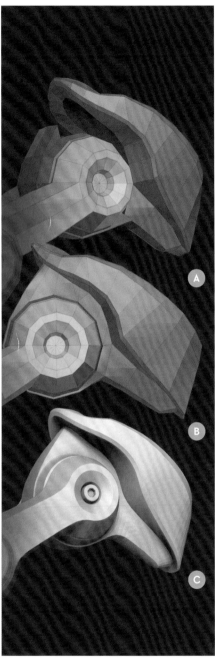

▲ 48 Connecting the upper foot to the leg joint

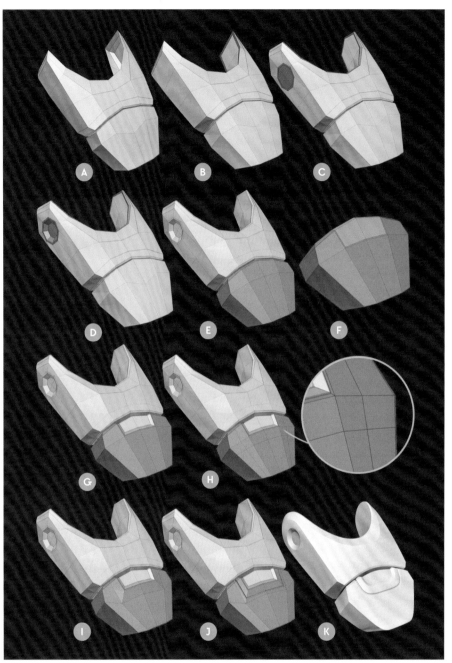

▲ 49 Creating new topology for the remaining lower part of the foot

edges of both parts together (B), use Bridge (Edge Actions > Bridge > Edges). In the last image (C) you can see what the new part looks like in Dynamic Subdiv mode, and to which areas I have applied Crease. Insert a screw in the center of the joint using the InsertMesh brush we made earlier (see step 36).

49 Toe topology

Create a simple new topology for the toe, as we did for the foot in step 47 (A and B in image 49).

When that is prepared, apply a new edge loop to the round upper shape of the toe, so that we can add a round detail with Split (C and D). We will place a screw here later.

Rearrange the Polygroups (E) to keep the sections of the toe clear. Apply an indented detail to the pink lower section of the mesh using Inset and Inflate (Polygon Actions > Inflate > Polygroup Island) (F and G). It would be an interesting touch to create an extra loop

of detail around this new indent, for which we need a new polygon loop. To do this, add two new polygon loops (H) and knit them together with Stitch until all unnecessary points are deleted and only one loop is left around the blue polygons (I in image 49). Detail this groove with Insert, Bevel, and QMesh (J). Add Crease to the areas shown in part K of step 49.

50 Preparing the body

Before fastening the legs onto the body, create new topology for the body with the process described in steps 24 to 27. In image 50a you can see how I apply the new topology and how the Polygroups are distributed. As with the cap, the polygons follow the flow of the model's gaps and shapes, and I apply Panel Loops (refer to step 27) to add depth and visually separate the sections from one another.

Create some new topology for the connecting piece that we made in step 18, which will keep it from cutting into other parts, and includes a hole on the bottom side for the joint (image 50b). As I mentioned in step 23, creating new topology is not necessary for a good render in ZBrush, but it is beneficial to do it for the sake of completeness, as it is good practice for potentially moving your project into other 3D modeling software at a later date.

51 Adding the legs

Now we can mount the finished leg onto the body and duplicate it. Put the single leg in place with Transpose and click Mirror And Weld to mirror it to the other side of the robot. Duplicate this pair, place it again, and repeat until you have placed all three pairs of legs.

Now the modeling stage is complete, and in the following sections we will cover detailing with alphas and textures, painting, and rendering the final image.

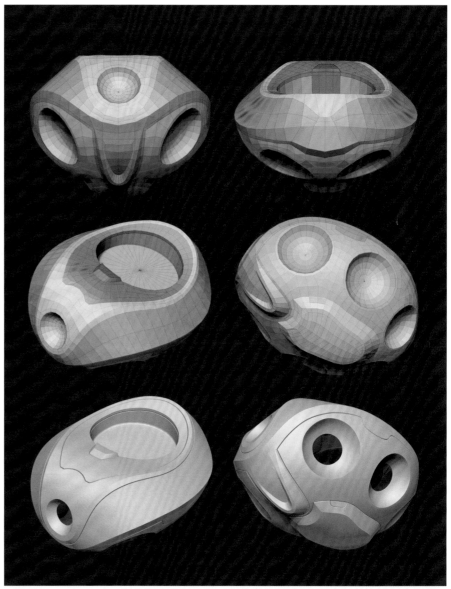

▲ 50a The new topology for the body, split into handy Polygroups

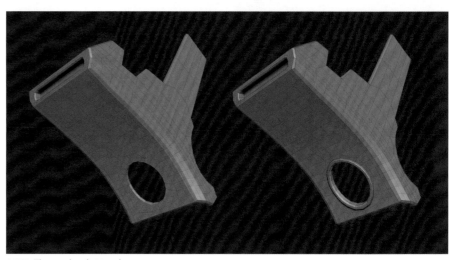

▲ 50b The new bracket topology

▲ 51 The finished legs are now added and duplicated. The model is complete, so now we can add some cosmetic details and render it

Detailing

52 Alphas

In step 36 we looked at how an Insert mesh brush can be a very useful tool for adding a diversity of detail to your models. Now, in a similar vein, I want to talk about alphas. Using alphas, all kinds of three-dimensional shapes can be stamped onto the model directly, both additively and subtractively, creating complex surface detail. ZBrush already includes some alphas which you can find in the Alpha menu, but we are also able to add our own files using the Import button in the bottom-left corner of the same window. Let's look at the processes for creating several mechanical details before saving them as custom alphas.

▲ 52 Alphas can be used to add 3D shapes as well as painted effects

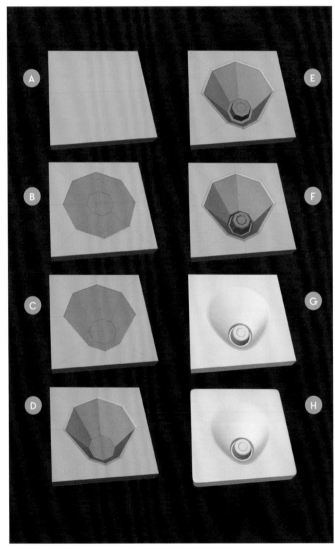

▲ 53 Creating an indented screw cap detail with ZModeler

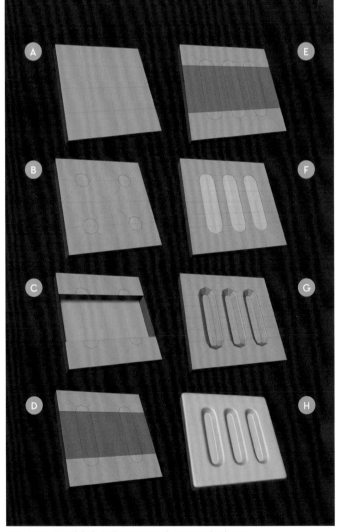

▲ 54 Using ZModeler's Bridge to create long capsule shapes

53 Screw cap detail

To make the first model, start with a simple flat box (A in image 53). Divide all the surfaces once and create two concentric circles using Split (B). Move the smaller circle downward with MaskLasso and Transpose, and move two vertices of the big circle closer inwards with Slide (C). Push the smaller circle downwards into the mesh using Transpose to create a concave shell shape (D). Model a cylindrical detail with QMesh, Inset, and Bevel (E and F). I imagine this could be a covering for the head of a screw. You can see in the Dynamic Subdiv version (G) which edges have been creased, such as the areas around the screw, and the narrow end of the surrounding shell shape. However, some of these edges would look better if we softened them, losing the shape created by Crease. Deactivate Dynamic Subdiv mode and divide the model three times with Divide (H). Then click UnCreaseAll in the Tool > Geometry > Crease menu and subdivide the model two more times. Now the desired edges are still sharp but not unnaturally razor-sharp, and we can use the Smooth brush to partially soften the edges further. We will save this as an alpha after creating a few more objects.

54 Capsule detail

Start the next model with a flat box again, this time split by three horizontal and three vertical edge loops (A in image 54). Make four circles with Split and delete the rows of polygons in the middle (B and C). It is important to also remove the middle edge loop from the back. Now connect the opposite edges again with ZModeler > Bridge (D). If there was still an edge loop on the back, ZBrush would not automatically connect the sides of the red surface and leave a gap, because it does not accept n-gons (polygons with more than four vertices).

Add three edge loops to the new form in the middle (E and F) and create three recessed capsule shapes using QMesh (G). Repeat the same combination of Divide and UnCreaseAll (H) just as we did before in step 53. The edge loops added in part F to ensure that the desired shape is retained when dividing.

55 Screw capsule detail

The third model is a recess for a screw or rivet. The capsule shape (A and B in image 55) is created similarly to the previous step. This time, we only need to push half a shape into the model (C) and make two concentric circles there with Split (D). Use Ctrl + QMesh to duplicate the circles and give them thickness, creating the basis for a rivet (E and F). Check which edges require Crease using Dynamic Subdiv (G).

▲ 55 This model combines elements of the previous two designs

▲ 56 A closer look at the round rivet from step 55

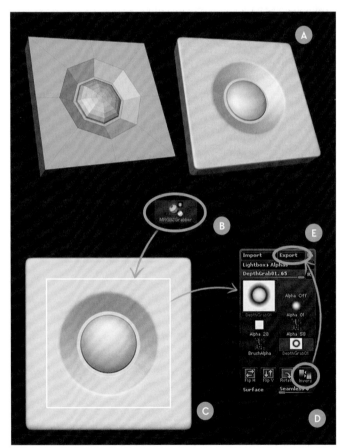

▲ 58a Creating a button detail and saving the alpha

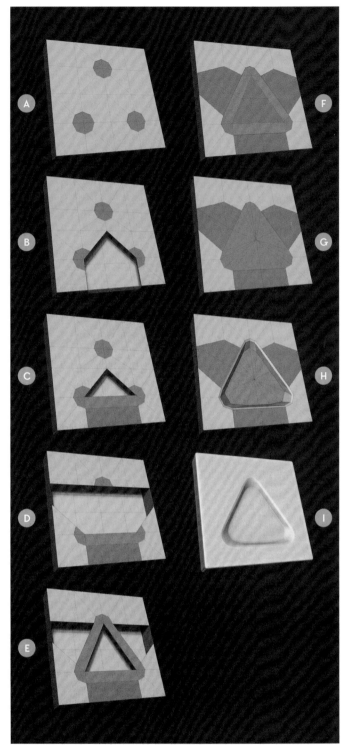

▲ 57 A triangular detail takes a little more working out

56 Rivet detail

Here we will look at the curvature of the rivet from step 55 in more depth. Delete the top and use Edge Actions > Close to close it again. Before releasing the mouse or pen, we have the opportunity to define the resolution of the new surface and its curvature. Moving the tool up or down changes the number of edge loops, and moving it left or right changes the degree of bulge. The Edge Actions modifiers offer more options concerning the shape, if you wish to experiment, but this is a simple solution.

57 Triangle detail

Now let's create a triangle with rounded edges. Start by creating three circles with Split (A in image 57). Similar to the capsule shape, delete the polygons between the circles one side at a time, connect the edges again with Bridge, and

finally fill up the holes (B–F). When we have outlined and bridged a whole triangle shape (G), we can delete it and seal the hole with Close, creating a triangle where all the edges run into the middle together.

The shape in (H) is created with Inset, Transpose, and Bevel. Arrange the vertices evenly on the inner triangle with Point Action > Slide to make the inner shape softer than the outer. Part I shows the finished model after Divide and UnCreaseAll.

58 Button detail and saving an alpha

Create another round button shape (image 58a), which should be no challenge for you now. Use Split to create a circle, then Inset, Transpose, and Bevel and create the concave button detail. Finally we can get to the actual magic of saving an alpha!

Click on the SimpleBrush icon in the Tool panel to view 2.5D brushes; here you will find the MRGBZGrabber tool. 2.5D brushes provide more options for experimenting with color, depth, and material effects, for users interested in "painting" with ZBrush. Arrange the model into a flat frontal view (C), turning off Perspective view by hitting the P key. Using the MRGBZGrabber tool, drag a rectangle around one of our modeled details. If you hold Shift, the rectangle becomes a square, and if you hold the Space bar, you can move the selection. When you release the cursor, ZBrush creates a grayscale image from the model's height information; the highest point of the selection defines the white of the image and the lowest the black. Invert the generated image using the Inverse button in the Alpha palette (D in image 58a) and save it with the Export button (E). Repeat this for all the details you have just modeled. Image 58b shows the saved alphas I have created.

59 Applying alphas

In order to use the alphas, we must ensure our model offers sufficient resolution. All surfaces of the model must be divided several times to be able to display the alpha at the intended quality. Proceed to add alphas to each part of the robot as described below, using a similar process as we did when modeling the alphas: applying two or three subdivision levels, then applying UnCreaseAll and more subdivisions. With each subdivision level, the number of vertices quadruples. How high this number can go depends on your computer – in my case, it is usually 10–15 million.

Choose the Standard brush, deactivate Lazy Mouse, and select DragRect or DragDot (steps A and B in image 59) instead of the default Dot. With DragRect, we can place an alpha on a specific place, and define the size and rotation by dragging the mouse or pen. With DragDot, the size of the brush defines the size of the alpha, and by dragging the cursor the created shape can be moved. Focal Shift (C) determines how soft a brush becomes towards the fringe, so to apply the alphas in crisp quality, it is best to set it to -100. The Z Intensity refers to the amount of depth applied, and varies depending on the chosen alpha – you can experiment here to find the appropriate level of depth. In part D of image 59 you can see the alphas placed on different regions of the cap.

▲ 58b The saved alphas I created

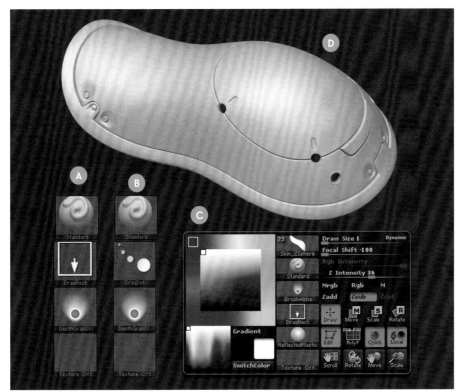

▲ 59 The alphas can now be applied to the model, adding subtle surface detail

60 The rest of the body

Image 60 shows the other parts of the body and the different alphas in place. In the Alpha > Modify tab you will find some more options to edit the alphas. One useful option here is being able to tile an alpha. Set the H Tiles slider to 2 in the Alpha > Modify menu to create the six slots on the side of the head, creating six grooves out of the three-groove detail alpha.

The details on the remaining parts of the body, such as the legs, are added without any special treatment, only varying the Z Intensity slightly. Try to allow room for each detail, keeping a balanced ratio between large and small shapes.

61 Applying a base color

Now that the modeling and details are complete, we can start adding color to the design. A simple and sporty coloration will work well for *Nosy-N-42*. In the following steps, we will cover some simple ways to design a model with color.

The fastest way to cleanly fill an object with a color is with FillObject in the Color tab. If only a specific part needs to be filled with color, there are various options to do so: we could paint it by hand with a brush, make a mask and fill it, use an alpha again, or hide everything we don't want to colorize first.

We will use the last option to add color to the body. First, use Polygroups > Auto Groups and Merge Similar Groups (A). The former setting assigns a Polygroup to each coherent mesh, and the latter combines meshes of similar topology into a Polygroup. Now we can click on a Polygroup with the SelectRect brush (Ctrl + Shift + LMB) and all the other Polygroups are hidden automatically (B). Note that clicking Ctrl + Shift + LMB in an empty space unhides all hidden elements, and Ctrl + Shift and dragging in empty space inverts the selection. Now we can use FillObject to dye the visible mesh in the chosen gray color (C).

62 Adding a stripe and stamp

The sporty blue stripe in this step is created in a similar fashion. A feature of the SelectLasso brush will help us to make the selection: when

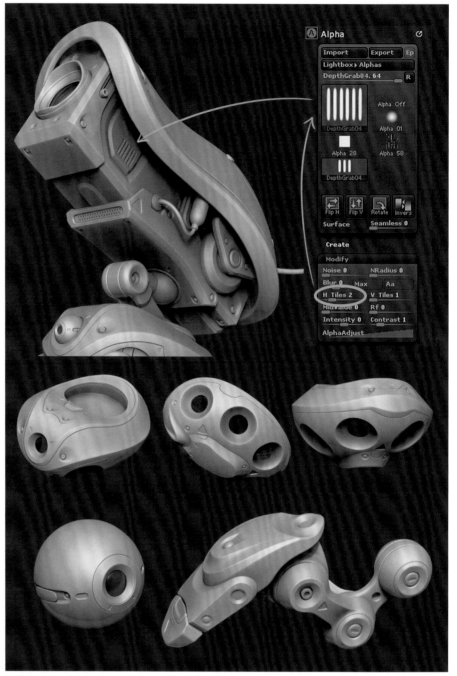

▲ 60 Applying alpha details to the rest of the body

you click on the edge between polygons with it (Ctrl + Shift + LMB), the whole polygon loop will be hidden independently from the Polygroup. In this way, we are able to hide a polygon loop all the way around the rim of the body, then invert the selection, and fill the now-visible stripe of polygons with blue.

The small "42" on the front is made with an alpha; the settings for the brush are the same

as in step 59. Check the Brush settings on the top shelf to ensure that the sculpting settings (Zadd and Zsub) are deactivated, and that Rgb (for applying color) is activated. Note that if an alpha appears pixelated, it is due to an insufficiently divided mesh. In ZBrush you don't apply a texture with a defined resolution, but apply it directly via the polygons, and each polygon can only display a gradient between four colors.

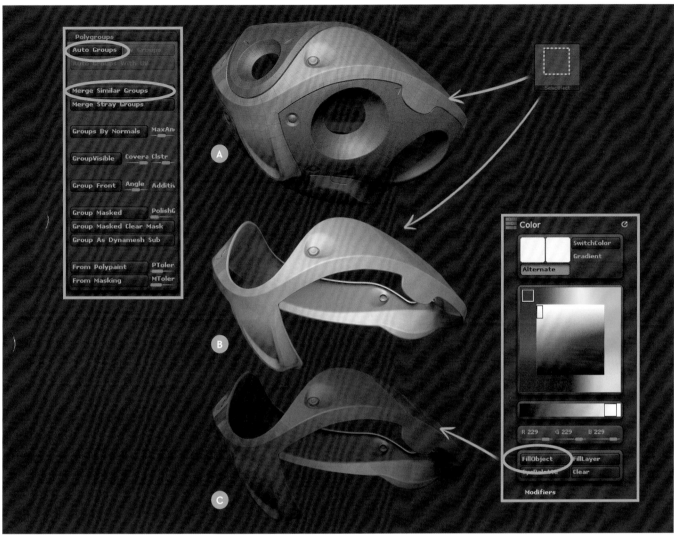

▲ 61 Using FillObject to apply simple base colors to the chest

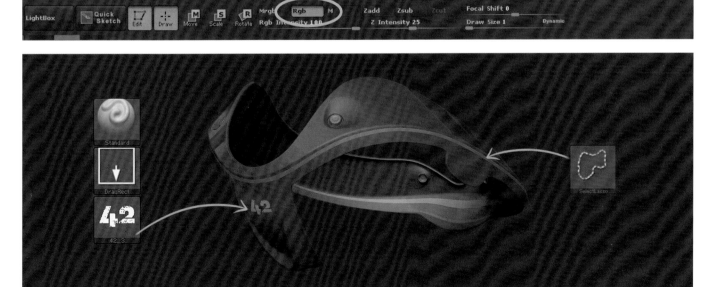

▲ 62 Coloring a loop of polygons creates a sporty stripe effect

▲ 63 Using Spotlight to paint a stamp onto the robot's underside

▲ 64 Faking a transparency effect gets the cleanest result

▲ 65 This stripe cannot be achieved using polygons like in step 62 – instead, it is drawn using Lazy Mouse

63 Adding colored decals

When using alphas, we can only apply one color at once, because it works like a stamp rather than an image. If we need to transfer a multicolored image or a colored structure onto a model, Spotlight makes it possible. In this case, I want to apply a colored logo that I have made for this robot (feel free to make your own in Photoshop). Go to Texture > Import (A in image 63) to import the image you want, and click Add To Spotlight. The image will appear in the viewport (B), enabling you to place and scale it to fit the little hatch on the belly of the model. When you are happy with the sticker's placement, press the Z key to hide the Spotlight

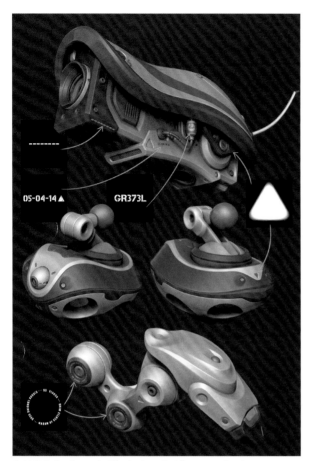

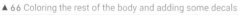

▲ 66 Coloring the rest of the body and adding some decals

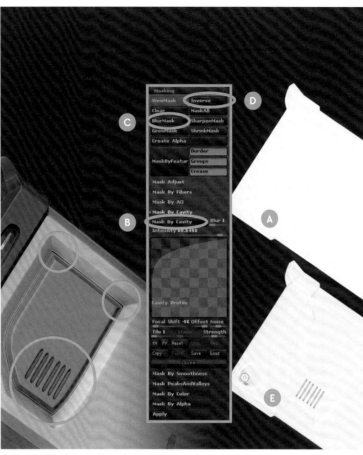

▲ 67 Using Mask By Cavity to darken grooves and crannies

wheel and transfer the image onto the model with a brush in Rgb mode (C). Transparency is a bit tricky when using this method, but I will explain that in the next step.

64 Spotlight transparency

In image 64 you can see three files I have loaded into Spotlight, and also what they look like when transferred onto the model. Black becomes transparent in Spotlight, so in the first example, I have used Photoshop to color black everything that I wanted to be transparent. The problem is that only pure black becomes transparent and everything else stays visible. This results in some unsightly dark artifacts, since my image is not particularly high resolution. The second file is a PNG with a transparent background, but the transparency does not transfer perfectly here either. The last file has the specific RGB color of the model in the background, so no real transparency has to be transferred, and the outcome is the cleanest of the three.

65 Coloring the cap

For this design, it is best to stay quite minimal when choosing the colors. The cap is colorized piece by piece, like the body. The blue stripe cannot be achieved by isolating the polygon loops as we did in step 62, because the topology of our robot's cap doesn't fit it. Instead, we can use the Standard brush in Rgb mode with Focal Shift set to –100 and Lazy Mouse activated. With some practice and patience, very precise shapes can be drawn freehand this way. You can fill the smaller gray areas with the same brush, but without Lazy Mouse.

66 Coloring the body

Use the same technique as the previous step to colorize the entire model. Image 66 shows my color scheme for each part, and which alphas I applied. I keep my choices simple and avoid being too elaborate, using the colors to emphasize the shapes rather than distracting from them. Some details I previously applied with the help of alphas are now colored with

the same alphas in Rgb mode. If you are feeling confident in the future, you can save time by activating Zadd and Rgb together to apply the alpha's shape and color at the same time.

67 Mask By Cavity

To make the colored surfaces more vivid, let's darken the robot's recesses and furrows. One can imagine that dirt has gradually accumulated in these areas, so this detail will make the design feel more real. There are various masking modes available in the Tool > Masking panel which are suitable for this.

In order to show this effect more clearly, I have selected Flat Color from the Standard Materials menu and colored the model white (A in image 67). I apply Mask By Cavity with the settings shown (B) to mask the depths, then press BlurMask (C) for a smoother effect, and finally Inverse (D) to invert the selection. The recessed areas are now unmasked and can be filled with additional color or structure (E).

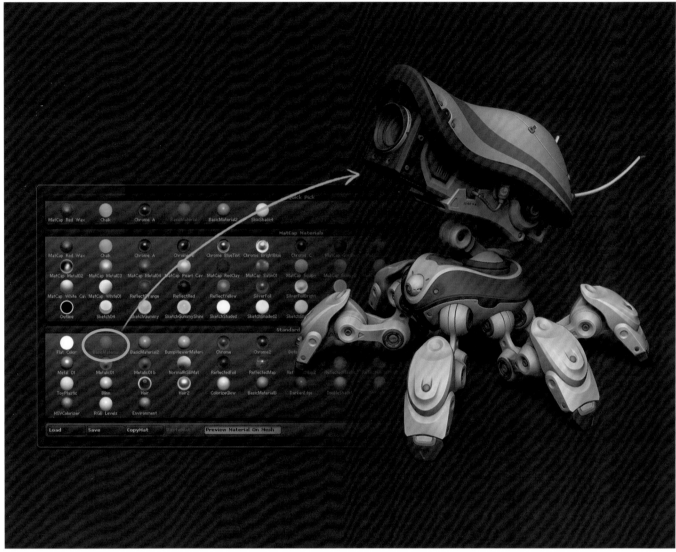

▲ 68 ZBrush offers a range of materials whose properties respond differently to lighting and environment conditions

Rendering

68 ZBrush materials

Now we are going to make a final presentation render using the tools available in ZBrush. We will cover how to create a studio-style lighting scenario, and how to render a portfolio image from it. If you have KeyShot and would like to advance straight to that instead, turn to chapter 06 to start learning about the KeyShot interface.

First let's look at materials, as we need to establish the materials of our model before we can start creating an appropriate lighting scenario. By clicking on the Material

icon, we can access a variety of different materials directly within ZBrush, and can change between them as we work to look at our model in different materials and lighting situations. For rendering purposes, we want a material that only reacts to the lighting situation and environment, without embedded colors, lighting directions, or reflections. ZBrush's MatCap options contain embedded lighting and reflections which can be very useful, but we are going to keep things simple, so select BasicMaterial from the Standard material options.

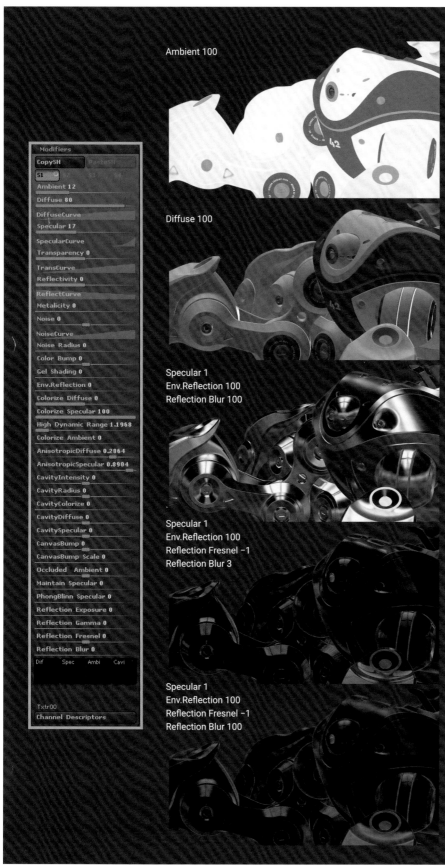

Ambient 100

Diffuse 100

Specular 1
Env.Reflection 100
Reflection Blur 100

Specular 1
Env.Reflection 100
Reflection Fresnel −1
Reflection Blur 3

Specular 1
Env.Reflection 100
Reflection Fresnel −1
Reflection Blur 100

Modifiers panel (left):

Modifiers
CopySH PasteSH
S1
Ambient 12
Diffuse 80
DiffuseCurve
Specular 17
SpecularCurve
Transparency 0
TransCurve
Reflectivity 0
ReflectCurve
Metalicity 0
Noise 0
NoiseCurve
Noise Radius 0
Color Bump 0
Gel Shading 0
Env.Reflection 0
Colorize Diffuse 0
Colorize Specular 100
High Dynamic Range 1.1968
Colorize Ambient 0
AnisotropicDiffuse 0.2864
AnisotropicSpecular 0.8904
CavityIntensity 0
CavityRadius 0
CavityColorize 0
CavityDiffuse 0
CavitySpecular 0
CanvasBump 0
CanvasBump Scale 0
Occluded Ambient 0
Maintain Specular 0
PhongBlinn Specular 0
Reflection Exposure 0
Reflection Gamma 0
Reflection Fresnel 0
Reflection Blur 0
Dif Spec Ambi Cavi

Txtr00
Channel Descriptors

▲ 69 Editing the properties for each of the materials

69 Material modifiers

Now we need to add different effects to the surface of our model. In image 69 you can see the Material > Modifiers panel. Here we can find and edit all the material properties we need. We could assign a material to each object and each detail, and render the model afterwards, but we would have to render a new version each time if we wanted to change something. Instead, we will export all the properties individually, so that we are free to combine them non-destructively in Photoshop. For this purpose, level all of the properties of the Modifier panel to 0.

On the left-hand side of each material in image 69, you can see which settings make that material: flat colors, a diffuse material without reflections, rough metal, glossy black plastic, and rough black plastic. Save each of the five materials with Material > Save.

70 Lens transparency

Let's take a moment to look at the lens individually. If we want to render a transparent material, such as a glass lens, we have to start this process in three different places. First, go to the SubTool palette and turn on the little transparency icon for the lens SubTool. Then go to Render > Render Properties and activate the Transparent button. Finally, under Tool > Display Properties, activate the BPR Transparent Shading button. Now each material we apply to the lens will be transparent when we render the image.

71 Adding LightCaps

Now let's creating our lighting scenario. Rather than deriving lighting from the environment, which is how we would create lighting with

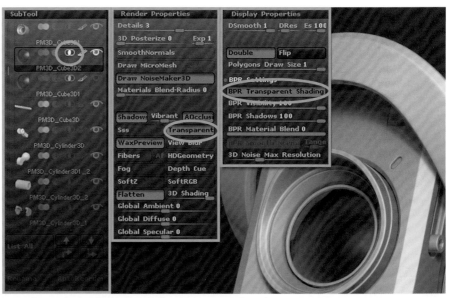

▲ **70** A few settings are required to achieve the transparent lens glass

▲ **71** Build a lighting setup by adding lights of varying colors and intensities in the LightCap panel

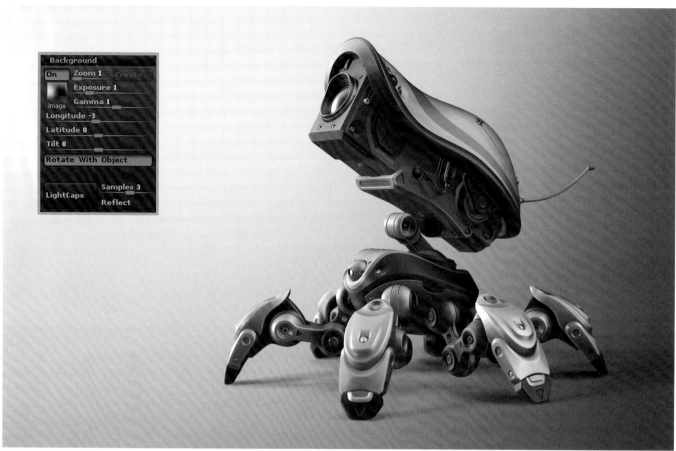

▲ 72 The result of setting up an artificial lighting scenario with LightCaps

an HDRI (see Key Concept on page 222 and chapter 06), we will do the opposite here and create an environment for the model based on our own self-made lighting and LightCap tools.

In the Light tab, turn off any orange light-bulb icons currently lighting the scene, and set the Ambient slider to 0, so that we can clearly see the effects of our new lights as we add them. Open the LightCap panel. Now we can start to add lights with the New Light button, the settings for which can be seen in image 71. Each light can be moved around the sphere to change its position, and adjusted in size, color, intensity, and shape.

To layer lighting effects in different ways, the Blend Mode button offers options similar to the blending modes in Photoshop. You can also see that there is an Alpha option applied to some of the lights, which slightly alters their effect. To navigate back and forth between the multiple lights, use the Light Index slider.

72 Create Environment

Now click Create Environment down in the LightCap panel, and ZBrush will create a fitting environment for the placed light sources. Your result should look similar to the scene pictured above in image 72. We can adjust this environment in the Background panel, if we need to rotate it and adjust its brightness. Now we can move on to rendering images to composite together in Photoshop.

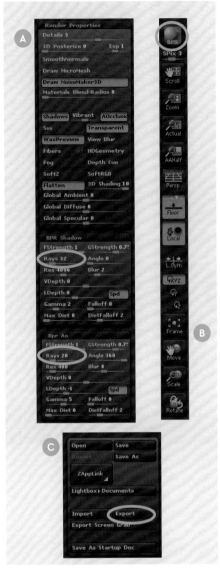

▲ 73 The important render settings

▲ 74 The ZBrush To Photoshop CC plug-in menu

73 Render settings

Here you can see the Render Properties tab (A in image 73), where we can set the information we would like to render from our scene. Set the Rays value to 32 in the BPR Shadow panel, which I find to be a good compromise between quality and speed. Then set Rays to 20 in the BPR AO panel.

Near the top-right corner of the viewport you will find the BPR button (B). Click it (or press Shift + R) and wait until ZBrush has rendered the image in the document window. The resulting render passes will be shown in the Render > BPR RenderPass tab, where you can click on them to save them out individually as PSD files. To save a version of the image with the background, you must select Export in the Document tab (C). It doesn't matter which material you choose for this.

74 ZBrush To Photoshop CC

A very useful plug-in is ZBrush To Photoshop CC, which can be found in the ZPlugin tab. If you can't find it there already, you can download it from the Pixologic website for free. This plug-in enables you to choose which render passes and materials to send directly to Photoshop.

In image 74 you can see which of the passes I have chosen. Sequentially load the materials that we saved in step 69 and assign them to the Material buttons (activated by pressing the right-hand section of each button). Then click Send To Photoshop and wait for the plug-in to render all of the selected options. The plug-in

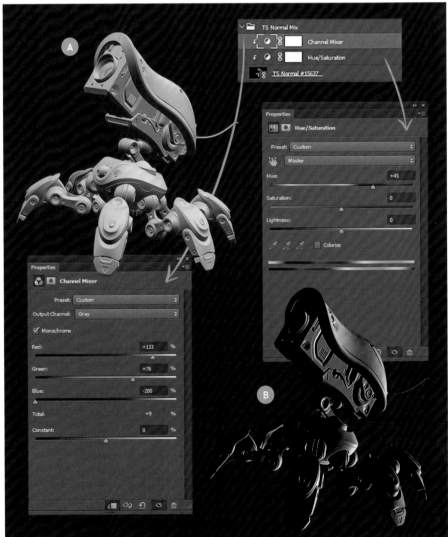

▲ 75 Change the Hue/Saturation settings of the Tangent Space Normals pass to change the lighting angle

will automatically open everything as a layered PSD in Photoshop.

75 Useful passes in Photoshop

Now you can composite the final render in Photoshop, applying blending modes to the various layers until they are to your liking. You can use masks to apply material effects to specific parts of the robot, and tweak the overall color of the model using Curves adjustment layers. A useful pass for tweaking lighting is the Tangent Space Normals pass (see the TS Normal button in image 74), which is a color-coded map showing in which direction the surfaces of the model are pointing. Using Photoshop's Channel Mixer, we can make a grayscale color image from this which looks as if it is lit solely from one side. The smoothness of the light can also be adjusted. It is worth playing a little with the settings, such as using the Hue/Saturation sliders to freely rotate the "lighting." Now we can create a selection from one of the RGB channels (click on a channel icon while holding Ctrl) and use it as a layer mask, which is very convenient.

To create a photographic look, you can flatten the final image into one layer and open the Lens Blur filter (Filter > Blur > Lens Blur). In the Lens Blur settings, set the Depth Map source to the depth render pass, and then choose the eye for the Blur Focal Distance. To add a "vignette" effect, just copy the blurred layer and apply a Lens Correction filter with Chromatic Aberration and Vignette enabled.

76 Final renders

Image 76a shows the final ZBrush render after editing in Photoshop. If you would like to take your model a step further, turn to chapter 06 to learn about rendering with KeyShot to create results like those shown overleaf (image 76b).

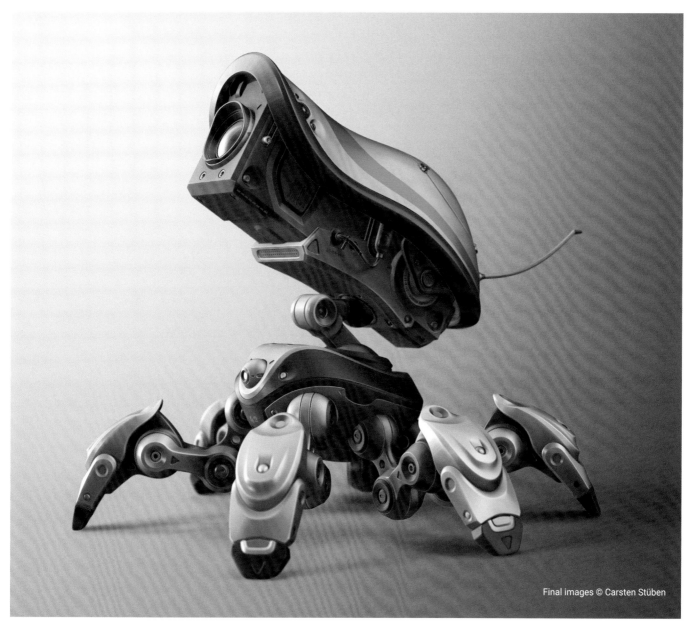

Final images © Carsten Stüben

▲ 76a The final render after compositing in Photoshop

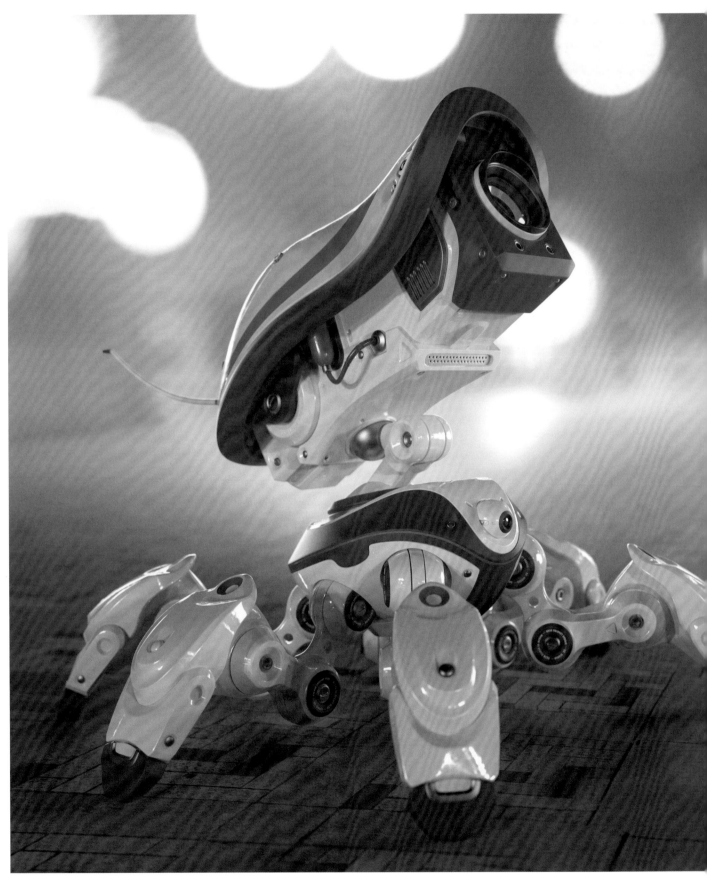

▲ 76b Final KeyShot renders

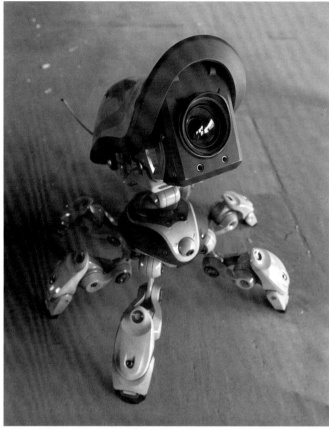

Final images © Carsten Stüben

Beyond ZBrush

The projects in this book have mostly focused on using ZBrush's native Best Preview Render (BPR) for generating your final images. However, if you are ready to introduce additional software into your 3D process, you can easily take your models a step further by rendering them with KeyShot. KeyShot's ease of use and high-quality results have made it a hugely popular rendering option for users of different 3D-modeling software. In chapter 06 Mohammad Hossein Attaran will cover the essentials of the KeyShot interface to help you get started in this great program.

Finally, we wanted to offer you an overview of 3D printing. Even people who haven't heard of ZBrush have probably heard of 3D printing – a process that seems to make something from nothing! But what is it and how does it work? 3D printing is a wide, complex field that advances faster than a book can keep up with, but in chapter 07 Raul Tavares and Matt Le Quesne will offer you some insights into the general process, introducing you to some key concepts of 3D printing and bringing Raul's character Kyra from chapter 03 to life as a resin figure.

06
Rendering with KeyShot

By Mohammad Hossein Attaran

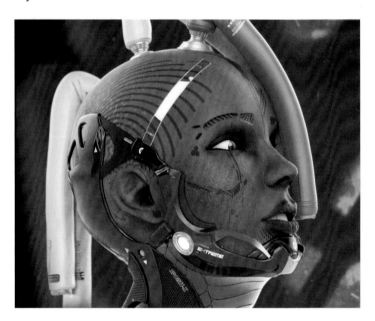

KeyShot is an essential piece of software for 3D modelers and 3D sculptors, especially those who don't want to get involved with complicated render engines and lighting settings. It is a very user-friendly program, so you shouldn't find anything too complicated or difficult. KeyShot has huge potential and can be used in commercials, architecture, jewelry design, product visualization, and many more fields requiring 3D rendering.

The software delivers beautiful renders for you in an easy-to-use way and is available in different versions. There is a standalone edition of KeyShot, which is compatible with many 3D packages, and KeyShot for ZBrush, which is an edition specific for ZBrush and ZBrushCore users. At the end of this chapter you should feel confident with the software and be able to easily make professional-looking renders for your portfolio. You will learn how to import your model into KeyShot, select suitable materials from KeyShot's rich library, select a lighting setup, and frame your model to create a strong composition. Then you can hit "Render" and enjoy the magic!

Chapter sections
- Getting started
- Materials and rendering
- Customizing your scene
- Advanced tips

Artwork © Mohammad Hossein Attaran

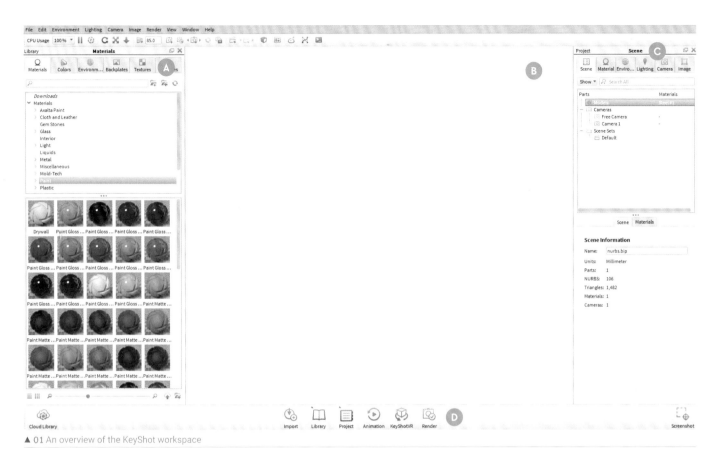

▲ 01 An overview of the KeyShot workspace

Getting started

01 The KeyShot interface
When you open KeyShot, you will be faced with the layout shown in image 01. There are four main sections of the interface that you will always work with:

A Library panel: the Library is used to assign materials, environments, backplates (see page 237), and textures to your model.

B Viewport: this is where you orient and manipulate your model and view the results in real time. What you see here will be very similar to your final image.

C Project panel: this is where you manage all of the assets in your project. You can edit everything you assign from the Library here. The panel includes tabs for materials, lighting, and environments, which you will learn more about later.

D Toolbar: you can easily import and render objects by clicking on the dedicated icons. You can also show and hide the Project and Library panels by using the respective buttons here.

02 Importing your model
To import your model into KeyShot, you can either use the Import button (Ctrl + I) or use the ZBrush to KeyShot Bridge to import your model directly from ZBrush (note that you will need to have installed KeyShot for this option to be available). ZBrush to KeyShot Bridge is very convenient, as all you need to do is activate the KeyShot option in ZBrush's Render > External Renderer menu. Then every time you hit the BPR button in ZBrush, you will see the result in KeyShot; it will automatically update the project every time you hit the button.

If you are not able to use ZBrush to KeyShot Bridge for any reason, you can export the model in OBJ format (Tool > Export) and open it in KeyShot manually. In the Import panel, go to Materials and Structure and set

▲ 02 Selecting KeyShot from within ZBrush

Group By to Objects so that KeyShot recognizes the ZBrush Polygroups as separate objects. This will enable you to work on the Polygroups individually and assign different materials and textures to them.

Note that this only works for the full, standalone version of KeyShot. If you have KeyShot for ZBrush – a more affordable version for use specifically with ZBrush – it will only import objects directly from ZBrush via the Bridge plug-in, or as a KeyShot scene file (BIP) or KeyShot Package (KSP).

03 Moving around

You can rotate the camera around your model simply by dragging the mouse cursor in the KeyShot viewport. You can also pan around the scene by dragging while holding the middle mouse button, and zoom in and out by using the mouse wheel. If your model consists of multiple parts, you can select each one separately by clicking on it while the Scene tab is active in the Project panel (see image 03). Here you will see a hierarchy of all the scene's contents. An orange outline appears around a part once it is selected.

04 Positioning your model

People often don't pay attention to floor grids in ZBrush, so you might find that your model is buried half underground when you open it in KeyShot. There is no ground or grid by default, but the shadows cast by your object show its location. To reposition your model, go to the Scene tab under the Project menu; under the Models list, you will find all your imported

▲ 03 Select a part from the Scene tab and the part will be highlighted in orange

objects and their subgroups. Select the ones you need to move, and go to the Position tab in the window beneath. Here you can apply the three transformation functions (Translate, Rotate, and Scale), either by manually entering parameters or by using a universal 3D gizmo,

just like that found in Autodesk's Maya or 3ds Max, and later versions of ZBrush. Activate the gizmo by clicking on the Move tool button under the Position tab. If you don't want to reposition your model manually, just press the Snap To Ground button for a quick result.

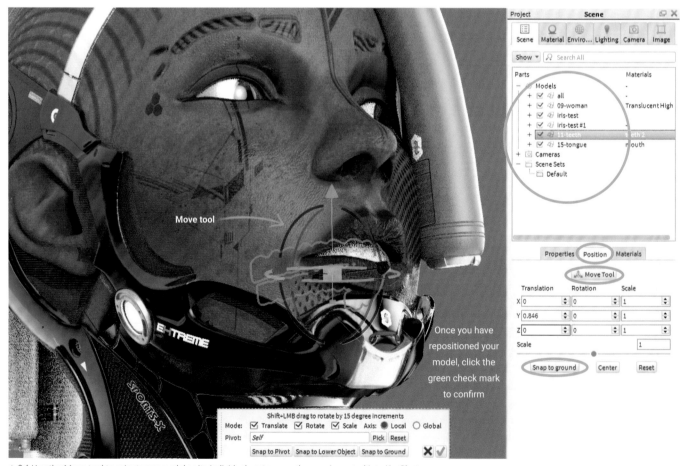

▲ 04 Use the Move tool to orient your model or its individual parts, once they are imported into KeyShot

▲ 05 Selecting materials from the Materials Library

▲ 06 Some of the default KeyShot lighting options

▲ 07 The Render options, where you can set the file path and dimensions of your final image file

Materials and rendering

05 Assigning materials

Once you have imported your model, you can begin assigning the desired materials to each part. Materials are sorted into numerous groups (such as Glass, Metal, and Plastic) so you can easily find the type you want. It is also possible to search for a specific material by using the search bar in the Materials tab.

You can assign materials simply by dragging the material thumbnail from the menu straight onto the object in the viewport. You can preview the result while you are holding the cursor over the object. If you don't like how it looks, just release the material over a blank area of the viewport and choose another one. You can find almost every material you can think of in KeyShot's Library; feel free to play around and have fun with them.

06 Lighting environments

You can change the scene's lighting conditions by choosing an HDRI from the Environments tab in the Library. The HDRIs are sorted into categories just like the materials, and simulate various diffused lights and light boxes. There are many studio lighting presets in the Library, but don't worry if most of them look the same to you; choose one for now and we will discuss the options in more depth later (see step 17).

07 Rendering an image

Now that you have applied materials and chosen your lighting, you can render the project. Click on the Render button in the main toolbar along the bottom of the interface. In the Still Image tab, set a filename, destination folder, and format for the output. You can enter the resolution specifications manually or by choosing from a list of presets. If you plan to print your final image, remember that resolution and print dimensions are dependent on each other.

In the Passes section, choose your desired render passes – these are different 2D layers

235

of information that are generated from your model at render time, and are used in compositing to provide fine control over the look of your image. The Depth Pass and Clown Pass are essential for doing post-work in Photoshop: you can use the Depth Pass in post-processing to add focal effects or create fog, while the Clown Pass enables you to easily select different parts and work on them separately. Now just hit the Render button and wait for the render to complete.

Customizing your scene

08 Adjusting materials

KeyShot gives you a chance to edit the materials if you can't find the perfect ones for your project in the Library. Once you have applied materials to the scene, double-click on an object to go to its Material edit panel, or just open the Materials tab from the Project > Scene panel and double-click on the material you want to edit in the lower panel (image 08a).

You can then adjust the material under its Properties tab (image 08b). These properties are more or less unique to each material. Try tweaking the Roughness and Refraction Index sliders to see the results. I am personally a fan of the Mold-Tech material, which is perfect for hard-surface subjects.

09 Applying textures

You can set the textures for your model in the Textures tab in the Project > Material panel. Simply drag textures from the Library to the desired texture boxes as shown in image 09 (Texture, Specular, Bump, or Opacity), or just import your own by double-clicking on the boxes. If there is a UV map available for the object, select UV Coordinates from the Mapping Types dropdown menu. Otherwise select a mapping template that best suits the shape of your object, such as Box Map, Spherical, or Cylindrical (Box Map is a generally reliable fallback for most models). Some materials, such as Mold-Tech, come with

▲ 08a Selecting an existing material to edit

▲ 08b Making changes to an existing material

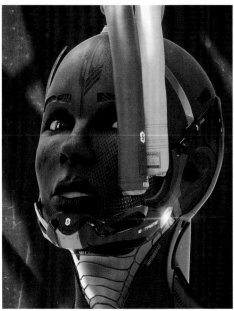

▲ 08c You can customize your own KeyShot materials

▲ 09 Apply a texture or UV map using the Textures menu

diffuse or bump maps by default, which you may need to modify or switch off (you can use the trash can icon next to the Texture dropdown to delete a map you don't want).

10 Adjusting environments

You can easily manipulate the HDRI environments to achieve better lighting results for your scene. At the top of the Environment

▲ 10 Adjust your HDRI using the sliders

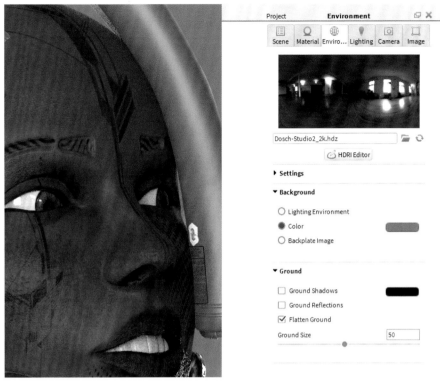

▲ 11 You can change the background of your scene to a solid color or a backplate image

tab, the current HDRI is shown in a box, and there are four sliders beneath it (see image 10). If the scene is too bright, simply adjust the Brightness slider; if it lacks highlights you can improve this by increasing the Contrast. The Size slider determines the environment size if you are using the environment as a background. If your HDRI seems to be in the wrong position, you can rotate the environment and set its height with the last two sliders. During these adjustments, you can check the changes in the preview box (see the area circled in image 10) and see the effects in the scene simultaneously.

11 Background

In the Background section of the Project > Environment tab, there are three choices of background for your scene. This is set to Lighting Environment by default, but you can change it to a solid color (in the case of that shown in image 11, red) or a backplate image. Backplate images are flat backdrops that don't affect the scene's lighting or reflections, unlike HDRIs. You will find a small collection of backplate images in KeyShot's Library, or you can import your own. In the

▲ 12 Creating a new camera in the Camera tab

Ground section of the tab, you can turn the Ground Shadows and Ground Reflections on or off as needed; reflections on the ground usually work well for commercial shots.

12 Camera angles

You may have multiple angles in a scene that you want to render. Cameras are used to save these views for returning to in the future. This way you can play around with setting the scene's materials, environments, and so on, then return to your camera view to check the results. Navigate the viewport until you are happy with the view, then go to the Project >

Camera tab and click on the camera with a plus icon in the top box. Now you should have two cameras in the list. Click the lock icon on the right-hand side of this new camera to freeze its position and save that viewpoint for later.

▲ 13a Customize your camera's position and view

13 Camera settings

There are additional parameters which allow you to customize a camera view in more detail. Select a camera from the list, making sure it is not locked. Under the Position and Orientation section, set the camera's position using the four sliders, then adjust the camera lens properties in the Lens Settings section (images 13a and 13b). Note that the Perspective/Focal Length and Field Of View sliders are relative to each other, and using the Orthographic camera mode will disable these adjustments. Under the Image tab, you can change the resolution and aspect ratio of the frame (image 13c).

Advanced tips

14 Labels

If you would rather have no textures than UV-unwrap an object, this feature is for you! Labels are an amazing feature of KeyShot, enabling you to add multiple graphics (such as logos and decals) to an object without worrying about the UVs and textures. Select a material from the scene and go to the Project > Material > Labels tab. To add the desired image you can either click on the plus icon (circled in image 14a), drag and drop the image into the Label list, or drag and drop it directly onto the object

itself, selecting Label from the pop-up menu that appears. The image will immediately appear on your model using the default Normal Projection – to reposition it, all you need to do is click on the Position button and then drag the label across the surface of your object to where you would like it to be. When using Normal Projection the label will always align itself to the position of the camera, so it is best to line up your model in the main viewport first. You may need to use a different Mapping Type depending on the shape of your model.

Once the label is roughly in position you can use the sliders to change the angle and scale, if need be, and make fine adjustments to the X and Y position. To finish, click on the green check mark in the little floater window. If you don't want the label to show on the opposite side of your model, either uncheck the Two Sided toggle (which you will find if you scroll down the Labels tab a little), or change the Depth slider to a lower figure.

15 Light sources

As well as lighting by HDRI, KeyShot allows you to insert local light sources into the scene. Emissive (light-emitting) materials are easy to make in KeyShot; it is common to import spheres or planes into KeyShot and assign one of the Light materials to them (like you did in step 05 but this time by selecting a material from the Light material family) – almost like a studio photographer's lamps. Area Light materials shine and can add glow to the scene, while IES Lights mimic the properties of real-world light fixtures and are ideal for interiors. Uncheck the Visible to Camera option to hide the light source in the final render.

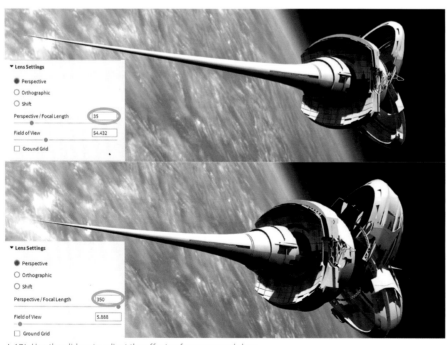

▲ 13b Use the sliders to adjust the effects of your camera's lens

▲ 13c Change the size of your image's frame here

▲ 14a The Labels function offers an easy way to add stickers and decals

▲ 14b The result of applying various labels to an object in KeyShot

▲ 15 Applying light-emitting materials is a simple way of turning imported objects into local light sources

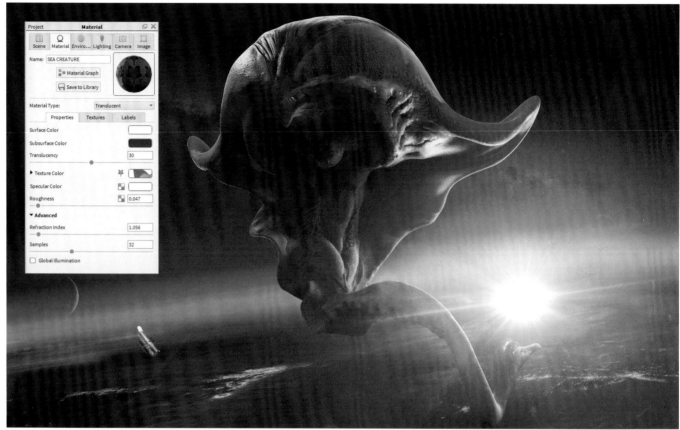

▲ 16 Use a material with sub-surface scattering to add realism to your lighting, especially for organic subject matter

16 Sub-surface scattering

The ideal material to use for organic subjects is one with sub-surface scattering. Sub-surface scattering is an inner glow generated by light passing through a translucent surface – it is especially noticeable with extremities such as the ears or fingers. You can find this type of material in the Translucent material family in KeyShot. There are two human skin templates available, but through trial and error I have settled on the one called Translucent High, as I have found that it works better than others for models like that shown in image 16.

You can import your own diffuse and bump textures, and adjust the Roughness and Refraction Index of the material. It is also possible to control the strength and color of the scattering effect using the Translucency slider and the color selection boxes.

17 Advanced lighting

Let's delve deeper into lighting. Despite all of the environment controls you have learned so far, they are just not enough sometimes. There may be some dark areas or bad highlights, and these problems can be especially noticeable on reflective surfaces. In these cases, you have to manually manipulate the HDRI.

Click on the HDRI Editor button below the viewer box in the Project > Environment tab (image 17a). KeyShot gives you more advanced color and orientation controls in the Adjustments tab, but the best feature available here is the Pins tab (image 17b). Pins are additional light sources that you can place onto your HDRI. Click on the plus icon to add a new pin to the map. Now keep dragging it while keeping an eye on the result in the viewport. You can adjust the pin's settings (such as Shape, Size, Angle, Falloff, Color, and Brightness) using the control sliders. Images 17c and 17d show how pins can be used to enhance the mood of a scene.

▲ 17a Make changes to HDRIs with the built-in editor

▲ 17b The Pin tool enables you to add extra light sources to your HDRI

▲ 17c The default HDRI lighting doesn't really match with the background

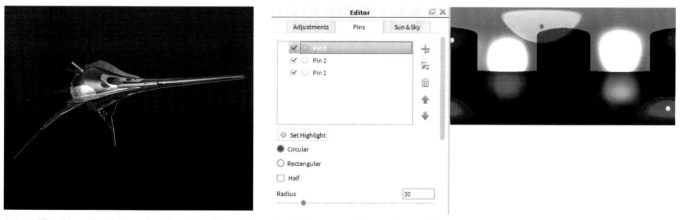

▲ 17d Adding three colored pins makes the end result more dramatic and in keeping with the overall look of the scene

▲ **18a** Synchronizing the background and Sun & Sky lighting together makes everything look logical

▲ **18b** Use Match Perspective to set up your camera

18 Sun and sky lighting

Most of the environment lighting presets in KeyShot create soft, diffused shadows. But what if you need to create sharp shadows with cast sunlight? The good news is that KeyShot has a great tool called Sun & Sky.

You can access the Sun & Sky tab from the HDRI Editor. It is a smart tool that simulates outdoor lighting scenarios perfectly. You can choose a particular city from the list, or just enter its coordinates manually, and KeyShot will simulate the sun's position for that location.

You can also set an accurate time by using the Time slider. Just click the Generate HDRI button to see the result. This tool is perfect for creating natural golden light for a sunrise or sunset scene (image 18a).

To try this for yourself, first choose one of the default backgrounds from the Library. Click on the Match Perspective button and edit the camera's direction (image 18b). Then change the Ground Shadows color if necessary.

If you look at image 18c, it is obvious that there is something wrong with the shadows: the shadows cast by the object are not consistent with the shadows in the background. To fix it, you have to guess the hour of the day and the sun's altitude in the sky from the shadow of the column in the background, and try to simulate it with the HDRI Editor (image 18d). You then just need to set the sun's direction by rotating the environment.

As you can see in image 18e, the shadows are much more consistent throughout the image.

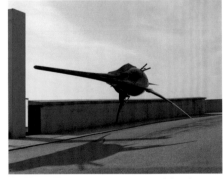

▲ **18c** Shadow mismatch between model and image

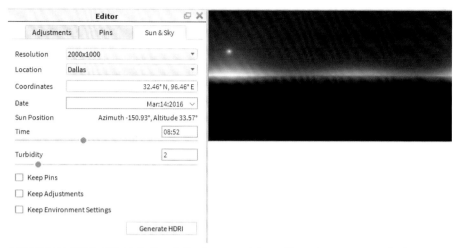

▲ 18d You can choose from a selection of cities from around the world, or enter your own coordinates

▲ 18e Success! The shadow cast by the model matches the backplate, making it feel part of the image

PRO TIP

Ideal reflections

You have already learned some of the methods for adjusting an HDRI in order to get the best reflections and lighting, but it is not always easy to get there using KeyShot alone, especially in scenes with numerous shiny objects. If a single lighting setup is not quite sufficient for your model, try compositing together multiple versions. For the cyborg woman below, for example, I rendered the scene a few times, each time with unique HDRI settings (for example one that creates the best eye reflections, and one that works best for the metallic parts). Then I combined all of them in Photoshop using Clown Pass as a mask. This created a final image with better reflections than you could otherwise achieve in one pass.

▲ Render several passes for the best results

19 Limiting CPU usage

If you want to continue using your computer while KeyShot is busy rendering in the background, you may wish to limit the CPU cores the program can use. This will prevent lag in other tasks, enabling you to carry on working while KeyShot does its thing. You can do this via the CPU Usage dropdown menu (see image 19). You can also pause the real-time viewport rendering to temporarily free up CPU usage by clicking the pause button on the right-hand side of the CPU Usage dropdown. And remember, a smaller viewport will resolve much more quickly than one running full-screen.

▲ 19 If you want to multi-task while rendering, limit KeyShot's CPU usage to save processing power

20 Keep practicing

There are some things in KeyShot that you can only learn by experience because they will be down to your own tastes, like the ideal number for a material's roughness, or which HDRI is best for particular scenes. You will learn more as you keep working with it. The images shown here were all rendered using KeyShot.

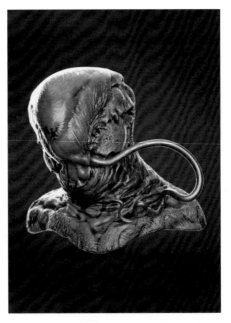

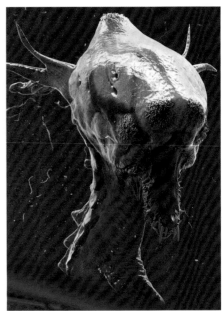

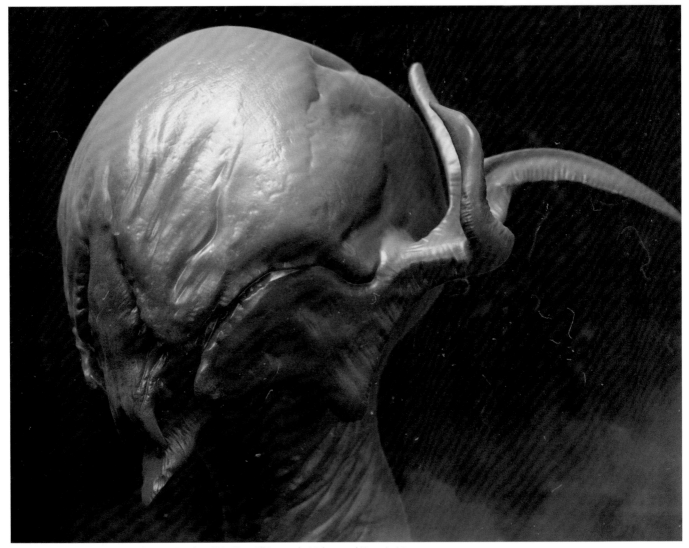

▲ 20a Creature concepts created using ZBrush and KeyShot. All images by Mohammad Hossein Attaran

▲ 20b Another creature concept created using ZBrush and KeyShot. Image by Mohammad Hossein Attaran

07
Introduction to 3D printing

By Raul Tavares

3D printing has come a long way since its conception in the early 1980s, and we have only yet seen a fraction of what it has to offer. From 3D printing entire houses, to aiding in kidney transplants, its uses and applications grow exponentially every day, so this is the perfect time to jump in and try it.

In this chapter we will look briefly at the history of 3D printing, its common uses, and some of the technical aspects to consider when choosing a printer or making an object for print. Finally, Matt Le Quesne will walk us through the process of 3D printing a model you may recognize from an earlier chapter.

Chapter sections

- An overview of 3D printing
- What you need to consider
- The 3D printing process

▲ A 3D printed figure by digital sculptor James W. Cain (jameswcain.co.uk)

An overview of 3D printing

What is 3D printing?

For those of you unaware of how it works, 3D printing is the process of transforming a digital model, properly adapted for that purpose, into a three-dimensional physical object, through an additive (layer by layer) procedure carried out by a 3D printer. There are several types of printers, techniques, and materials for this purpose.

3D printing requires a digital file which is read by a 3D printer and then divided into layers. The printer then translates the digital file into a physical object by converting the several digital layers into three-dimensional layers. At this stage the process may be different depending on the technology applied by the 3D printer: it can range from the melting of a plastic material to more advanced techniques such as using a laser or digital projector to melt a metal powder. The printing time varies according to

the size and complexity of the model, the type of technology applied, and the 3D printer used.

Evolution of 3D printing

Although the concept of 3D printing has now seen a lot of attention and become rather familiar, it has in fact existed for decades. Chuck Hull is the "father" of 3D printing and the STL file format, developing and patenting the first 3D printing process, which was called "stereolithography."

The process has been improved over the years but, given the patents and high costs involved, 3D printing was mostly limited to an industrial level until the late 2000s. Then, in 2009, some of the major patents started to expire, allowing the general market to have access to this technology. This knowledge dissemination led to a considerable reduction of the learning curve for 3D printing, and to a much faster development of several different types of 3D printers.

As the market (and interest) has grown and sales have increased, prices have fallen

considerably. The increase in demand (and subsequently production) has led to the emergence of more practical, smaller, and mobile equipment, which in turn has broken down the "barrier" that used to limit 3D printers to an industrial environment. Now 3D printing technology is easily accessible to small companies and even the individual consumer.

3D printing for a ZBrush artist

3D printing is used across several industries and for many varied purposes. We are still only scratching the surface of the growth and applications of this technology. 3D printing is an area with massive potential and is now an essential tool for many fields, from the creative industries (such as creating toys and collectibles) to scientific sectors (such as for medicine and engineering). Uses for 3D printing include: prosthetics, jewelry design, sculpture, the prototyping or manufacturing of new concepts, products, and tools, and creating spare parts for DIY projects and repairs.

A 3D printer is a strong ally for ZBrush artists because it allows them to visualize their

creations in a real material and a physically three-dimensional way, which is useful for correcting errors, optimizing shapes, improving processes and workflows, and ensuring a faster learning experience. With a 3D printer at their disposal, a ZBrush artist can, for example, rapidly prototype a sculpt of a character, find and fix errors before sending the final file to a client, and thus reduce costs as well as increase the speed of the project's development. This is, of course, only one of many examples of its usage. In fact, anything designed in ZBrush can potentially be printed to help visualize the final product.

In addition, a 3D printer can even allow for a ZBrush artist to develop and sell their own work without the need for intermediaries, enabling them to build an industry name, create a new revenue stream, and develop a close relationship with their target audience. An excellent example of this can be found with the artists Jon Troy Nickel and Layna Salazar (ihaztoys.com), who left their careers at WETA Workshop to dedicate themselves exclusively to the development and commercialization of collectibles.

Another great example is the use of ZBrush to design affordable 3D-printed prosthetics, as is done by Jonathan Shaller and the e-NABLE organization (enablingthefuture.org). In the past few years, e-NABLE has helped to create thousands of free 3D-printed hands and arms for children and adults in need of assistive prosthetics.

What you need to consider

How to choose the right 3D printer

With the recent boom and rapid development of the 3D printing industry, there are now hundreds of different printers available on the market. Although this growth has a positive effect on the quality and evolution of the 3D printing scene, it also makes it difficult to choose the most appropriate equipment.
There are a few key points to consider to

ensure an appropriate choice (besides your budget, which is an obvious start). You must take into account the printer's intended use. If the user has little experience in the 3D printing field, it would be wise to buy a 3D printer that is intuitive and user-friendly. If the end user is a professional company where quality and accuracy is of the utmost importance, they should consider a more advanced range.

The printer's technology and its advantages and disadvantages must also be taken into account. In 3D printing, there are two main technologies used: FDM (fused deposition modeling) and SLA (stereolithography), which we will look at in more detail next.

ASK YOURSELF

What is your budget?

What size prints do you want to make?

How experienced are you?

What materials do you wish to print with?

What is the intended purpose of the prints?

FDM or SLA printing?

Let's compare FDM and SLA printing, the two main types of 3D printing mentioned above. In FDM printing, the material used (thermoplastic) is heated to become moldable. It is then printed in layers, from the bottom layer upwards, on the printer platform bed. Ultimaker and MakerBot are two of the most popular brands of FDM printers on the market.

The SLA process is also additive, but instead uses a curable photopolymer (usually liquid resin), which is hardened using a laser or a digital projector that emits a UV light. In most smaller domestic printers, this typically involves the model being lifted upside down

from a tank of resin, being cured as it goes. Formlabs' Form series is a popular make of SLA printer.

FDM printers usually allow for greater flexibility when it comes to the material choice, since there are several types of filaments made from different materials (such as ceramics, metals, and carbon fiber). These are normally available in a large variety of colors. In addition, the cost of printing with FDM printers is considerably lower than SLA printers.

SLA printers have a very limited choice of resins, which are only available in four colors (black, white, gray, and clear resins) and cannot be interchanged between different printer models. The maintenance costs of an SLA printer is higher because the resin tanks have to be changed every two or three liters of printed resin, and the construction platform must also be changed regularly.

However, 3D printers with SLA technology can offer 3D impressions with higher precision and resolution, as well as smoother surfaces. These printers also have fewer problems and errors during the printing stage. SLA printers such as Formlabs' Form 2, which we will see more of in the next section, enable ZBrush artists to create high-quality prints of their work at home.

IMPORTANT CONSIDERATIONS WHEN SCULPTING AND EXPORTING FOR 3D PRINT

While sculpting should be done without restrictions that limit your creativity, there are some important considerations when your end goal is a 3D print with real-life constraints. Here is a brief list of things to think ahead for when sculpting for print:

- **Thinking about material.** Plan or ask ahead what material your sculpt will be printed in, so that you can design it to fit the specific rules of the material.

- **Making sure it is watertight.** To prevent errors and waste, the 3D mesh has to be watertight, meaning that if you were to dive your model in water it would be waterproof. Any holes need to be closed. Software like Autodesk's Meshmixer or Netfabb help you find these holes and fix them for you.

- **Merging, slicing, keying, and hollowing.** Usually models consist of several SubTools inside ZBrush. In order to print a model, it is typical to combine all the parts, find the appropriate places to slice the model, create "keys" so that the pieces will fit together, and make all the parts hollow. This basically cuts down on 3D printing costs as the model is not solid. In some cases, hollowing the model yourself might not be necessary because the printing software might have an option to create hollowed interiors.

- **Using Decimation.** ZBrush's brilliant Decimation Master can drastically reduce polygon count without compromising quality. This needs to be done because most printing services or home printers need printing files (usually STL files) that are in the range of 100 MB in size. If your sculpt has millions of polygons it is more than likely that it will go beyond that value.

- **Using Fix Mesh.** Under ZBrush's Geometry menu, there is a sub-menu with two options: Check Mesh Integrity and Fix Mesh. These will find and fix some topology errors. If Netfabb or Meshmixer cannot fix your mesh's errors for some reason, try running these options before exporting your files.

- **Exporting.** Using the 3D Print Exporter (ZBrush 4R7) or the most recent 3D Print Hub (ZBrush 4R8), make sure you update your size and choose either millimeters or inches and then define the final size. Choose if you would like to export all the SubTools, visible SubTools only, or just the selected SubTool, and then the file type required by the printer (usually STL).

▲ Progress shots of *Gibson Girl* by James W. Cain (jameswcain.co.uk). From left to right: the cleaned-up 3D print, the print after spray-painting, and the finished figure

The 3D printing process

By Matt Le Quesne

In this section, we will cover the process of taking a 3D model from STL file to finished 3D print. The 3D printer used here is Formlabs' Form 2, an SLA printer that uses a 250 mW laser to cure resin layer by layer, resulting in a highly detailed printed model.

01 Print settings
To begin, the print's resolution is set to 0.05 in PreForm, Formlabs' print preparation software. This resolution carries enough detail for the character without increasing the risk of print failure.

02 Importing the STLs
The character's STL files are imported into PreForm. In image 02, you can see that the artist has split the character into parts that will be easier to print, and created square "keys" so they can be pieced together afterwards.

03 Rotating parts for the best finish
When creating a 3D print you need to support your model, as the printer cannot print sections floating in space. The printing software will

▲ 01 Set the resolution of the print

therefore automatically generate supports (the scaffold-like structures shown in image 05) in order to print the model, but you can adjust the orientation of the pieces to influence where the supports appear and minimize their effect on important parts of the model. For example, you wouldn't want supports coming out of the character's face, as they can leave blemishes on the surface of the model. In order to combat these, each piece needs to be aligned so that the supports will be hidden when the model is assembled. For this model, the supports will connect to the backs of the legs and body,

and the insides of the arms, thus reducing the chance of blemishes on the more visible parts of the figure. Printing the pieces at an angle will also help reduce the effect of layer lines.

04 Scaling the print
In order to make the best use of the available print area, the model is scaled to the desired size while leaving enough room between model parts for generating supports.

05 Generating supports
In PreForm, when the layout is finished, supports

▲ 02 Import the character model

▲ 03 Rotate the parts into a better position

can be automatically generated, and these are represented graphically within the software. The print can now be laid out efficiently on the print bed, with the user taking care not to let any models or supports intersect.

06 Sending the project to the printer
Once the layout is finished, I save the project, then send the file to the printer over Wi-Fi.

▲ 04 Scale the model to a larger size, filling up the print area

▲ 05 A preview of the supports as they will be printed

▲ 06 Send the model to print

▲ 07 Check the printer is ready for use

07 Preparing the printer

Before the project can be printed, it is important to check that the print platform of the Form 2 is clear and locked into place, that the protective cover is closed, and that the cartridge cap is open to allow air into the cartridge as it empties.

08 Starting the print

Now that the printer is ready, the project is selected using the printer's on-board display, and the printing process is started. As you can see in image 08, this model will take several hours and a few hundred layers to be completed.

09 File printing in progress

Once the resin has been heated to its optimal temperature (31°C), the platform is lowered into the tank, where the laser cures the resin,

▲ 08 The file is ready to print – it will take nearly eight hours

▲ 09 The printing process beginning

▲ 10 The final print, still attached to the printing platform

▲ 11 The separate pieces after removal from the printing platform

forming the shape of the first layer. Between each layer, the wiper crosses the resin tank to clear any floating pieces of resin.

10 Finished print on print bed

Once the printer has finished all the layers, the printing platform rises up. After most of the

excess resin has dripped back into the tank, the printing platform can then be removed from the printer. In image 10 you can see what the print looks like with the supports still attached.

11 Removing the print from the print bed

After any remaining excess resin is wiped

from the printing platform, the print can be separated from the support base, using flush cutters to get under the edge of the base.

12 Initial rinse

The raw print is placed into a tub of isopropyl alcohol (IPA) which cleans excess resin from the surface of the print. This is the "dirty" IPA bath which will contain any resin that is washed from the surface of the model. The model can be left to soak for five minutes.

13 Removing supports

To begin removing the supports, the print is taken out of the IPA bath and carefully patted dry with a paper towel. Most supports detach cleanly, although some can require the use of flush cutters to remove them.

14 Soaking

The print is returned to a clean IPA bath for a further fifteen minutes to clean off any remaining residue.

▲ 12 The model soaking in an alcohol bath

▲ 13 The supports can now be removed

▲ 14 A second bath in IPA further cleans off the model

15 Cleaning the surface

After removing the model and letting it air dry, any rough surface detail left over from support removal can be removed.

16 Final print

The final model is then assembled, ready for finishing. This model could now be painted or airbrushed, for example.

17 45-mm miniature

It is possible to print the same model at different scales. Images 17a and 17b show a 45-mm miniature version alongside the final full-sized print – just the right size for a tabletop game character.

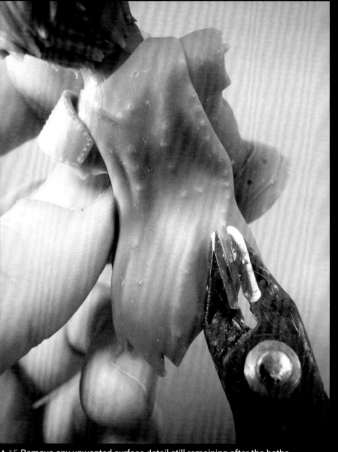

▲ 15 Remove any unwanted surface detail still remaining after the baths

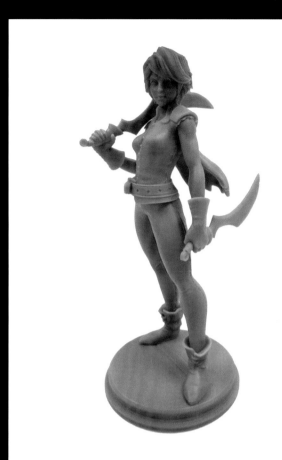

▲ 16 The finished print, all pieced together

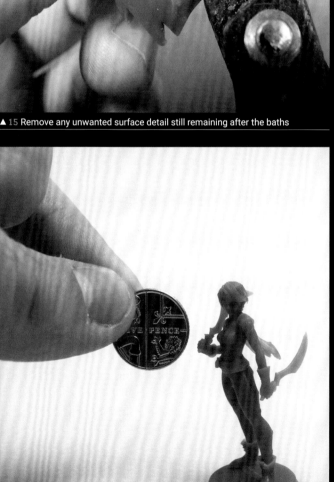

▲ 17a A 45-mm miniature version with a five pence coin for scale

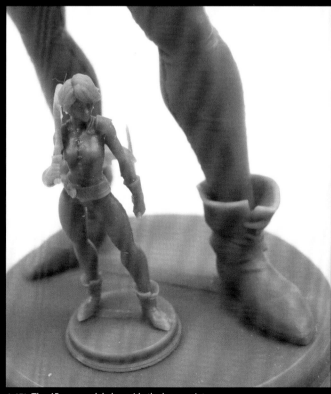

▲ 17b The 45-mm model alongside the larger print

Glossary

Alpha

A grayscale image that can be used to add painted or sculpted textures and effects to your model via the Alpha panel. The closer the alpha "map" is to white, the more the effect will be seen.

Backplate

A flat image that can be used as a background in KeyShot. Unlike an HDR panorama, a backplate does not affect a scene's lighting.

Bump map

A texture map (see next page) used to simulate irregular surface height on a 3D model, such as lumps, debossing, and wrinkles.

Composite

The process of putting together and editing your final 2D image using the render passes of your 3D model. This is usually done in Photoshop.

Diffuse map

A texture map containing the raw color or painting of a 3D model.

DynaMesh

An essential ZBrush tool that evenly redistributes polygons across a model's surface, helping to resolve any problematic distortion of your geometry that may occur as you sculpt.

Edge

A line connecting two points or vertices.

Edge loop

A continuous line of edges that loops around the model and meets back on itself.

Polygon

A closed 2D shape comprised of at least three points (vertices) joined together with three edges, creating a polygonal face. The visible surface of your 3D model is comprised of polygons. When modeling in ZBrush, it is ideal to use four-sided polygons, also known as quads.

Polygon loop

A continuous ring of polygons that loops around the model and meets back on itself. Sometimes referred to as a "Polyloop" in ZBrush.

Polygroup

Polygroups are a way to break a model down into sets of polygons, allowing you to isolate certain areas to work on.

Polypaint

A ZBrush texturing tool that allows you to apply color to a model.

Material

In 3D modeling, the material a model is made of that determines how the model reacts to light.

Mesh

Any polygonal model. In ZBrush, your ZTools and SubTools are meshes.

n-gon

A polygon with five or more vertices (a polygon with "n" number of sides). ZBrush cannot use these and will convert any model being imported into triangles and quads.

Quad

A polygon with four vertices and four edges. Most polygons in ZBrush should ideally be quads.

Render pass

A 2D image generated by rendering. Each render pass contains a layer of information about your 3D model, such as its color, shadows, or lighting. Render passes are used to create the final 2D image, in a process called compositing.

Specular map

A texture map containing information on the model's highlights and surface shine.

Subdivision

A process that divides polygons in order to produce a higher-resolution mesh to work with.

SubTool

SubTools, like Polygroups, offer a way to organize a mesh and isolate different parts to work on. Unlike Polygroups, SubTools are individual meshes that can be re-arranged, edited, or deleted via the SubTool menu.

Texture

In 3D modeling, a pattern or color added to the surface of a model.

Texture map

A 2D image that can be imported and wrapped around a 3D model based on UV coordinates.

Triangle

A polygon with three vertices and three edges, sometimes nicknamed a "tri."

Topology

This is how the polygons and edges flow together to make up a polygonal mesh. Good or "clean" topology flows in natural lines, like muscles, and makes the model easier to deform for posing or animation. To achieve this, it may be necessary to "retopologize" your mesh.

World center

This is the very epicenter of the "world space," the area in which you are working and modeling in ZBrush.

ZTool

A name used in ZBrush to describe the project files you can drop into your scene, like primitive shapes and proprietary tools such as ZSpheres. A ZTool may consist of multiple SubTools.

Component index

On the following pages, we have provided labeled "maps" of each finished sculpt, indicating the tutorial step numbers for the various parts of each model. On the opposite page, for example, you can see that the steps covering the character's legs are 07, 08, 16, and 25 in chapter 03.

We have not labeled every step of the process, as many parts are built up gradually, but if you need a quick refresher on modeling a particular body part or accessory, we hope you find these visual guides useful.

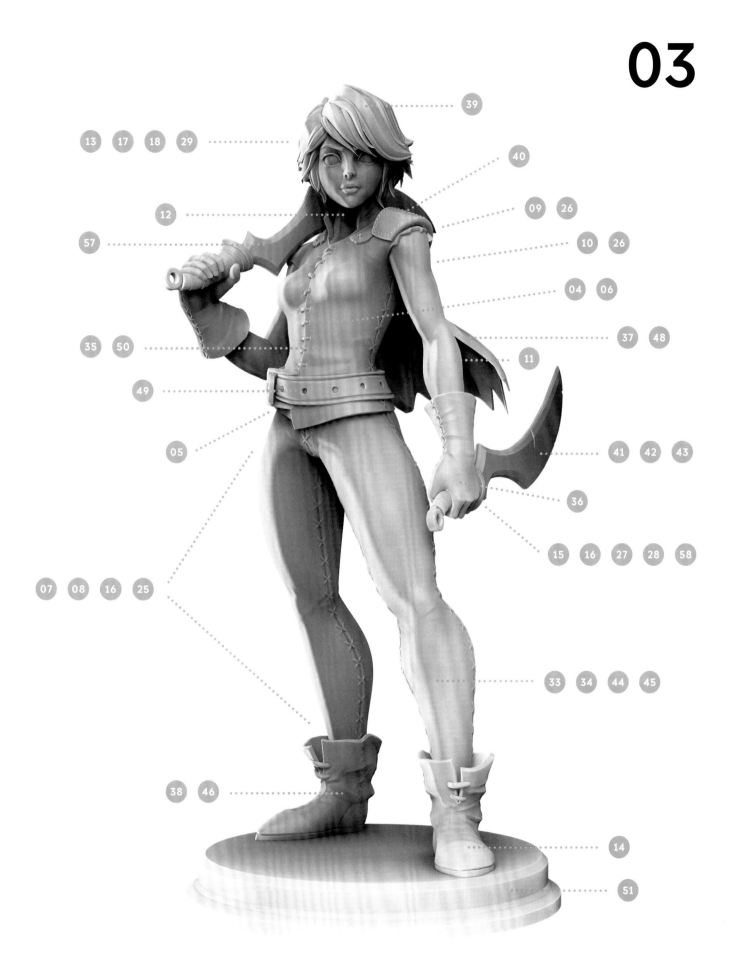

39

13 17 18 29

40

12

09 26

57

10 26

04 06

37 48

35 50

11

49

41 42 43

05

36

15 16 27 28 58

07 08 16 25

33 34 44 45

38 46

14

51

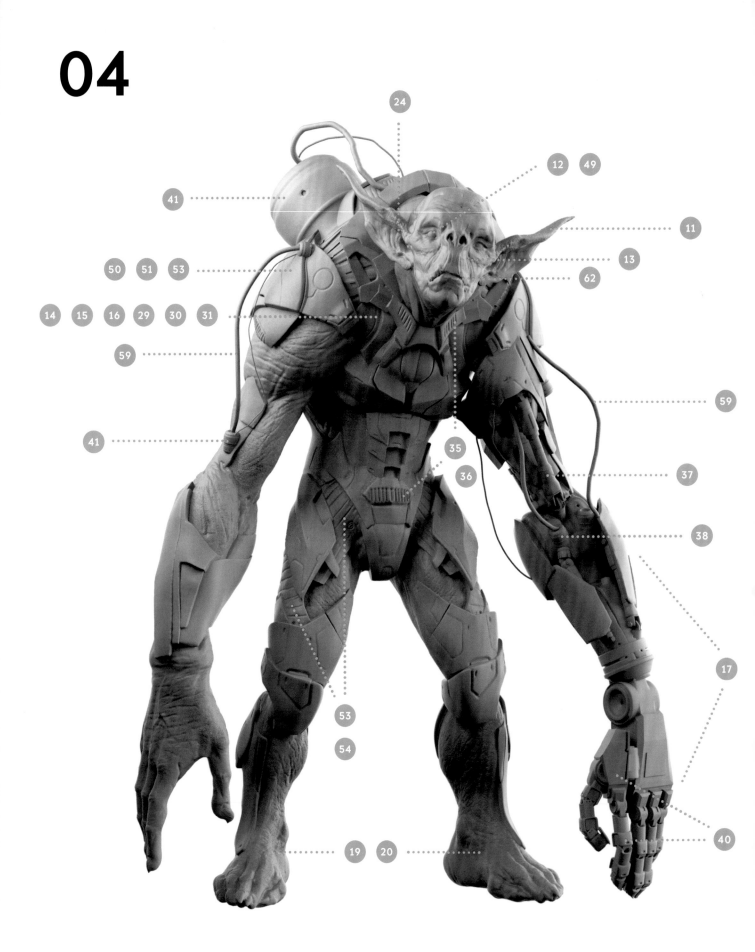

05

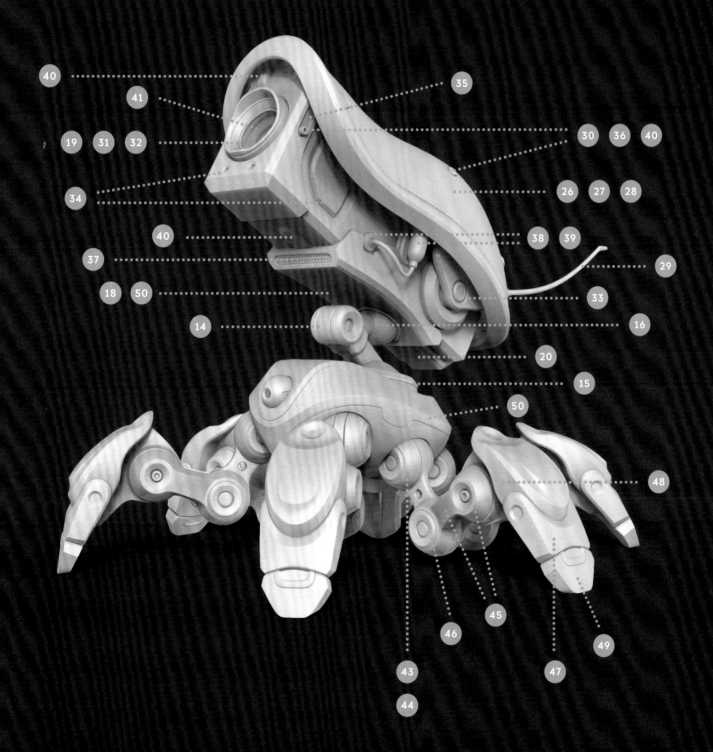

40
41
35
19 31 32
30 36 40
34
26 27 28
40
38 39
37
29
18 50
33
14
16
20
15
50
48
45
46
49
43
47
44

261

Index

In this index, as well as general terms, you will find the locations of the Key Concepts from throughout the book highlighted in orange. The Key Concepts refer to useful tools, essential ideas, and important techniques that a ZBrush user should take the time to experiment and practice with.

A

B

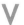

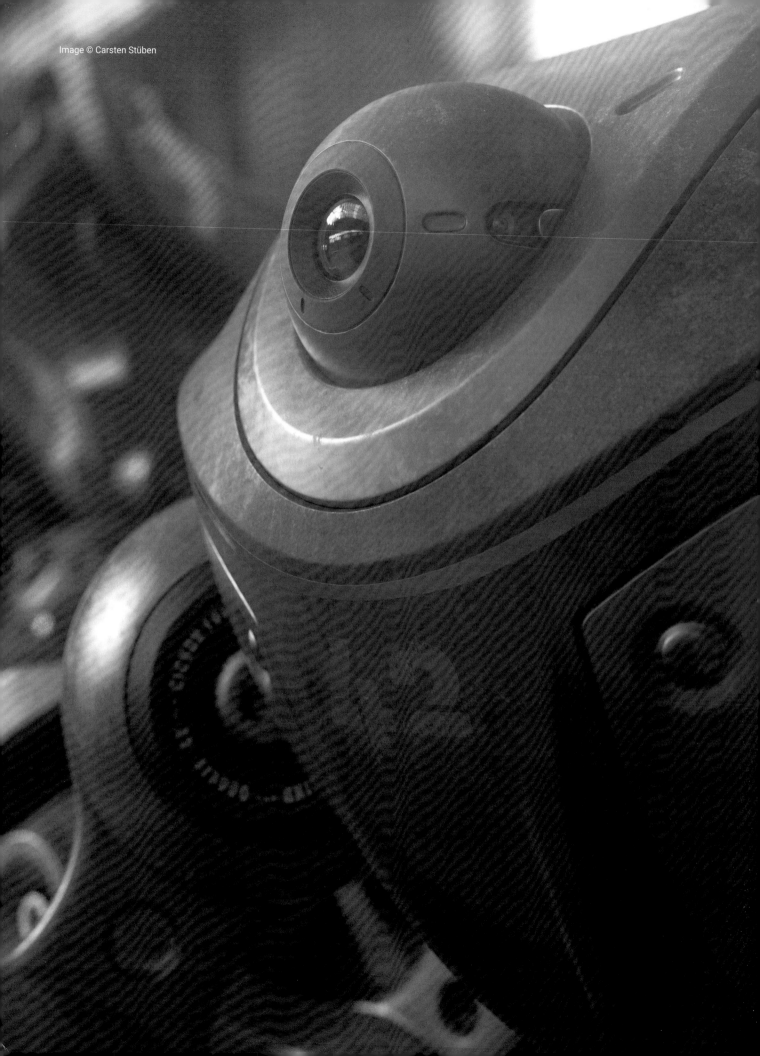

Contributors

Ruben Alba
Freelance concept designer | rubenalba.com

Ruben Alba is a Spanish concept artist based in the Netherlands. He has been involved in film and video game projects in his several years of experience in the entertainment industry, working for companies such as Blur Studios and The Aaron Sims Company, among others.

Mohammad Hossein Attaran
Mechanical concept designer, character artist, and director | mhattaran.com

Mohammad Hossein Attaran is a 3D artist based in Iran. A BS in Mechanical Engineering and an MA in Animation Directing give him the expertise required to create believable mechanical creatures. He is also the founder of Teamcheh Art Studios.

Matt Le Quesne
Digital designer | southerngfx.co.uk

Matt Le Quesne is a Cheshire-based (UK) 2D and 3D designer, specializing in the technical modeling of assets used in motion graphics for film and television. Matt has worked on a wide range of projects for companies including Sky, Sainsbury's, and Nike.

Glen Southern
Director, SouthernGFX | southerngfx.co.uk

Glen Southern runs SouthernGFX, a small studio with clients including Sky, Nike, Sainsbury's, Adidas, ATI, Screen Scene, Disney, Lego, Pixologic, and Wacom. He has been using and training people in ZBrush in the UK for over fifteen years and is a Wacom Ambassador for the UK and Ireland.

Carsten Stüben
3D artist and designer | carstenstueben.com

Carsten Stüben is a designer and 3D artist based in Germany. He loves sci-fi design – creating vehicles, environments, props, and characters – and ZBrush has become his favorite tool for realizing his ideas from the initial sketch to the finished project.

Raul Tavares
3D character artist | art.artstation.com

Raul Tavares is a Portugal-based freelance artist specializing in creature and character creation for any medium: television, film, video games, cinematics, and collectible figures for print. He loves art, games, and film, and is always trying to push his personal boundaries.

ZBrush Characters & Creatures

ZBrush Characters & Creatures focuses on the design and creation of a variety of character and creature sculpts by world-class artists including Mariano Steiner, Maarten Verhoeven, Caio César, and Kurt Papstein. Topics covered by the panel of industry experts include alien concepts, quadruped designs, and inventive creatures, while a collection of speed-sculpting tutorials offers fantastic insight into working quickly with this revolutionary sculpting software. Aimed at aspiring and experienced modelers alike, *ZBrush Characters & Creatures* is a go-to resource for those looking to learn tips, tricks, and professional workflows from the digital art masters, taking you from concept to completion across a variety of imaginative projects.

To see our full range of books visit shop.3dtotal.com

3dtotalAnatomy

Whether you use pencil and paper, paintbrushes, clay, ZBrush, Maya, 3ds Max, or Photoshop, our anatomical reference figures are invaluable if you want to understand the form and structure of the human body.

All figures are neutrally posed and of an athletic build, standing between 16 and 34 cm tall. Cast in gray resin in order to make the variation in the surfaces and directional flow of the muscles easy to see and understand, the size and low price tag make these models a perfect desktop reference, while also maintaining the level of detail an artist requires.

To see our full range of figures visit shop.3dtotal.com

3dtotalPublishing

3dtotal Publishing is a small independent publisher specializing in inspirational and educational resources for artists. Our titles proudly feature top industry professionals who share their experience in step-by-step tutorials and quick tip guides placed alongside stunning artwork to offer you creative insight, expert advice, and all-essential motivation.

Initially focusing on the digital art world, with comprehensive volumes covering Adobe Photoshop, Pixologic's ZBrush, Autodesk Maya, and Autodesk 3ds Max, we have since expanded to offer the same level of quality training to traditional artists. Including the popular *Digital Painting Techniques*, *Beginner's Guide*, and *Sketching from the Imagination* series, our library is now comprised of over forty titles, a number of which have been translated into different languages around the world.

3dtotal Publishing is an offspring of 3dtotal.com, a leading website for CG artists founded by Tom Greenway in 1999.

3dtotalpublishing.com | 3dtotal.com | shop.3dtotal.com